TWENTIETH-CENTURY AMERICAN FOLK ART AND ARTISTS

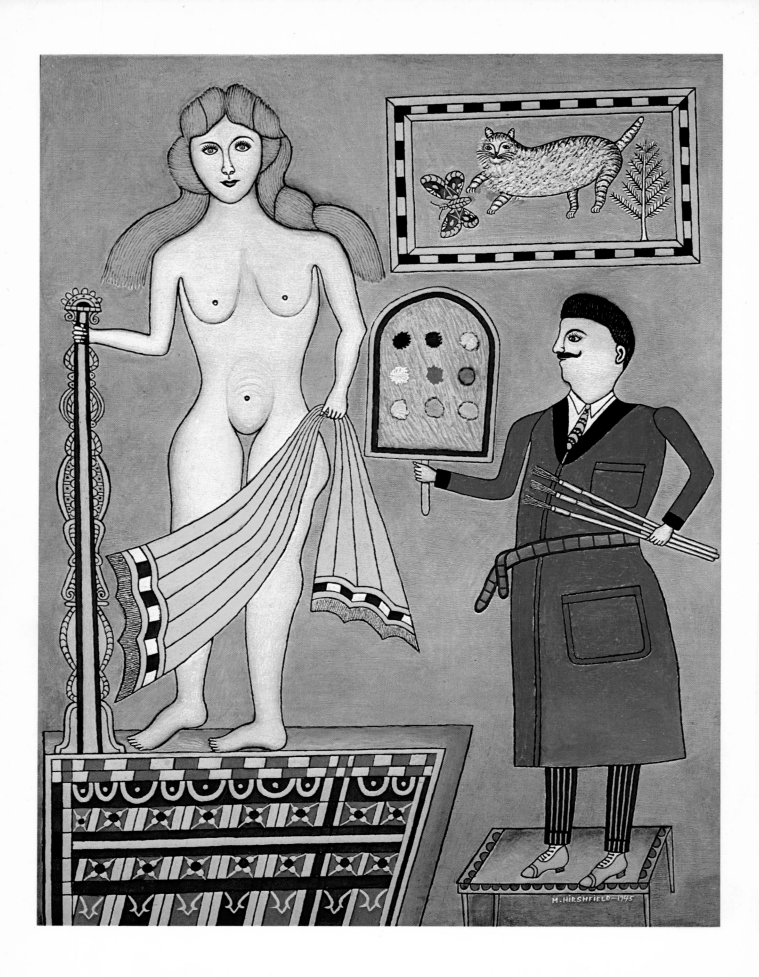

TWENTIETH-CENTURY AMERICAN FOLK ART AND ARTISTS

by

Herbert W. Hemphill, Jr.

Julia Weissman

NEW YORK
E. P. DUTTON & CO., INC.
1974

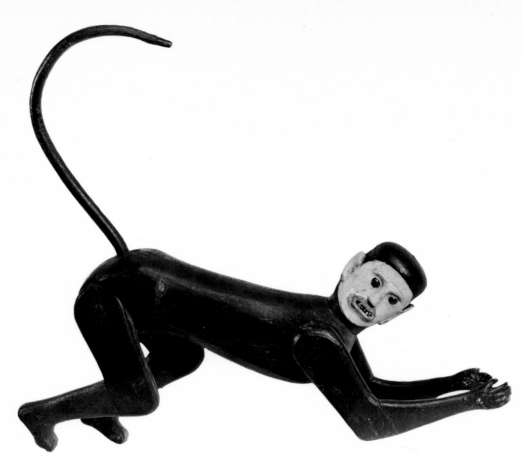

Figure 1, page 2: Morris Hirshfield: *The Artist and the Model*. 1945. Oil on canvas. 34″ x 44″. New York. ". . . even in my young days I exhibited artistic tendencies—in wood carving, at the age of 12 I produced a unique noisemaker for Purim; the furor it created was such the Rabbi [asked] my father [to] hide my work of art in order that prayers could be rendered." (Sidney Janis). Courtesy Sidney Janis Gallery. Photograph: Eeva-Inkeri.

2 (above). Anonymous: *Monkey*. c. 1930. Polychromed wood. L. 24″. New York. Private collection. Photograph: Michael D. Hall.

First published, 1974, in the United States by E. P. Dutton & Co., Inc., New York. / All rights reserved under International and Pan-American Copyright Conventions. / No part of this book may be reproduced or transmitted in any form or by any means, electronic or mechanical, including photocopy, recording, or any storage and retrieval system now known or to be invented, without permission in writing from the publishers, except by a reviewer who wishes to quote brief passages in connection with a review written for inclusion in a magazine, newspaper, or broadcast. / Published simultaneously in Canada by Clarke, Irwin & Company Limited, Toronto and Vancouver. / Printed and bound by Dai Nippon Printing Co., Ltd., Tokyo, Japan. / Library of Congress Catalog Card Number: 74-12934 / ISBN 0-525-22473-4. *First Edition*

PREFATORY NOTE

This book is essentially a broad survey of the wealth and variety of American folk art produced since 1900. It is, therefore, not divided into chapters; instead, it has been arranged more or less chronologically. An index to the artists whose works are illustrated will be found on page 234 following the bibliography.

ACKNOWLEDGMENTS

The authors of this book are indebted to the generosity of individuals and organizations acknowledged below and in the captions. Particular thanks are owed to the following:

Jacqueline Airamée, for use of her research papers for an as yet unpublished project on outdoor folk sculpture in the West; the American Federation of Arts, for photographs from the *Symbols and Images* catalogue; Gregg N. Blasdel, for his biographical files on the artists in that catalogue; E. Lorenz Borenstein, for many fruitful leads and help; James Eakle, for permission to choose freely from a generous selection of his arduously accumulated slides; Mr. and Mrs. Elias Getz, for unlimited access to the photographs of their collection; M. J. Gladstone, for such strong support, when he was director of the Museum of American Folk Art, to the concept of the show upon which this book is based; Michael D. Hall, for his constructive interest and access to his collection and photographs; Mr. and Mrs. Sterling Strausser, long known for their staunch interest in this field of art, for sharing their many discoveries; Cyril I. Nelson, the editor, and Robert Bishop, the book designer, for their understanding and patience; and Max Gartenberg, the literary agent, for his faith in this book.

INDIVIDUALS

Richard Ahlborne
Jacqueline Airamée
Mary Allis
Bunty and Tom Armstrong
Joan and Darwin Bahm
Jack Balton
Robert Bishop
Mary Black
Joanne Bock
Jess Bollinger
Edward Bragaline
Roger Brown
Mr. and Mrs. Vincent A. Carrozza
Mr. and Mrs. Douglas E. Cohen
Mr. and Mrs. Shalom Comay
Mr. and Mrs. Louis Costa
Joseph Lee Cotton
Allan L. Daniel
Mrs. Nora Dorn
James Eakle
William A. Fagaly
Dr. Elizabeth Fehr
Evan Frankel
Alfred Frankenstein
Peter B. Frantz
Mr. and Mrs. Frederick P. Fried
Mrs. Estelle Friedman
Mr. and Mrs. Elias Getz

Dr. and Mrs. William Greenspon
Boris Gruenwald
Mr. and Mrs. Michael D. Hall
Whitney Halstead
Mrs. Anna Harpool
Mrs. Roy Henry
Jay K. Hoffman
Susan Hopmans
Mr. and Mrs. Alan Jaffee
The Sidney and Harriet Janis Collection
The Barbara Johnson Collection
C. R. Jones
Dr. and Mrs. Louis Jones
Mr. and Mrs. Harvey Kahn
Stephanie J. Kahn
Annette and Louis Kaufman
Phyllis Kind
Dr. and Mrs. A. J. Korff
Jim Kronen
Jean Lipman
Bertram K. and Nina Fletcher Little
The Low Family
Michael Malone
Richard and Elizabeth Moore
Mr. and Mrs. J. Roderick Moore
Milo M. Naeve
Mr. and Mrs. B. S. Nelson
James and Gladys Nutt
Toshio Odate

Peter Odens
Tony and Angela Palladino
Mr. and Mrs. Richard Polsky
William H. Plummer
Vincent Porcaro
Peter Prince
Marshall M. Reisman
Mr. and Mrs. Jerry Riordan
Mr. and Mrs. Sam Rosenberg
Jeremy and Barbara Samson
Mr. and Mrs. Samuel Schwartz
Mr. and Mrs. Walter E. Simmons
Dorothy Swale Smith
Chuck Spalding
Mr. and Mrs. Jeffrey Stark
Nina Howell Starr
Mr. and Mrs. Sterling Strausser
Chris Sublett
Werner Tiburtius
Eric S. Vogel
Sandra Weiner
Morris Weisenthal
Mr. and Mrs. Joseph Wetherell
Mr. and Mrs. Dan C. Williams
Marcia Wilson
Mrs. Lois Wright
Ray Yoshida
Virginia Zabriskie

INSTITUTIONS

American Federation of Arts, New York

Arkansas Arts Center, Little Rock, Arkansas

Berea College, Berea, Kentucky

Bishop Hill Heritage Association, Bishop Hill, Illinois

Bishop Hill Memorial, Illinois, Department of Conservation, Bishop Hill, Illinois

Brooklyn Museum Art School, Brooklyn, New York

Broome County Historical Society, Binghamton, New York

Colorado Springs Fine Arts Center, Colorado Springs, Colorado

Columbus Museum of Arts and Crafts, Columbus, Georgia

Combank Mortgage Funding, Ltd., Chicago, Illinois

Greenfield Village and Henry Ford Museum, Dearborn, Michigan

Melrose Plantation, New Orleans, Louisiana

Memorial Art Gallery of the University of Rochester, Rochester, New York

Museum of American Folk Art, New York

The Museum of Modern Art, New York

Museum of New Mexico, Santa Fe, New Mexico

New York State Historical Association, Cooperstown, New York

Pennsylvania Academy of the Fine Arts, Philadelphia, Pennsylvania

Preservation Hall, New Orleans, Louisiana

Red Hook Senior Citizens Center, Brooklyn, New York

Abby Aldrich Rockefeller Folk Art Collection, Williamsburg, Virginia

Shelburne Museum, Shelburne, Vermont

Sheldon Memorial Art Gallery, University of Nebraska, Lincoln, Nebraska

Smithsonian Institution, Washington, D.C.

Margaret Woodbury Strong Museum, Rochester, New York

Taylor Museum, Colorado Springs, Colorado

Tennessee Fine Arts Center at Cheekwood

United States Department of the Interior, Indian Arts and Crafts Board, Washington, D.C.

University of Washington School of Art, Henry Gallery, Seattle, Washington

Viterbo College, La Crosse, Wisconsin

Whitney Museum of American Art, New York

ART GALLERIES

Babcock Galleries, New York

E. Lorenz Borenstein Gallery, New Orleans

Bernard Danenberg Galleries, New York

David & David, Inc., Gallery, Philadelphia and New York

Albert E. Eisenlau Decorative Accents, New York

Harold Ernst Gallery, Boston, Massachusetts

Explorers Shop, New Orleans, Louisiana

Rhea Goodman: Quilt Gallery, Inc., New York

Jay K. Hoffman Associates, New York

Sidney Janis Gallery, New York

Kennedy Galleries, Inc., New York

Phyllis Kind Gallery, Chicago, Illinois

Jim Kronen Gallery, New York

Morris Gallery, New York

The Galerie St. Etienne, New York

Fannie Lou Spelce Associates, Dallas, Texas

Stony Point Folk Art Gallery, Stony Point, New York

Valley House Gallery, Dallas, Texas

INTRODUCTION

A WORK OF ART:

". . . the sense of beauty [is] a very fluctuating phenomenon, with manifestations in the course of history that are very uncertain and often baffling. Art should include all such manifestations . . . and whatever [one's] own sense of beauty . . . admit . . . manifestations of that sense in other people.

"We always assume that all that is beautiful is art, or that all art is beautiful, that what is not beautiful is not art, and that ugliness is the negation of art . . .

"Art . . . is not the expression in plastic form of any one particular ideal. It is the expression of any ideal that the artist can realize in plastic form.

"It may produce effects of terror or horror which are powerful and even sublime, and then . . . we are in the presence of a work of art.

". . . whether beautiful or ugly, all these objects may be described as art."

Herbert Read, *The Meaning of Art*

Edgar Tolson (shown in figures 3 and 4, above and below, and figure 5, opposite): *The Fall of Man.* c. 1969. Whittled and painted wood. The figures in this series of eight carvings are from 12½″ to 15″ high; the platforms are approximately 13″ long. Campton, Kentucky. *The Fall of Man #1* (opposite): Paradise. Courtesy Mr. and Mrs. Michael D. Hall.

The genesis of this book was the exhibition "Twentieth-Century American Folk Art and Artists," organized by Herbert W. Hemphill, Jr., and shown at the Museum of American Folk Art in New York in the fall of 1970. If not unique in concept and content, it was, we believe, the first time within the perimeters of one show that American folk art of the twentieth century had been so broadly explored by a public institution beyond the area of painting. In addition to pictorial modes, the exhibition included wood carvings that ranged from Edgar Tolson's stark, whittled figures to the more detailed *santos* of latter-day New Mexican religious tradition, naïve neon and ebullient road signs, toys and decoys, astonishing pieces done with fabric and needle skills, assemblage objects built of collectors' mania and memorabilia, and photographs showing examples of storefront art, graveyard art, scarecrows, fantasy gardens, and environments. It was abundant evidence that as an art expression with sources in American craft traditions, folk art is as vibrant and important in this century as it was in the eighteenth and nineteenth.

When it came time to translate the spirit and significance of that 1970 exhibition into a book, a troublesome matter arose: that of defining "folk art" and identifying the "folk artists" of the United States in the twentieth century.

Not that there is a scarcity of nomenclature for these artists. Sidney Janis, a noted dealer in modern art, after some self-debate, termed them "self-taught" in his book *They Taught Themselves*, which he wrote in 1942. Writers and critics in the field have called them "primi-

tives," and in The Museum of Modern Art's show in 1938, held in collaboration with the Grenoble Museum in France, they were referred to as "popular" artists, not because they were widely known and admired (which they were not), but because they were from the ordinary run of people, the populace. Oto Bihalji-Merin, the European authority, prefers to call them "masters" of "naïve" art, in the sense of artists who display total candor of technique and intent. Others have labeled them "Sunday artists," which seems to derogate their seriousness, since for many of them, their art rather than their livelihood is their really important work, even if done during "idle" hours. "Amateur" suggests something less than first-rate ability, while "art of the common people" has an aura of political polemic. Other often-used terms are "grassroots" art, or "compulsive," "spontaneous," and "unconscious." These latter, though certainly expressing qualities inherent in this art, have the gloss of patronizing psychoanalysis.

It may well be that any one or all of these terms are more accurately descriptive than "folk" when applied to the art and artists in this survey. Yet, considering the history and continuity of such art, its nature and content, and the areas of American life from which so many of these artists or their work emerge, "folk" art seems to us to be the most fitting term after all. For, although there are special cases or exceptions, what are presented here are, on the whole, the works of truly American folk: everyday people out of ordinary life, city and suburban, small town and country folk, who are generally unaware of and most certainly unaffected by the mainstream of professional art—its trained artists, trends, intentions, theories, and developments.

If there is any one characteristic that marks folk artists, it is that for them the restraints of academic theory are unimportant, and if encountered at all, meaningless. In effect, the vision of the folk artist is a private one, a per-

sonal universe, a world of his or her own making. There exists only the desire to create, not to compete, not necessarily to find fame (although many are not without ego and pride and do very much enjoy the pleasure of being recognized). Hence, the products of the folk art world are truly the art of the people, by the people, and for the people, and the vigorous life of this art has no limit in time.

Nor in space. Folk artists are just as likely to come from crowded Bronx environments, like Ralph Fasanella and the Reverend Maceptaw Bogun, as from the mountains of Appalachia, like Edgar Tolson, or the Texas prairies, like Clara Williamson; from the jumble of the Red Hook section of Brooklyn where Gustav Klumpp lives, or a neat flat in Manhattan, the home of retired school teacher Margaret Crane. They may pursue their private visions within the old traditions of the New Mexico Catholics and Indians of the Southwest; or spend a lifetime creating fantasy worlds in the middle of a desert, just as Calvin and Ruby Black did (see pages 130–133). Simon Rodia built his ornamented towers of cement lace in the crowded Watts section of Los Angeles (pages 66–69), and S. P. Dinsmoor's concrete biblical figures seem to fly in the air around his house in the hinterlands of Lucas, Kansas (pages 80–81).

Habitat, however, can be of importance in the making of some folk artists, either as source material for content (as in the many memory paintings), or sometimes as chance inspiration. Thus M. T. Ratcliffe found himself in Jacumba, California, during the Depression, and remained there for two years, carving with hand chisel and mallet to free the monsters he seemed to see imprisoned in the huge, time- and water-tumbled granite stones of Boulder Park Caves (page 88).

Identifying the folk artist doesn't entirely clear muddy waters, however, for the art must also be defined. American folk art has seemingly been confused in the minds of much of the general art public—collector and merely curious gallery visitor alike—with the period of American history prior to 1900, the date, more or less, for the coming of age of the country: the end of our pioneer days, the passing of the era of handcraft and innocence into the age of mass transportation, mass production, mass media, and mass ideas. Education, discovery, and the duties of tourism, if not love of art alone, have forced a sufficient traffic through enough museum corridors so that most people easily recognize examples of American folk art of the past: the "non-professional" oil and watercolor portraits, nobly proportioned ships' figureheads, stolid cigar-store Indians, incised whale ivories called scrimshaw, wooden or copper weathervanes, handmade toys, painted tole ware, samplers cross-stitched with prim moralities, painted and embroidered mourning pictures, and handhooked rugs, to say nothing of the quilts now coveted for the contemporaneity of their graphic patterns and the excitement of their color organization, the artless

statuary of gravestones, bright, calligraphic *frakturs* done with pen and watercolor, and even handmade tools.

All of this was the work of both amateurs and craftsmen who fulfilled the commercial and domestic demand for art and decoration at the level below that of the wealthy and highly educated. Much of it carried strong echoes of the craft guild tradition of Europe, though the artisans themselves may not necessarily have had such training. It was neither the rich elite nor learned professional who populated colonial America, but rather those who had worked for them: farmers, weavers, servants, silversmiths, furniture makers, blacksmiths, millers, pewterers, etc.—people who knew how to "coordinate the activity and the eye and had the art of making things with their hands . . ."[1] Much of what these artisans produced as utilitarian objects has come to be recognized and valued by modern collectors as true works of art.

What is surprising about early American folk art, including portraiture, is how early it appeared and how vital and widespread it was. Though the settlers themselves thought they were simply trying to "blend the useful with the agreeable," it seems apparent to modern eyes that "they had something they wanted to express and they proceeded to set down what they had to say with the means and materials at hand."[2]

This tradition—where the craftsman unconsciously makes his product into a work of art, or consciously tries to paint a portrait or decorate a wall, as did the itinerant limners—persisted through the nineteenth century and even into the twentieth. But this art diminished in quantity, at least publicly, as mass-production industries destroyed the need for handmade products.

It is in the sense of this engagement between individual art statement and folk craft that we assert American folk art stems from a craft tradition. Today, the distinction is not always a clear one, particularly since so many craft objects of the present as well as the past are enshrined for their art qualities, and when so many trained artists use craft media and techniques. Yet it became evident during the research for this book that a distinction between folk art and folk craft would have to be made, even though any such definition courts argument.

There *is* a difference between folk "art" and folk "arts and crafts." The "arts" of a folk craft tradition are applied to functional objects generally made according to a localized or indigenous tradition. The term has a connotation of peasantry. The intention is to liven objects of daily use with a touch of gaiety or color. The technical skill, which is not necessarily meticulous, to produce objects of use and the decorative art forms—designs, patterns, shapes, colors, materials—that embellish them are passed down from one generation to another. These, as well as the purpose or usage of the object are institutionalized into a repeated tradition, and are often refined and stylized in the process. The inherited embroidery patterns of Eastern Europe, the pottery decoration of the Indians of

the Southwest, or the carvings of the Northwest coast Indians come to mind.

The artisan may and often does swerve from traditional design or invent new rules. However, as in the case of the American folk artists, the utilitarian purpose of the object is never lost sight of. It is in the originality, the bending of tradition to serve a personal vision that the craft artisan of previous eras becomes a folk artist, in the eyes of the modern collector.

In this century, in the period after World War I and particularly in the last thirty years, the folk artist is often partner to the craft tradition by coming to it from another direction: that of aesthetic or creative drive alone rather than, and quite apart from, utilitarian intent or financial need. The folk artist today frequently either deliberately chooses a craft medium and craft materials for his or her art expression, or else uses, often by accident, such "conventional" media as oil paints, acrylics, wood, clay, or stone, and brings to them the same respect that any dedicated craftsman has for his tools or his trade. Mary Borkowski, an urbanite of Appalachian descent, chose quilting and appliqué for her bed-size wall hangings and a form of self-taught stitchery for her thread paintings (page 156). With them she materializes a personal vision that others might express in oil on canvas. Needlepoint is such a precise embroidery technique that most people feel secure doing it only after the design has first been printed on the canvas in the colors to be used; yet Pauline Shapiro used the technique with a freehand abandon to produce both abstract and figurative work presketched only in her mind, never on the canvas, and often of scenes she had never seen (page 157). In the wood inlay of *World War I, or Tribute* there is the unaffected emotion of an anonymous artist thoroughly familiar with the techniques of woodworking, but who cared nothing for the rules of academic art (page 49).

The folk artists of today and yesterday are alike in an even more subtle way. They participate in an art tradition that can perhaps be described only with the clichés of timelessness of vision, attitude, and content, and in varying degrees, even style and technique. If the word "primitive" is to be applied to folk art, it should be in the context of "beginning," for the folk artist of every generation of each era is constantly renewing the origins of art. The folk artists of our time link hands and minds with those of previous times and peoples, even back to the earliest artworks known in the caves of Altamira and of Lascaux. Frank Mazur's wooden girl, *The Messenger, Let My People Go,* is directly comparable to the ancient funerary Haniwa figures of Japan, or the gravestones of New England cemeteries, or the angels in medieval English churches. Symbolically, they all memorialize the dead by proclaiming immortality, and technically they are related in a candidness of technique that allows the unhindered primacy of their statements.

Herbert Read refers to primitive art as "an art of the senses, an art which delights in liveliness, in concentration on the essential vitality of characteristic elements . . . such art is organic, vitalistic, sensuous. Its opposite type is abstract art . . . art which takes no delight in the organic nature of things, but tends to deform them in the interest of some ulterior motive . . ."[3]

It may be that the phrase "organic nature of things" explains the appeal of folk art to those of us who find ourselves deeply committed to art, professionally or otherwise. This is not to imply that an interest in folk art necessarily indicates a personal dissatisfaction with or a deprecatory attitude toward abstract art. It simply means that for many of us folk art, in remaining connected to the "organic nature of things," and requiring no knowledge of art history or an explanation of the artist's intentions, is a more accessible and comprehensible art.

We would have preferred to present this art without the interference of analysis. However, a brief glance backward may serve to emphasize how untaught expression is an enduring phenomenon whose essence has been less buffeted by progress than other manifestations of creativity.

To us as observers, who have synthesized impressions and information accumulated from experiences with art as collectors and viewers, it almost seems that art has been largely reportorial from its earliest beginnings to the end of the nineteenth century. However personal in impetus and statement, however decorative in usage, accurate or distorted in detail, whatever its allegorical application or symbolism, its essential purpose seems to have been to represent the artists' impressions and perceptions of fact or reality or of ideology and religion. Art thus recorded, and instructed in pictorial or plastic form and in known symbols the substantiality of beliefs, the presence of gods, beasts, humans, and the encompassing universe. Art and artists were, until the end of the nineteenth and the onset of the twentieth century, journalists of the human condition. Art was an essential form of communication, and in that sense artists were scribes and teachers, necessary and functional in their societies. Seldom, if ever, did the artist stray so far from familiar symbology or forms that the viewer did not absorb the message, for artist and audience shared the same objective substantivity, if not always the same emotional or mental perception of it.

None of this is to say that all art served these offices or that it was ever at any time exclusively considered as having so educative a purpose; or even that art developed less from the human being's aesthetic sense and pleasure than from the need to document ideas and events and stabilize them into some kind of visible order. It is at best a simplistic conception of the importance of art and artists from the beginning of social organization.

When knowledge altered superstition and religion in the Western world, and intellectual and scientific concepts widened, and wealth and the church created new aesthe-

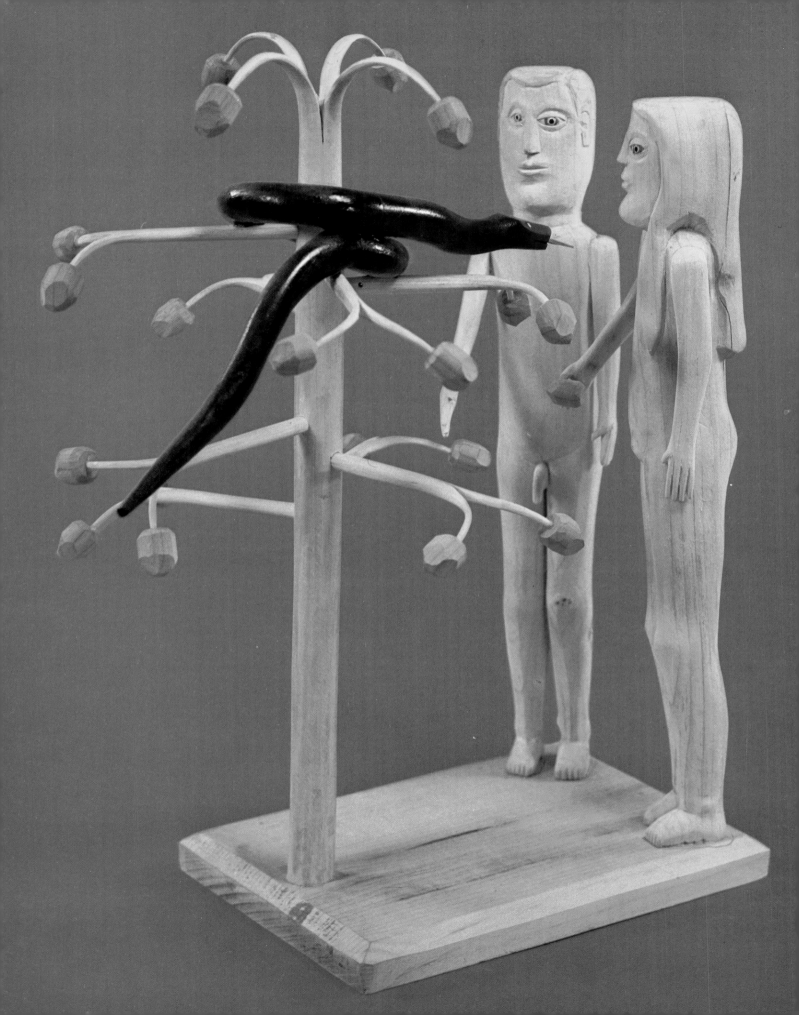

tic demands, the pressure on artists was for verisimilitude and naturalism, with an insistence upon factual dimensions, exact proportions, correct spatial relationships, even the application of optical laws to produce "what the eye sees." This was the lodestone of the academic tradition, which required that art, in the words of Roger Fry, "conform to the appearance of the actual world."

This tradition, though it still influences and survives in art education, was shaken by the Industrial Revolution. The sociological consequences of the rapid development and interaction of communications, science, medicine, and the factory manufacture of so much of what had hitherto been made by hand all affected the very behavior and thoughts of daily life in general—and art and the arts and crafts in particular.

If there was any one invention that affected art and artists to a degree that artists themselves may not have recognized, it was photography. The coinage of the camera roiled the content and function of art, and deflected the role and importance of the artist. As much as it was a revolt against the rigidity of academicism, the emergence of impressionism and "modern" art during the latter part of the nineteenth century may also have been a realization, subconscious perhaps, that photography could record more rapidly and cheaply and repetitively what artists had been doing until then.

Photography phased out almost completely the work of the itinerant American portrait painter, who was replaced by the itinerant photographer, for the obvious reason that photographic portraits were much cheaper and thus available to many more people than could afford the work of the itinerant limner. It isn't hard to imagine how fascinating it was for people to be able to record the family's history from infancy to marriage to grave in pictures that could be distributed as easily as a letter.

Very likely it was photography, as much as anything else, that forced professional artists to look for new ways and other styles, to look beneath shapes and to become subjective about *persona*. Composition, balance, color, and space relationships became aesthetic problems in and of themselves and sometimes the only purpose of the work.

The professionally trained artist, or one who chooses to experiment by breaking rules intentionally, recognizes his conflict with academic tradition. A partial explanation of the continuous appeal of folk art is that it is for the most part unaffected by academicism yet possesses the essential aesthetic qualities of form and composition, as well as content. The folk artist is neither aware that he functions within a tradition—his own—nor that that tradition has undergone certain permutations; he is probably quite unaware that whereas the professional artist records the state of art relative to society, the folk artist reports the state of nature.

Not that the untaught artist is totally unaffected by events. On the contrary, a good many indicate a sharp

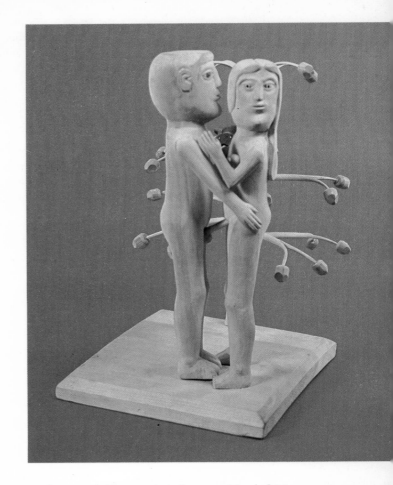

#2 (opposite): Temptation. Courtesy Mr. and Mrs. Michael D. Hall.

#3 (above): Original Sin. Courtesy Mr. and Mrs. Michael D. Hall.

awareness of them. But because such artists are not concerned with movements, fads, or theories, or the need to make a living from art, there is a direct communication between mind and hand. They do not deliberately look for new structural forms or seek consciously to experiment with style. They are generally satisfied with whatever style or technique emerges right at the beginning. It is not the philosophy or meaning of art per se, but their own philosophies, the meaning of their own lives relative to their world *and* our world, that concern them. The absence of intellectualism allows for a free flow of ideation. The result is often a closer personal relationship between artist and viewer.

In innate impulse, all artists, untaught or otherwise, start from the same point. Herbert Read speaks of this as the "creative aspect of art,"[4] which he describes as occurring in five phases:

1. There is first a predisposing emotional mood, a state of readiness or awareness, perhaps a sense of the momentary availability of the unconscious level of the mind.

2. Whilst he is in this state, there comes to the artist the first premonitions of a symbol, or thought to be expressed, not in words, but in visible and tangible material shape—perhaps "this landscape," "this dish of fruit," perhaps only an abstract adumbration of planes and masses.

3. Then, as a third step . . . the mental elaboration of this symbol, the introduction of selection of images which the mind intuitively associates with the symbol, the determination of the emotional value or pressure of the images.

4. Next, the artist seeks an appropriate method, including an appropriate material, by means of which he can represent the symbol.

5. Finally, there is the actual technical process of translating the mental perception into objective form—a process during which the original symbol may receive considerable modification.

"In actual practice," Read continues, "this takes place as an integral and inseparable activity . . . the artist does not necessarily always begin at the beginning . . . He may begin at almost any stage and go backwards before going forwards—he may, and very often does, begin with the material, paint, or stone, and from a concentration on this, and perhaps from a playful preliminary activity with his tools, he induces the preliminary mood. But fundamental to . . . the creative process is . . . that art is the expression through . . . intuition, perception, or emotion peculiar to the individual. Nowhere . . . [is] there justification for the notion that art is primarily an intellectual activity concerned with the formulation of absolute ideas or ideal types . . . Art is concerned with sentience, with visual cognition, with symbolization, but never with intellection, generalization, or judgment."

Read quotes the philosopher Henri Bergson's definition of laughter as being at the same time a definition of art. It seems, as well, a particularly close definition of art from the folk source:

"From time to time . . . nature raises up souls that are more detached from life . . . with a natural detachment, one innate in the structure of sense or consciousness, which at once reveals itself by a virginal manner, so to speak, of seeing, hearing, or thinking . . . one man applies himself to colours and forms, and since he loves . . . [and] perceives them for their sake and not for his own, it is the inner life of things that he sees appearing . . . Little by little, he insinuates it into our own perception, baffled though we may be at the outset . . . he diverts us from the prejudices of form and colour that come between ourselves and reality, and thus he realizes the loftiest ambition of art, which . . . consists in revealing to us nature."[5]

It may be thought that our modern capacity to flood even the remotest corners of the country with the same ideas, clothes, movies, TV programs, newspapers, magazines, advertisements, books—all the materials and appurtenances for the simultaneous education of our society—would have produced a sophistication on such a scale as to overwhelm the folk artist, just as mass production has vitiated the commercial practicality of handcraft.

But this hasn't happened. Spread throughout America, in its cities, in towns, in back country areas, there is an extraordinary wealth of folk art, far more than could possibly be included in this survey. Much more surely remains to be discovered, and much still needs to be recognized by the public as true art, rather than oddity—for example, Edward Leedskalnin's "Coral Castle" in Florida (page 56); or Peter Mason Bond's now dismantled "Peace Garden" in San Francisco (page 121); or the whirligig of dolls and found materials by T. J. Little standing in its creator's front yard in Bellingham, Washington (page 174).

Environmental folk art very frequently inspires as much awe as appreciation of its aesthetic qualities. Often it is the mere fact that such art is *there* that impresses, and its presence alone may cause something of the same impression as the monoliths at Stonehenge or the pyramids of Mexico. As astonishing as these ancient monuments are, they are no more astonishing than the fact that there are folk environments and fantasies of unbelievable size and complexity, made by single individuals without a prepared plan or design, and that their inner vision has fired them with the energy and inspiration to persist in their backbreaking labors for as long as thirty years.

These creations, however, have an integrity as works of art beyond their power to amaze. Too often they suffer from the common prejudice against the *outré*, but once this feeling is overcome, they can be seen as art compositions in balance with their settings. As Read has said, "Art is indeed the discovery and establishment of a new world of forms, and form is rational; but art is a con-

tinual transformation of form by forces that are vital and irrational."[6]

Possibly one might be tempted to say that the creators of such gigantic fantasies are mad, but their work lacks affectation and artifice, and doesn't have the stamp of the conscious iconoclast. Theirs is not heterodoxy for its own sake, but for the sake of their own beliefs.

Familiarity with much outdoor art may breed contempt and cloud judgment. The Brown Derby at Hollywood and Vine seems "corny" or "camp," belonging to a particular era of Hollywood outsize. But isn't it possible for us to view it as an outdoor example of the kind of Surrealism produced by René Magritte, or even an early realization of Claes Oldenburg's sketches of monuments for New York City—those enormous, everyday objects he would like to see poised over the Hudson River?

A house-size building shaped like a duck out on Route 24 on the eastern end of Long Island—would it not serve as one of the grotesques of Hieronymus Bosch? In making these comparisons, we are not saying that these examples can automatically be considered good folk art. There is good folk art and bad folk art, just as there is good and bad establishment art. However, the duck-shaped building possesses a boldness, brashness, and exuberance stemming from a lack of self-consciousness and the very direct expression of what it stands for, in the same way that seventeenth- eighteenth- and nineteenth-century signs were visual definitions.

If there is a difference in the sources of modern folk art and that of previous centuries, it seems to be a difference in the nature of the support, the stimulant, and in the age groups producing the bulk of it. In past eras, people of all ages produced folk art, because people of all ages were accustomed to the various crafts and the arts of embellishing them.

In this century, particularly since the days of the Depression, a good deal of folk art as well as craft has been carefully, even conscientiously, nurtured. It may come as something of a surprise to discover how much of this is owing to federal influence, some of it as far back as the end of the nineteenth century.

Our government, by establishing a tradition of community support during the Depression, has been remarkably effective in fueling the energy of creativity at the popular level and aiding its growth. In the United States we may not use taxes to sustain the arts as much as artists might legitimately wish, but community participation in and maintenance of art programs in local centers, and even recognition of the therapeutic value of art, are a direct outcome of government interest.

The present-day absorption in do-it-yourself projects and crafts of all kinds is in some measure due to increasing costs of materials and a dwindling supply of skilled workers, as well as a personal protest against the shoddy quality of industrial production. But this absorption also derives from the basic and instinctive need to create.

This was a possibility foreseen by William Morris as long ago as 1887, when he wrote in his essay, "The Aims of Art:"

I suppose that this is what is likely to happen; that machinery will go on developing . . . till the mass of people attain real leisure . . . they would accordingly do less and less work, till the mood of energy . . . urged them on afresh . . . Nature, relieved of the relaxation of man's work, would be recovering her ancient beauty, and be teaching men the old story of art. And as the artificial Famine, caused by men working for the profit of a master, and which we now look upon as a matter of course, would have long disappeared, they would be free to do as they chose, and they would set aside their machines in all cases where the work seemed pleasant or desirable for handiwork; till in all the crafts where the production of beauty was required, the most direct communication between a man's hand and his brain would be sought for.

The current popularity of ethnically or regionally derived art and arts and crafts is not just a recent phenomenon. The history of salvaging American crafts from total obliteration by mass production goes back at least 76 years.

In 1897, Henry Lewis Johnson, a young printer in Boston, impressed by an exhibition of English handcrafts, organized a similar one for America. This germinated the National League of Handicraft Societies, and since the very first years of the century, there has been a steady and slowly increasing drive to preserve and develop art and arts and crafts outside the commercial sphere of professionalism. The emphasis has not been solely on tradition, but also on encouraging originality of method and design.

The American Federation of Arts is linked to this early movement through its president and director, Frederic Allen Whiting, first secretary of the Society of Arts and Crafts. AFA worked diligently and successfully to win major museum recognition for the work of the Southern Highland Handicraft Guild, and with the cooperation of the Russell Sage Foundation, gained government acceptance. The first National Rural Arts Exhibition in the country was a feature of the 75th-anniversary celebration of the United States Department of Agriculture.

Preoccupation with American craft traditions centered on keeping them alive and well in an expanding industrial culture; interest in folk art tended to focus, in the beginning, on paintings (and later, sculpture) of the past rather than on contemporary examples. Hamilton Esther Field, founder of *The Arts Magazine* in 1920 and a supporter of the modern movement, saw the same qualities in the early American paintings he was collecting that others were discovering in the art of "primitive" civilizations in Africa, the South Seas, and Central and South America. Many of the young modern painters and sculptors who knew him and his collection also began acquiring; and

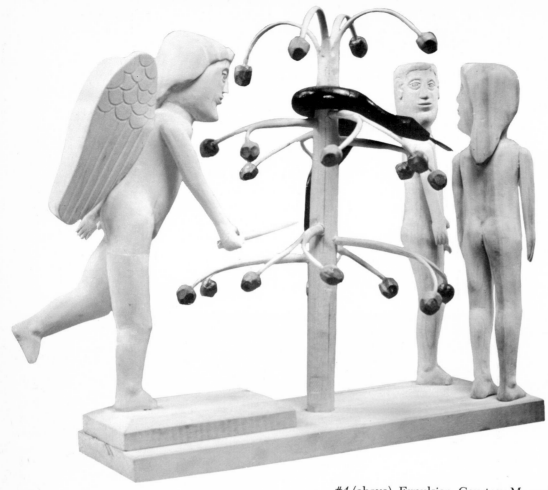

#4 (above). Expulsion. Courtesy Mr. and Mrs. Michael D. Hall.

in 1924 the Whitney Studio Club organized a small exhibition. In 1931, in response to the urging of Holger Cahill, The Newark Museum organized a show that went on tour as far as Chicago. The Museum of Modern Art held its show, "American Folk Art, the Art of the Common Man," which included sculpture, in 1932.

All the foregoing may have tended to place on American folk art the historical connotation we mentioned earlier, and imply that the best of it lay in the country's past. A correction of this implication came with the 1938 show "Masters of Popular Painting" in which modern primitives from Europe and America were exhibited at The Museum of Modern Art and which included such great contemporary American folk artists as Joseph Pickett, Horace Pippin, John Kane, Morris Hirshfield, Lawrence Lebduska, Emile Branchard, Patrick Sullivan, and others. Among the collectors and lenders listed were Sidney Janis, Mr. and Mrs. John D. Rockefeller, Adelaide Milton de Groot, Mr. and Mrs. William S. Paley, E. Wehye, and four art galleries. The Metropolitan, Whitney, and Newark museums also lent to the show.

How directly these two trends—to maintain the vigor of American craft traditions and to emulate the European attitude of appreciation for the untaught artist—affected those in the federal government is hard to tell. But 1929 was the year of the Crash and the onset of the Depression, and 1932 was the year Roosevelt was elected and the government put into action a number of projects to give the nation a sense of wholeness and to restore to the common people their feeling of personal and community worthiness. (Among these projects was the monumental compilation of the Index of American Design, one of the most comprehensive documentations of eighteenth- and nineteenth-century arts and crafts.) No matter what the political or economic reasoning behind the programs, these were the stated intentions and the effect.

Of all the restorative efforts, the most encompassing was the Works Progress Administration, which not only built roads and post offices, but, through the establishment of the W.P.A. Art Project, gave evidence that the federal government was acting on a principle that opportunity for creative expression was next to or on a par with

full employment as an essential for the country's well-being and health. Though possibly intended to provide employment for professionals and teachers in the arts, while at the same time siphoning off into some kind of satisfactory activity the fretfulness of others who were unemployed or unemployable, the result for the arts has been broader and more durable than most of us realize. There were hundreds of day and evening classes conducted in settlement houses, Y's, high schools, museums, recreation halls, granges, etc., under the tutelage of art associations and established professionals. By being open to everyone of every age, art was recognized by officialdom, federal and cultural, as an important, even necessary community activity.

Though the W.P.A. Art Project dissolved long ago, its philosophy remains quite alive and motivates activity in

areas such as union-sponsored classes, courses at Christian and Hebrew Y's, projects in rural homemaking programs of the Extension Service of the Department of Agriculture, in adult education classes, neighborhood houses, Golden Age or Senior Citizen Clubs, etc. It is more than likely that the acceptance of arts and crafts as therapy for those who are institutionalized, and as a healthful, rewarding activity for the elderly, receives community support as a consequence of the government's fostering of creativity through the W.P.A. Employees' art shows in various governmental agencies or business firms, such as the telephone company, the Transit Authority in New York City, the United Nations, the Post Office, etc., as well as organizational sponsorship of shows of prison art —all derive from the example set by the W.P.A.

The encouragement of art as a respected activity for

#5 (below): Paradise Barred. Courtesy Mr. and Mrs. Michael D. Hall.

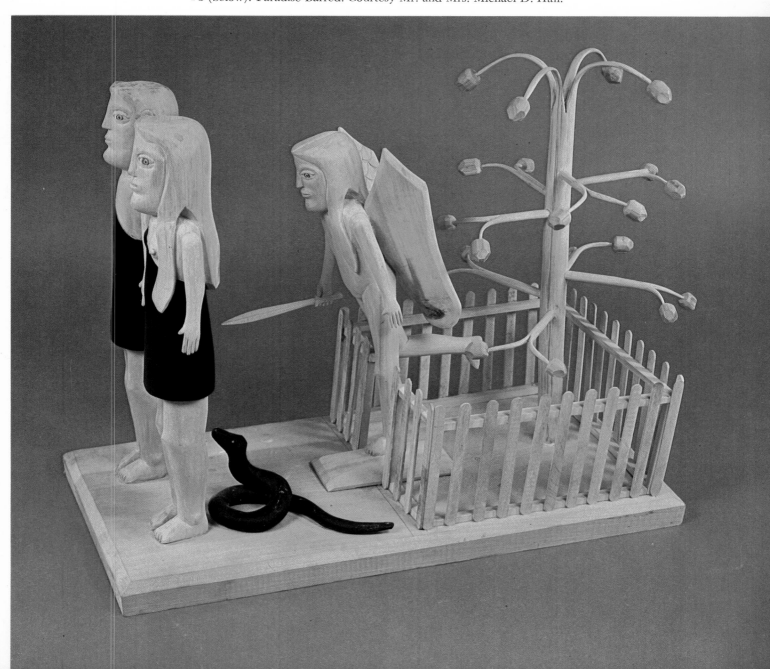

adults, with its important concomitant of making studio resources available, explains to some degree why so much modern folk art (but not all, by any means) is the work of people who are middle aged or older, quite often considerably older. Don Martin started his felt collages in the recreation room of a hospital when he was in his late 50s; Harry Lieberman took up his brush in a senior citizen's center at 80; Morris Hirshfield at 65; Frank Mazur began sculpting in wood and clay at 60; Fannie Lou Spelce was 65 when she began; Clara Williamson and Sophy Regensburg were about 60; Samuel Colwell Baker 70; Joseph Fracarossi 71; Joseph Yoakum in his late 70s; Grandma Moses close to 70.

These are only a few of the well-known and lesser-known names, but they are reasonably typical of a list that is long, so long that there is a tendency to ascribe modern naïve art to the elderly and/or simple (in the sense of plain and modestly educated) folk. And another prevalent asumption, possibly because of Grandma Moses's fame, is that such art is not only of a primitive level in technique, but preoccupied with sentimental memories of a healthy, hardworking American past.

The most overworked words used to describe American folk art are "charming," "quaint," and "delightful," all of which, although they often do apply, simply are not adequate. Much of this art is powerful, dramatic, awesome, impressive, intense.

It seems that the folk art that receives the most publicity is that done by retired or older people, possibly to emphasize the point that art is considered an acceptable, healthy, and viable diversion at this point in life. And no doubt about it, retired people do produce a good deal of folk art, if for no other reason than that the demands upon their attention are different. Their working and active social lives are not what they once were, and they do have the time for memories and practice. Indeed, a number of the older artists have spoken to us of their art as a "second life" or a "new beginning" giving their days a focal point, since they felt that they were accomplishing something worthwhile and important.

At this point, several things need to be said at once. To begin with, there are folk artists who are not elderly, or even middle aged. Bruce Brice, painter, of New Orleans is one, Jerry Casebier, sculptor, is another. Albert Price is now only in his early 40s; Ralph Fasanella, though 60, has been painting for well over 25 years. Simon Rodia spent more than 33 years building his towers, but he was not yet middle aged when he began; Patrick Sullivan was in his 30s.

It is not age that determines a folk artist, nor is it his station in life or his education. Charles Hutson, when a young man, was a teacher of Latin, Greek, and French, and some time after the Civil War became head of the Chair of Economics at a southern university. Calvin Black, on the other hand, had to leave school at the age of 13 to support a mother and brothers and sisters. Harry Lieberman's education prepared him for the rabbinate, while Minnie Evans stopped school after the sixth grade; and "Driftwood Charlie" Kasling is an ex-sailor and old-time prospector.

Educated, uneducated, old or simply adult, these artists have this in common; they are untaught or self-taught, and ". . . the inner world they paint (*or sculpt or make of other materials*) is theirs alone and does not come to them through cultural associations and the study of art and its history. If they visit museums and enjoy the works of art they see there, they are not actually inspired by them . . . the restrictions of their lives and interests leave them pure to paint with total honesty their inventions, their memories, their dreams, and even the life around them as they, and they only, experience it . . . They paint from the heart . . . not from the intellectual or the scientific or anything they have learned or been taught.[7]

Thus it is that Ralph Fasanella can read books on art, go to an exhibition now and then, and still remain artistically unaffected, working out his own problems of perspective, balance, and composition in his own unvarying and rather remarkable way, painting not what he sees is there but what he knows is there. At most, he questions only why it is that others can paint landscapes, but he must paint people entangled in the multilayered life of New York City. Trained optician Max Reyher qualifies as an untaught artist, and someone who was socially as sophisticated and knowledgeable as Sophy Regensburg belongs on the list for the same reason he does.

These artists—those within this book and the entire spectrum of artists and artistic expression they represent —are not concerned with the development of their styles. They are engrossed with the visual enlargement of the content of their ideas. Style quite often comes forth full blown, and though there may be some development in it, there is seldom any genuine deviation or radical change. The last Pippin is unmistakably by the same hand as the first; Jack Savitsky's style over the years shows evidence of a quicker facility in stating his contours, but this is little more than a cursory polish. The artistic ideology (if one can call it that) doesn't change, as it does or has with artists who are or were quite capable of producing in the academic vein, but with conscious effort broke away from tradition and academicism and turned to impressionism, expressionism, and experimentation with other stylistic innovations.

The folk artist neither wants to do this, nor, for that matter, can. Such artists are either indifferent to or else quite unaware of the fact, as is Eddie Arning, that their style is not one of photographic realism. The work says what the artist wants it to, and that is enough. Horace Pippin was convinced that his paintings were an exact copy of real life. And they were, of course, in content and emotion.

Innocence of style is a distinctive quality and almost instantly distinguishes the folk artist from the trained professional. However, contrary to a general impression, it is by no means always so simplistic as to be ranked with children's art.

There are several levels of "competence," if we equate the word with approximating accuracy or degrees of skill, ranging from lively distortions in works such as Harry Lieberman's and "Grandpa" Wiener's to the meticulous architectural details and classical perspectives in paintings by Velox Ward, Steve Harley, or Samuel Colwell Baker. (The folk artist is not averse to using special methods to achieve a desired effect: Grandma Moses threw glitter on her snow to make it shine, and Maceptaw Bogun heaped white paint half an inch high to give a third dimension to a waterfall in one of his paintings.)

Further, there is, on the surface, what appears to be a commonality of style at the various levels of "competence," and of composition, too, that again instantly identifies the untaught artist, not only of the present century but of other times and other cultures. We previously referred to this in the framework of the word "timelessness."

Surface stylistic similarities exist in any body of art, even in the anarchic turbulences of modern art. The terms *Japanese prints*, *Chinese scrolls*, *Dutch school*, *Renaissance art*, *Baroque art*, *Impressionism*, *Nonobjectivism*, and *Surrealism* all evoke images of specific kinds of art, and art that represents a complex interplay of influences to which artists are by nature sensitive and responsive. Style is the deliberate consequence of the absorption or rejection of the norm or standards of theories of the time.

For the folk artist pattern of style is to some extent the unwitting and predictable eventuality of a certain stage in physiological and perceptual development. This is a phenomenon that was studied and documented in the works of the German philosopher, Gustav Britsch, whose theories were tested in this country by Henry Schaefer-Simmern.[8]

In normal individuals, the ability to produce graphic or plastic representations develops in an evolutionary manner. First statements are in simple linear forms. Progress in indicating spatial relationships comes with growth of awareness and understanding and the maturing of one's ability to coordinate visual perceptions with motor skills. It is almost a cliché to point out how this is demonstrable in the progress to be seen in the artworks done by children who are left free to work out their own conceptions rather than being taught what to see and how to reproduce such images.

Equally trite is the statement that artistic ability exists to a greater or lesser degree in everyone. However, the statement is generally true, and those who can successfully incorporate the traditions of their times into their perceptual expressions survive as artists; less fortunate are those who try to accommodate perception to academic demands or current trends—which means most of us— only to fail altogether or become poor artists. Read observes that we all start out, as children, with "the physical or sensational equipment" necessary to become artists, but we are made insensitive and are physically and psychically "deformed" by education that forces our minds and bodies to "accept a social concept of normality which excludes the free expression of aesthetic impulses."[9]

Britsch demonstrated, and Schaefer-Simmern corroborated in his experiments with adult groups, that there are specific stages of stylistic organization or compositional arrangements that will be passed through, provided there is no interruption by teaching procedures that force students to "adapt to preconceived ideas of others."[10] In other words, the art of the individual will be self-derivative rather than the consequence of imposed sources or examples. Ideally, there would be a gradual development and "step by step . . . an unfolding and development of an inherent evolutionary process of visual conceiving . . ." The artwork is "attuned to a specific mental state of the creator . . . there is an interconnection between the formative processes and the psychophysical responses . . ."[11]

Transition from a simpler stage to the next is usually gradual, with a lingering of early structural forms alongside later ones, often within single figures as well as in compositions. Sometimes, when an object is rather complicated and presents difficulties, the artist may retreat back to a less complicated stage. Untaught artists frequently paint not what they *see* is there, but what they *know* is there, so that they may include the front, the back, the side, and what lies behind, producing startling and dramatically unusual solutions to problems of perspective and space that are far more effective than those determined by rules.

Inasmuch as general education is geared to the acquisition of knowledge that consists of facts and ideas, the spontaneous drive for *visual* perception and comprehension is neglected if not stifled almost entirely, and in most persons, visual conception and its pictorial or plastic realization seldom develop beyond the stages reached in childhood. *But the ability itself has not vanished. It is always latent and can be awakened . . . A revival of inherent abilities can only start, however, from the individual's stage of visual conception.*[12] (Authors' italics)

In other words, the adult who takes up pencil or crayon or brush or clay picks up personal style organization where he or she left it off in early years. Going beyond that stage will depend upon self-judgment as to its adequacy in expressing what the artist has in mind. If it functions satisfactorily, there may be no desire to alter or improve style, and there will be relatively little change. There have been instances of self-taught artists who have developed more awareness of style and theory and who have therefore attempted to and perhaps succeeded in moving away from the unconscious technique. This does

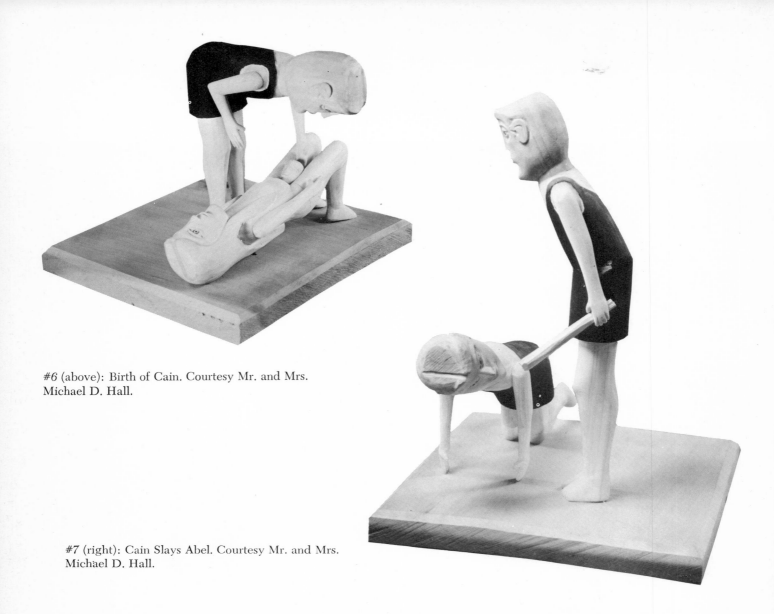

#6 (above): Birth of Cain. Courtesy Mr. and Mrs. Michael D. Hall.

#7 (right): Cain Slays Abel. Courtesy Mr. and Mrs. Michael D. Hall.

not negate the validity of their earlier works, any more than does the fact that children move on to other stages demean their youthful essays.

But in the end, in the words of Schaefer-Simmern, "a just artistic evaluation of a work of art can only be concerned with artistic quality— the intelligent organization of form—no matter how simple its structure may appear . . . the overstressed distinction between artistic works of gifted and ungifted people is not of fundamental importance."[13]

An adult's art is rich in content and reveals his life, the substances of its pasts, and its present. It will contain ideas and subject material children cannot have in their art. Folk artists will have been influenced by news media, by events, and will use materials and media that require a knowledge of the way things work. They will have read, they will have formed opinions, and their fantasies will have been fed by their memories, experiences, and their personal creeds or beliefs. In presenting their visions without consideration of accepted theory or rules, their art is a splendid testament to the innate creativity present

and recurring spontaneously in every generation—and even within us, the viewers, if we will but restore our intuitive perception.

NOTES

1. Holger Cahill, *American Folk Art: The Art of the Common Man in America, 1750–1900* (New York: W. W. Norton & Co. for The Museum of Modern Art, 1932), p. 3.
2. Cahill, *op. cit.*, p. 5.
3. Herbert Read, *Art and Society* (London: Faber and Faber, 1956), p. 12.
4. Herbert Read, *Art Now* (London: Faber Paperback, 1968), p. 37.
5. Read, *Art Now*, p. 39.
6. Read, *Art Now*, p. 42.
7. Donald and Margaret Vogel, *Aunt Clara: The Paintings of Clara McDonald Williamson* (Austin, Tex.: University of Texas Press, 1966), p. 2.
8. Henry Schaefer-Simmern, *The Unfolding of Artistic Activity* (Berkeley, Calif.: University of California Press, 1970).
9. Read, *Art and Society*, pp. 99–100.
10. Schaefer-Simmern, *op. cit.*, p. 28.
11. Schaefer-Simmern, *op. cit.*, p .28.
12. Schaefer-Simmern, *op. cit.*, p. 29.
13. Schaefer-Simmern, *op. cit.*, p. 200.

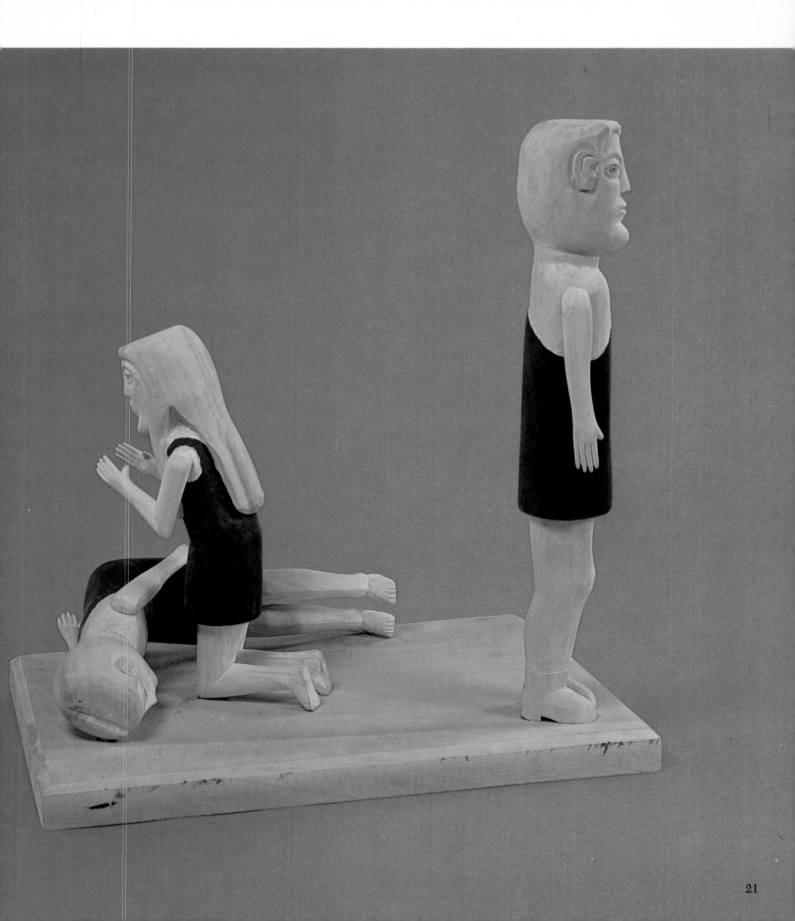

#8 (below): Cain Goes into the World. Courtesy Mr. and Mrs. Michael D. Hall.

JOSEPH VELGHE (Father John), wrote Alfred Frankenstein in his book, *Angels over the Altar*, was born in Courtrai, Belgium, on July 15, 1857, and ordained as Father John in 1888. He was sent to the Marquesas Islands in December of that year and soon became known for being, in the records of a fellow priest, "an enthusiast of vivid and sprightly character," who "painted murals in churches, conducted choirs, organized a brass band, and played in pantomimes." Tropical illness forced him to leave the Marquesas. He went to Tahiti, painted more chuches, and then went to Hawaii in 1899 when a yellow fever epidemic in South America prevented his assuming a post there. In Hawaii, he built the present church of St. Benedict at Homaunau.

He returned to Europe in 1904, and died in Lier, Belgium, on January 20, 1939. He was a totally untaught artist, and—Mr. Frankenstein quotes from the annals of the Congregation of the Sacred Heart at Rome— "He gladly gave all the service his poor health permitted him to give, always faithful to the art of painting, in which he might have excelled if he had had proper training. He held the brush almost to the end of his life, until the day when his poor eyes refused their service. When he realized that he could no longer command the brush as he wished, he understood that God demanded of him a huge sacrifice which he dreaded."

13 (opposite), 14 (below). Joseph Velghe (Father John): *Panels in St. Benedict's, the Painted Church of Hawaii.* c. 1900–1904. The artist designed, built, decorated, and painted St. Benedict's. Courtesy Alfred Frankenstein. Photographs: Norman Carlson.

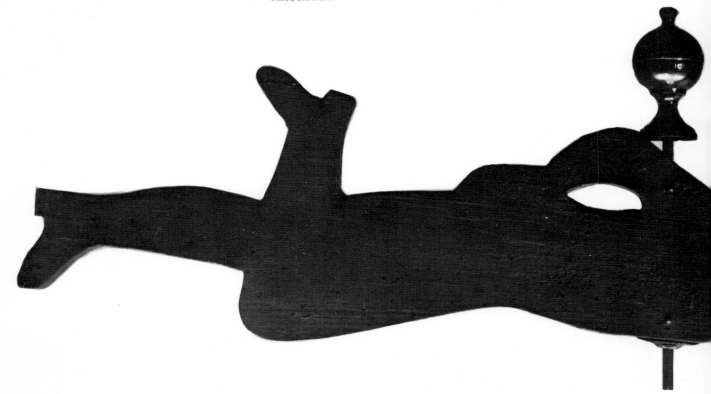

15 (below). Anonymous: *Angel Weathervane*. c. 1900. Glass and wood. L. 30″. Courtesy New York State Historical Association.

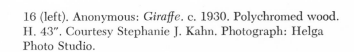

16 (left). Anonymous: *Giraffe*. c. 1930. Polychromed wood. H. 43″. Courtesy Stephanie J. Kahn. Photograph: Helga Photo Studio.

17 (opposite, left). Anonymous: *Theodore Roosevelt*. Whirligig. c. 1908. Painted wood with wire spectacles. H. 11″. Courtesy Mr. and Mrs. Michael D. Hall.

18 (opposite, right). Anonymous: *Father Time*. c. 1900. Polychromed wood and metal. H. approximately 48″. Courtesy Museum of American Folk Art.

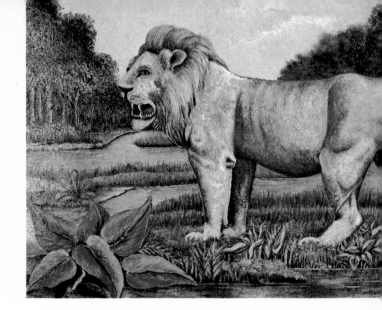

19 (above). Anonymous: *Owl Decoy*. Early twentieth century. Painted wood with glass eyes and leather ears. H. 14¼". New Jersey. Courtesy Herbert W. Hemphill, Jr. Photograph: Eeva-Inkeri.

20 (above). Anonymous: *Lion*. c. 1910. Oil on canvas. 28" x 40". Hand-carved frame. Courtesy Mr. and Mrs. Harvey Kahn.

HENRY CHURCH was born May 20, 1836, in Chagrin Falls, Ohio, and died there April 17, 1908. The son of a blacksmith, he, too, was a blacksmith. As a youngster, he wanted to draw, but his father quite literally whipped him out of the idea. The elder Church died when Henry was 42, and eight years later, Henry, now a spiritualist and deeply religious, gave up the blacksmith shop and devoted himself full-time to painting, hunting, and sculpture. He did several carvings on nearby rocks, chiseled out his own tombstone—an angry lion with green glass eyes—and filled his own front yard with a clutter of strange carvings. Most of his many paintings were burned by his daughter when she had to move. Fearful that no one would care for them as she had and having no storage space, she preferred to destroy them herself than to let them be vandalized.

21 (below). Henry Church: *The Monkey Picture*. 1908. Oil on canvas. 28″ x 44″. Chagrin Falls, Ohio. The owner suggests that the painting was meant to ridicule the abundance of staid Victorian still lifes of fruit. Courtesy Mr. and Mrs. Sam Rosenberg. Photograph: Sam Rosenberg.

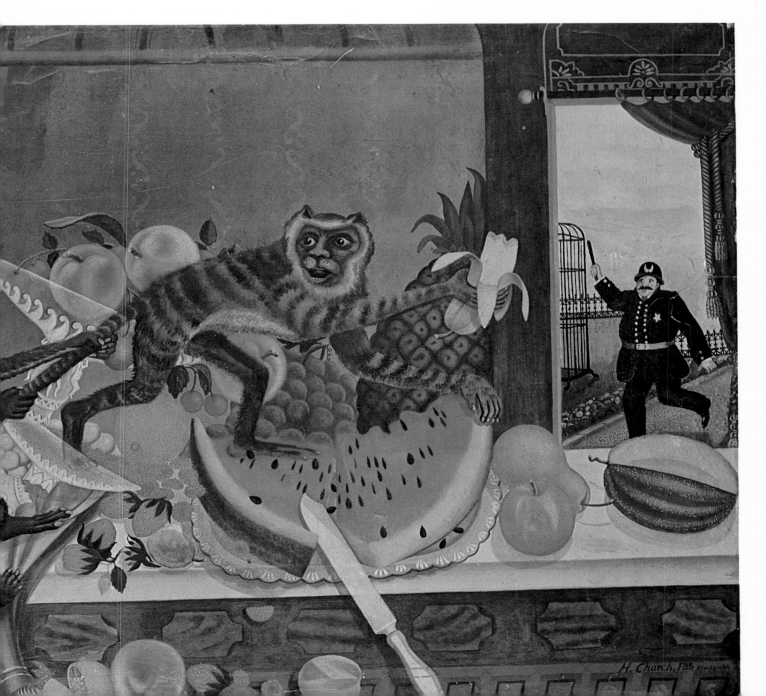

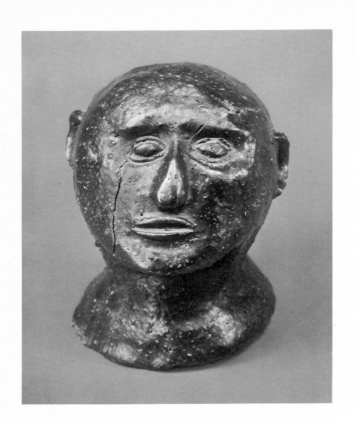

22 (left). Anonymous: *Sewer Tile Head.* c. 1913. Glazed terra-cotta. H. 8¼″. Ohio. Like glassworkers, tileworkers made whimsies with materials left over at the end of the day. Courtesy Mr. and Mrs. Michael D. Hall.

24 (below). Anonymous: *Eagle.* c. 1910. Polychromed wood. H. 26″. Providence, Rhode Island. Courtesy Herbert W. Hemphill, Jr. Photograph: Eeva-Inkeri.

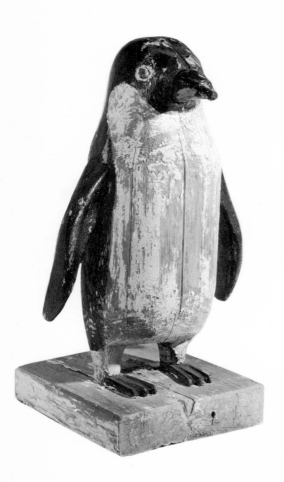

23 (left). Anonymous: *Penguin.* c. 1910. Polychromed wood. H. 20″. Massachusetts. One of a pair found on the gateposts of a fence on Nantucket Island. Private collection. Photograph: Eeva-Inkeri.

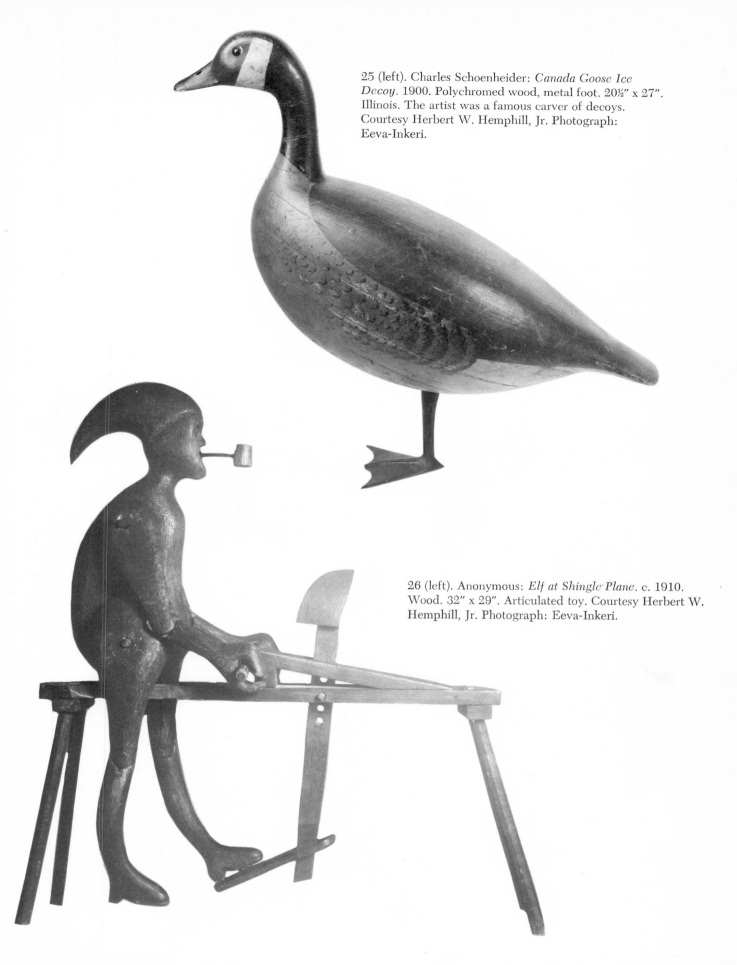

25 (left). Charles Schoenheider: *Canada Goose Ice Decoy.* 1900. Polychromed wood, metal foot. 20½" x 27". Illinois. The artist was a famous carver of decoys. Courtesy Herbert W. Hemphill, Jr. Photograph: Eeva-Inkeri.

26 (left). Anonymous: *Elf at Shingle Plane.* c. 1910. Wood. 32" x 29". Articulated toy. Courtesy Herbert W. Hemphill, Jr. Photograph: Eeva-Inkeri.

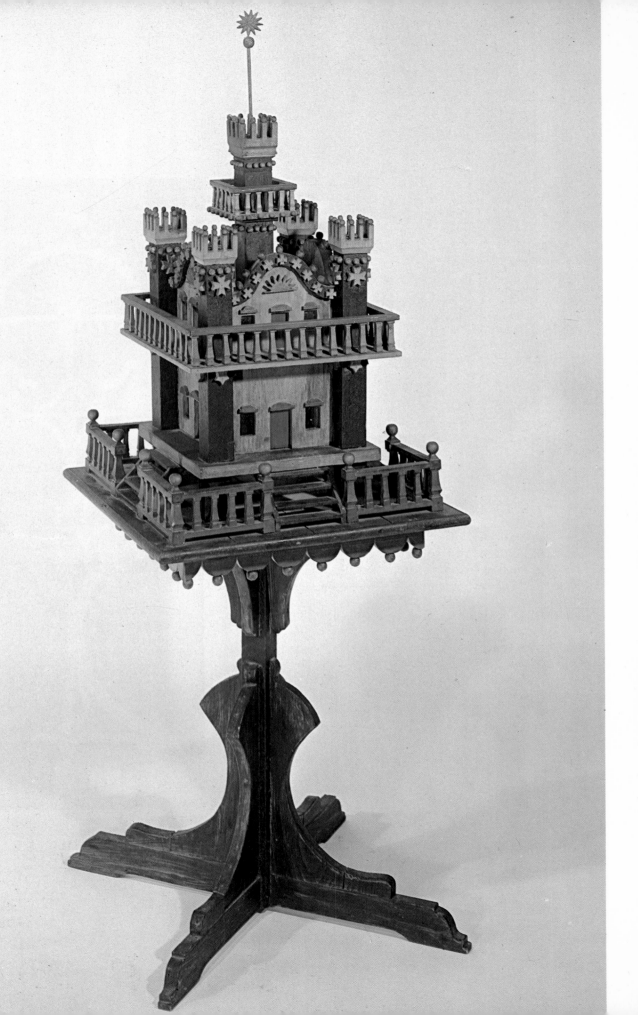

27 (opposite). John Scholl: *Castle*. c. 1910. Polychromed wood. H. 35″. Germania, Pennsylvania. Courtesy Mr. and Mrs. Richard Polsky.

28 (right). John Scholl: *Crested Swan*. c. 1910. Polychromed wood. H. 83½″. Germania, Pennsylvania. Courtesy Memorial Art Gallery, University of Rochester.

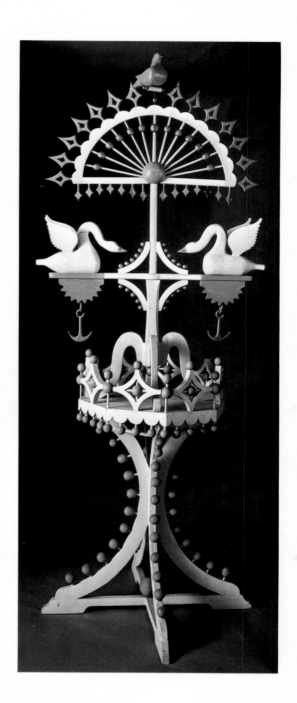

JOHN SCHOLL was born in Würtemburg, Germany, in 1827, and died around 1916. A carpenter by trade, he emigrated to the United States in 1853, settling in the forest region of Germania, Pennsylvania. He cleared his own land, built his own house as well as others, built the village church, the local brewery, and the general store. He did his fanciful carvings between 1907 and 1916, after his retirement at the age of 80. His only tool was a jackknife. His motifs derive from traditional Pennsylvania German designs: the dove, bird-of-paradise, tulip, anchor, peacock, star-crossed circle, and swan, generally embellished with Victorian fretwork of his own design. He never sold or gave away his works, and his entire collection of some 40 pieces remained intact in the possession of his children and grandchildren until recent years.

29 (below). Anonymous: *The Black Forest Beer Bottle Cap Cord Car*. c. 1935. Metal and wood. Approx L. 24″. New York. Courtesy Tony Palladino. Photograph: Eeva-Inkeri.

30 (bottom). Anonymous: *Car Weathervane*. c. 1925. Sheet iron, painted black. L. 19¾″. Greenfield Village and Henry Ford Museum.

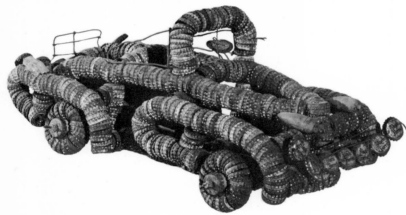

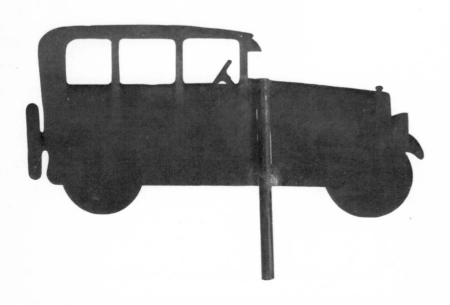

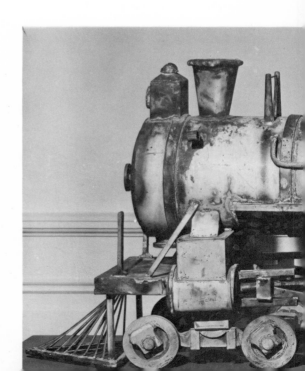

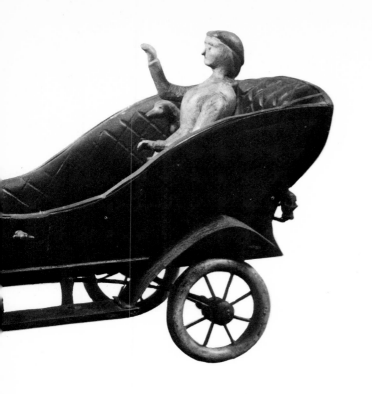

31 (left). Anonymous: *Touring Car.* c. 1907. Polychromed wood and metal. L. 24". Long Island, New York. Private collection. Photograph: Eeva-Inkeri.

32 (below). Anonymous: *Car Weathervane.* c. 1907. Copper. L. 42". Greenfield Village and Henry Ford Museum.

33 (bottom). Anonymous: *Locomotive and Tender.* c. 1910. Copper. L. 7'. From the top of a New Haven and Hartford railway station outside of Boston. Courtesy Dr. and Mrs. William Greenspon.

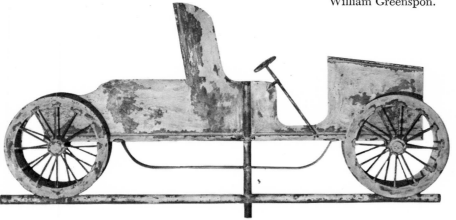

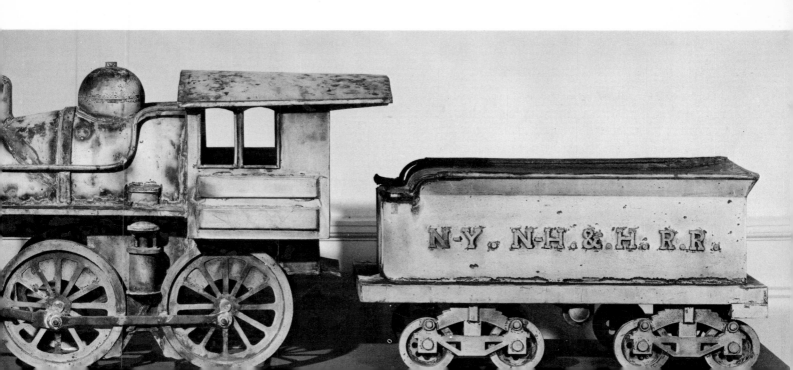

OLOF KRANS was born Olof Olson, November 12, 1838, in Silja, Vestmanland, Sweden. He emigrated with his parents in 1850 to join the colony of religious dissidents founded at Bishop Hill, 160 miles northwest of Chicago, in 1846. He had shown a talent for drawing at the age of twelve, but this interest had to be set aside. He worked in the paint shop of the colony, and then in the blacksmith shop. In 1861, he took the name of Krans when he enlisted in the 57th Regiment of the Illinois Volunteer Infantry. After the Civil War, he moved to Galesburg, Ohio, married, and in 1867 became a painter—house, outdoor, interior, theatre backdrop and curtain. He also created hand-lettered road signs. Crippled in a fall around 1896, he had to curtail his work and began painting memory pictures of Bishop Hill as a pastime. He painted portraits from photographs, but his other works are his record of life at Bishop Hill. He was remembered as a jovial man who much enjoyed talking to children. He died in Altona, Illinois, in 1916.

34 (below). Olof Krans: *Harvesting Grain*. c. 1900. Oil on canvas. 29½" x 47". Illinois. As the men cut the wheat, the women follow behind, and gather and tie it into bundles. Courtesy Bishop Hill Memorial, Illinois Department of Conservation.

35 (opposite). Olof Krans: *Self-Portrait*. 1908. Oil on canvas. 24½" x 30½". Bishop Hill, Illinois. Courtesy Bishop Hill Heritage Association. Photograph: Soren Hallgren.

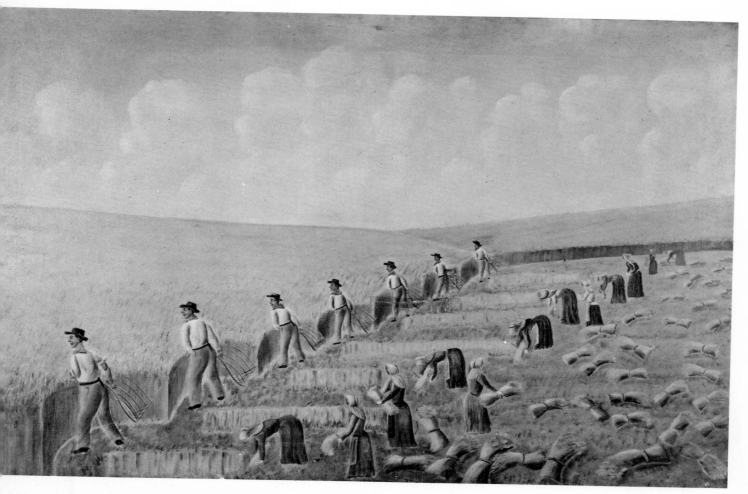

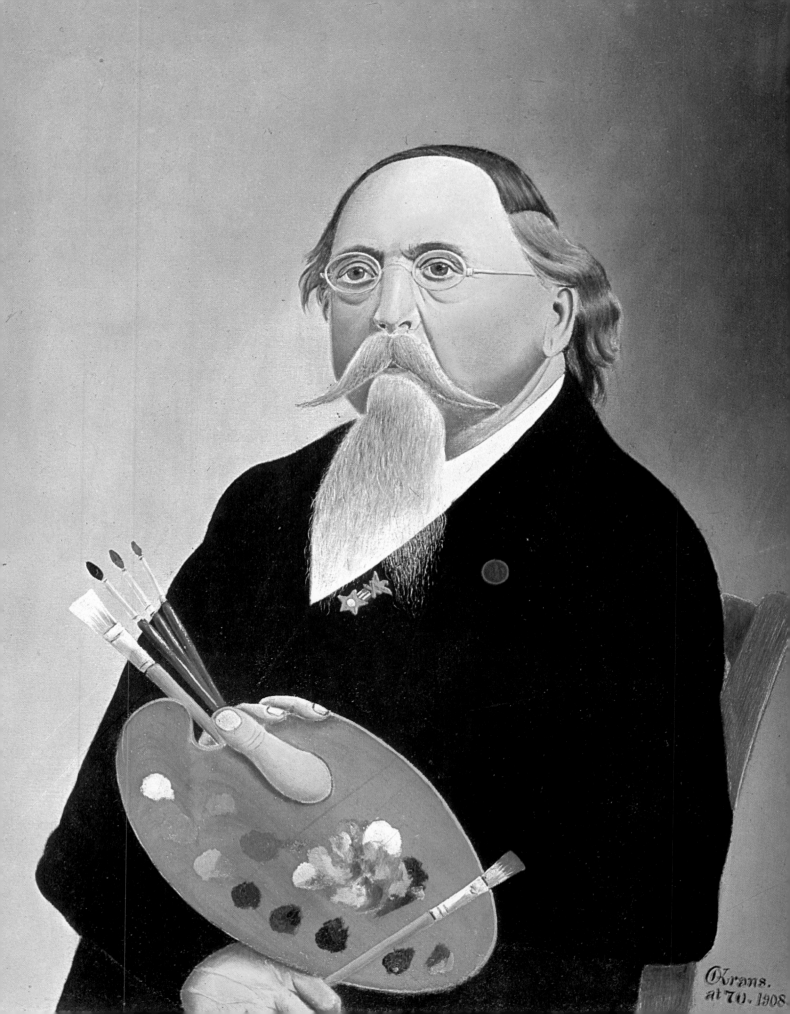

Krans.
at 70. 1908

36 (below). Clark Coe: *Girl on a Pig.* c. 1910. Polychromed wood, articulated. H. 37″. Killingworth, Connecticut. This sculpture was originally part of an almost life-size water-powered whirligig that Coe constructed to amuse a crippled nephew. There were some 40 articulated figures and animals grouped in and around a shed near a waterfall that activated the waterwheel that put the giant toy into action. Courtesy Herbert W. Hemphill, Jr. Photograph: Helga Photo Studio.

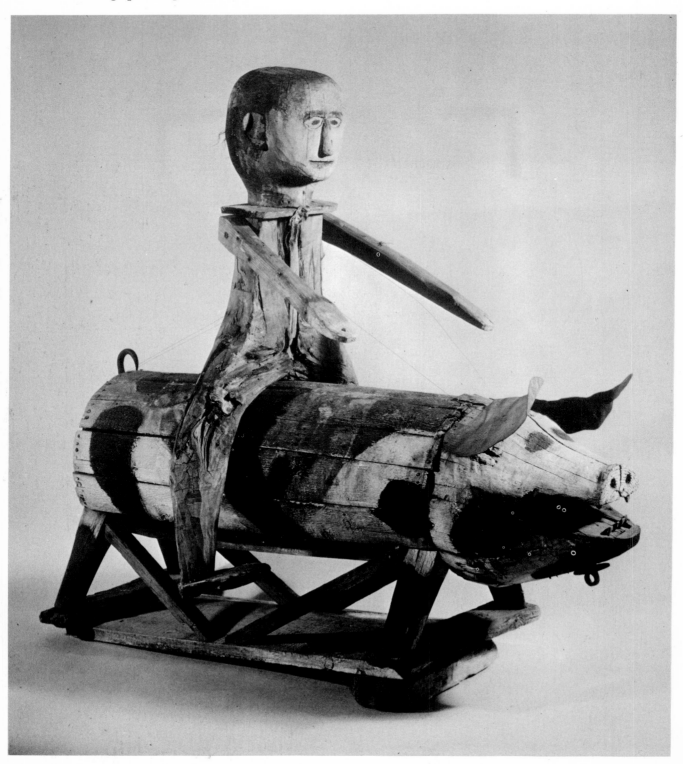

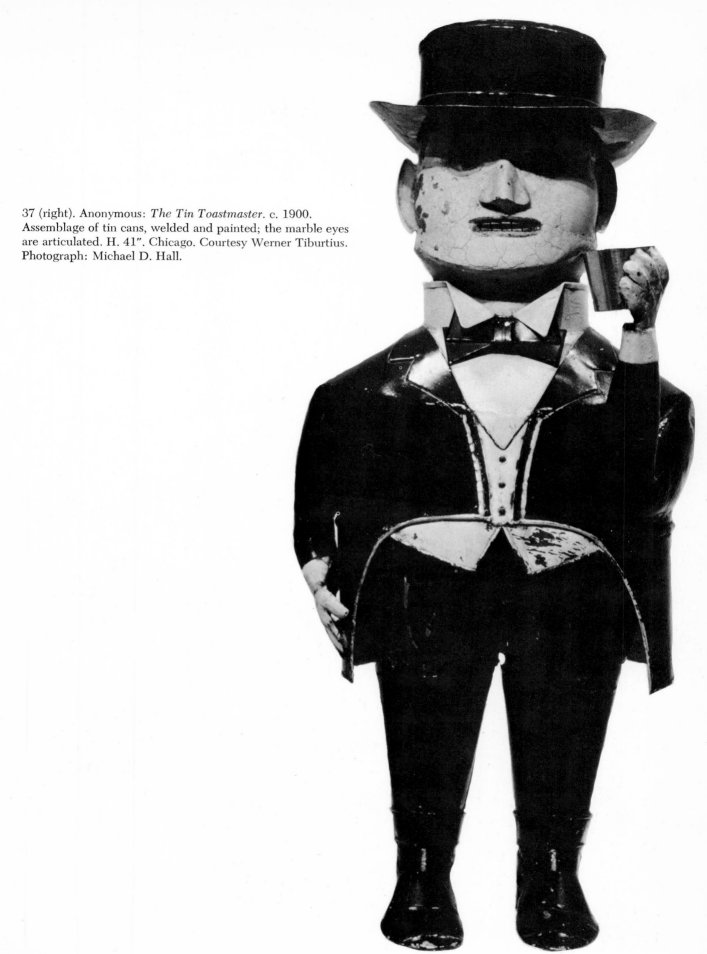

37 (right). Anonymous: *The Tin Toastmaster*. c. 1900. Assemblage of tin cans, welded and painted; the marble eyes are articulated. H. 41″. Chicago. Courtesy Werner Tiburtius. Photograph: Michael D. Hall.

38 (opposite). G. Van Dalind: *The Happy Cottage.* Dated: 1939. Oil on canvas. 30″ x 19¾″. Found in Pennsylvania. Private collection. Photograph: Eeva-Inkeri.

39 (above). W. A. Cox: *Property of Mrs. Fred L. Keith.* 1910. Ink on paper. 26″ x 36″. Cattaraugus, New York. A handwritten note on the back of the drawing states: "Cattaraugus, N.Y. 4-10-1911. Said drawing is the Property of Mrs. Fred L. Keith of Ellicottville, N.Y. Drawn by W. A. Cox, Cattaraugus, N.Y., June 1910, from 74 year memory." Courtesy Kennedy Galleries, Inc. Photograph: Eeva-Inkeri.

40 (below). Cleo Crawford: *Christmas.* 1938. Oil on canvas. 28″ x 40½″. Haverstraw, New York. A depiction of Christmas in the deep South. Crawford (1892–1939), a poor Black laborer who lived in Haverstraw, painted in his spare time. He was discovered by Sidney Janis and Walter Fleischers, and he died not long after his works received their first public recognition in a group show. Courtesy Sidney and Harriet Janis Collection. Photograph: Eeva-Inkeri.

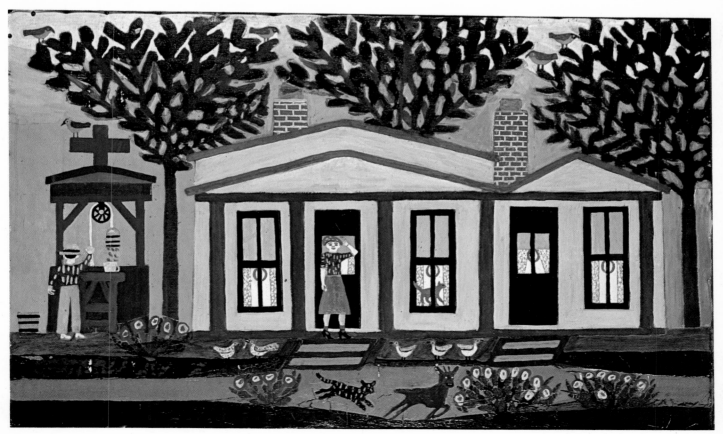

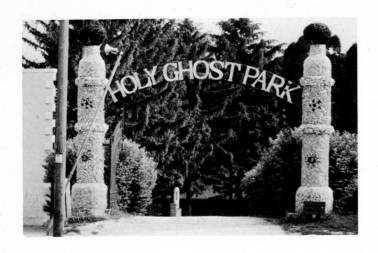

FATHER MATHIAS WERNERUS was born in Germany in 1873 and died in Dickeyville, Wisconsin, in 1931. Gregg Blasdel reports that he began building his Holy Ghost Park about ten years before he died. He was aided by parochial school children, who also helped him collect choice rocks—during school hours. There is a central sanctuary, two cemetery shrines, a monument to Columbus, and various other objects.

ED ROOT was born in 1868 and died in 1959. He lived in Wilson, Kansas, where he farmed his father's homestead, and in between chores built hundreds of concrete figures, plaques, and monuments. When a broken hip put an end to his outdoor activities, he embellished his house with creations made of paper, soap bars, fruit jars, foil, and tinsel.

43 (below), 44 (opposite). Ed Root: *Farm Garden*. 1926–1956. Concrete and mixed media. Various sizes. Wilson, Kansas. Photographs courtesy Roger Brown.

41, 42 (above). Father Mathias Wernerus: *Holy Ghost Park*. c. 1921–1931. Mixed media. Dickeyville, Wisconsin.

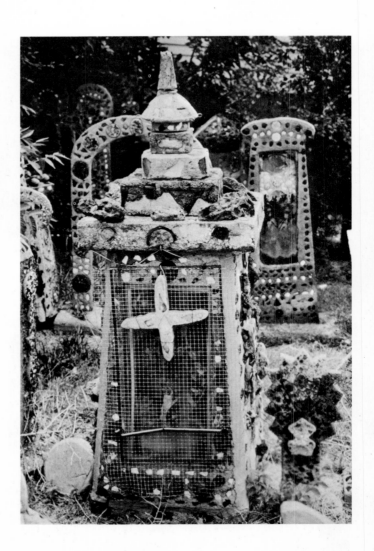

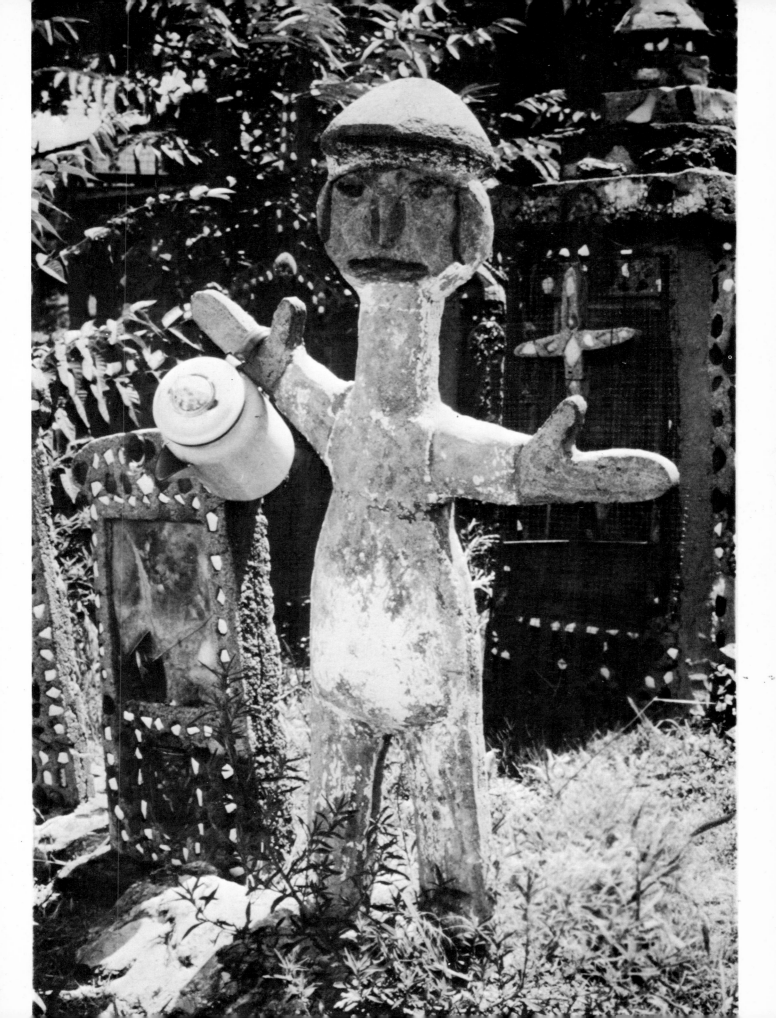

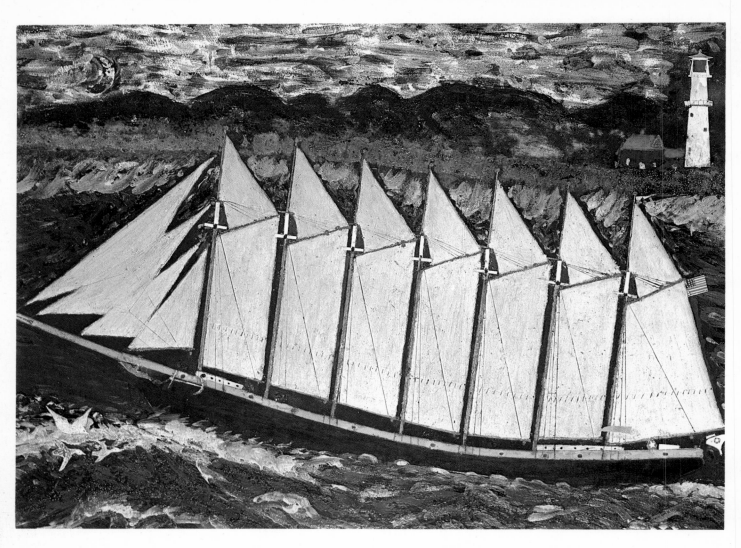

45 (above). Anonymous: *The Thomas W. Lawson.* c. 1920. Oil, sand, and collage on paper. 24″ x 32″. Staten Island, New York. A painting of the only seven-masted schooner. Private collection. Photograph: Eeva-Inkeri.

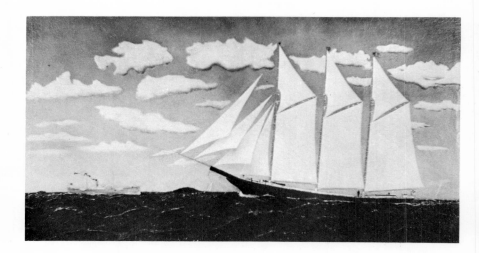

46 (above). Captain Cooke: *Sail and Steam.* c. 1915. Oil on sailcloth. 19½″ x 36½″. Probably New England. The artist was later the harbor master at Miami, Florida. Courtesy Robert Bishop.

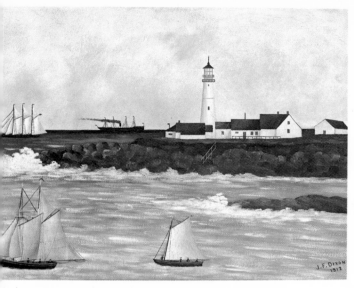

47 (above, left). J. F. Dixon: *The Ships Off Cape Cod.* 1912.
Oil on board. 18½″ x 24½″. Massachusetts. Private collection.
Photograph: Eeva-Inkeri.

49 (below). William A. Lo: *Prusia.* c. 1907. Oil on canvas.
35½″ x 47⅞″. The ship's actual name was *Preussen.* Courtesy
Herbert W. Hemphill, Jr. Photograph: Eeva-Inkeri.

48 (above, right). William O. Golding (1874–1943): *Bodie
Island.* 1934. Colored pencil on paper. 9″ x 12″. Savannah,
Georgia. "Can't get along like I used to on the ship, so I have
to give up going to sea, now only go to sea in my
sleep . . ." Courtesy Joseph Lee Cotton. Photograph courtesy
David & David.

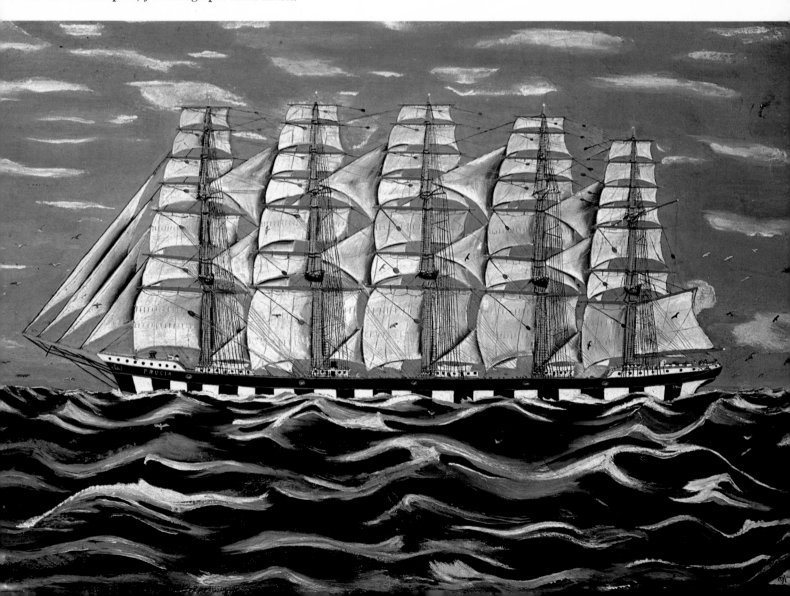

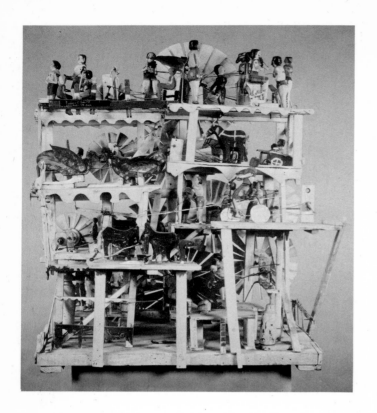

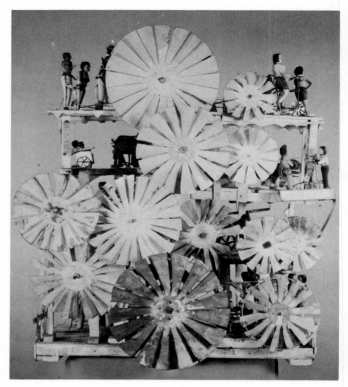

50 (left), 51 (below). Anonymous: *Four Storey Whirligig* (front view and back view). 1958. Polychromed wood and tin. 24″ x 27″ x 20″. Ohio. Courtesy Jeremy and Barbara Samson.

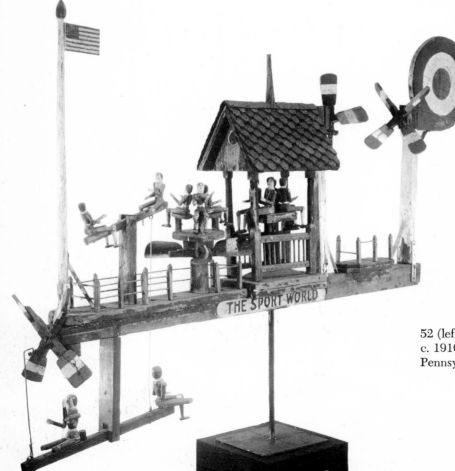

52 (left). Anonymous: *The Sport World.* Whirligig. c. 1910. Polychromed wood and metal. L. 90″. Pennsylvania. Courtesy Mr. and Mrs. Michael D. Hall.

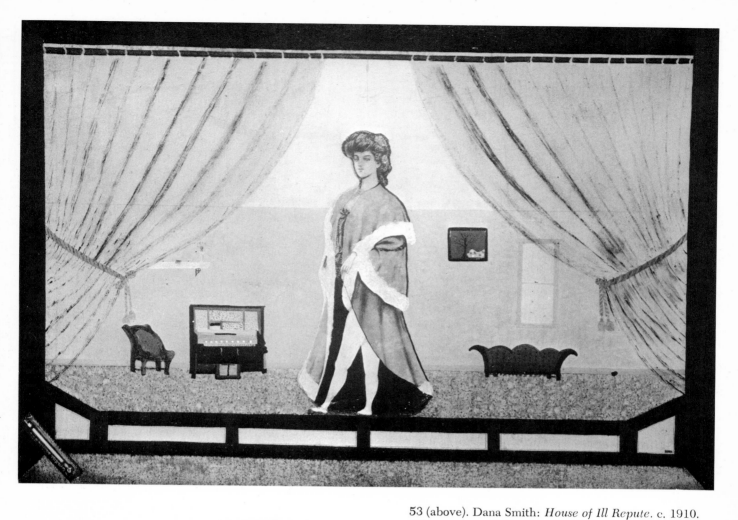

53 (above). Dana Smith: *House of Ill Repute*. c. 1910.
Oil on canvas. 18¼″ x 26″. Franklin, New Hampshire.
Private collection. Photograph: Eeva-Inkeri.

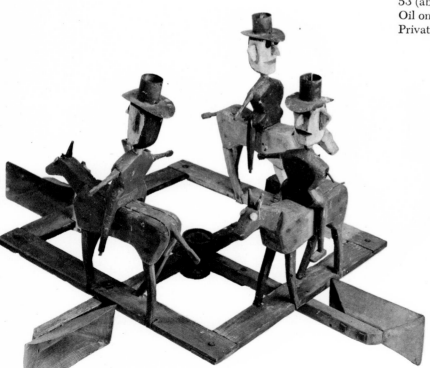

54 (above). Anonymous: *Four Horsemen*. Whirligig.
c. 1920. Polychromed wood and metal. W. 28½″. Ohio.
Private collection. Photograph: Helga Photo Studio.

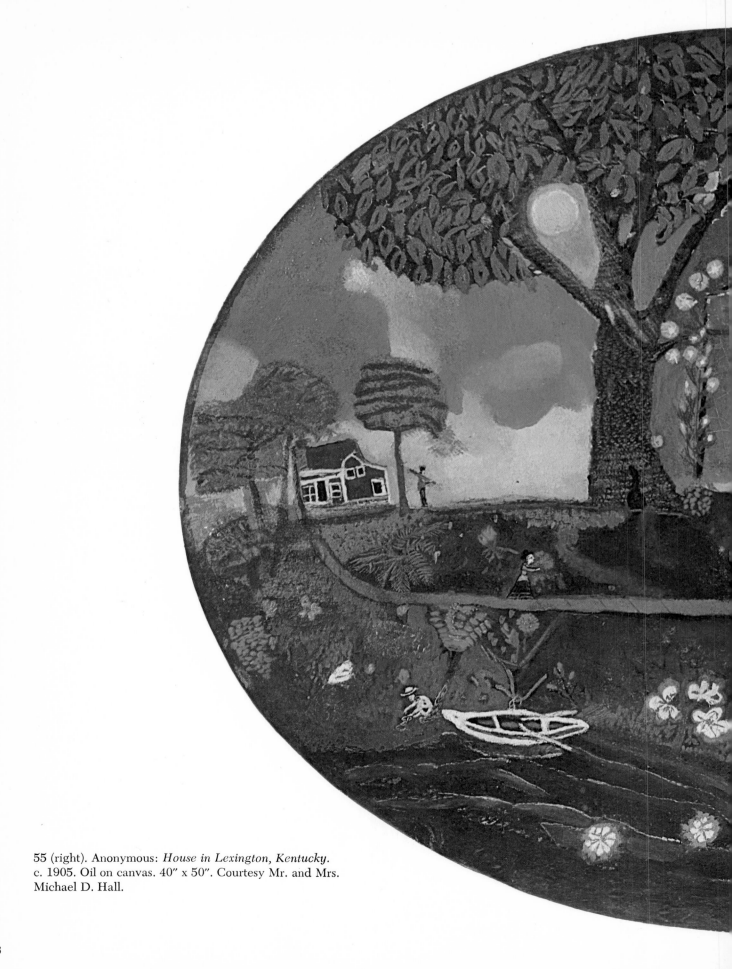

55 (right). Anonymous: *House in Lexington, Kentucky.*
c. 1905. Oil on canvas. 40″ x 50″. Courtesy Mr. and Mrs.
Michael D. Hall.

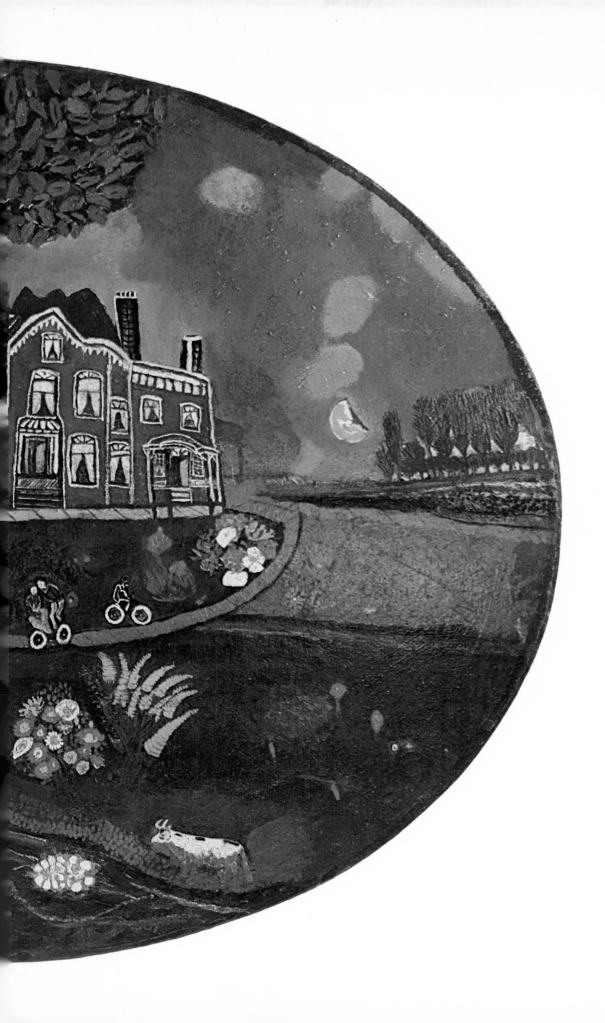

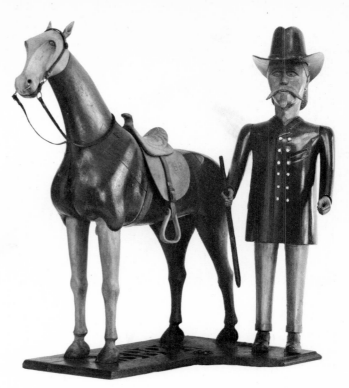

57 (above). Anonymous: *Buffalo Bill Cody.* c. 1910. Cherry and maple wood, leather trim, ivory buttons. H. 18". Vermont. This is one of the many genre carvings known to have been done by the same artist who carved the funeral procession. The series was at one time acquired in its entirety by a museum, but is now dispersed in several collections. The base with openwork initials BB appears to have been made from a scrap of furniture paneling. Courtesy Margaret Woodbury Strong Museum.

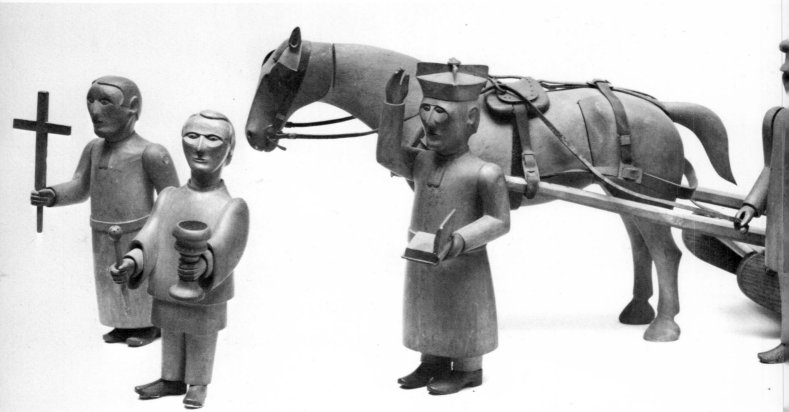

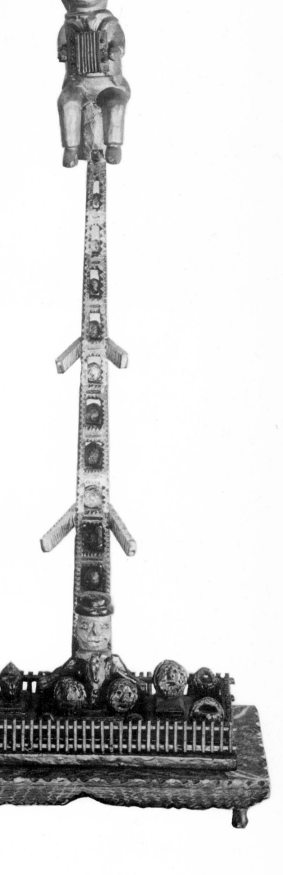

56 (opposite, above left). Anonymous: *Figure in a Tin Cap*. Whirligig. c. 1920. Polychromed wood and metal, with marble eyes. H. 43¾". Michigan. Courtesy Robert Bishop. Photograph: Michael D. Hall.

58 (opposite, below). Anonymous: *Catholic Funeral Procession*. c. 1910. Unpainted wood. L. 36". Figures are articulated. One of a series of genre groups carved by an unknown artist. Private collection. Photograph: Eeva-Inkeri.

59 (above). Anonymous: *World War I, or Tribute*. c. 1918. Inlaid wood. 13¼" x 20½". Washington, New York. Private collection. Photograph: Eeva-Inkeri.

60 (right). Anonymous: *Man on a Pole*. c. 1910. Polychromed wood and peach pits. H. 30". Private collection. Photograph: Eeva-Inkeri.

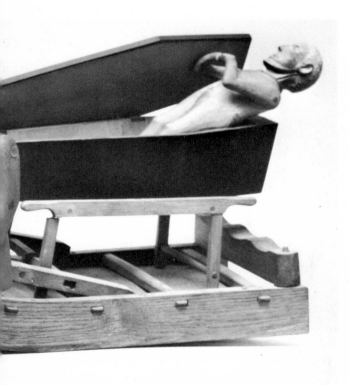

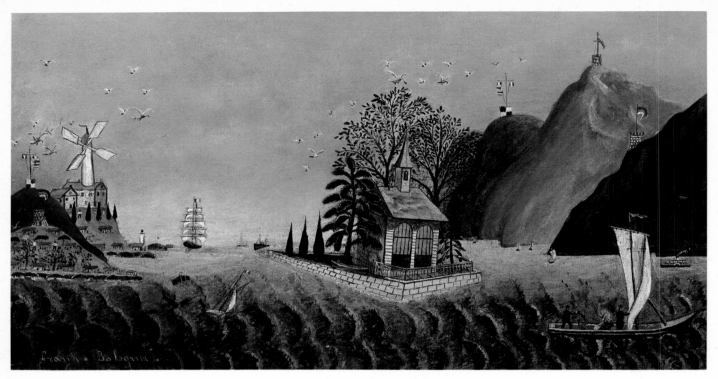

61 (above). Frank Bologna: *The Bay of Martinique*. 1914. Oil on canvas. 18¾″ x 35½″. Corona, Long Island. Nothing is known about the artist. Private collection. Photograph: Helga Photo Studio.

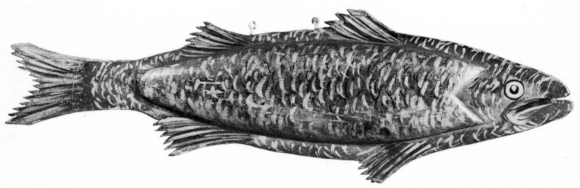

62 (above). Anonymous: *Fish Sign*. c. 1920. Polychromed wood. L. 30¼″. New York. Private collection. Photograph: Helga Photo Studio.

JOSEPH PICKETT was born in New Hope, Pennsylvania, in 1848, and died there in 1918. In between those dates he did some roving with carnivals as a concessionaire, mostly of shooting galleries, and at the age of 45 married and settled down in New Hope. Sidney Janis reported that his neighbors recalled him as handsome, gregarious, likable, and a great talker. In his early youth, he worked with his father as a canal locks repairman, but "Although he had this early training and did a great deal of manual work, there is good evidence that he was not a master-craftsman; still he was an ingenious man with ideas and ability to carry them out . . . he built two houses, made a pair of calfskin boots, a chest of drawers elaborately patterned in marquetry, and a homemade barber chair, crude but inventively made . . ." He began painting after his marriage, using house paint at first but later regular artists' supplies. He mixed sand, earth, rocks, and shells in his paint to imitate textures, and would work for years on one painting. Although there are only four known paintings extant, they are not his sole art efforts, for he was known to have painted his own backdrops for his concessions in carnivals.

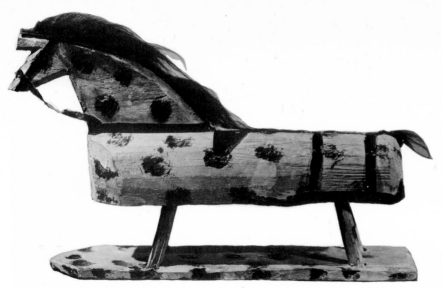

63 (above). Anonymous: *Horse*. c. 1920. Polychromed wood and mixed media. L. 23½". Private collection. Photograph: Eeva-Inkeri.

64 (below). Joseph Pickett: *Coryell's Ferry, 1776*. c. 1914–1918. Oil on canvas. 47½" x 48½". New Hope, Pennsylvania. Courtesy Whitney Museum of American Art.

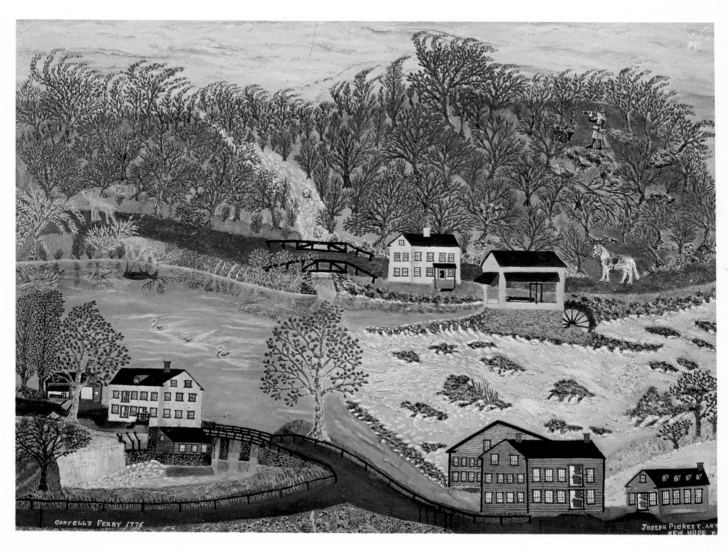

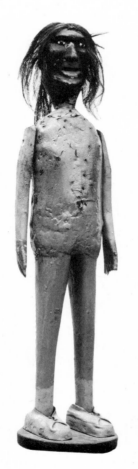

65, 65a (above). Anonymous: *Indian Doll*. c. 1920. Polychromed wood, horse hair, and tar. H. 24″. Ohio. Private collection. Photograph: Helga Photo Studio.

66 (left). Anonymous: *Indian Figure*. Early twentieth century. Wood, tar, leather, horsehair—painted. H. 28¾″. New York State. Courtesy Mr. and Mrs. Michael D. Hall.

67 (opposite). Anonymous: *Baron Samedi*. c. 1920. Wood and metal. H. 32½″. New Orleans, Louisiana. Voodoo figure, found in the back of a Black barbershop in New Orleans. Chicken blood and feathers were encrusted on the sculpture when it was found. Private collection. Photograph: Eeva-Inkeri.

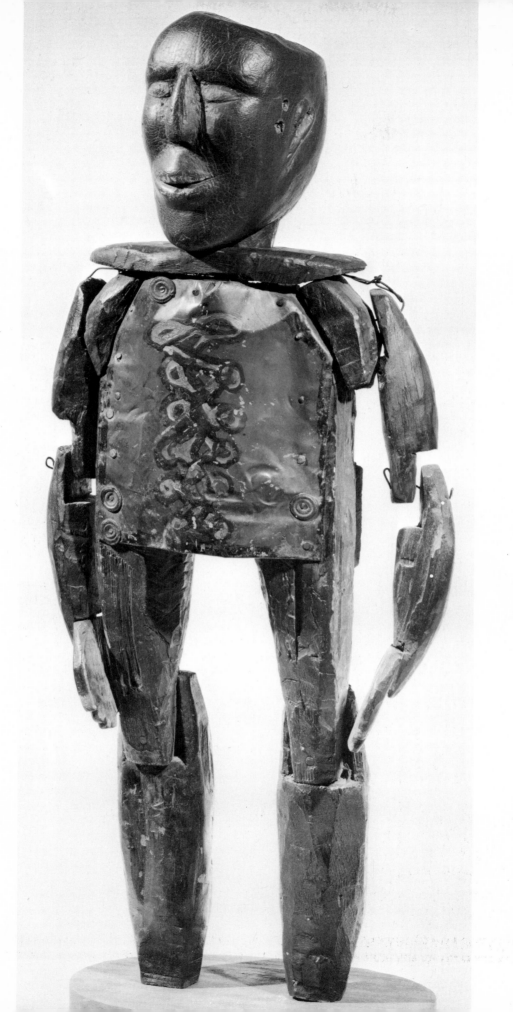

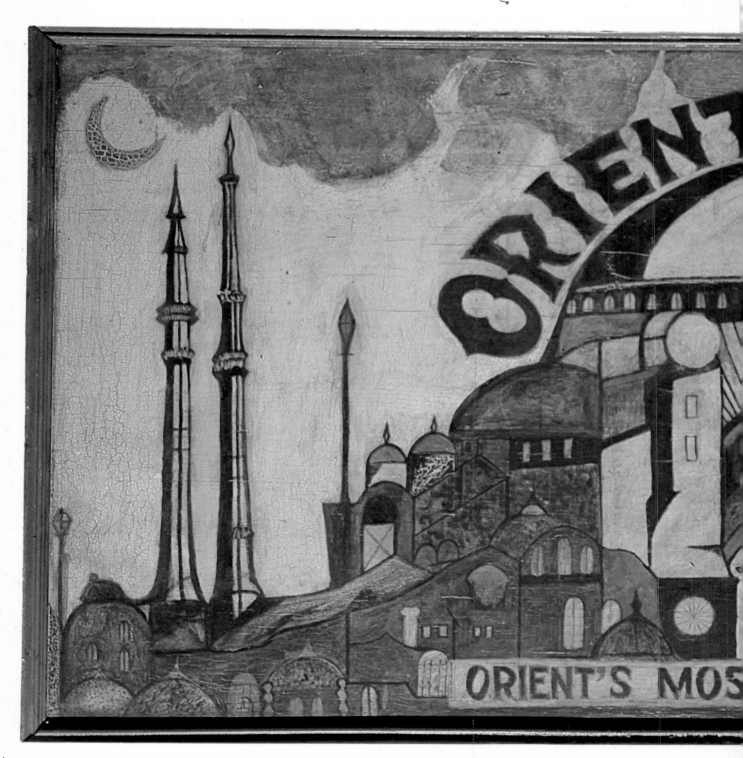

68 (below). Anonymous: *Orient Delights.* c. 1920. Oil on board. 35½″ x 72″. A sign from a candy factory in Hoboken, New Jersey. Courtesy Herbert W. Hemphill, Jr. Photograph: Helga Photo Studio.

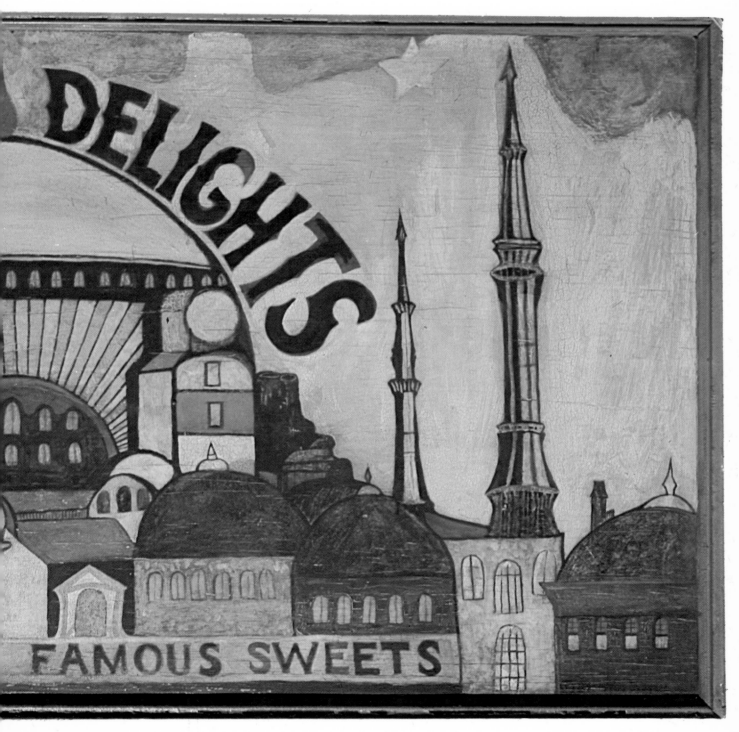

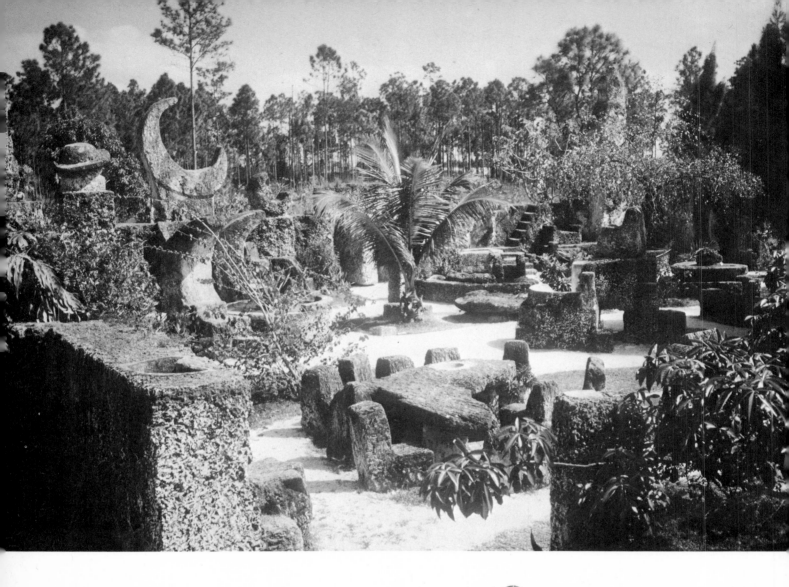

EDWARD LEEDSKALNIN was born in Latvia in 1887, of peasant stock. Brokenhearted when jilted on the eve of his wedding day, he emigrated to America in 1921. After some traveling, he settled near Florida City, Florida, acquired land, and began his life's work: quarrying and sculpting huge blocks of coral rock, many weighing more than six tons, to create a castle. He used only hand tools. It was to be a monument to his love. He equipped it with huge furniture—table, chairs, beds, rockers, a cradle—which could be swung, turned, or rocked with the touch of a finger. Asked how one person (he was five feet tall and weighed less than 100 pounds) could quarry, build, and balance such enormous and heavy stones, he said he knew the secret of the Egyptian pyramids and understood the principle of weights and levers, and that when one had it in one's head, one did not need muscle. Self-taught in astronomy and electromagnetic engineering, his fascination with the stars is reflected in his gigantic 23-ton crescent and 18-ton planets. He died in December, 1951, of malnutrition, leaving a cash hoard of $3,500 in his castle.

56

69 (opposite, above). Edward Leedskalnin: *The Coral Castle*. Begun .c. 1921, completed c. 1950. Thirty miles south of Miami, Florida. Photograph: Cline Photo, Inc.

70 (opposite, below). Anonymous: *Flagpole Finial*. c. 1920. Painted wood. H. 28″. Oneonta, New York. Courtesy Mr. and Mrs. J. Roderick Moore.

71 (left). Anonymous: *Water Derrick*. Whirligig. c. 1925. Polychromed wood and metal. Pennsylvania. Private collection. Photograph: Eeva-Inkeri.

FRANK MORAN was a carpenter. He was born in Vermont, lived for a time in upstate New York, and moved back to Vermont, where he died. Most of his carvings were done in the 1930s and 1940s, after he had retired from his work.

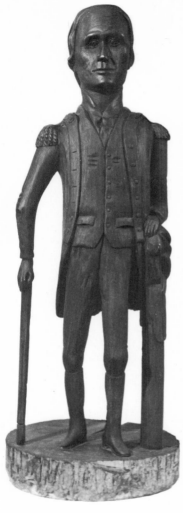

72 (above). Frank Moran: *George Washington*. c. 1932. Wood. H. 26½″; base diameter, 10½. New York. Courtesy New York State Historical Association.

73 (left). Frank Moran: *Old Abe*. c. 1940. Unpainted pine, sanded. H. 54″; D. 20″; W. 17″. Vermont. Carved with knives and chisel from a single log. Courtesy New York State Historical Association.

74 (opposite). Anonymous: *Liberty*. c. 1920. Polychromed wood, articulated arms. H. 82″. Found in Connecticut. Courtesy Mr. and Mrs. Michael D. Hall.

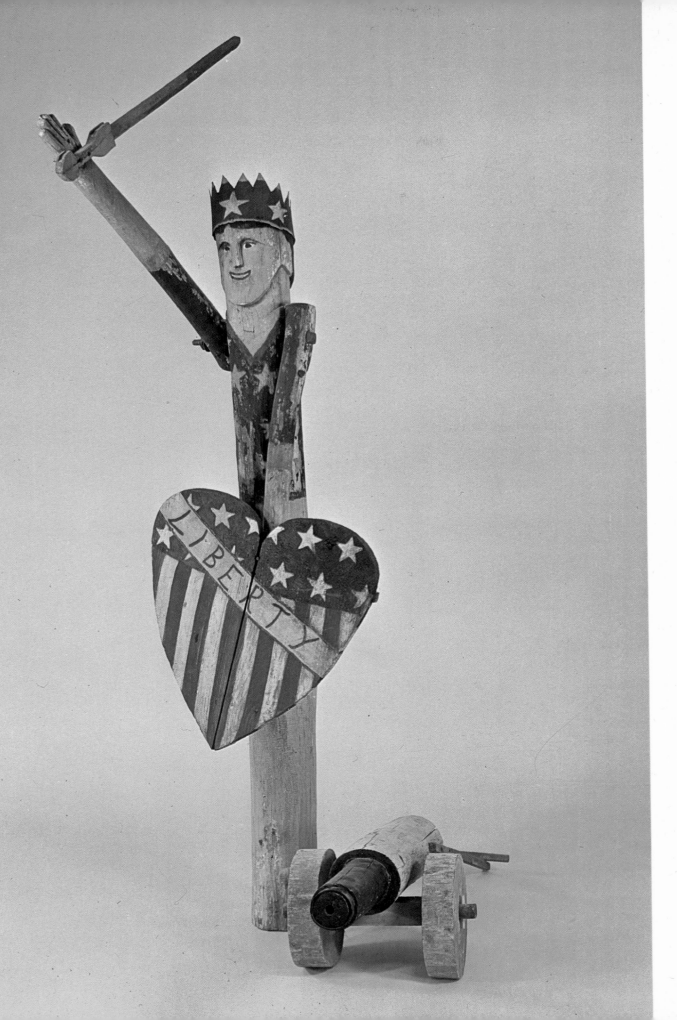

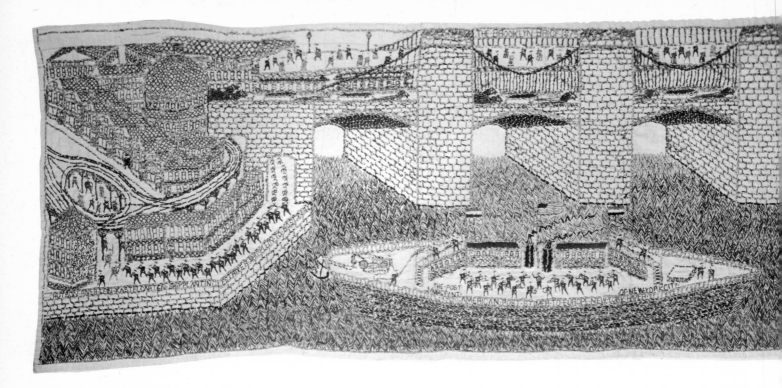

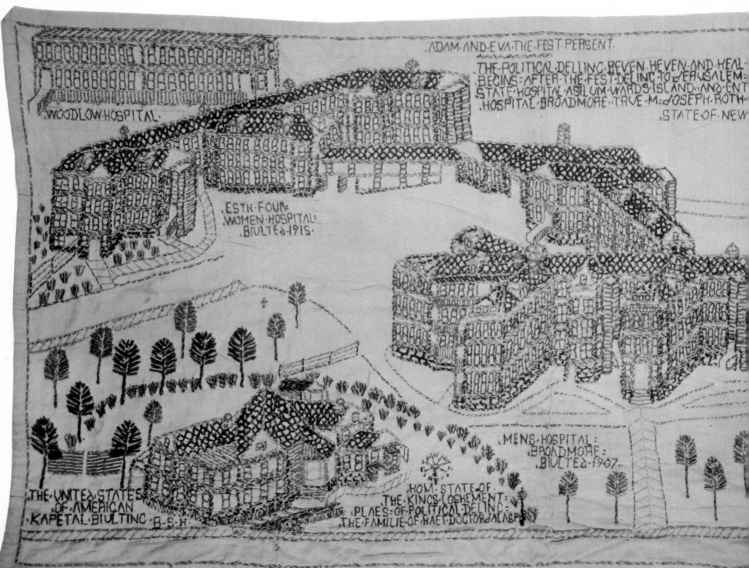

75 (opposite, above). Anonymous: *Brooklyn Bridge*. c. 1919–1921. Embroidered white cotton. 28″ x 44″. New York. Made by a patient at the Binghamton State Hospital. Courtesy Broome County Historical Society. Photograph: Eeva-Inkeri.

76 (opposite, below). Anonymous: *Hospital Buildings*. c. 1919–1921. Embroidered white cotton. 22″ x 39″. New York. Made by a patient at the Binghamton State Hospital. Courtesy Broome County Historical Society. Photograph: Eeva-Inkeri.

77 (right). Anonymous: *Policeman*. c. 1920. Polychromed wood and leather. H. 20″. Private collection. Photograph: Eeva-Inkeri.

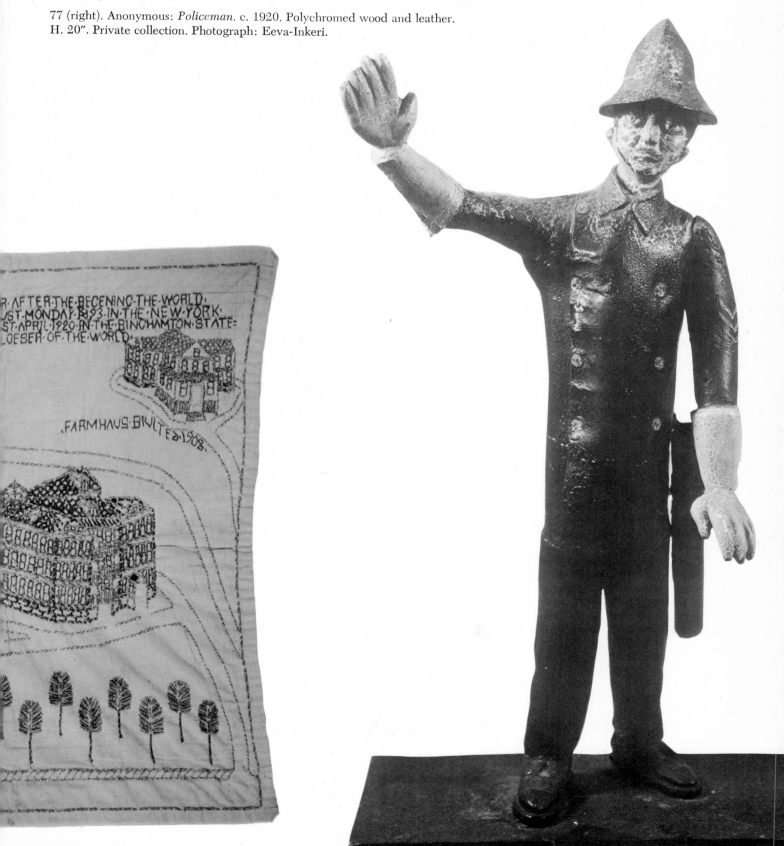

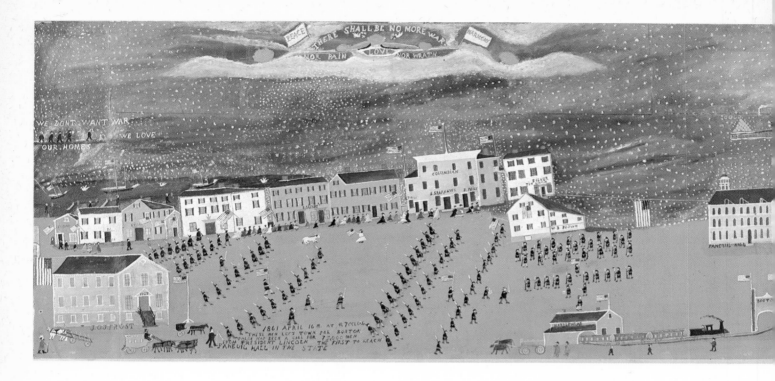

78 (above). J. O. J. Frost: *There Shall Be No More War.* c. 1925. Oil on wallboard. 32″ x 71½″. Gloucester, Massachusetts. Courtesy Bertram K. and Nina Fletcher Little. Photograph courtesy *American Heritage.*

J. O. J. FROST was born January 2, 1852, in Marblehead, Massachusetts, and died there November 3, 1928, after a career that included halibut and cod fishing out at sea, restaurant cook and owner, and painter. He went to sea at 16, in 1868, to help his widowed and penniless mother, but quit in 1870. "It was not through fear of danger, but ambition spurred me on, to get into a better paid business so I could marry my sweetheart and establish a home. She became my compass to steer by, and we never parted after our marriage until her death in 1919." His wife's father was in the restaurant business; Frost learned from him and opened his own business, which became famous for its high quality and low prices. When he retired, he joined his wife in her outdoor florist business, until she died. In August 1923, a visitor asked him to draw a picture of an old-time Grand Bank fishing vessel. This led him to try a sketch in crayons, and out of this small beginnng came some 80 oil paintings.. It became his aim to make a pictorial history of Marblehead and her people, beginning with the arrival of the white man in 1625. Such facts as could not be pictorialized—like names and dates—were simply painted in. In 1926, he opened his "new art building" to display his paintings. Admission was twenty-five cents.

79 (above). J. O. J. Frost: *A Gale at Sea.* c. 1925. Oil on canvas. 32½″ x 64½″. Gloucester, Massachusetts. Private collection.

80 (left). Charles W. Hutson (1840–1936): *Corinna and Her Legends.* c. 1920. 9″ x 12″. Oil on academy board. New Orleans, Louisiana. ". . . the thoughts of Corinna as she stands to receive her award. The story he wants to tell is her dream of myths in her poem. She has surpassed her teacher, a fact that interested the artist, for he greatly admired womankind and gloried in any honor bestowed on them." Courtesy Mrs. B. S. Nelson. Photograph: Weber Studios.

81 (below). Clementine Hunter (Black artist, b. about 1882): *Louisiana Syrup Makers.* 1965. Watercolor on paper. 48″ x 72″. New Orleans, Louisiana. "I paint just what come in my mind. What hits me. Cotton's right in front of you; you just have to pick it from the bush. You have to study your head to paint." Among the characters in the painting are "Miss Cammie" (the artist's patron) in her black skirt and white shirtwaist; J. H. Henry with his broken arm; and Dr. Scruggs on horseback with his pet buzzard. Courtesy Preservation Hall. Photograph: Industrial Photography, Inc.

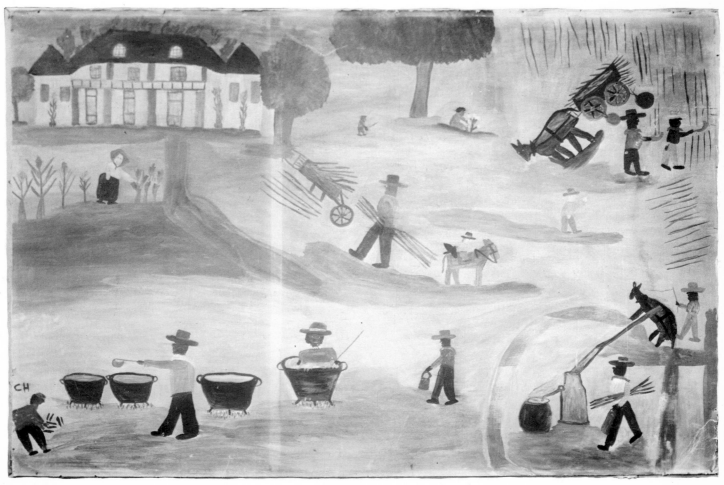

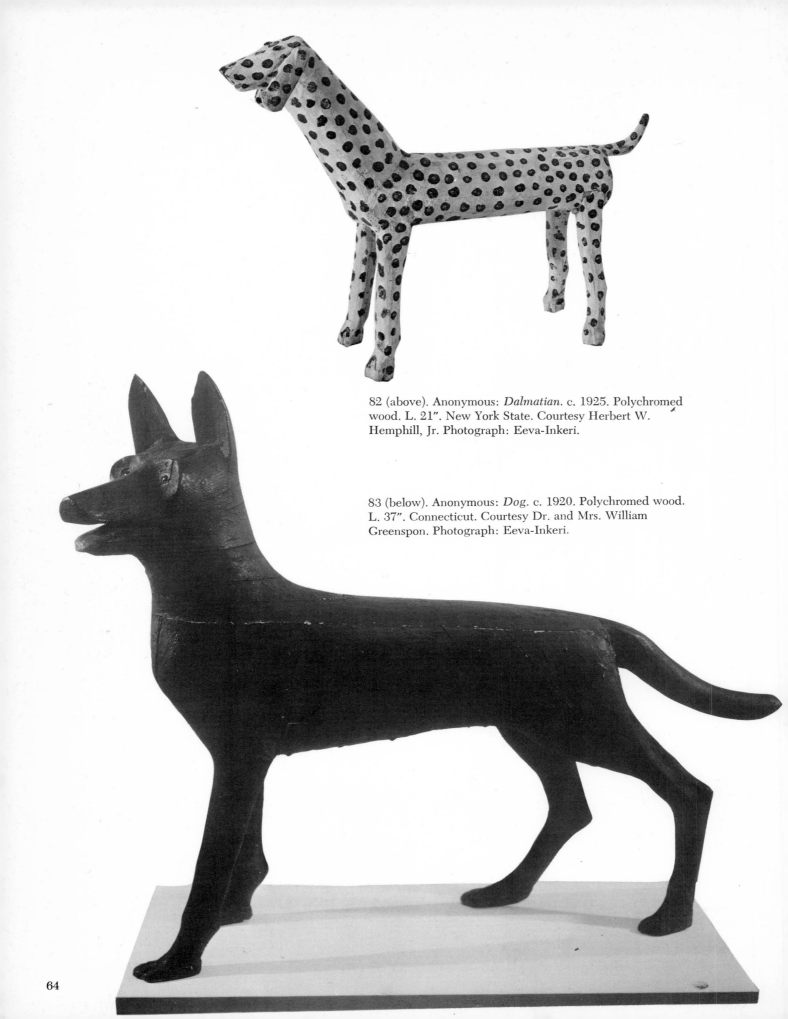

82 (above). Anonymous: *Dalmatian*. c. 1925. Polychromed wood. L. 21″. New York State. Courtesy Herbert W. Hemphill, Jr. Photograph: Eeva-Inkeri.

83 (below). Anonymous: *Dog*. c. 1920. Polychromed wood. L. 37″. Connecticut. Courtesy Dr. and Mrs. William Greenspon. Photograph: Eeva-Inkeri.

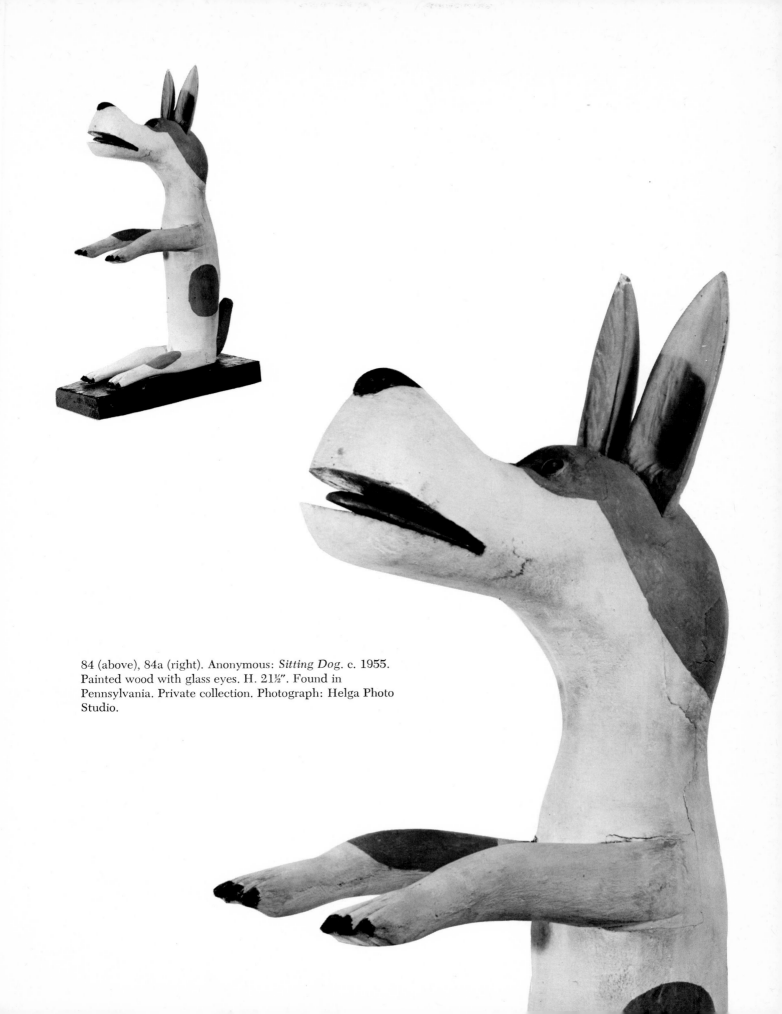

84 (above), 84a (right). Anonymous: *Sitting Dog*. c. 1955. Painted wood with glass eyes. H. 21½″. Found in Pennsylvania. Private collection. Photograph: Helga Photo Studio.

SIMON (SAM) RODIA was born in 1879 in Rome, Italy, and came to the United States before he was 12; he died in 1965. He had worked in logging and mining camps, was a night watchman, a construction worker, a tile setter, a telephone repairman. He bought a house and a large lot in the Watts area of Los Angeles. At that time the neighborhood was largely Spanish-speaking, and he was known as Sam Rodilla. A widower, he was gay and outgoing, fond of women, and sped about in his 1927 Hudson touring car. When he began his Towers in 1921, he welcomed the neighborhood children and paid them for their bits of broken tile, bottles, and dishes to put into his construction, but as he grew older, his tolerance diminished, and he began to seclude himself. In 1954, he deeded his lot and his Towers to a neighbor, and disappeared. He was found in Martinez, California, in 1959. Meantime, the Towers were vandalized and threatened with destruction by the Los Angeles City Building Department, but through the efforts of William Cartwright and Nicholas King, a committee was formed to preserve and protect them. Rodia never explained why he left his work of 33 years. Literature issued by the Committee for Simon Rodia's Towers in Watts quotes him: "I no have anybody help me out. I was a poor man. Had to do a little at a time. If I hire a man, he don't know what to do. A million times I don't know what to do myself. Some of the people think I was crazy. I wanted to do something in the United States because I was raised here you understand? . . . because there are nice people in this country."

85 (center), 86 and 87 (opposite), 88 (overleaf). Simon (Sam) Rodia: *Watts Towers*. Begun in 1921, completed 1954. Steel rods, mesh, and mortar decorated with broken bottles, dishes, tiles, and seashells. Los Angeles, California. Built without predrawn designs, machinery, or scaffolding, the complex comprises towers, arches, fountains, pavilions, and labyrinths. Photographs courtesy James Eakle.

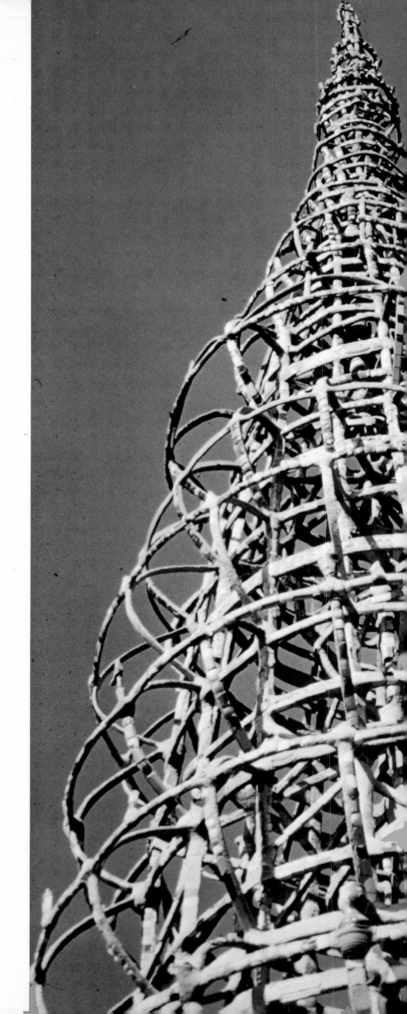

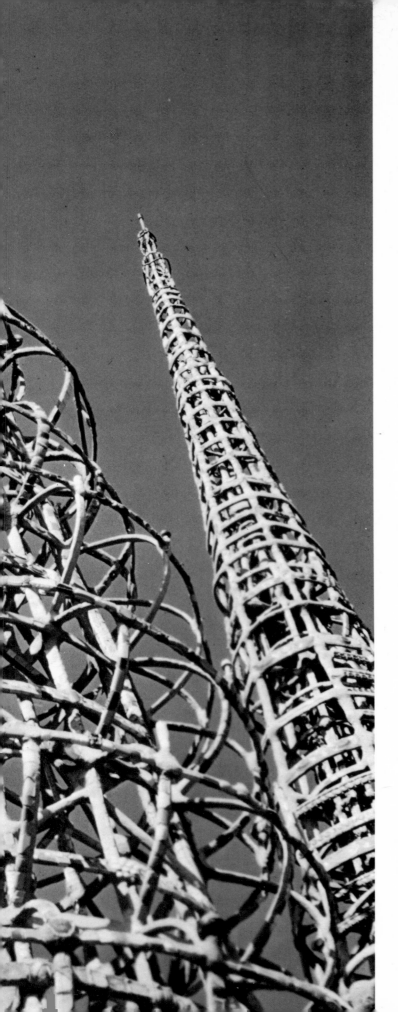

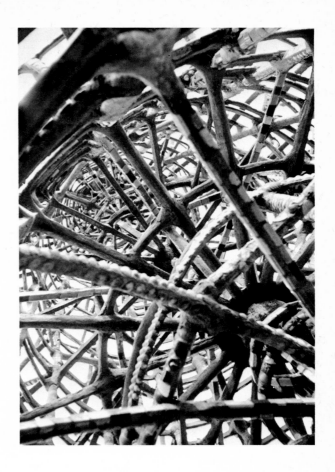

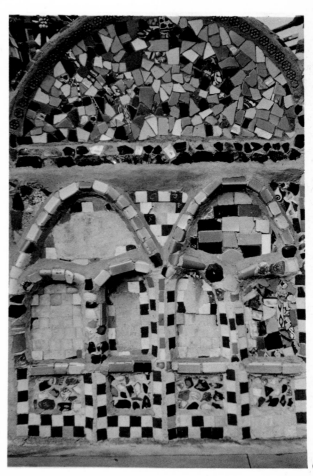

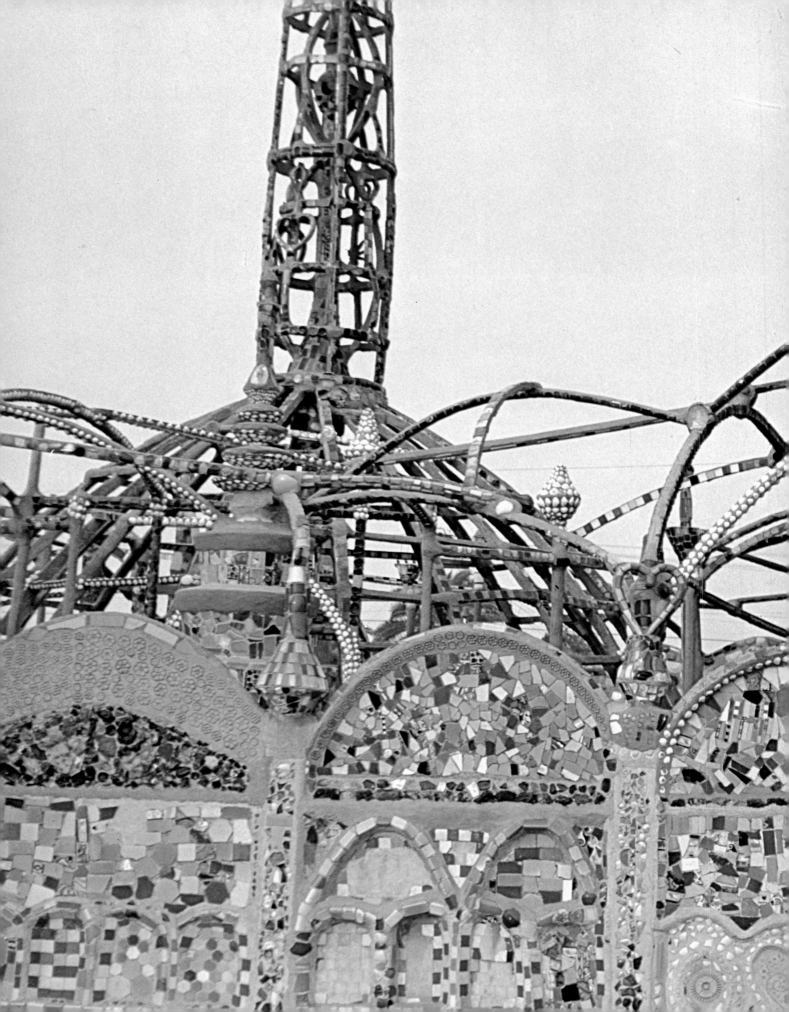

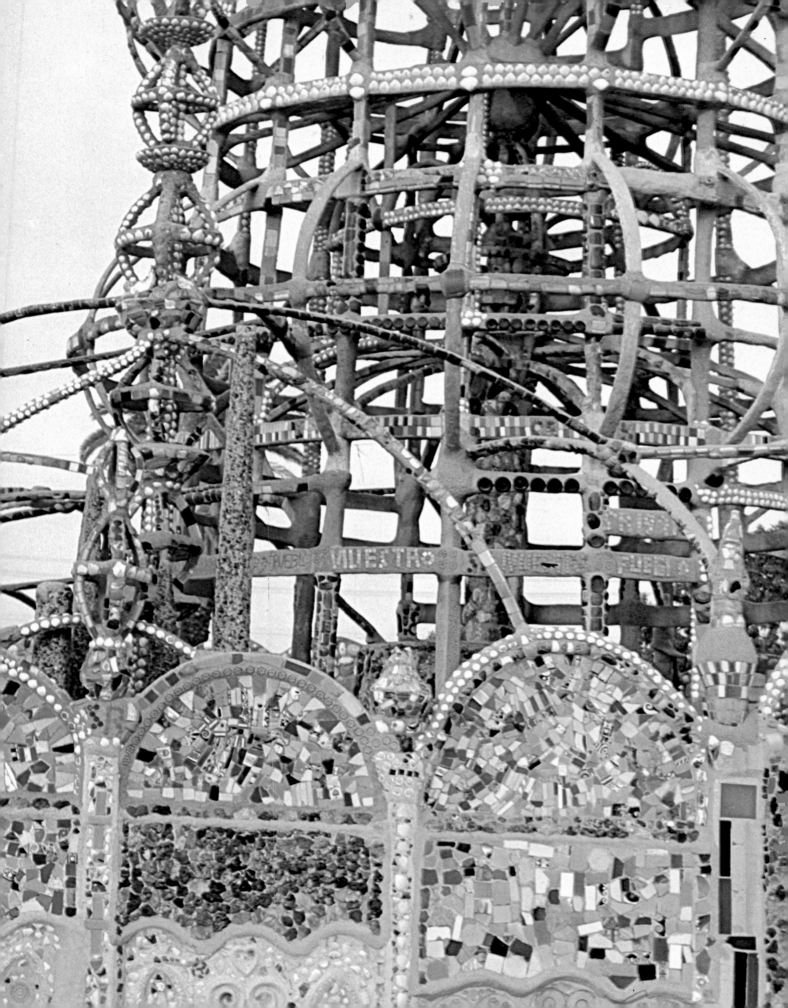

89 (left). Samuel A. Robb: *Santa Claus*. c. 1923. Polychromed wood. H. 33½″; base 2½″. New York. The last show figure made by Samuel A. Robb, this was a Christmas gift for his daughter. Courtesy Mr. and Mrs. Frederick Fried.

90 (below). Anonymous: *Horse*. c. 1920. Wood, covered with fabric, metal trim. L. 59″. Private collection. Photograph: Helga Photo Studio.

EDGAR ALEXANDER MCKILLOP, a blacksmith, was born in 1878 in Balfour, North Carolina. He lived there until his death in 1950. Only four of his wood carvings are known. His daughters wrote to the Henry Ford Museum: "Edgar Alexander McKillop was a talented man. He could cook and sew and make rustic and fancy furniture. He could make anything from wood or any kind of metal. He was an inventor. We don't know of any kind of work that he could not do some of."

91 (above). Edgar Alexander McKillop: *The Hippoceros.* 1928–1929. Carved walnut. L. 58¼". Balfour, North Carolina. Cut into the back is a hinged lid that reveals a record player. Courtesy Abby Aldrich Rockefeller Folk Art Collection.

92 (right). E. A. McKillop: *Figural Group.* c. 1929. Wood. H. 51½". Balfour, North Carolina. Courtesy Greenfield Village and Henry Ford Museum.

STEVE HARLEY (figure 93, below) was born in Michigan in 1863, and died in Scottsville, Michigan, in 1947. He inherited the farm he was born on and when it failed in the early 1920s, he went to Washington, Oregon, California, and Alaska. The beauty of the Northwest so moved him that he tried at first to capture it with photographs. Disappointed by the lack of color, he began to paint, using a magnifying glass to help him perfect each detail and refine his brushstrokes. Even with photographs as reminders, it took him many months to complete a painting. He returned to Scottsville in the early 1930s, penniless and too ill to paint. He lived in a shack with three of his canvases, his only known works. On the back of his painting, *Wallowa Lake,* he wrote, "Painted by S. W. Harley 'the Invincible.'"

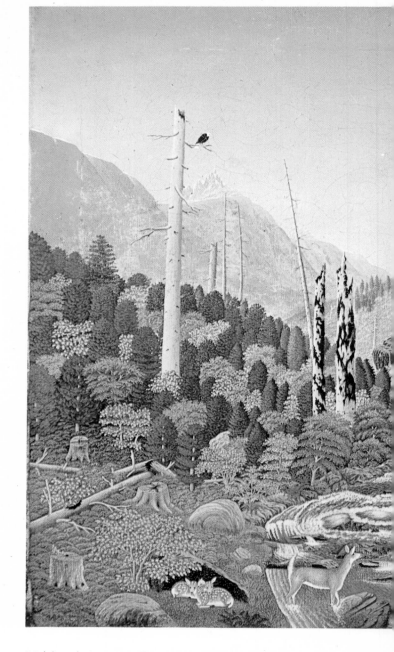

94 (above). Steve Harley: *Upper Reaches of Wind River, Washington,* 1927–1928. Oil on canvas. 35″ x 20″. Found in Scottsville, Michigan. ". . . he never thought of himself as an artist. He wanted an exact duplication of the things that thrilled his senses." (Robert Lowery, *Flair,* June, 1950.) Courtesy Abby Aldrich Rockefeller Folk Art Collection.

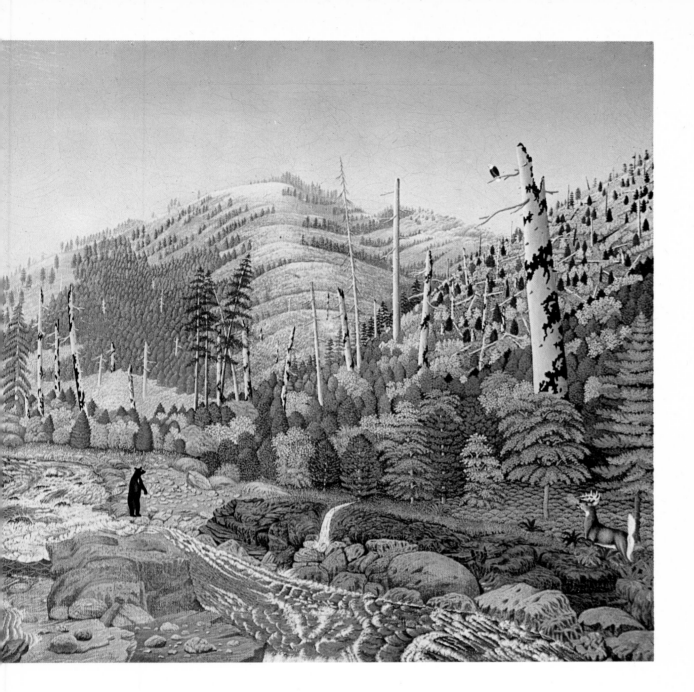

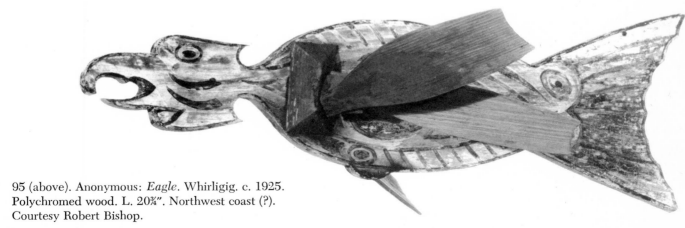

95 (above). Anonymous: *Eagle*. Whirligig. c. 1925. Polychromed wood. L. 20¾". Northwest coast (?). Courtesy Robert Bishop.

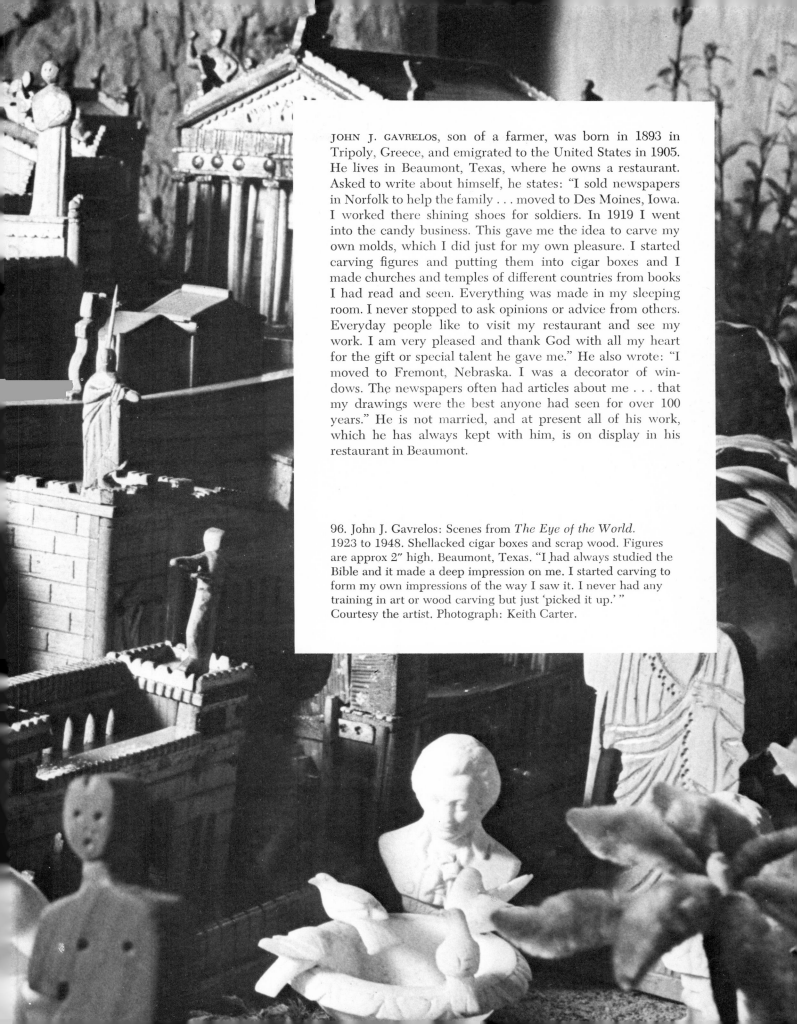

JOHN J. GAVRELOS, son of a farmer, was born in 1893 in Tripoly, Greece, and emigrated to the United States in 1905. He lives in Beaumont, Texas, where he owns a restaurant. Asked to write about himself, he states: "I sold newspapers in Norfolk to help the family . . . moved to Des Moines, Iowa. I worked there shining shoes for soldiers. In 1919 I went into the candy business. This gave me the idea to carve my own molds, which I did just for my own pleasure. I started carving figures and putting them into cigar boxes and I made churches and temples of different countries from books I had read and seen. Everything was made in my sleeping room. I never stopped to ask opinions or advice from others. Everyday people like to visit my restaurant and see my work. I am very pleased and thank God with all my heart for the gift or special talent he gave me." He also wrote: "I moved to Fremont, Nebraska. I was a decorator of windows. The newspapers often had articles about me . . . that my drawings were the best anyone had seen for over 100 years." He is not married, and at present all of his work, which he has always kept with him, is on display in his restaurant in Beaumont.

96. John J. Gavrelos: Scenes from *The Eye of the World*. 1923 to 1948. Shellacked cigar boxes and scrap wood. Figures are approx 2″ high. Beaumont, Texas. "I had always studied the Bible and it made a deep impression on me. I started carving to form my own impressions of the way I saw it. I never had any training in art or wood carving but just 'picked it up.'" Courtesy the artist. Photograph: Keith Carter.

97 (opposite). John Kane: *Self-Portrait*. 1929. Oil on composition board. 36½″ x 27⅛″. Pittsburgh, Pennsylvania. "The next job I had was the one contributed most of all towards my artistic work. I became a painter. I painted freight cars. The best thing in the world for a young artist would be to hire himself out to a good painting contractor." (*Sky Hooks*, Kane's autobiography as recorded by Marie McSwigan.) Courtesy The Museum of Modern Art.

JOHN KANE was born in Scotland in 1870, and died in Pittsburgh, Pennsylvania, in 1934. He emigrated at the age of 19, laid rock road beds for the railroad, mined coke, worked in steel mills, dug coal in Alabama, Kentucky, and Tennessee, paved streets, became a freight car painter, enlarged, retouched, and repainted photographs, and did house painting. He was also a formidable amateur boxer. His "career" as an artist, and he considered himself this above all else, began in 1928, when the Carnegie Institute bought one of his paintings. His lonesome and protracted wanderings away from his family were occasioned by his intense grief over the death of an infant son in 1904.

"I liked to go up on the hills to draw. Beauty of whatever kind. But I did not learn to paint for a long time. I painted freight cars. I believe many a young art student would profit greatly if he learned to paint as an outdoor painter does rather than to confine his training to the art school. They never teach how to get those colors for themselves. A house painter knows how to get it for himself. Often I have been at a loss to know how to overcome some significant point in artistic form which I would have learned easily in an art school. But my spirit of observation has helped me to acquire knowledge and so the source of my information did not matter." (*Sky Hooks*)

98 (above). A. G. Carter: *Dirigible*. c. 1930. Oil on canvas. Appalachia, Virginia. The artist was a cobbler. Courtesy Dr. and Mrs. William Greenspon. Photograph: Eeva-Inkeri.

99, 100, 101, 102 (below and right). Paul L. Wagner: *Garden with Chapel of Brotherhood.* c. 1930. Concrete and mixed media. Sparta, Wisconsin. Photographs courtesy Roger Brown.

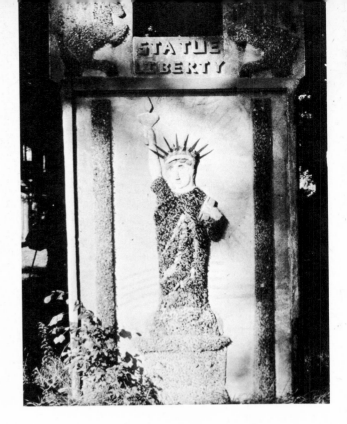

103 (opposite). Anonymous: *Tin Man.* c. 1930. Polychromed tin. Iowa. Photograph courtesy Roger Brown.

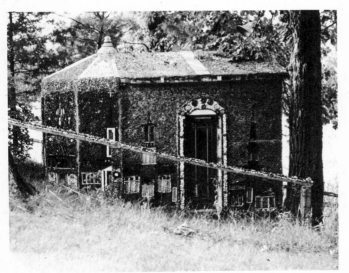

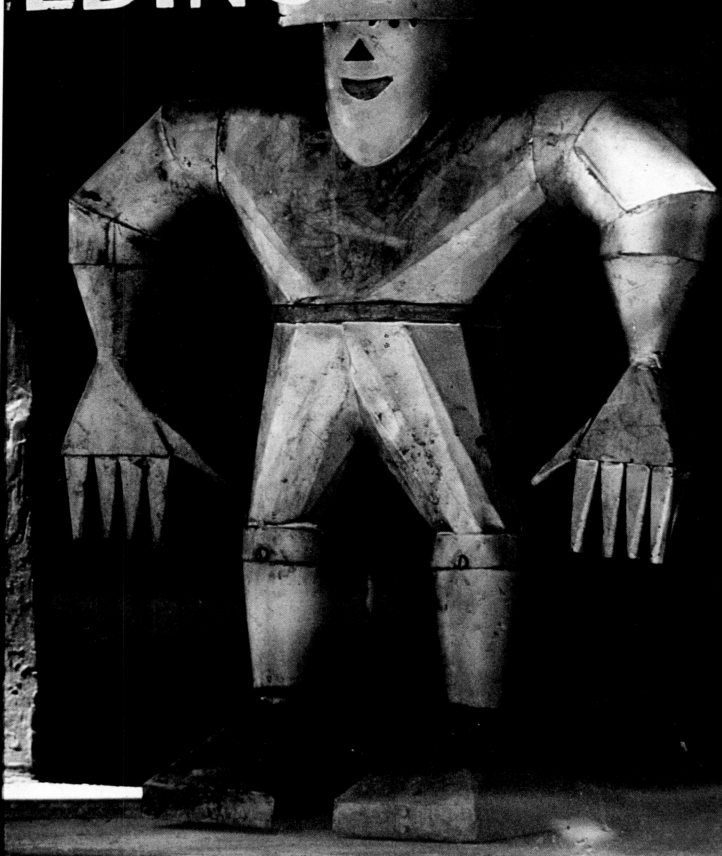

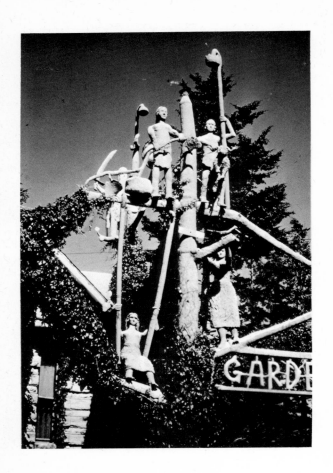

S. P. DINSMOOR was born near Coolville, Ohio, March 8, 1843, but built his "Cabin Home" of log-shaped stone in Lucas, Kansas, where he died in 1932. The Home is surrounded by his aerial sculptures, part of which he dubbed the "Garden of Eden" and the other part "Modern Times." Nearby is his mausoleum also made of notched logs of limestone. He wrote a little booklet, the *Pictorial History* of his home and garden, wherein he says: "I served three years in the Civil War . . . came to Illinois in the fall of 1866. Taught school five terms. Married. Farmer by occupation. Moved to Lucas, Kansas, in the fall of '88. Moved to Nebraska . . . back to Lucas. Built the Cabin Home in 1907 and later on the Garden of Eden. I was 81 when I married my present wife and she was 20. I was past 81 when our baby girl was born." Of the glass-covered coffin in which he lies, he wrote: "This lid will fly open and I will sail out like a locust. I have a cement angel outside to take me up." However, Dinsmoor believed in hedging his bets, for he had himself buried with an ax by his side just in case the coffin lid failed to fly open as planned.

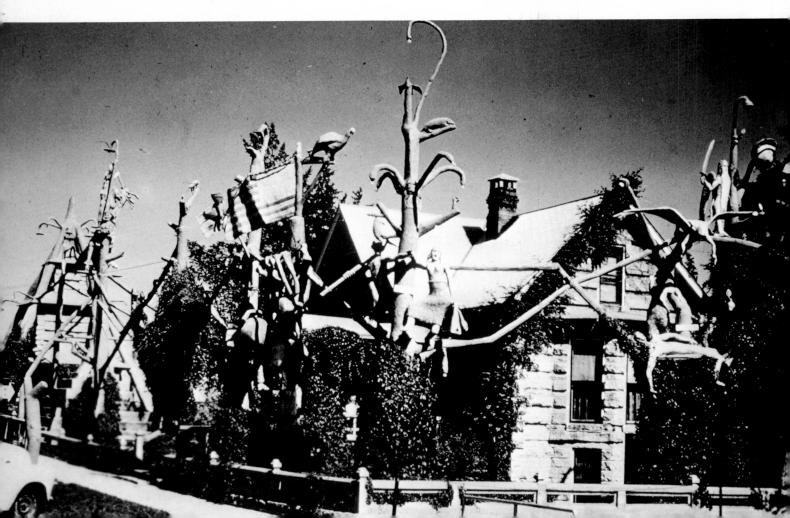

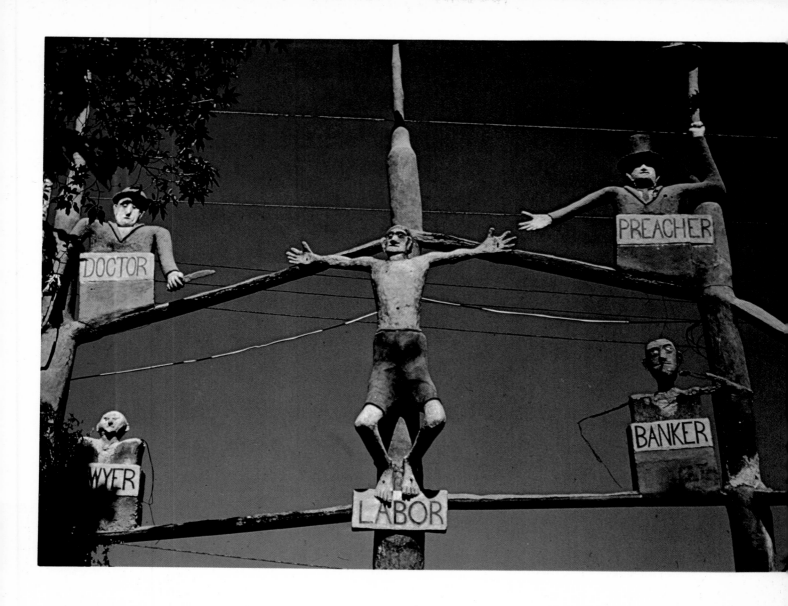

104, 105, 106, 107 (opposite, above, and right).
S. P. Dinsmoor: *The Garden of Eden* and *Modern Civilization*. Begun 1907, completed 1927. Cement and limestone. Lucas, Kansas. ". . . U.S. Flags, Adam and Eve, the devil, coffin, jug, labor crucified, bird and animal cages, trees 8 to 40 feet high are all made with cement—modern civilization as I see it. If it is not right, I am to blame, but if the Garden of Eden is not right, Moses is to blame. He wrote it up and I built it." Photographs courtesy Roger Brown.

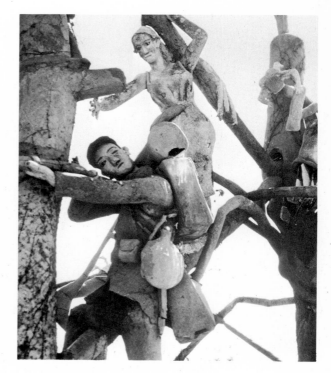

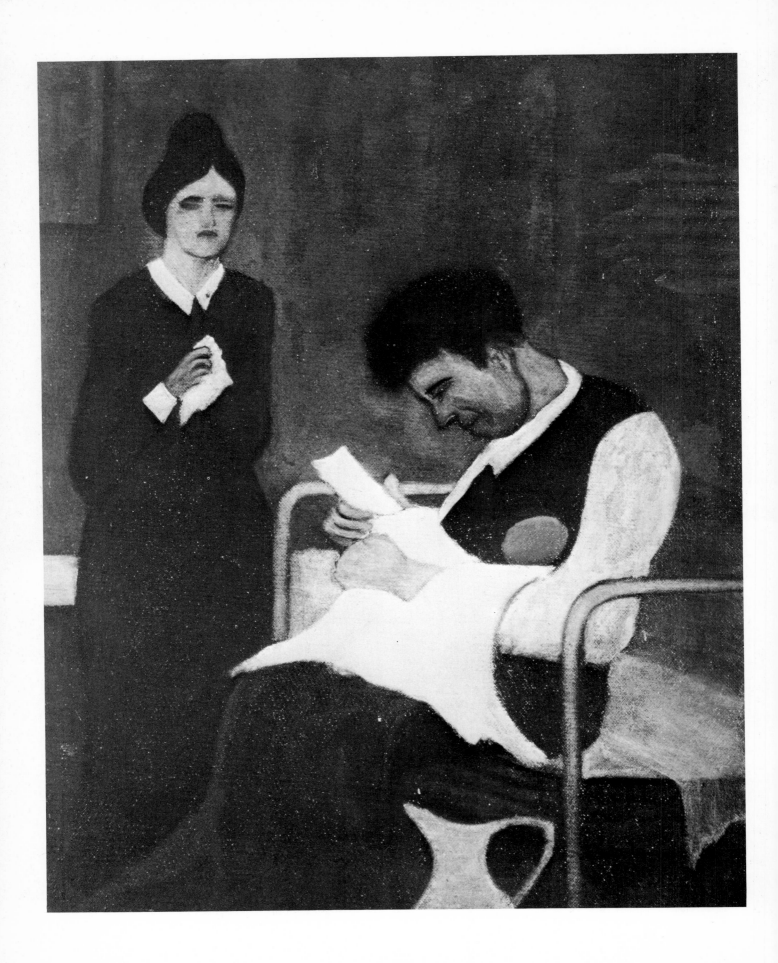

108 (opposite). Emile Branchard: *The Sick Baby.* c. 1928. Oil on board. 20″ x 16″. New York. ". . . here are the paints and brushes. Surely you have something in your head that wants to be painted, go ahead and paint it." Courtesy Mr. and Mrs. Elias Getz. Photograph: Eeva-Inkeri.

109 (above). George E. Lothrop: *The Muses.* c. 1920. Oil on canvas. 13¾″ x 22½″. Boston, Massachusetts. Nothing is known about this artist except the information contained in two stickers on the back of one of a group of his paintings that were found in a junk store. Courtesy Mr. and Mrs. Elias Getz. Photograph: Eeva-Inkeri.

EMILE BRANCHARD was born in New York in 1881. He worked at a variety of jobs, among them truck driving and, during World War I, as a Home Defense Force policeman. Tuberculosis forced him into early retirement, and he took up painting, using materials an artist-roomer had left in lieu of rent. Sidney Janis quotes him in *They Taught Themselves* as insisting that: "Painting is like cooking. You must have the right ingredients and know how to mix them. Colors are like men and women. Some mix and some don't. When they do, it's marriage, and when they don't, it's divorce." He preferred painting landscapes to people; the family scene, hence, is relatively rare. Even so, he worked largely from memory and imagination rather than from nature, saying . . . "nature runs faster than you can catch her."

GEORGE E. LOTHROP. Sidney Janis credits the discovery of this painter to Peter Hunt, who found a group of his works in a Boston junk store. "The only concrete evidence to give some direct information is in the two stickers found pasted to the back of [a] painting . . . a photograph of himself in a fantastic costume as Father Neptune, and bathing girl cutouts pasted around him. The text reads: 'THE POET KING—Copyrighted 1912 by Geo. E. Lothrop, Boston. Plays, Songs, Monologues, Poems, Novels. Bids received for rights to 8 Plays, 150 G. E. Lothrop Poems, 40 songs and Photographs of the "Poet King." Also for interest in new Moving Picture invention revolutionizing the business, improving the films 200 pr. ct. and making $2.00 picture houses a success. MARITIME CO., Fenway, Boston, Massachusetts.'"

110 (above). Thalia Nichlan: *Untitled* (Patriotic panel). Dated: January 1931. Embroidery on silk. 26¾" x 35½". New York. Courtesy Mr. and Mrs. Elias Getz.

111 (opposite), 111a (right). Mrs. Cecil White: *Scenes from Life in 1930*. c. 1930. Appliqué quilt. 66" x 77". Hartford, Connecticut. Courtesy Rhea Goodman: Quilt Gallery, Inc.

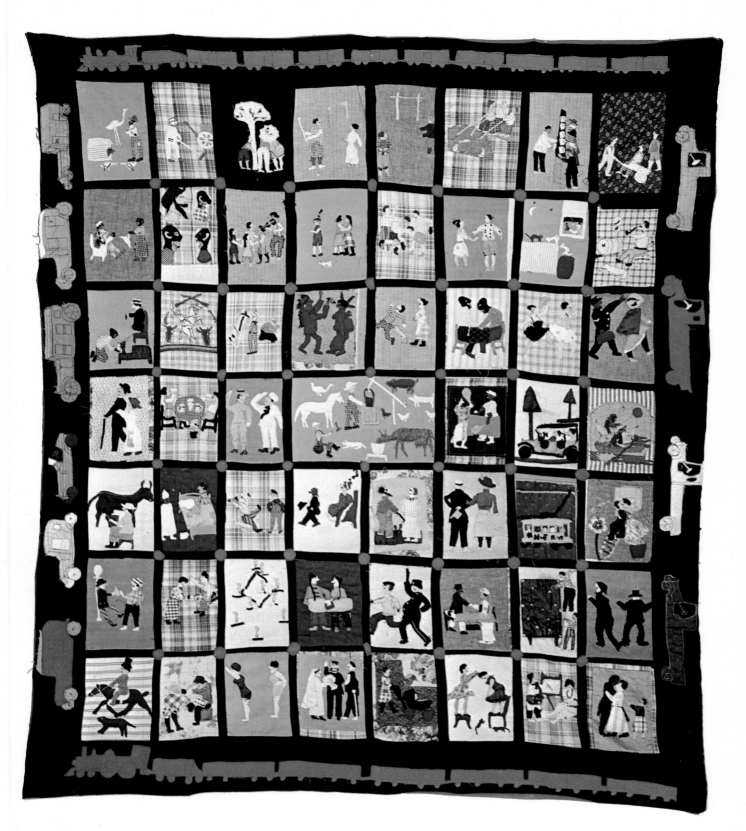

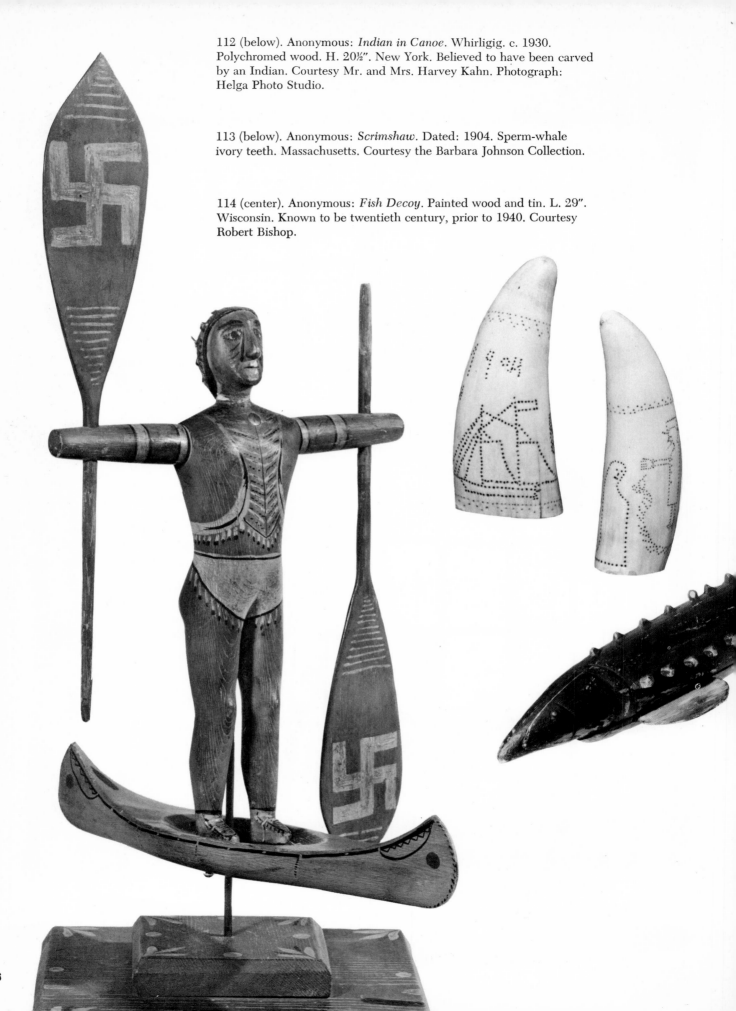

112 (below). Anonymous: *Indian in Canoe*. Whirligig. c. 1930. Polychromed wood. H. 20½″. New York. Believed to have been carved by an Indian. Courtesy Mr. and Mrs. Harvey Kahn. Photograph: Helga Photo Studio.

113 (below). Anonymous: *Scrimshaw*. Dated: 1904. Sperm-whale ivory teeth. Massachusetts. Courtesy the Barbara Johnson Collection.

114 (center). Anonymous: *Fish Decoy*. Painted wood and tin. L. 29″. Wisconsin. Known to be twentieth century, prior to 1940. Courtesy Robert Bishop.

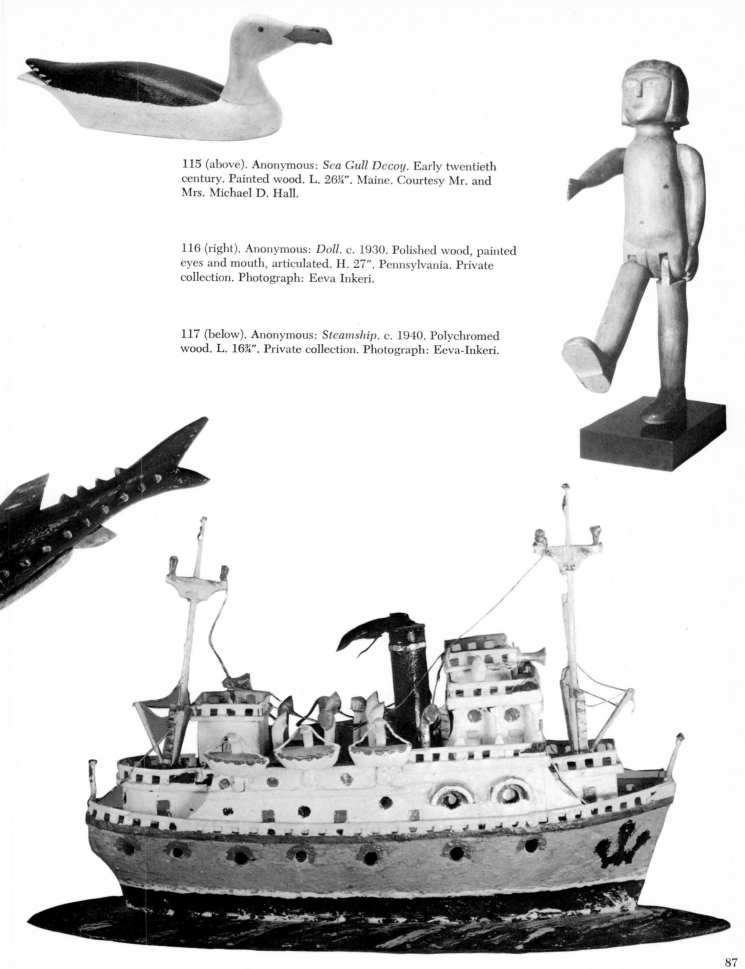

115 (above). Anonymous: *Sea Gull Decoy*. Early twentieth century. Painted wood. L. 26¼". Maine. Courtesy Mr. and Mrs. Michael D. Hall.

116 (right). Anonymous: *Doll*. c. 1930. Polished wood, painted eyes and mouth, articulated. H. 27". Pennsylvania. Private collection. Photograph: Eeva Inkeri.

117 (below). Anonymous: *Steamship*. c. 1940. Polychromed wood. L. 16¾". Private collection. Photograph: Eeva-Inkeri.

M. T. RATCLIFFE. Elizabeth Moore, writer-journalist of Los Angeles, California, who has researched the origin of the Desert View Tower and the carvings in the Boulder Park Caves, writes: "I have the following facts about the sculptor so far: The name of M. T. Ratcliffe is etched at the bottom of one of the figures. He is described as being an engineer who visited Vaughn's construction during the Depression. He had come from somewhere in the 'east' and was ill, asthma or possibly tuberculosis. He was intrigued with the strangely shaped rocks and spent a period of about two years creating the figures with hand chisel and mallet. Thirteen identifiable figures remain. There were others but they have been stolen or destroyed by vandals."

118 (above), 119 (below). M. T. Ratcliffe: *The Boulder Park Cave Monsters*. c. 1930–1932. Granite. Jacumba, California. Photographs courtesy Richard and Elizabeth Moore.

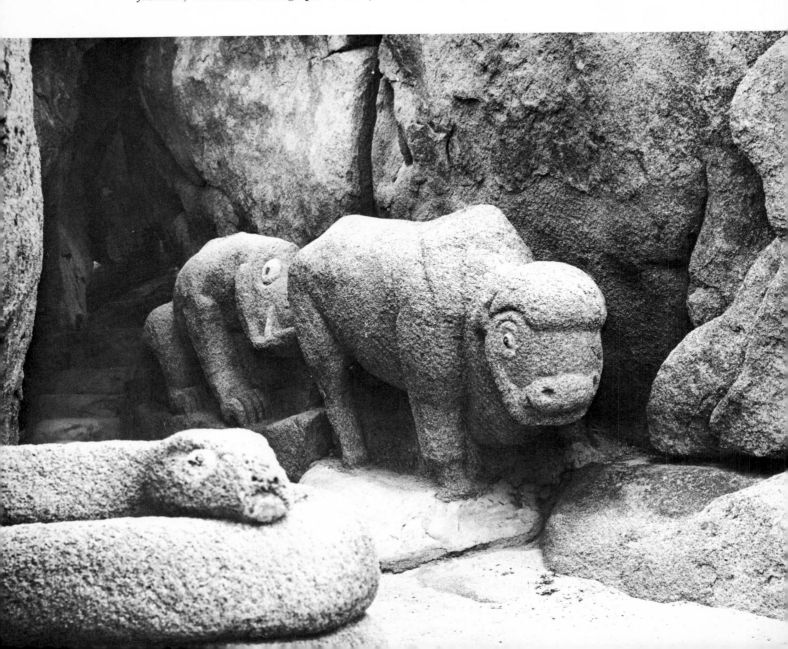

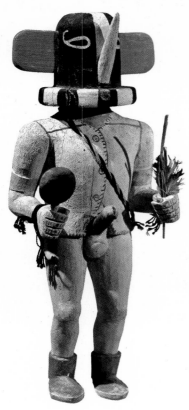

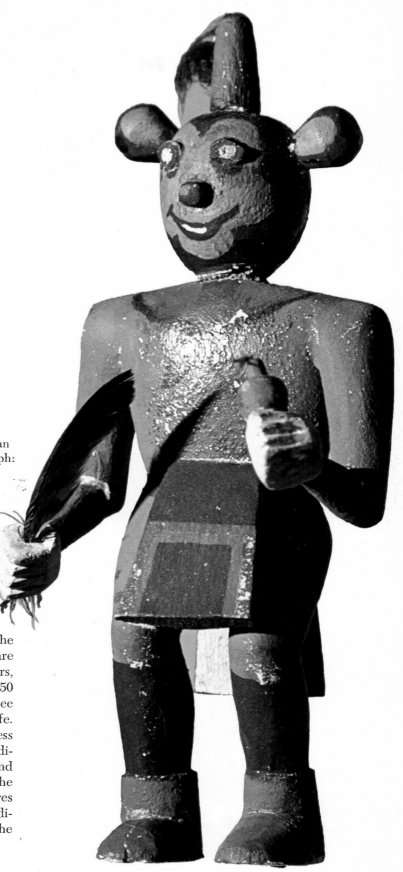

120 (above). Anonymous. *Kókopölö or Kokopelli Kachina Doll.* c. 1930. Polychromed cottonwood and feathers. H. about 20″. Hopi Reservation, Arizona. It symbolizes a fertility ceremony, which was itself a symbolic rather than an actual performance. Courtesy Elbert O. Eisenlau. Photograph: Eeva-Inkeri.

121 (right). Hopi Reservation: *Mickey Mouse Kachina.* c. 1925. Painted wood and feathers. H. 11¾″. New Mexico. Courtesy Herbert W. Hemphill, Jr.

Kachina dolls are familiar to all the Pueblo Indians of the Southwest, but especially to the Hopi and Zuni. They are intended to be small effigies of ceremonial performers, each of whom in turn represents one of well over 350 kachinas—good or supernatural personages that oversee the various religious and social activities of Pueblo life. Although identifying characteristics of masks and dress are ordained by tradition, each doll is unique and individually designed. The larger, realistically carved and costumed sculptures of recent years are intended for the tourist trade and not for religious usage. Kachina figures have the further function of teaching ceremonial tradition to the children, to whom they are given during the celebrations.

WILLIAM DORIANI was born in the Ukraine in 1891, and came to this country as a young child. He returned to Europe to study voice, and became a successful operatic tenor there. Rather suddenly, at the age of 40 he felt a strong urge to paint. He bought materials, but was unable to start. One night he had a dream: a group of elders in robes appeared and placed a brush and palette in his hand. He awoke, rose, and painted his first picture, the *Toe Dancer*. He never showed his work publicly until his return to the United States. He had a few works in a Greenwich Village outdoor show, where Sidney Janis discovered him.

122 (right). William Doriani: *Flag Day*. 1935. Oil on canvas. 12¼″ x 38⅝″. New York. After an absence of thirteen years, the artist returned to the United States—on Flag Day. Courtesy the Sidney and Harriet Janis Collection. Gift to The Museum of Modern Art.

123 (below). Anonymous: *The Boxers*. c. 1935. Polychromed wood. Figures are approx 11¾″ high; base is 14″ x 14½″. Courtesy the Barbara Johnson Collection.

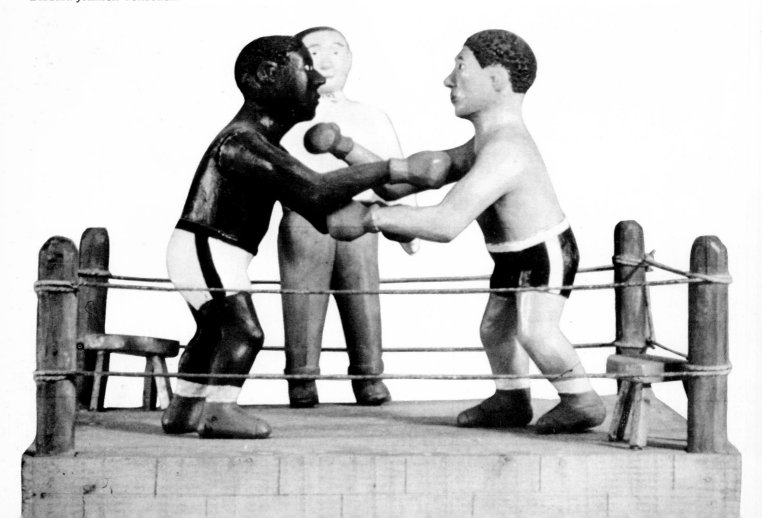

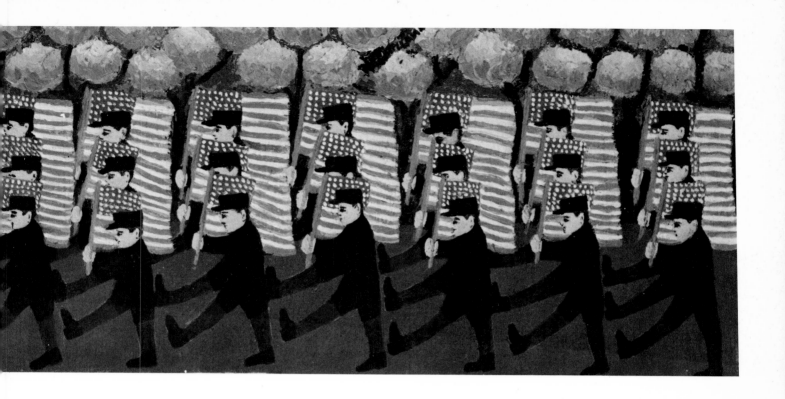

124 (below). William Doriani: *The Green Tablecloth*. 1934. Oil on canvas. 7½″ x 11¾″. Courtesy Sidney and Harriet Janis Collection. Photograph: Eeva-Inkeri.

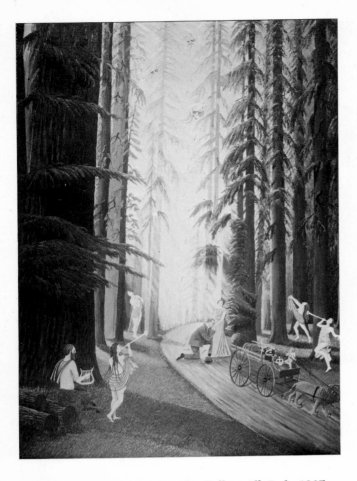

CARLOS CORTES COYLE was born December, 1871, in Bear Wallow (now known as Dreyfus) near Berea, Kentucky. His diary, which he left to Berea College, though revealing little of his personal life, indicates that he moved to Canada, and had lived in Seattle and San Francisco, working in the lumber business and as a ship builder. He retired to Leesburg, Florida, where he died April 28, 1962, impoverished and almost blind. He kept a meticulous record of the size, cost, content, date begun and finished of all his paintings, which were comments about life, current events, and history. Apparently he began painting in the thirties, and was planning a 6' x 8' work on biblical themes when he died. The large canvas was found in his room, empty. In 1942 Coyle bequeathed a number of his paintings to Berea College, stating: "I resolved to give my art to the land of my birth. In those drawings are a set of plans. I hope someday you will be able to build and let our little city become the cultural center of our beloved Kentucky. I am now an old man—71—I am now confined to my bed. That is why I am parting with my beloved pictures now." He lived and painted for twenty more years.

125 (above). Carlos Cortes Coyle: *Calling All Gods.* 1937. Oil on canvas. 59½" x 77½". California. ". . . little Dan Cupid, being the God of Love, has given Edward an American wife and has exacted from him in return his kingly glory, his uniform, sword, and crown, and is taking them away as he invokes all the Gods to stand by. I consider this one of my greatest pictures." Courtesy Berea College, Kentucky. Photograph: Warren Brunner.

127 (opposite). Carlos Cortes Coyle: *The Transformation.* 1934. Oil on canvas. 79" x 54". California. ". . . entirely an idea of my own and I expect a storm of protest from women. I have used for my background the craggy rocks of the Temple Sinawava in Zion National Park, bringing the picture on down throughout the ages to the present-day marriages and alimony divorces; I have shown Eve as the serpent coiled about the man's body so he cannot move, his pockets wrongside out and empty, she puts her tongue out at Adam in contempt." Courtesy Berea College, Kentucky. Photograph: Warren Brunner.

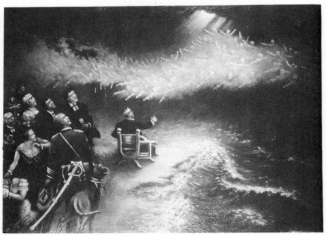

126 (left). E. Stearns: *King Capital Forbits the Rising Tight of the Poor* (sic). Dated 1931. Oil on board. 18" x 24". Provenance unknown. Found in a New York City secondhand store. Private collection. Photograph: Eeva-Inkeri.

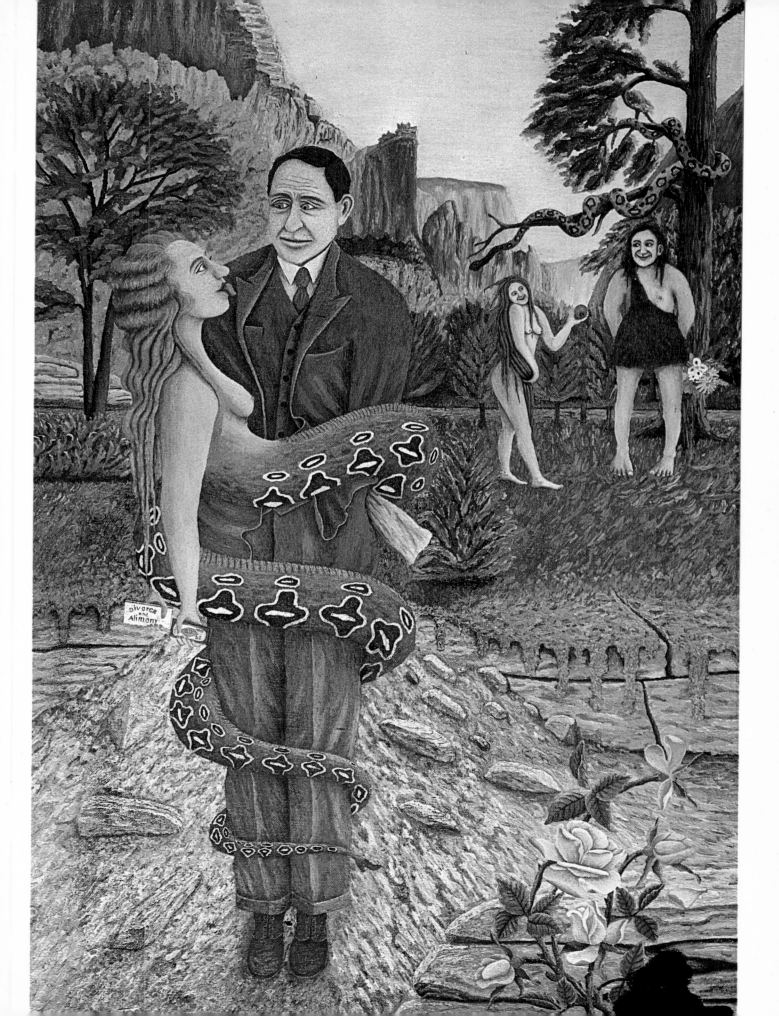

WILLIAM EDMONDSON, Black sculptor, was born in Davidson County, Tennessee, probably between 1865 and 1870. He died February 8, 1951. First a farmhand, then a railroad employee, a racehorse swipe, and a hospital orderly, he became, in 1929, an apprentice stone layer. In 1934 he had a vision. God appeared and ordered him to get a mallet and chisels. "I knowed it was God telling me to cut figures . . . first to make tombstones, then figures. He give me them two things." He carved birds, beasts, "varmints," little preachers, angels, "courtin' gals," and "uplifted ladies"—women who had been good members of his church and were uplifted to heaven. "The Almighty talked to me like a natural man. He talked so loud He woke me up. It's wonderful. When God gives you something, you've got it for good, and yet you ain't got it. You got to do it and work for it. The Lord just say, 'Will, cut that stone—and it better be limestone, too.' Wisdom, that's what the Lord give me at birth, but I didn't know it till he came and told me about it." (John Thompson, *The Nashville Tennessean*, February 9, 1941)

128 (left). William Edmondson: *Angel.* c. 1940. Limestone. H. 23″. Nashville, Tennessee. "This here stone and all those out there in the yard—come from God. It's the word of Jesus speaking his mind in my mind. These here is miracles I can do. Cain't nobody do these but me. I cain't help carving . . . Jesus has planted the seed of carving in me." Courtesy Mrs. Estelle Friedman. Photograph courtesy Michael D. Hall.

129 (below). William Edmondson: *Ram.* c. 1945. Limestone. L. 24″. Nashville, Tennessee. Courtesy Mrs. Estelle Friedman. Photograph courtesy Michael D. Hall.

130 (below). William Edmondson: *Eve*. c. 1935. Limestone. H. 32″. Nashville, Tennessee. Courtesy Tennessee Fine Arts Center at Cheekwood.

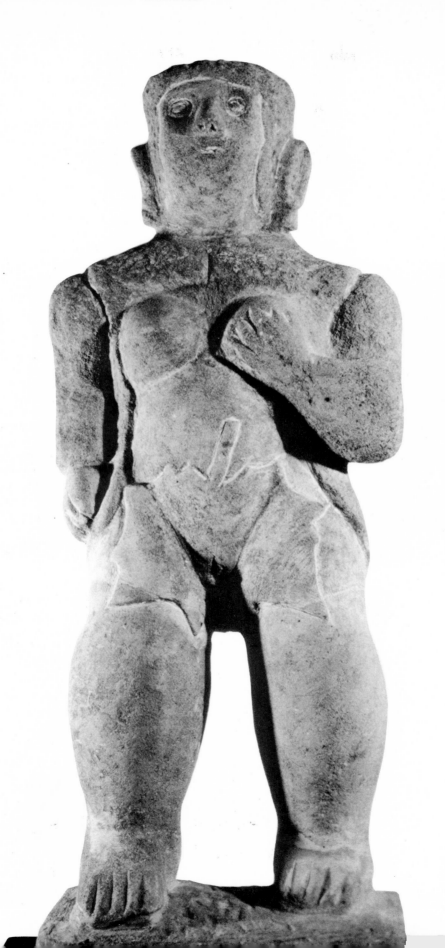

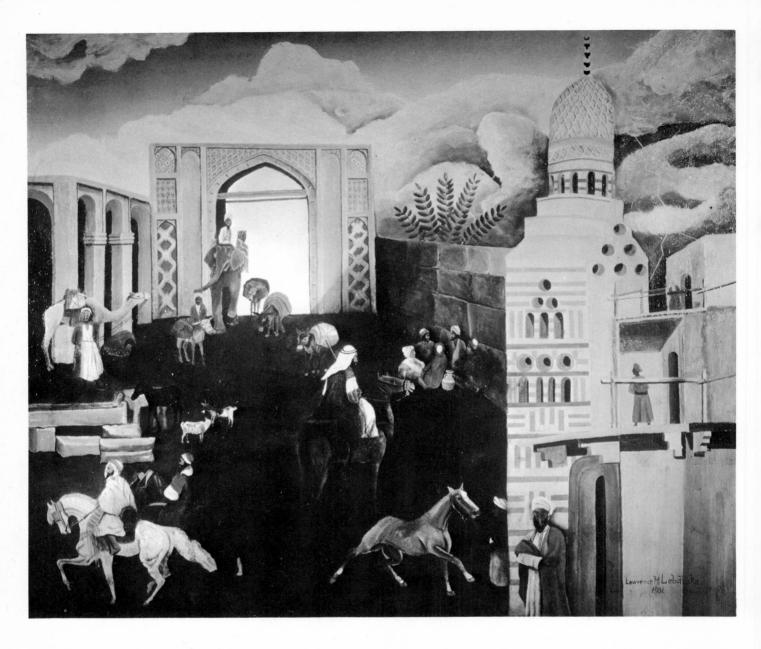

131 (above). Lawrence Lebduska: *Land of the Pease* (sic).
1931. Oil on canvas. 28″ x 33″. New York. The title refers to
the passage in the Bible: "The peace that no tempest could
destroy." "In the foreground, part of the Blue Mosque of
Ibrahim Agha, a place of worship built by Emir Aksunkor
in 1396, restored by a Turkish governor 300 years later and
retained his name. Background, Resht Gateway of Kazvin."
(Artist's description, written on the back of the painting.)
Courtesy Annette and Louis Kaufman. Photograph:
Alfred Stendahl.

132 (opposite). Lawrence Lebduska: *The Collector: Portrait
of Louis Kaufman.* c. 1930. Oil on canvas. 30″ x 22″.
New Work. Lebduska loved each painting he created and was
happiest when painting those he loved. Courtesy Annette
and Louis Kaufman. Photograph: Alfred Stendahl.

LAWRENCE LEBDUSKA was born of Bohemian parents in
Baltimore, Maryland, in 1894. His father was a stained-
glass maker, and when the family went back to Europe,
Lawrence, too, studied the craft. He also studied deco-
rating. He returned to the United States in 1912, and a
year later was working as a decorative mural painter for
Elsie de Wolfe. He began painting in his spare time.
Elizabeth Fehr, who knew him well, remarked that he
shunned museums and training, wanting to please only
those friends for whom he painted. His themes were
taken from childhood recollections, fairy tales, and
Czechoslovak folklore as well as from sources nearer at
hand, even postcards or nursery books. There was a
20-year gap in his career between 1940 and 1960, when
he was "rediscovered." He died a few years later.

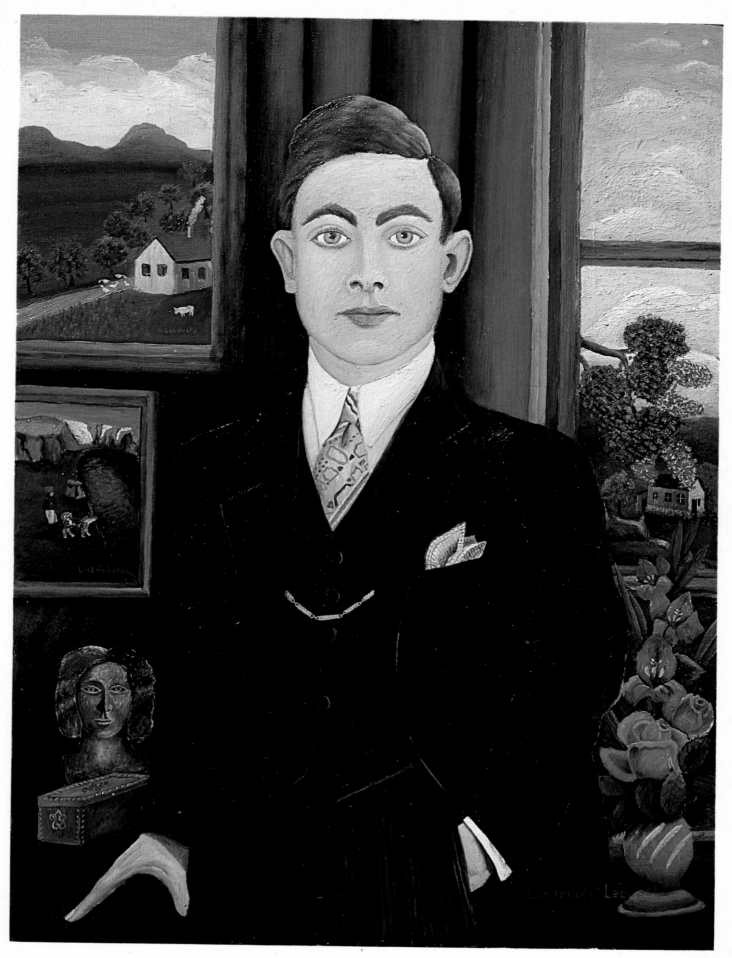

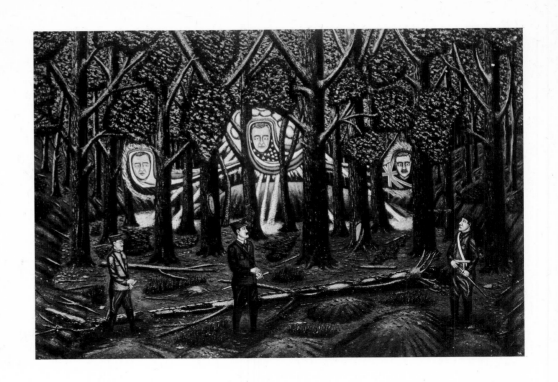

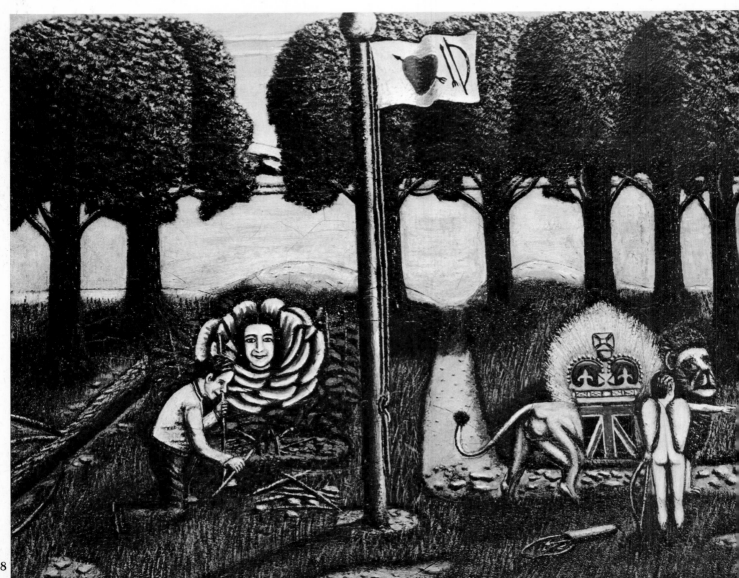

PATRICK J. SULLIVAN was born on March 17, 1894, in Braddock, Pennsylvania, the son of an Irish father and an English mother. He worked in a sheet-iron mill in McKeesport, Pennsylvania, and in Wheeling, West Virginia; then he became a house painter. This inspired him to try his hand at art on wrapping paper or window blinds, but World War I interrupted this interest. After the war he was once again a house painter, and once more began painting on his own. His first exhibited painting was *Man's Procrastinating Pastime*, which Sidney Janis discovered at a Society of Independent Artists show in 1937. They corresponded, and in his various letters he stated: "I never run out of ideas to paint. I don't care for some, or should I say, most of so-called modern art. If one must paint pictures, I say paint them so that they can be viewed from any angle or distance and look clean and plain. I never took an art lesson in my life. I just like to paint and from now on I shall paint things that come to mind—powerful stuff that will make people think."

He worked carefully, often building up his pigments to give a relief quality to his paintings, some of which took a year to complete. All of his canvases had a specific theme, which he explained in considerable detail. "I always get the idea that the critics and the art public view a primitive as though he were a strange sort of being. I sometimes think they have in their minds that a primitive is an overgrown kid with the mentality of a kid, and again there are those who give this thought out, 'What does he know about art? He never took any lessons, never studied.' I think Doriani can teach many of the so-called artists plenty, especially about color, and I sincerely hope that his efforts are rewarded in a manner commensurate with his very fine work."

133 (opposite, above). Patrick J. Sullivan: *Haunts in the Totalitarian Woods.* 1939. Oil on canvas. 20" x 28⅝". Wheeling, West Virginia. "Hitler, Mussolini and Hirohito have been running rampant. Suddenly, three spectres appear before them. They are fearful. Chamberlain, Daladier and Roosevelt seem to come out of the same cloud. For the time, at least, these mad men have been halted. Thru' appeasement, but mostly thru' fear of the combined forces of democracy." Courtesy Sidney Janis Gallery. Photograph: Eeva-Inkeri.

134 (opposite, below). Patrick J. Sullivan: *An Historical Event.* 1937. Oil on canvas. 24¼" x 25". Wheeling, West Virginia. "The picture as a whole is the heart of the ex-king [Edward VIII]. The blue sky and water denote love surging in his heart. The trees [are] the sturdy qualities and manly characteristics of the ex-king. The uniformity of the trees denotes the harmony and exquisiteness of love. The fallen tree, the pain and anguish in giving up the throne. In the garden is the lovely rose (his love). In the center foreground, a bare ground spot . . . shapes . . . as Siamese twins. 'Wally' and Edward like the twins are inseparable—part them and it means the end of both." Courtesy Sidney Janis Gallery. Photograph: Eeva-Inkeri.

135 (right). Ed Davis: *Girl with Tambourine.* c. 1935. Polychromed wood. H. 17". Private collection. Photograph: Helga Photo Studio.

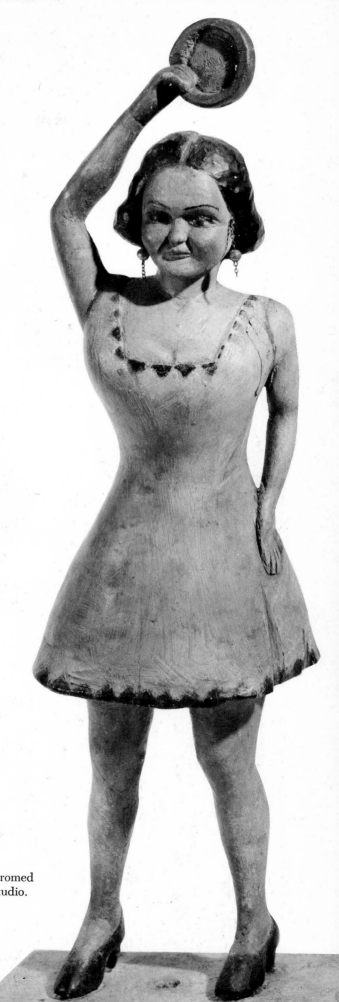

136 (opposite). Elijah Pierce. *Crucifixion.* c. 1933. Polychromed wood relief. 48″ x 30½″. Columbus, Ohio. Courtesy the artist.

137 (above). Elijah Pierce: *Presidents and Convicts.* c. 1941. Painted wood relief. 33½″ x 24¾″. Columbus, Ohio. Courtesy Boris Gruenwald.

138 (below). Elijah Pierce: *The Man That Was Born Blind Restored to Sight.* 1938. Carved and painted wood. H. 23¼″. Columbus, Ohio. Courtesy Mr. and Mrs. Michael D. Hall.

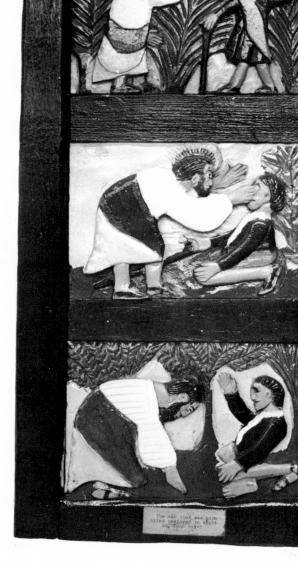

ELIJAH PIERCE was born on a farm close to Baldwin, Mississippi, in 1892. His family, of slave descent, was intensely religious. He learned to be a barber, and left the farm. During the Depression, he traveled throughout the South, then settled in Columbus, Ohio, in the mid-1930s. He still lives there and is still a barber. Although he carved with a pocketknife when he was a boy, making walking sticks, his first "serious" work was an elephant that he carved for his wife for her birthday. She was delighted, and he promised her a whole zoo—this was in the 1920s. He began to do figures and pictures based on cartoons, then from daily life, and then from his conceptions of the Old Testament—carving between haircuts. During the 1930s, at vacation time, he would load up his car and drive from state to state, selling his works at country fairs and local markets—and preaching to explain the moral purpose of his carvings.

MARTHA SWALE SMITH (figure 139, above) was born in 1872 and died in 1950. Her daughter, Dorothy Swale Smith of Glen Head, New York, writes: "My mother was born in Yorkshire, England. Her father was the tenth baronet of the second oldest baronetcy in England. She was born with such shortsighted eyes that she was never able to see more than seven or eight feet in front of her. However, her eyesight magnified everything she saw, so that she could detect minute details. Her sense of color seemed more acute than that of most people. Her needle paintings were done absolutely freehand. She sat with a piece of linen crunched up in her hand and did not avail herself of a frame. After working all day long, Mother would dye or bleach one strand of thread to get a certain spot of color she had previously visualized."

140 (left). Martha Swale Smith: *The Story of America*. 1929–1939. Needle painting tapestry, silk thread on linen. 80″ x 24″. Glen Head, New York. "When the troubles in Germany brought about Hitler, we used to come home and find her weeping for the afflicted Jews. I told her she must do something constructive and brought home American History books. She decided that if we learned our own history, we should be more careful to keep our freedoms. *The Story of America* deals with exploration, discovery, colonization, westward expansion, and the wars; a quotation from the Gettysburg Address and a picture of Abraham Lincoln is included." Courtesy Dorothy Swale Smith. Photograph: Eeva-Inkeri.

141 (below). Martha Swale Smith: *Global War*. 1924–1948. Needle tapestry painting, silk embroidery on silk. 67″ x 46″. Glen Head, New York. Courtesy Dorothy Swale Smith. Photograph: Eeva- Inkeri.

142 (above). Anna Mary Robertson Moses (Grandma Moses): *Sugaring Off*. 1943. Oil on board. 23″ x 27″. Eagle Bridge, New York. © Grandma Moses Properties, Inc. Photograph courtesy The Galerie St. Etienne.

ANNA MARY ROBERTSON MOSES, known more familiarly as Grandma Moses, was born September 7, 1860, in Greenwich, New York, and died December 13, 1961, in Hoosick Falls, New York. Her work has been well documented by Dr. Otto Kallir of The Galerie St. Etienne, New York, and her handwritten autobiography reproduced in part and in whole. Sidney Janis quotes from one of her letters in *They Taught Themselves*: "When I was quite small, my Father would get me white paper by the sheet. It was used in those days for newspaper. He liked to see us draw pictures, it was a pennie a sheet, and· it lasted longer than candy. For myself I had to have pictures and the gayer the better. I would color it with grape juice or berries, any thing that was red and pretty in my way of thinking. I dabbled in oil paints and made my *lamb scapes* as my Brother said I called them. Then long years went by." She was 77 when she began to paint again, and it was an activity that she fitted in between her daily tasks on the farm—canning, jelly making, baking, cooking, gardening, housecleaning, and even wallpapering.

143 (above). Anna Mary Robertson Moses (Grandma Moses): *Country Fair*. 1950. Oil on canvas. 36″ x 48″. Eagle Bridge, New York. © Grandma Moses Properties, Inc. Photograph courtesy The Galerie St. Etienne.

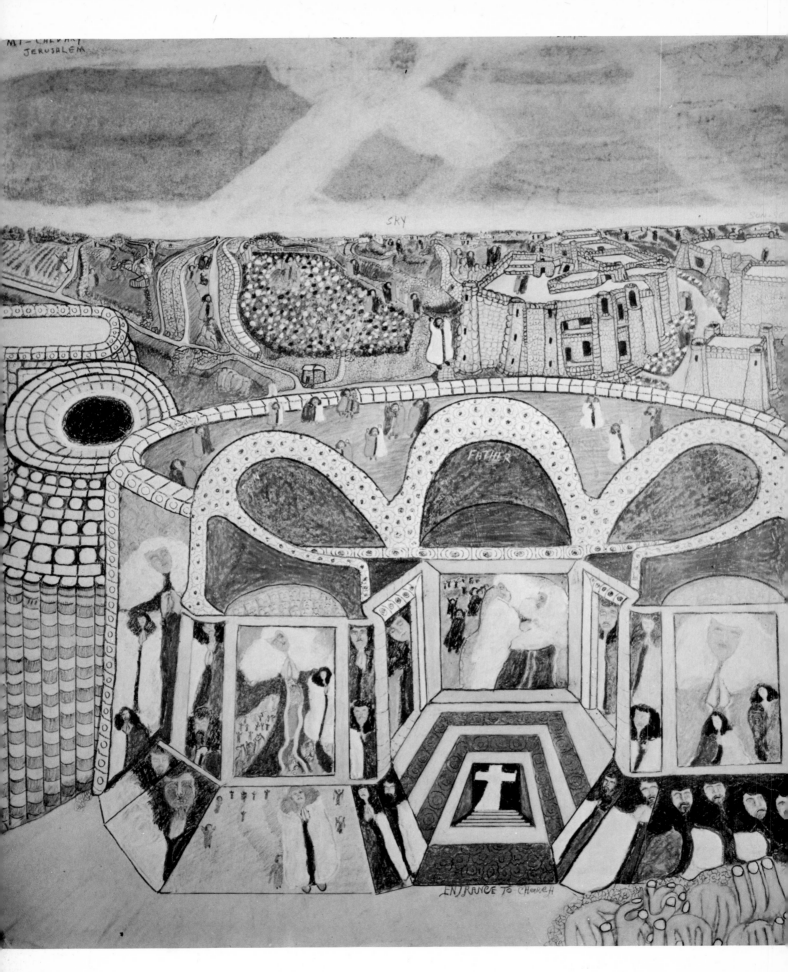

ALBERT PRICE was born in West Virginia, but he and his wife Jewel moved to The Springs, near East Hampton, Long Island over 20 years ago. He is 43 years old. His first carving was done five years ago, when, at his wife's behest, he made a totem pole. Then, evidently heeding an inner urge to compete with the classical and contemporary sculptures dispersed among the trees of Evan Frankel's estate where he worked as a gardener, Price began sculpting the logs from trees that had to be removed. Many of his works are massive—life size or larger—and generally of people. "I don't know what makes me do 'em," he said during an interview. "I just get notions. Sometimes I have something in my head, and I can't get it out, and my head hurts me like a band around it until I do."

144 (opposite), 145 (right). P. M. Wentworth: *Kingdom of Heaven* and reverse side. c. 1940. Pencil, crayon, gouache, and erasure on heavy paper. 29½″ x 25¾″. California. "Many of his images are created by erasing what he previously put down. Some lines were incised by extreme pressure of pencil." (Letter to the authors from James Nutt, who discovered the artist's work in California.) Courtesy James Nutt.

146 (below). Albert Price: *The Still.* c. 1965. Unfinished wood. Life size. East Hampton, New York. Courtesy Evan Frankel. Photograph: Tracy Bond.

JAMES HAMPTON was born in South Carolina in 1911 and died in Washington, D.C., in 1964. The son of a Baptist minister, and described as thin, timid, and bespectacled, he served in the armed forces during World War II, and then came to Washington and worked as a laborer for the General Services Administration. His thrones were built on evenings and weekends in an unheated garage that he rented for $50 a month. The symmetry of pairs and biblical inscriptions imply a personally conceived Christian ritual. There are typewritten labels referring to moments of revelation, such as, "This is true that on October 2, 1946, the Great Virgin Mary and the Star of Bethlehem appeared over the nations capital." A bulletin board was inscribed, "Where there is NO vision, the People Perish."

147 (right). James Hampton: *The Throne of the Third Heaven of the Nation's Millennium General Assembly.* Begun c. 1950, completed c. 1964. Assemblage, old furniture, light bulbs, glass jars, cardboard; covered with silver and gold foil. Built in a garage. Washington, D.C. There are 50 thrones, altars, pulpits, wall plaques, and crowns; touches of color, pen-and-ink geometric patterns, and symbols, inscriptions in English and a secret person script. Courtesy Smithsonian Institution. Photograph: Charles Phillips.

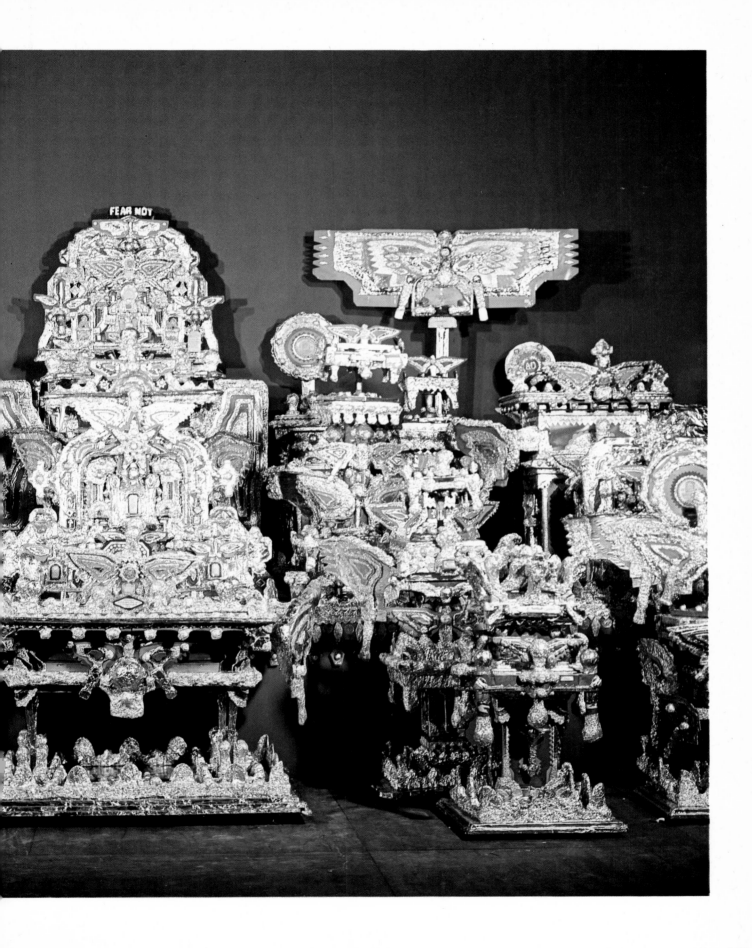

148 (left), 149 (below). John Roeder: *Sculpture Garden*. c. 1930–1948. Richmond, California. "If I am a failure/And cannot be true/Then please take me to heaven/And I'll be a gardener for you./Creator from heaven/I'm praying to thee/Protect me this morning/Cause I'm working for thee." (Poem by the artist.) Photographs courtesy James Eakle.

150 (above). John Roeder: *Bay with Islands*. c. 1948. Oil on plywood. 28⅜" x 16⅛". Richmond, California. Private collection. Photograph: Eeva-Inkeri.

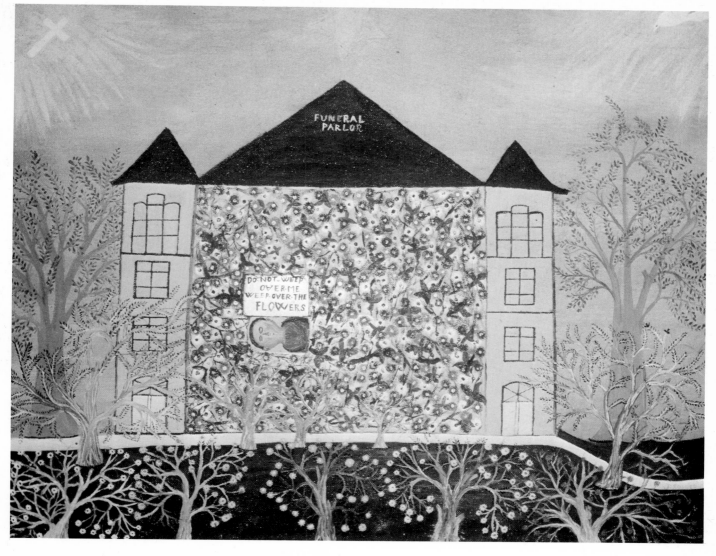

151 (above). John Roeder: *Do Not Weep Over Me, Weep Over the Flowers.* c. 1948. Oil on canvas board. 20¼″ x 16⅛″. Richmond, California. Courtesy Vincent Porcaro. Photograph: Eeva-Inkeri.

JOHN ROEDER (figure 149, opposite, below), son of a stonecutter, was born in Bollendorfe-brück, Luxemburg, in 1877. In 1909 he emigrated with his wife and two children to the United States, settling in Richmond, California, where he worked as a pipe fitter for Standard Oil. He bought a small ranch in 1915, but after 10 years, sold it and became a gardener at the Richmond Union High School. It was about this time that he began to build a miniature village and construct larger-than-life cement figures in his back garden. A Catholic and quite religious, he built a small chapel that he decorated with sculptures and paintings on glass, and often included his own poems in them. After his retirement in 1947, he devoted himself mostly to painting, but when his eyesight weakened seriously in 1952, he once again began making various kinds of things, assemblages, baskets, and canes. In 1958, he turned again to painting, signing these later works "John Roeder the Blind Man." Vincent Porcaro, who knew him in 1948, said that he had turned his chicken coop into a chapel, and that he worked in a little wooden building that was so decorated with grass, bones, religious paintings, etc., that it was like a voodoo or fetish shrine. His garden is now gone, but it is preserved in photographs by James Eakle of Richmond. A newspaper account in 1960 quotes Roeder: "I am a gardener. You must worship nature to worship God. I paint because I have to."

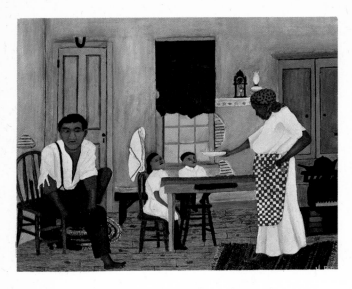

152 (above). Horace Pippin: *Family in the Kitchen.*
c. 1940. Oil on canvas. 21¾″ x 25½″. Pennsylvania. Private
collection. Photograph: Eeva-Inkeri.

153 (right). Horace Pippin: *John Brown Going to His
Hanging.* 1942. Oil on canvas. 24″ x 30″. Pennsylvania.
Courtesy Pennsylvania Academy of the Fine Arts.

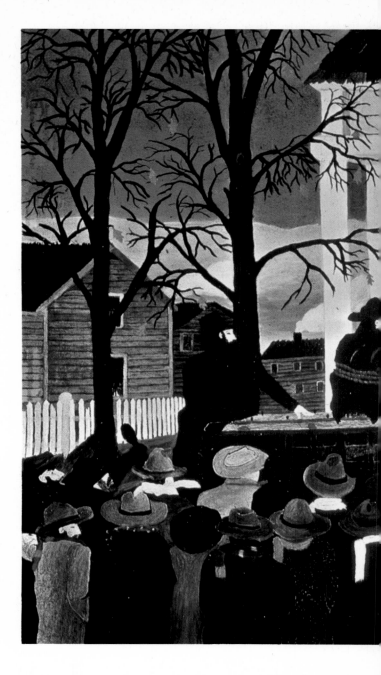

HORACE PIPPIN, Black artist, was born February 22,
1888, in West Chester, Pennsylvania. His family moved
to Goshen, New York, in 1892, and in 1911 he himself
moved to Paterson, New Jersey. In 1917 he enlisted in
the Army, was sent to France, and so wounded as to
suffer paralysis of the right arm. Even so, he could not
give up the drawing he had begun as a ten-year-old
with crayons and had continued in his diary during the
war. He supported his right arm with his left hand, and
had some small success. Then he developed an exer-
cise to strengthen his arm and in 1929 began painting,
first his quite clear recollections of the war, then
childhood memories, and a trio about John Brown. In
Masters of Popular Painting Holger Cahill quotes a
letter from Pippin: "*How I paint* . . . the colors are very
simple. The pictures I have already painted come to me
in my mind, and if to me it is a worth while picture, I
paint it. I go over that picture in my mind several
times and when I am ready to I paint it, I have all the
details I need. I take my time to be sure that the
exact color which I have in mind is satisfactory to me.
My opinion of art is that a man should have love for
it, because my idea is that he paints from his heart
and mind. To me it seems impossible for another to
teach one of Art."

GEORGE AULONT was born May 6, 1888, in Crete. His
mother was a schoolteacher, his father, a physician; he
was orphaned at fourteen. He came to the U.S. in 1907
and became a salesman, a toy mechanic, a handyman, a
carpenter, a painter, and was in the Army Transport Ser-
vice. He traveled in Mexico, the Pacific Isles, British
Columbia, and Alaska, as well as throughout the South-
west. Sidney Janis quotes him in *They Taught Them-
selves:* "I do hope that the people of this accursed planet
will come to their senses, disarm, have peace, allot some
space to persecuted minorities so that they too can de-
velop their own cultures. Then they can fight the forces
of nature, eradicate disease, encourage learning, music,
sports, arts, literature . . . what a world is coming . . .
live and let live (not however tolerating Fascism, injus-
tice, ignorance, greed or stupidity)."

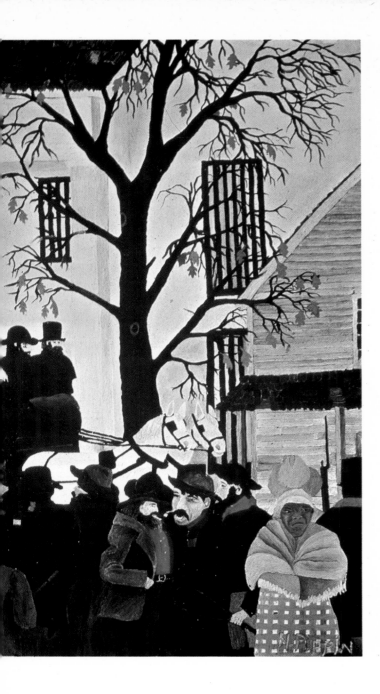

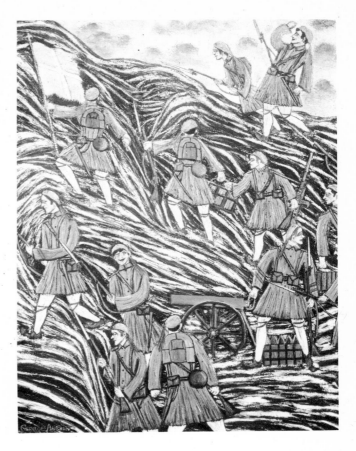

154 (above). George Aulont: *On Mt. Smolika.* 1941. Oil on canvas. 38″ x 29″. New York. "I began to paint in 1936. I tried in 1910, but gave up. The magnificent courage and contempt of the Greek troops gave me the idea of painting . . ." Courtesy Sidney Janis Gallery. Photograph: Eeva-Inkeri.

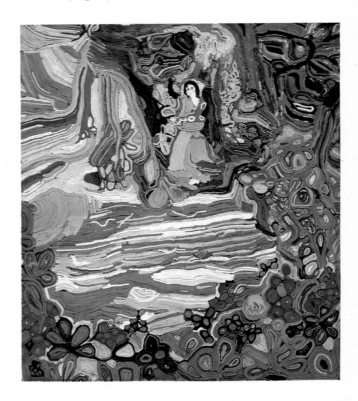

LOUISE BERG THIESSEN. Her son, Leonard Thiessen, wrote: "My mother was born in Sacramento, California, August 2, 1876. [In the early 1930s] my mother evolved her felt-mosaic expression as a means of finding a use for discarded felt hats. She resisted any attempt to get her to adopt conventional methods of design, with a preliminary sketch, etc. My mother died November 30, 1960."

155 (right). Louise Berg Thiessen: *Lady by a Lake.* c. 1940. Mosaic made of felt strips cut from hat bodies. 20″ x 21½″. Omaha, Nebraska. "She fabricated the individual motifs of her composition separately, laid them out in patterns to her satisfaction, then began the assemblage, filling the negative spaces with insertions." Courtesy Smithsonian Institution. Photograph: Charles Phillips.

EDGAR TOLSON was born in Lee City, Kentucky, in 1904. Educated through the sixth grade, he has been married twice and is the father of 18 children. A descendant of seventeenth-century settlers of English origin, he is a hard-drinking, tobacco-chewing, storytelling philosopher of Campton, Kentucky, where he now lives. He calls himself a woodcarver now, but he has been a preacher, farmer, cobbler, chairmaker, and itinerant worker. He recollects mountain feuds, whittling his own teeth, burning down two of his houses, and, while on a weekend binge, blowing up his own church during Sunday prayers. He has been carving for over 35 years, sometimes in stone but mostly in wood.

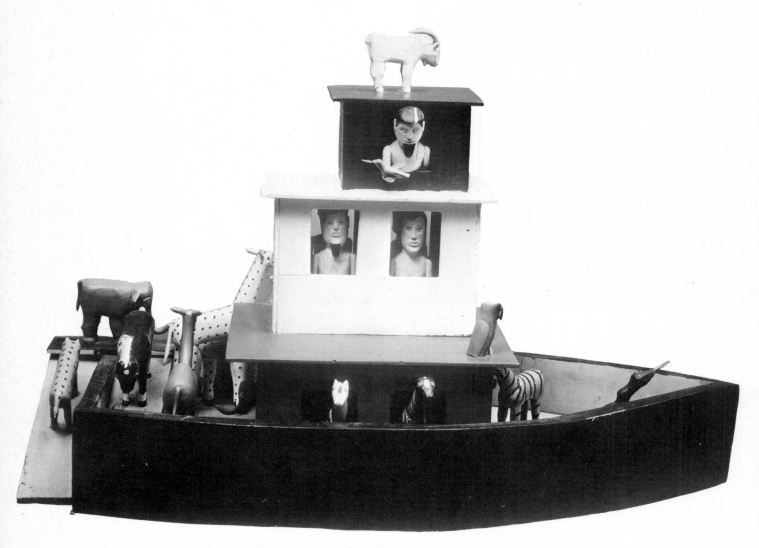

156 (above). Edgar Tolson: *Noah's Ark*. 1970. Painted wood. L. 35". Campton, Kentucky. Private collection. Photograph: Eeva-Inkeri.

157 (opposite). Edgar Tolson: *Man with Pony*. c. 1950. Painted wood. H. 31½". Campton, Kentucky. Courtesy Mr. and Mrs. Michael D. Hall.

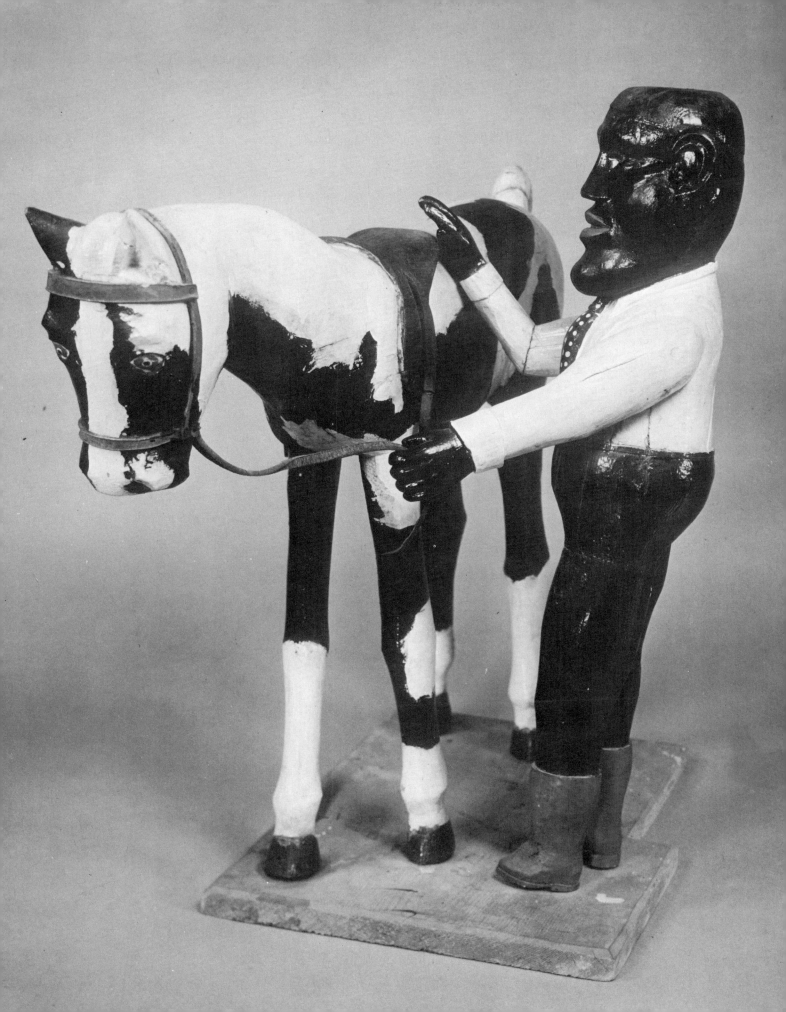

159 (opposite). Morris Hirshfield: *Girl with Her Dog*. 1943. Oil on canvas.
45½″ x 35½″. New York. "Hirshfield's occupational background has a very
important role in his paintings: in his textures, which remind one of fabrics,
and in his sense of design, which comes from pattern-making." (Sidney Janis).
Courtesy Edward Bragaline. Photograph: Eeva-Inkeri.

MORRIS HIRSHFIELD was born near the German border of Russian
Poland in 1872; he died in 1946. He came to this country at the age
of 18, worked in a women's coat factory, and went into business with
his brother, manufacturing women's coats and suits. They sold the
business and began manufacturing slippers. A long illness precipitated
his retirement, and in 1937 he began to paint. "It seems," he wrote to
Sidney Janis, "that my mind knew well what I wanted to portray, but
my hands were unable to produce what my mind demanded. After
working five months on one and then the other I put them to one side,
coming back again to them in 1938. I worked on them for about five
or six months . . . muchly improved, they still did not satisfy me. I
took them up again in 1939 [and] brought them out to my entire
satisfaction." (*They Taught Themselves*).

158 (above). John Podhorsky: *Untitled*. c. 1970. Colored pencil on paper. 24″ x 35¾″. Courtesy
Phyllis Kind Gallery. Photograph: Jonas Dovydenas.

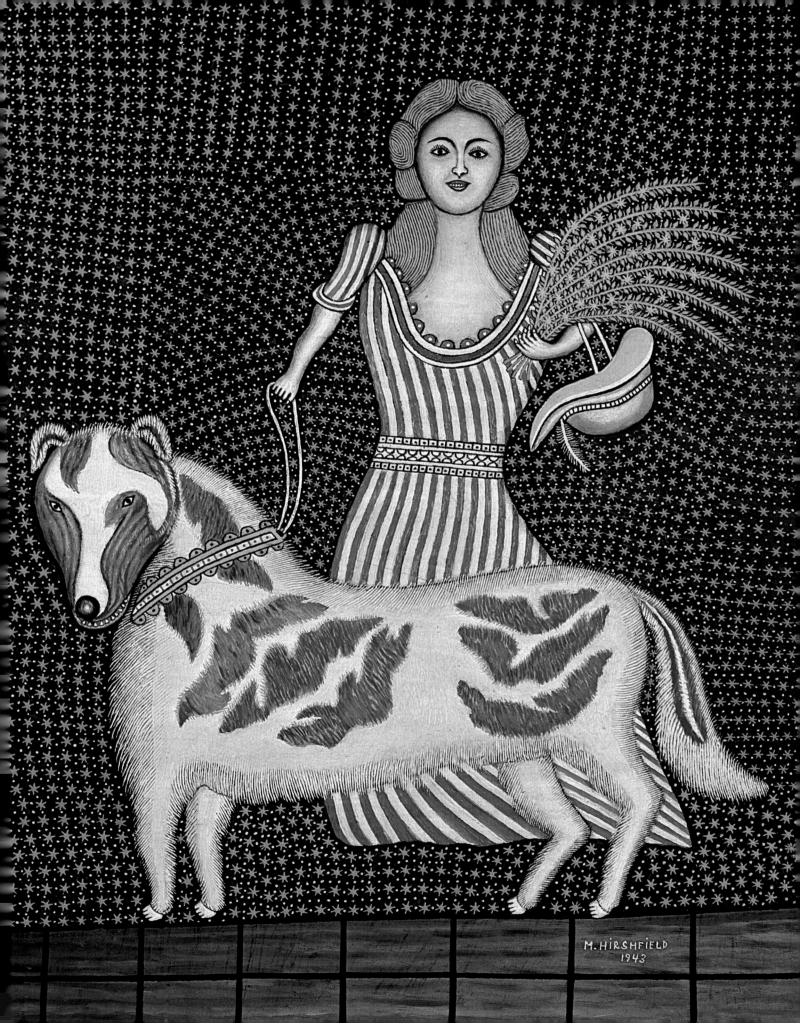

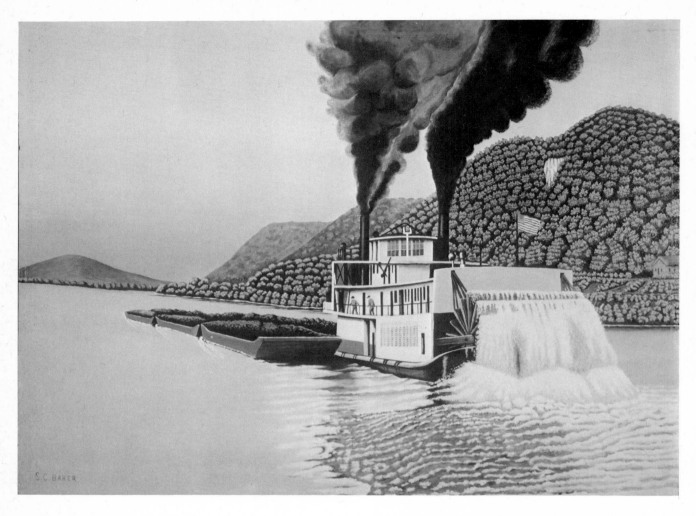

160 (above). Samuel Colwell Baker: *The Alexander McKenzie Going Up the Mississippi River.* c. 1957. Oil on canvas. 36″ x 48⅛″. Shenandoah, Iowa. Photograph courtesy Sheldon Memorial Art Gallery.

161 (opposite). Samuel Colwell Baker: *Christ in the Manger.* c. 1950. Oil on canvas. 38½″ x 48¼″. Shenandoah, Iowa. Courtesy Mrs. Roy Henry. Photograph courtesy Sheldon Memorial Art Gallery.

SAMUEL COLWELL BAKER. His daughter, Mrs. Roy Henry of Shenandoah, Iowa, writes: "Born May 4, 1874, died June 13, 1964. Born on a farm southeast of Villesca, Iowa. About 1901 my father drew a large picture of Joseph and Mary fleeing. In 1914 he bought a planing mill in Shenandoah, started building apartments. At 70 he started painting again. He loved nature, saw beauty in the rose or tomato, a storm with dark clouds." Mr. Baker once painted a mermaid under the sea, and when his wife objected to the nudity, he added a fringed bra. However, he felt that it distorted the picture, and painted the mermaid out, covering her over with fishes and water.

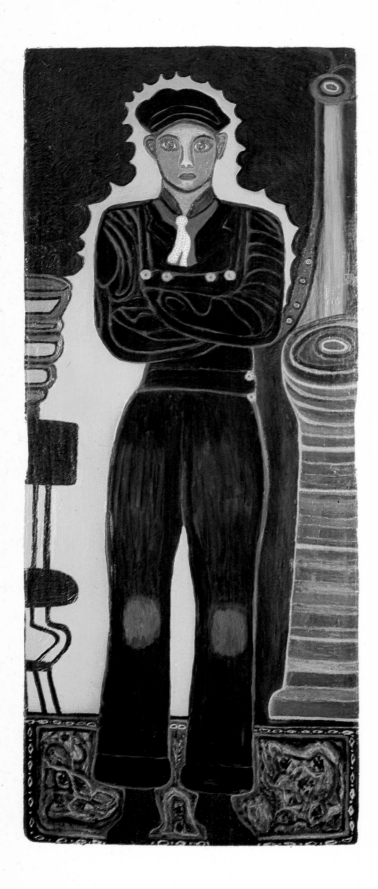

162 (left). Lynn Miller: *Boy in Blue*. c. 1960–1965. Oil on canvas. 59½" x 24". Augusta, Wisconsin. "My husband gave me the idea of how he was as a growing boy of 16." Courtesy Viterbo College.

LYNN MILLER was born in Glenbeulah, Wisconsin in 1906 and now lives in Augusta, Wisconsin. Many of her works are in private collections, but a few years ago she gave all of her remaining output to Viterbo College in La Crosse and apparently has not painted since then. "There's thirty years work there," she said in a telephone conversation, "and it's for the children who never see real painting." Much of her work is concerned with memory landscapes, but she has also done portraits and fantasies.

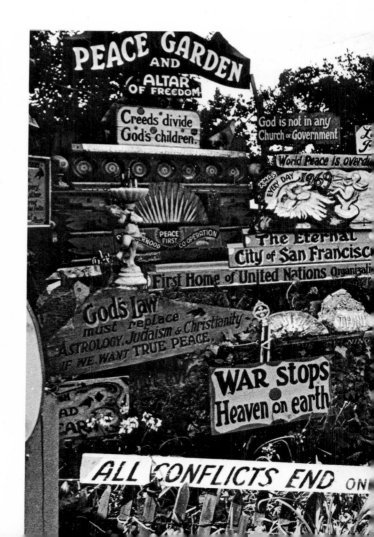

163 (center). Peter Mason Bond: *PEMABO's Peace Garden and Altar of Freedom.* Begun c. 1950 and dismantled c. 1972. San Francisco, California. "The guilty ones are 'We'—History shows this plainly and the sooner we regard one another as culprits, the better for constructive peace. I am a modern Christ; I am going to give a new approach to peace." Photograph courtesy James Eakle.

164 (above). Peter Mason Bond: *"Holiday," A Scene on STOW LAKE in famed GOLDEN GATE PARK, San Francisco.* c. 1950. Oil on canvas. 48" x 60". San Francisco, California. ". . . The Gondola in center is occupied by the Muse or 'Spirit of the Park' reflecting on memorable Park signs. This is an oil painting conceived and painted to portray many memories in one setting." Private collection.

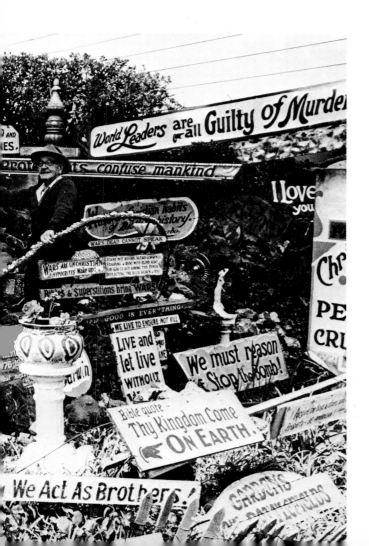

PETER MASON BOND, born in Sydney, Australia, in 1882, came to San Francisco in 1905; he died there in 1971. A sign painter and a religious eclectic given to expressing his philosophies in writing as well as in graphic signs, he began painting after retirement. His Peace Garden was dismantled when his house was sold after his death. In his privately printed book, *The Trio of Disaster,* he says: "I offer to mankind this humble account of my immediate knowledge of things during my honest endeavors as a warning to clean our path of life for proper involvement in this great journey among the stars. Not until you look into the eyes of your fellowman and see the reflection of yourself will there be any peace." He signed his works with the acronym PEMABO.

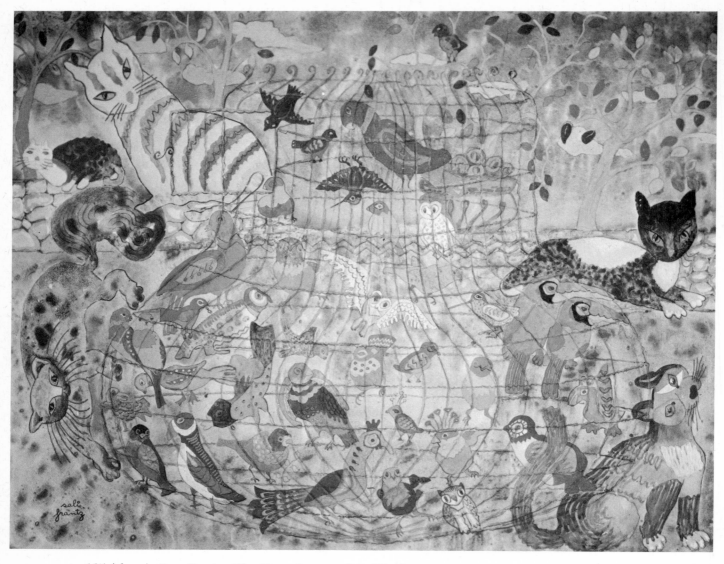

165 (above). Sara Frantz: *The Open Door*, or *Just Watching*. 1954. Opaque watercolor. 23½″ x 29″. Saginaw, Michigan. "My paintings aren't meant to be more than what you see when you look at them. I haven't got much imagination." Courtesy Peter B. Frantz.

SARA L'ESTRANGE STANLEY FRANTZ was born in Detroit, Michigan, on May 30, 1892, and died in Gettysburg, Pennsylvania, May 10, 1967. Although both her mother and grandfather were artists, she herself never took lessons and was never particularly interested, except as an onlooker, until long after taking her degree in landscape architecture and her marriage to architect Robert Frantz. During her career as a free-lance landscape designer, the drawing of maps led to painting. She presketched her work in the sense that she would pencil little figures or scenes on scraps of paper, then tape, arrange and re-arrange, and retape them on a work sheet. This served as the model for her finished work. She is reported to have emphasized the whimsical because "Life should be fun, don't you think? Too many people take themselves seriously and sit around and analyze and then don't get anything done." Of her work, she said, "I'm just not satisfied until every corner has got something silly in it."

ISIDOR WIENER was born near Kishinev, Russia, on January 1, 1886, and died in New York on September 1970. Alert to the dangers of the pogroms, he had himself smuggled out of Russia at the age of 17, and arrived in New York on June 28, 1903. Between that time and the middle 1920s, when he and his wife ran their own grocery store, he went through a series of jobs: ruffle maker in a dress factory, gravedigger, hatter, milkman, worker in a car-wrecking business, and for Scoville's Manufacturing Company. His wife's death—they had married when he was 19 and she 15—in 1950 so saddened him that he seemed unable to recover his normal optimism. His son Dan, a well-known photographer, having himself once had ambitions to become an artist, gave his father some paints and urged him to try painting as a hobby. This proved to be the spark that revivified his energies, and from 1951 until his death, he produced over 200 pictures as well as many woodcarvings.

166 (below). Isidor Wiener: *Lion.* c. 1957.
Polychromed plastic wood. L. 8″. New York.
Courtesy Mrs. Sandra Weiner. Photograph:
Sandra Weiner.

167 (below). Isidor Wiener: *Bar Scene.* 1960. Oil on
canvas. 20″ x 24″. New York. Courtesy
Mrs. Sandra Weiner. Photograph: Sandra Weiner.

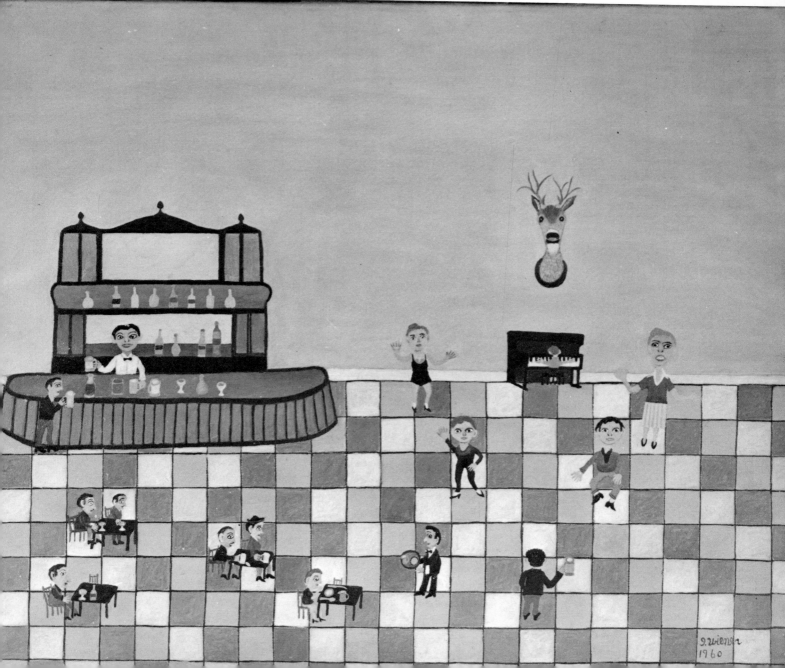

168 (above). Peter Charlie: *Lady Liberty of 1953*. Oil on canvas. 23″ x 28½″. Leechburg, Pennsylvania. Courtesy Herbert W. Hemphill, Jr. Photograph: Eeva-Inkeri.

PETER CHARLIE emigrated from Armenia before World War I, returned briefly to fight, and came back to settle in Leechburg, Pennsylvania. He is remembered there as a friendly but retiring man who worked as a house painter and jack-of-all-trades and rented the garage in back of a local hardware store. Not until after his death was it discovered that he had painted in secret. He left 69 canvases, most of them with themes of space invaders, Eastern mysticism, and Abraham Lincoln idolatry.

169 (opposite, above left). Martin Ramirez: *El Soldado*. c. 1950. Pencil and crayon on brown paper. 61″ x 35″. California. Courtesy Phyllis Kind Gallery. Photograph: Jonas Dovydenas.

170 (opposite, above right). Martin Ramirez: *Untitled* (detail). c. 1955. Pencil and crayon on brown paper. Dimensions of complete work: 142″ x 39″. California. Courtesy Phyllis Kind Gallery.

171 (opposite, below). Martin Ramirez: *Scroll*. c. 1955. Pencil and crayon on brown paper. 24″ x 100½″. California. Courtesy Phyllis Kind Gallery.

MARTIN RAMIREZ was born around 1885, of Mexican descent. For the last 45 years of his life, he was mute; he died in 1960 in the DeWitt State Hospital, California, at the age of 75. He began drawing at the age of 60, using whatever paper was nearest to hand.

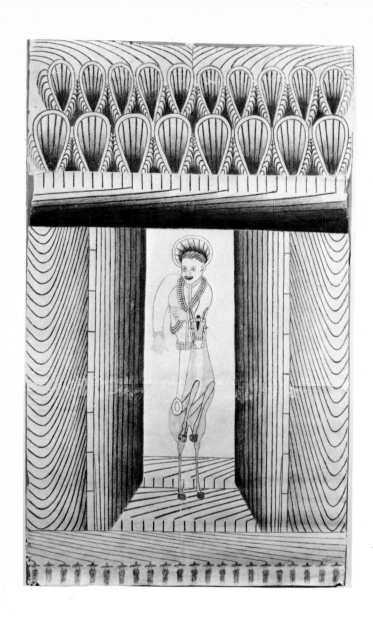

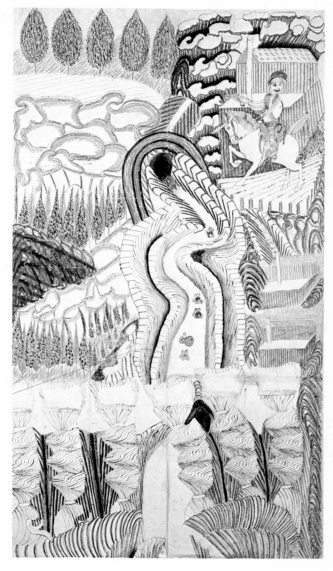

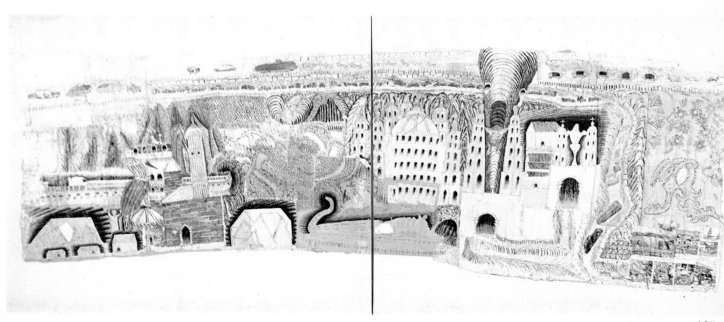

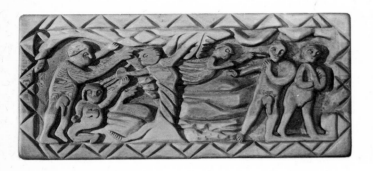

PATROCINIO BARELA was born in Bisbee, Arizona, the son of a Mexican healer and "doctor of wild weeds." He died in Taos, New Mexico, in 1964. His schooling was so brief that he never learned to read or write, and he became a sheepherder. Lenore G. Marshall, in *Arts Magazine*, August, 1956, quotes him: "My daddy he sent me to watch goats in the hills. I go here, there, nine years, dig potatoes, coal mines, work in WPA, haul dirt. One day the priest showed me old figure of Saint Angelo broken, he say 'Pat you think could be fix?' I say, 'Padre, we can try.' We work all night and fix. That Santo was done in joints. I came home and lay on bed and think how can you make it so is one piece. I can not sleep all night.

Next day I got pieces of wood. I choose some with no knots and I begin with pocketknife. My wife call, 'you no going to sleep?' I no answer her."

Patrocinio Barela: *Biblical Scenes.* 172 (above left). The Creation. 173 (left). Expulsion from the Garden. 174 (above, right). The Last Supper. 175 (below). The Crucifixion. Date unknown. Artist died 1964. Pine panels. 21″ x 47″. Taos, New Mexico. Courtesy Museum of New Mexico. Photograph: Ken Schar.

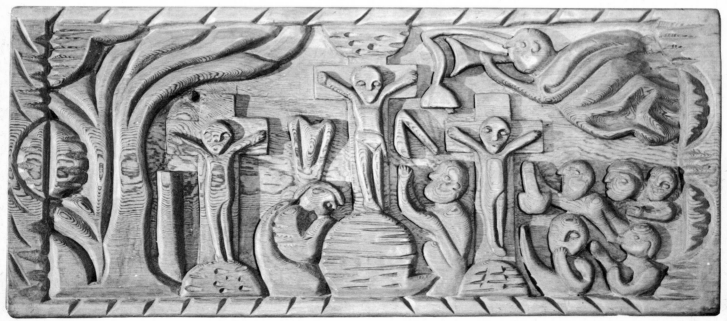

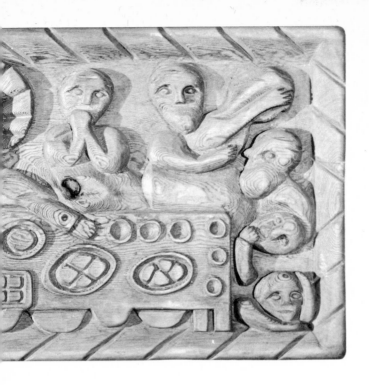

ISRAEL LITWAK was born in 1868 in Odessa, Russia. Sidney Janis describes him as a "jovial old man who likes to talk about art, especially his own art," and adds a charming anecdote. Someone told him that his work was like Rousseau's, and when he went to the library, he was given a book of reproductions by Theodore Rousseau, the Barbizon artist. He wasn't pleased. Later, however, when he saw the Douanier Rousseau's work, he said, "This is more like it. This is good work, very good work, plenty to criticize but all right." When he wrote his biography for Mr. Janis' book, he said: "One achieves good painting by imagination, talent, patience and a lot of hard work, detail, composition, proper colors." Later on, he says, "I look . . . just to get an idea; then I go home and make it the way I want it, not the way it is."

176 (below). Israel Litwak: *Waterfall, White Mts., N.H.* 1951. Oil on canvas. 22" x 32". Brooklyn, New York. "At the age of 68 was forced to retire. Not being used to idleness, I suddenly had an urge to do some drawing and followed it up with painting. I was pleased with the result, I did some landscape." Courtesy The Galerie St. Etienne. Photograph: Eeva-Inkeri.

FRED SMITH, former logger, bartender and bar owner, was born in Price County, Wisconsin, September 20, 1886. Bill Bohne, Chicago sculptor-photographer, interviewed him in the summer of 1970 at Pleasant View Rest Home, Phillips, Wisconsin. He started his *Wisconsin's Concrete Park* about 1950. "I put in so many hours daylight to dark for about 15 years. I figured I didn't have much time to do all that work . . . gotta get it done." Asked how he started to think about making his sculptures, he said, "I don't know how to explain it. It's in a person, or you can't never do it. Never. Can't teach it. There have been so many people who want to stay with me and learn to make 'em. They can work with me for ten years and they still wouldn't know which end to start on. It's interesting work, ya know."

Asked about his schooling: "None. Better off without it. Educators are outlaws . . . goddam crooks. Them damn young fellas get it in their heads they gotta be the boss. Nobody will work after they've been educated. I went to the logging camp. Worked for 99¢ a day."

There are 300 pieces in his park, and Mr. Smith allows free entry to it. "I tell folks if they don't make it in one day, they can stay overnight in the back yard. No charge. Kids 'n all. Everybody, they say they never seen nothing like it before. The best! I could've told them that though! That moose . . . seven tons. That won't fall apart. [My] wife didn't take much interest. But she understood that I was set on doin' it anyhow. The work's gotta have taste in it so it looks good . . . otherwise don't make it."

Asked where he got his ideas, he said, "Oh, all over the place, like that Ben Hur show. [At] the fair, right here in town there was a woman setting right on six horses and going lickety-split. Them ideas are hard to explain, ya know. Might be something ya see or like or hear from someone. Could be anything. It's gotta be in ya to do it. I like pictures. You can pick up a lot that way. Make up your mind that you're goin' to build it and by God you come out pretty good."

Although he made his own cement, the glass and mirror he used as embellishments were from bottles or were given to him. He decided to put glass with cement because ". . . I just liked it and I could get it for nothing. I liked it together. Otherwise your work is too dead. The mirror shines. You can see yourself in them—beautiful. You find things. There's a lotta things, ya know, you can make without no money at all. You find things and find a use for them. Don't cost a cent." He said he had never seen any sculpture at all. He also said he had used the heads of real horses that he encased in concrete. Otherwise he built over armatures. "People ask me if I need things from all over the country—every one likes me."

177, 178 (left, above and below), 179 (opposite). Fred Smith: *Wisconsin's Concrete Park*. Begun in 1950. Concrete set with bottle glass, mirrors, and glass insulators from telephone poles. Phillips, Wisconsin. There are 300 figures in the park. Photographs courtesy Roger Brown.

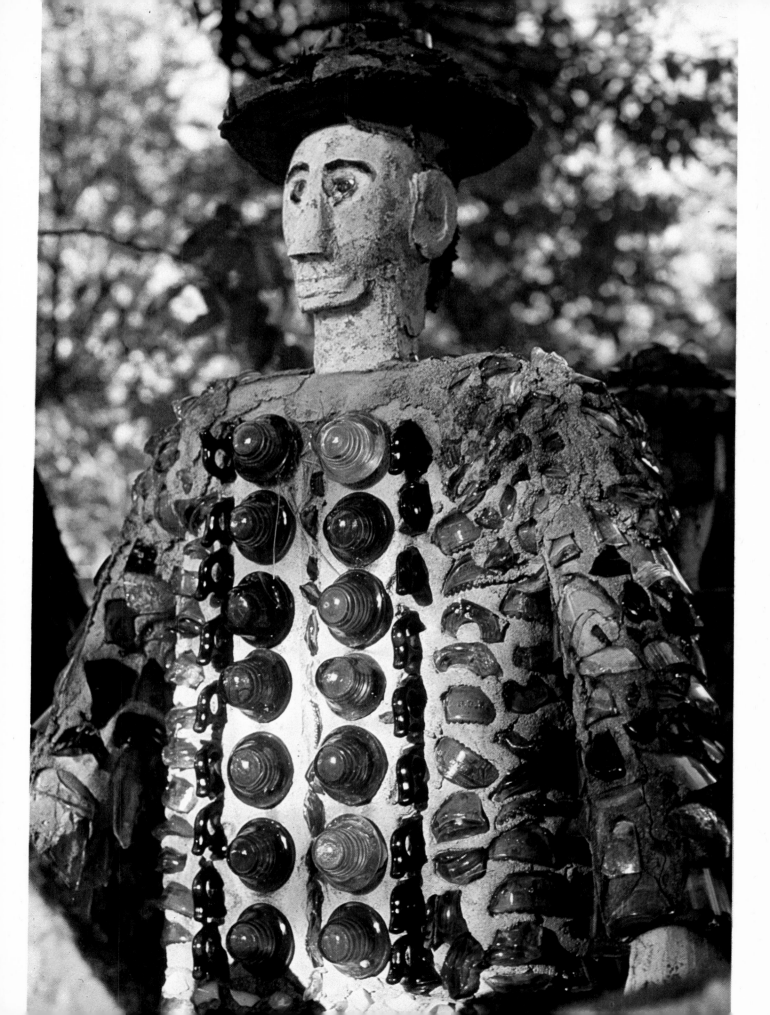

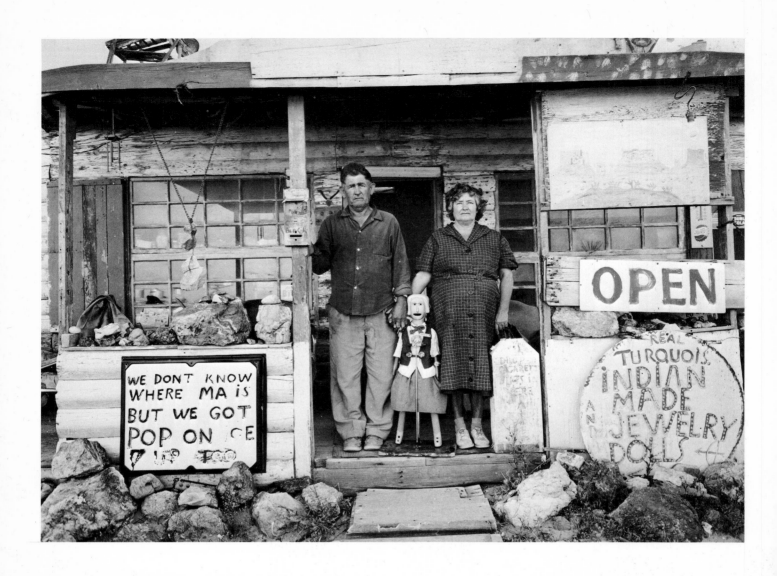

180, 181, 182, 183, 184, and 185 (above, opposite, and overleaf). Calvin and Ruby Black: *Possum Trot* and *Fantasy Doll Show*. Begun in 1953 and still extant in Yermo, California. The dolls, approximately one half to three quarters life size, are animated by wind machines and vocalized by means of tapes. There are 57 dolls, all of women, carved by Calvin and dressed by Ruby Black. "I carved wood and I done some of the finest paintings that ever been painted. The everyday person may just say 'OK, OK,' and go away. But if a person comes in here with a streak of art in his blood . . ." (Jane Wilson, *West* Magazine, June 20, 1971) Photographs: Tim Brehm.

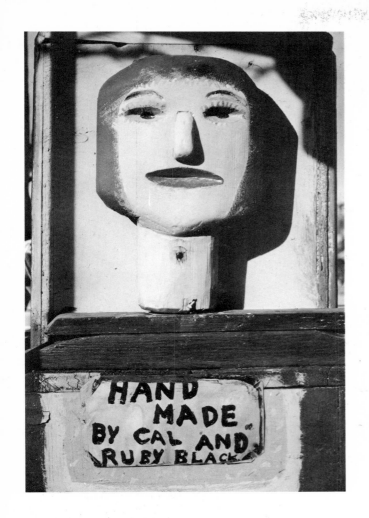

CALVIN BLACK was born in Tennessee in 1903, and died in March 1972 in Yermo, California. His wife, Ruby wrote: "At 13 years old he had taken over the load of raising his brothers and sisters and taking care of his mother. He taught himself to read and write out of catalogues, and he worked in the carnival and circus. A woman who was running puppet shows taught him to run her show and to be a ventriloquist so she could have time off. He learned to talk and sing in nine different voices. Calvin prospected for gold up in northern California during the Depression." The Blacks moved to Yermo, California, in 1953 because of Calvin's health, and started a rock shop, which was augmented with the Possum Trot wind-driven merry-go-rounds and Fantasy Doll Shows for which Calvin wrote dialogue, songs, and music.

RUBY BLACK says of herself, "I was raised on a farm in Georgia and I learnt to milk a cow when I was real small. Calvin and I met and got married in 1933. We lived in Los Angeles and in northern California and we came here in 1953, bought this place sight unseen, no road on it. This road in front of us was put in, then he started carving dolls. First he made a man and woman and dog to represent Rock Hound, then he started carving dolls that he danced to the music . . ." Ruby's contribution to the show was costuming the dolls, and she says, "I really enjoyed making dresses for them . . . one is an antique dress I made over to fit the doll."

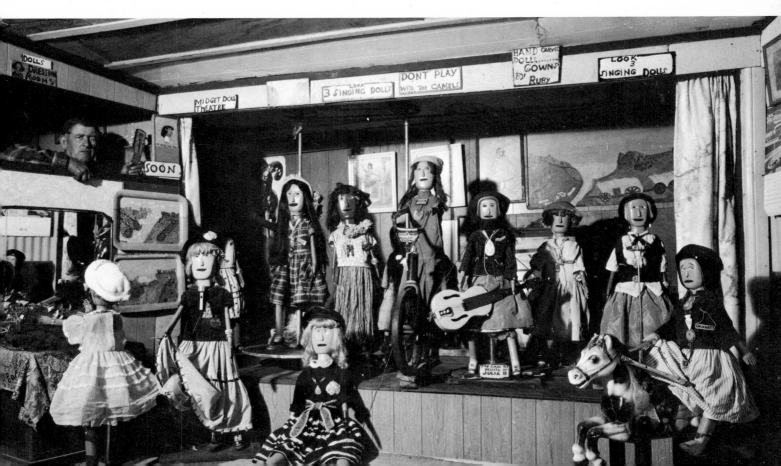

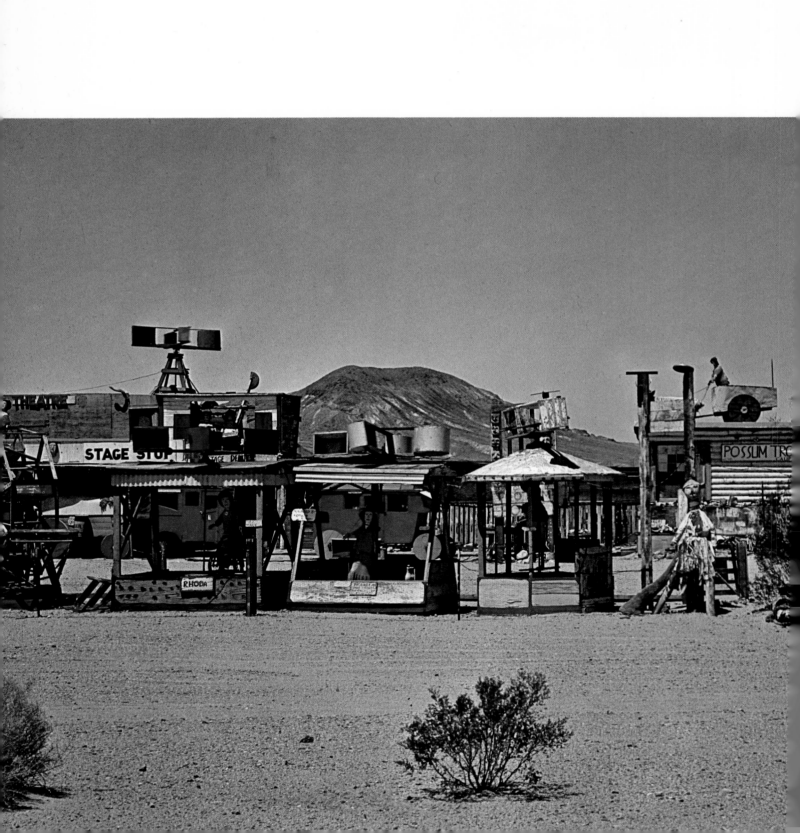

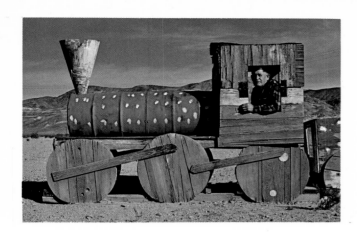

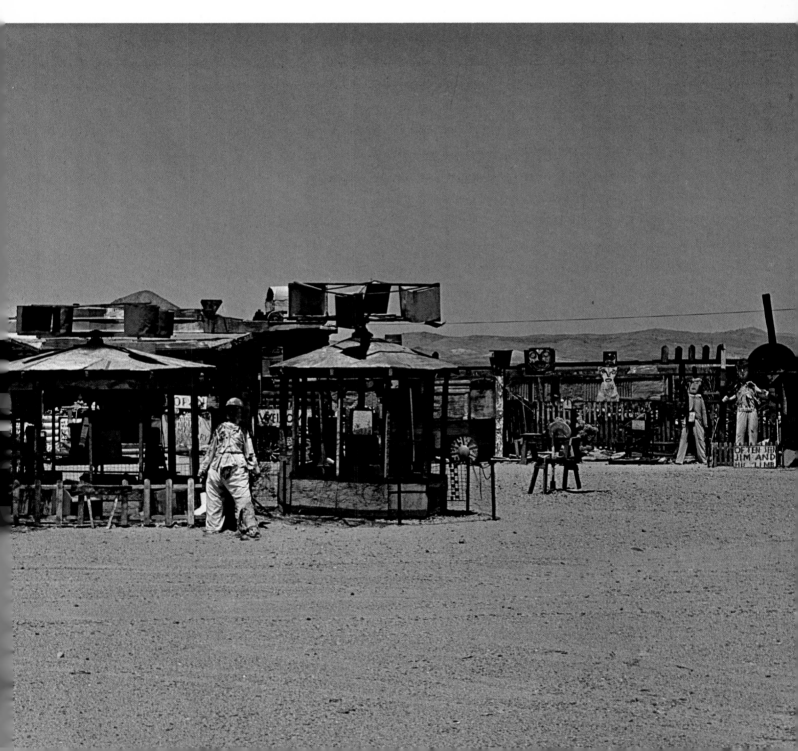

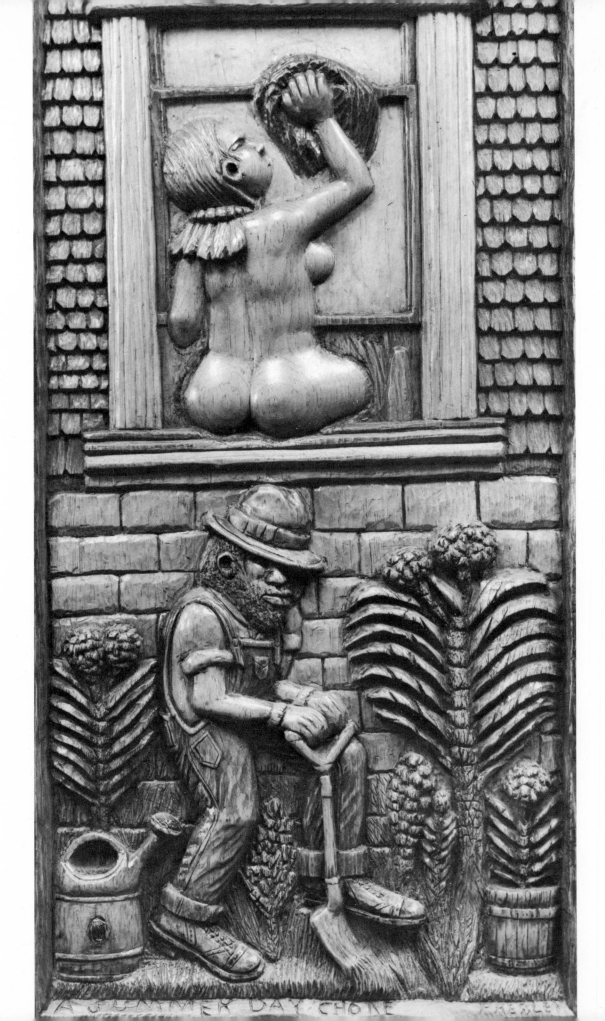

DANIEL PRESSLEY (figure 187, left) was born in South Carolina in 1918 and died in Brooklyn, New York, on March 17, 1971. He suffered a prolonged illness in 1962, and although he recovered, he never worked again, but devoted himself to painting and wood sculpture, and participated regularly in the Greenwich Village Outdoor Art Shows. Gregarious, something of a man-about-town, and so earnest about his art that he spent long hours at it, he still found time to keep a journal that was a combination of diary, autobiography, personal philosophy, and sketchbook.

Shortly before his death, he asked a fellow artist, Marcia Wilson, to photograph his works and portions of his journal (figure 188, below). In it he had written: "With only a limited Grama school learning, I Daniel Pressley Born at Wasamasaw, South Carolina. When asked my age my answer is that an artist age is as old as His Work . . . an artist Doesnt really have an age . . . Because its an artist Creations that counts if his Creations are youthful then the artist is young no matter How Old in age *His* age time . . . Mom loved reading old newspapers white folks finished with. That is how I learned there were others in the world besides the ones my poor old Negro teacher had us read about, such as Little Boy Blue . . ."

186 (opposite). Daniel Pressley: *A Summer Day Chore*. c. 1965. Polychromed wood, shellacked and waxed. 40″ x 20″. Brooklyn, New York. Courtesy Marcia Wilson. Photograph: Eeva-Inkeri.

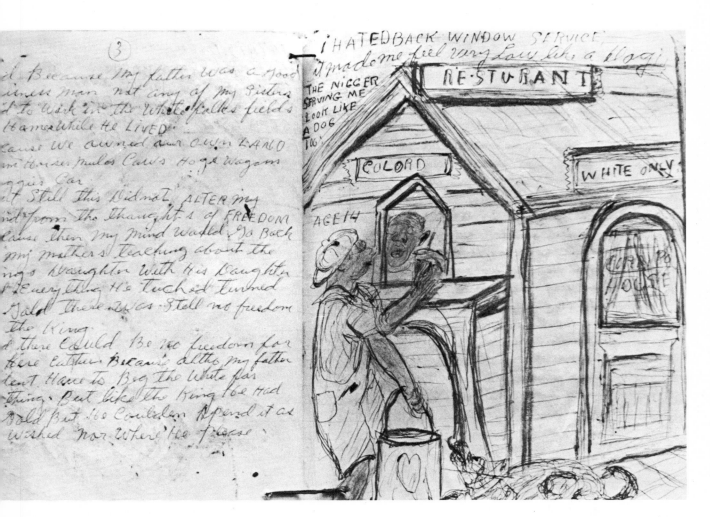

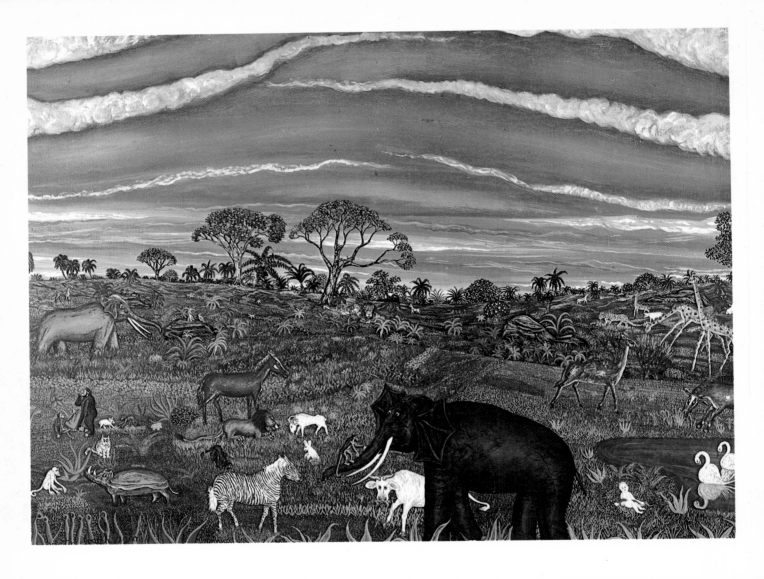

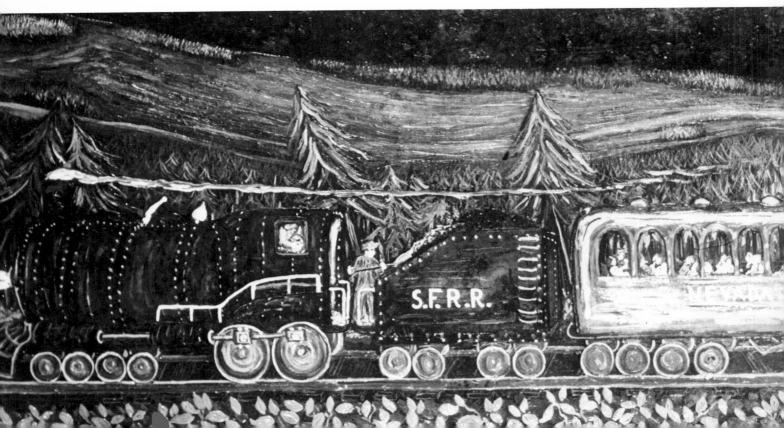

VICTOR JOSEPH GATTO (figure 191, right) was born in Greenwich Village in 1890 and died in Miami, Florida, in 1965. As a child he won a prize for drawing as well as words of praise from Theodore Roosevelt. Poverty and need, however, interfered with any ambitions he may have had either in art or in education, and he became a featherweight prizefighter, a plumber's helper, and a steam fitter. Not until he was 45, and still poor, did he begin to paint again. In 1938, at the age of 48, he showed his work in a Greenwich Village open-air exhibit, but sold nothing. He was living in a tenement at the time, working on a kitchen table, using house paint and dime store brushes, with a slab of glass as a palette. In 1943, some of his paintings found their way to the Charles Barzansky Gallery, which soon gave him a one-man show. Its success led him to devote himself entirely to painting. He worked as if driven, sometimes as much as 36 hours at a stretch. When his eyesight began to fail, he persisted, even against doctor's orders, using a magnifying glass.

189 (opposite, above). Victor Joseph Gatto: *The Peaceable Kingdom.* c. 1958. Oil on masonite. 35½″ x 47½″. New York. Courtesy Mr. and Mrs. Elias Getz. Photograph: Paulus Leeser.

190 (below). Victor Joseph Gatto: *The Santa Fe Night Train.* c. 1955. Oil on pressed wood. 13″ x 48″. New York. Private collection. Photograph: Eeva-Inkeri.

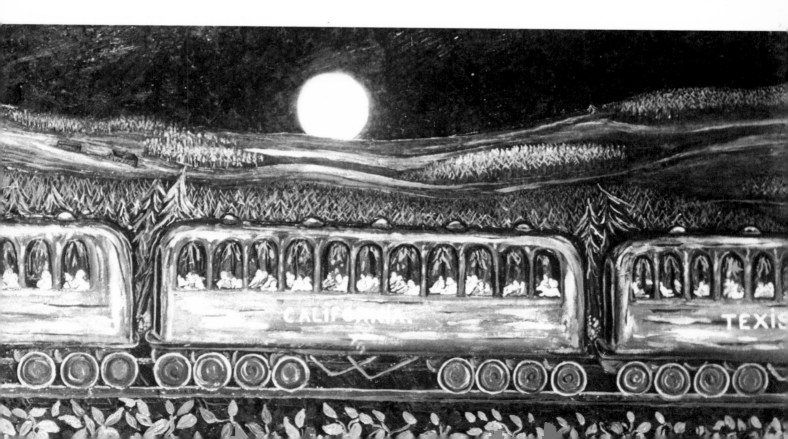

LESLIE GRIMES (figure 195, opposite). Susan Hopmans writes: "The Darling Downs of Australia's outback was Grimes' birthplace, and he spent the first 15 years of his life on the family cattle station. Winning an art scholarship lured the boy to the city (Melbourne). Grimes became an excellent wrestler and headed for the opposite end of the earth." He earned his way by wrestling and painting billboards, arriving in California in 1928, where he became a scenery painter at the Fox and at the Charlie Chaplin studios. Blackballed because of a disagreement, he returned to wrestling, and to writing stories for the sports sections of newspapers. By 1938 he was working again as a scenic artist and stunt man. A man of strong individualism, he is reported to have resisted following the designer's sketches, yet was not argumentative. He was noted for being an entertaining raconteur and "was considered a truly free man who created his own freedom. When work was slow, he might be found tropicalizing the interiors of Vic Tanny Gyms or painting virile stallions on Mae West's beach house walls if not on a wrestling tour."

It was his own idea, which he sold to Barney Clougherty, to do the Farmer John Meat Packing Company murals, and after some complicated haggling, he began on the Los Angeles plant in 1955, did Fresno in 1959, and Tucson and Phoenix in the 1960s.

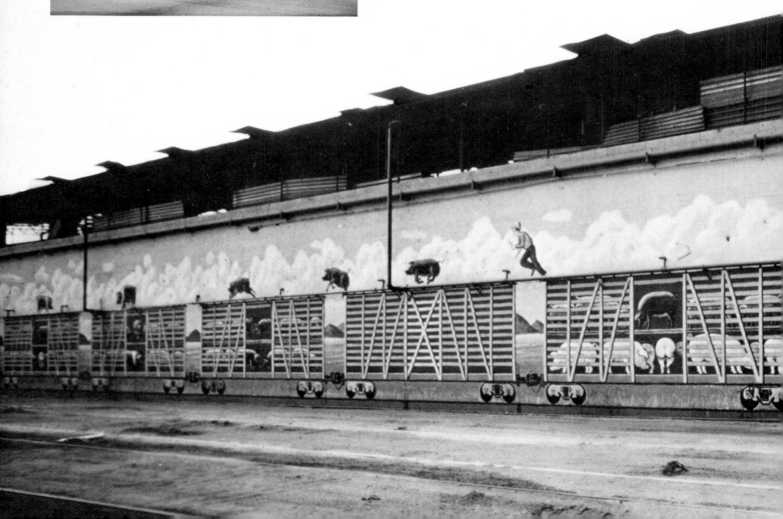

"He seldom made any preliminary sketches, and if he did, they would be of the roughest sort on newspaper. A majority of the paint was laid on with rollers and huge brushes. Grimes invented a 'fling' blend, flipping the paint off the end of his brush. There would be paint flying everywhere. Grimes would stand back three or four feet and flip flowers into place.

"On November 14th, 1968, some say, Grimes in a typically robust fashion was jumping up and down on the scaffold to test it. One of the supporting ropes broke . . . in a matter of seconds he lay dead at the bottom of his magical barn."

Much of Leslie Grimes's work has been destroyed by time and the elements in the Los Angeles area, whereas in Phoenix, they are still maintained.

192, 193, and 194 (opposite and below). Leslie Grimes: *Giant Murals for Farmer John Brand Meats*. 1955–1968. Outdoor sign paints. Vernon, California, and Tucson and Phoenix, Arizona. These were done for the Clougherty Meat Packing Company, producers of Farmer John meats. Courtesy Susan Hopmans. Photographs: Peter Kenner.

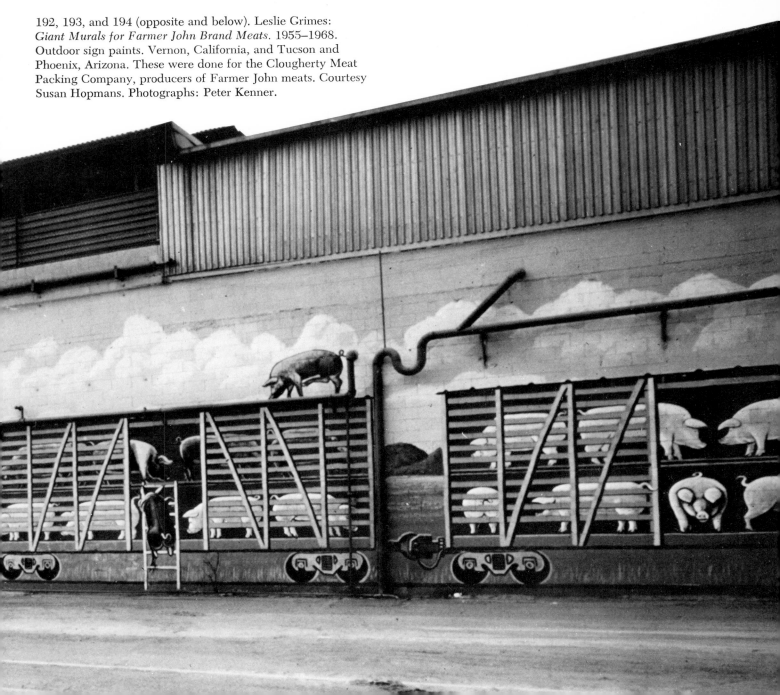

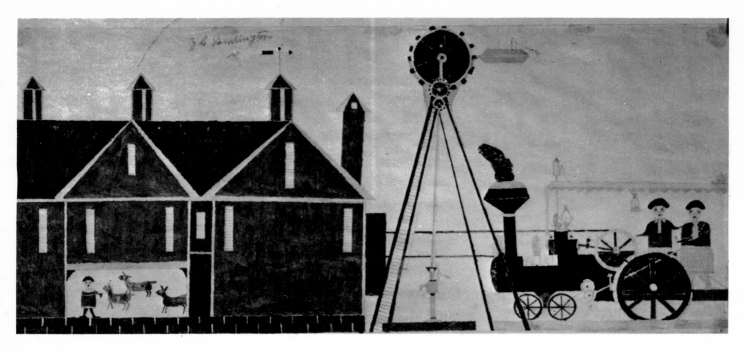

196 (above). J. C. Huntington: *Farm Scene*. c. 1920. Watercolor on paper. 19½″ x 42½″. Pennsylvania. Huntington was a retired railroad worker who lived in Sunbury, Pennsylvania. He used his daughter as a model for all his female figures. Private collection.

197 (below). J. C. Huntington: *Figures in a Garden*. c. 1944. Pencil and watercolor on paper. 20½″ x 40″. Pennsylvania. Courtesy Mr. and Mrs. Michael D. Hall.

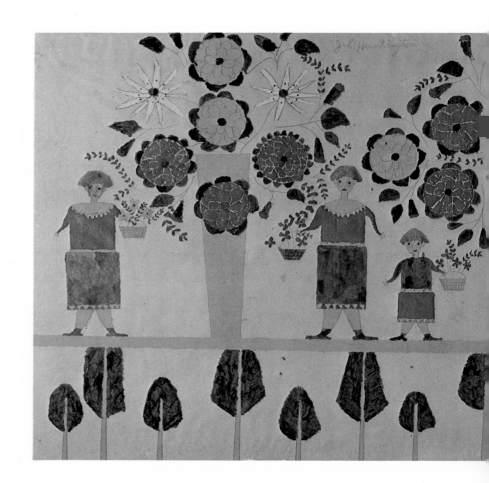

CLARENCE STRINGFIELD was born in Erin, West Tennessee, in 1903. As a young man he had been a farmer and cabinetmaking instructor, but in the 1930s, found himself bedridden with tuberculosis for a year. That was when his hobby of woodcarving began. Although he has kept busy with several kinds of shopwork—replacing gunstocks, filing saws, repairing musical instruments, metalwork—his carving tools are quite simple: jackknife, pocketknife, and a few hand chisels. He paints many of his figures, and finishes others with Mercurochrome or iodine and lacquer or wax. He is also a fiddler, and uses a fiddle he carved himself.

198 (right). Clarence Stringfield: *Bathing Beauty*. 1973. Polychromed wood. Life size. Nashville, Tennessee. Courtesy Mrs. Estelle Friedman.

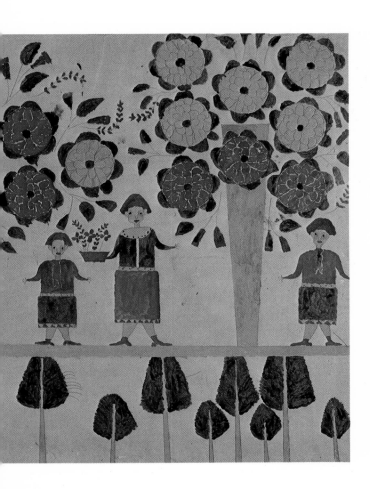

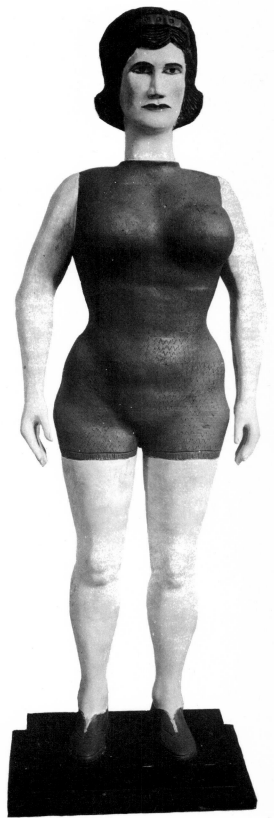

199 (right). Frank Leveva Day: *Women Killing Deer*. 1962.
Oil on cardboard. 13⅞″ x 16⅞″. California. Courtesy
U.S. Department of the Interior, Indian Arts and Crafts
Board.

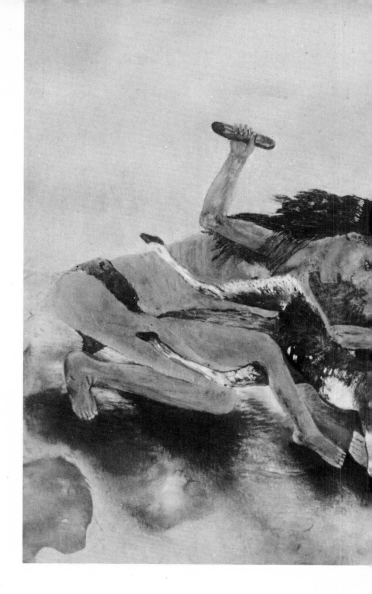

FRANK LEVEVA DAY, a Maidu Indian, was born around 1900 at Berry Creek, California. His father, a respected tribal elder of 60 when Frank was born, taught him the legends, technology, and religion of his people. As a young man, Day traveled and worked throughout Arizona, New Mexico, Montana, and Alaska, and settled in California in 1937. An automobile accident in the early 1960s propelled him into retirement, affording him the leisure to revive a neglected interest in art. Encouraged by his wife and several California anthropologists, he chose to concentrate on his knowledge of the mythology, lore, and customs of his own tribe.

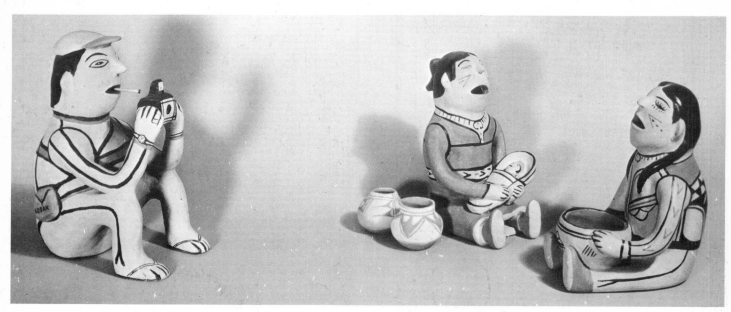

200 (above). Anonymous: *The Tourist at Cochiti*. 1967. Earthenware, slip painted. H. approx 12″.
Cochiti Reservation, New Mexico. Photograph: K. C. DenDooven, K.C. Publications, Las Vegas, Nevada.

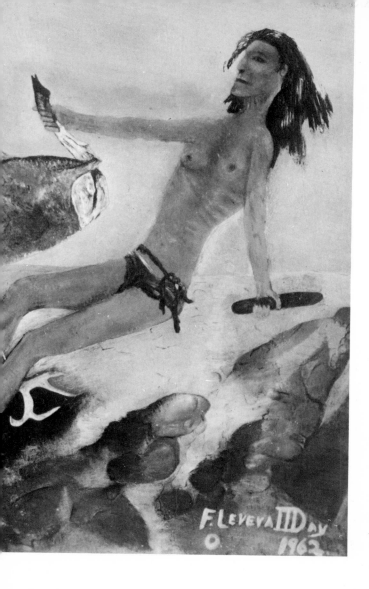

HELEN CORDERO (figure 202, below) was born in 1916 at Cochiti Pueblo, New Mexico. Cochiti potters are especially known for their whimsical, painted clay figurines. Helen Cordero became interested in this art form about ten years ago and began creating seated figurines, usually of an adult man or woman swarming with numerous children.

201 (below, left). Helen Cordero: *The Story Teller*. 1970. Earthenware, slip painted. H. 10⅝". Cochiti Reservation, New Mexico. "Their eyes [of the Indian figures] are often closed because they are thinking. Their mouths are open because they are chanting or telling stories." Courtesy U.S. Department of the Interior, Indian Arts and Crafts Board. Photograph: Charles Phillips.

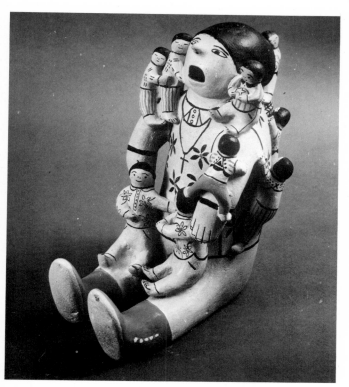

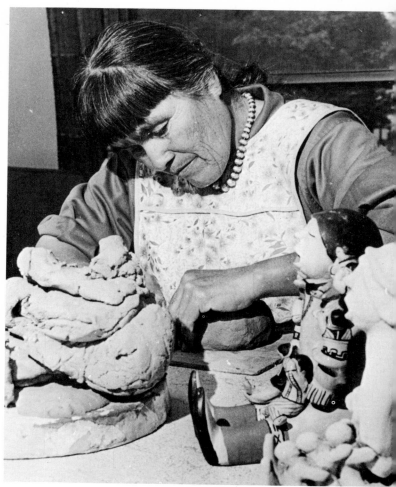

SOPHY REGENSBURG (figure 203, right) was born in New York City on July 28, 1885 and died in April 1974. She began painting in 1952. She had been doing much volunteer hospital work when her doctor advised her to slow down. "I didn't have anything to do. There are members in my family who are artists so I decided to paint. I sent some of my work to an *Art News Magazine* competition —I am very pushy—and won a gold medal and then a silver one. When I decided to paint, I did go to The Museum of Modern Art, but they said I had something and they didn't want to disturb it. I don't try to paint like anybody. I don't use an easel, and I don't do any previous sketching—except for a thumbnail sketch sometimes. I have made terrible mistakes, but I have learned how to be careful about composition, and color, and that the spaces in between objects is as important as the objects themselves."

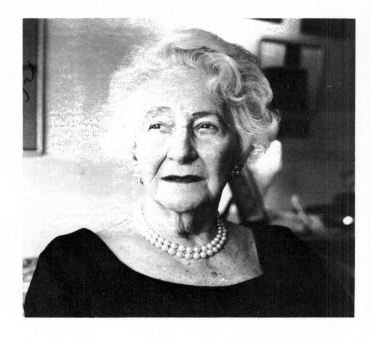

204 (above). Sophy Regensburg: *Blue and Red Composition*. 1969. Casein on canvas. 24″ x 30″. New York. Courtesy Peter Prince. Photograph courtesy Babcock Galleries.

205 (below). Sophy Regensburg: *Bohemian Glass, No. 2.* 1972. Casein on canvas. 20″ x 16″. New York. Courtesy Babcock Galleries. Photograph courtesy Babcock Galleries.

NOUNOUFAR BOGHOSIAN, though Armenian, was born in Istanbul, Turkey, in 1894. She fled to America—"freedom country"—in 1913. She married and had three children. After her husband's death, she moved to California in 1949, remarried, and turned to painting on her second husband's insistence as therapy when troubled by personal problems. In 1964, Suzanne Bravender, a Pasadena City College art instructor, encouraged her exuberance to experiment in the classroom. Many of her paintings and collages center around her recollection of Armenian traditions and her own childhood, others are based on current social and political situations. When the Armenian government wanted to purchase seven of her paintings for the Sarian and Capital museums, she refused the money but said she would donate them. ". . . I am happy to bring my dear family, my late grandmother, my precious grandchildren, and creative children of my soul HOME to Armenia. I will be proud to present the best of my artistry without charge."

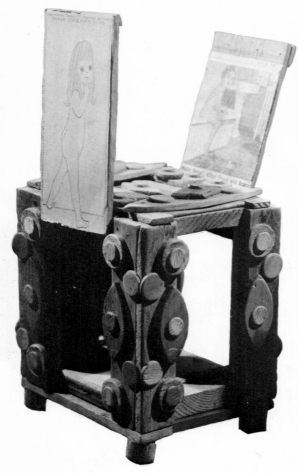

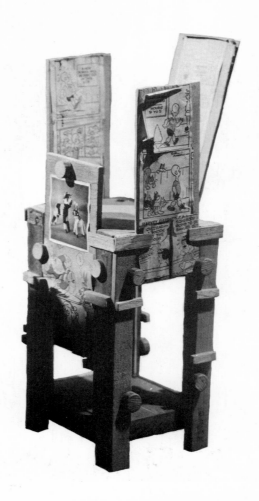

208 (opposite, below). Nounoufar Boghosian: *My Dream*. 1969. Mixed media and collage on canvas. 68″ x 42″. Pasadena, California. "My husband wanted me to be in heaven with him. He grabbed me by my neck. I am crying, 'I don't want to go. I haven't finished my paintings yet.' He said, 'If you can grab this silver bag, I let you stay.' I grabbed it, and I am happy. It was a dream." The artist has given the work to the Yerevan Museum, Armenia. Photograph courtesy American Federation of Arts.

206 (above and right). Ellsworth Davis: *Peep Show*. 1968. Unfinished wood, pasted paper appliqués. Pennsylvania. The artist was a deaf-mute, whose work was sold after his death in 1970 to pay for his grave marker. Private collection.

207 (opposite, above). Villeneuve: *The Ribbon Cutting*. c. 1950. Oil on board. 15½″ x 17½″. Michigan. The artist grew up in British Columbia and came to the United States in the 1940s. Courtesy Robert Bishop.

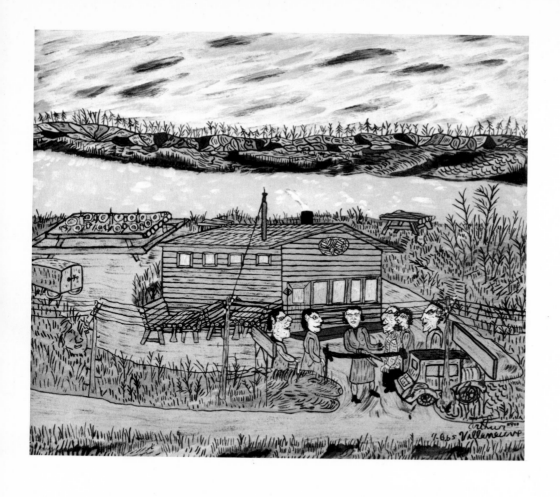

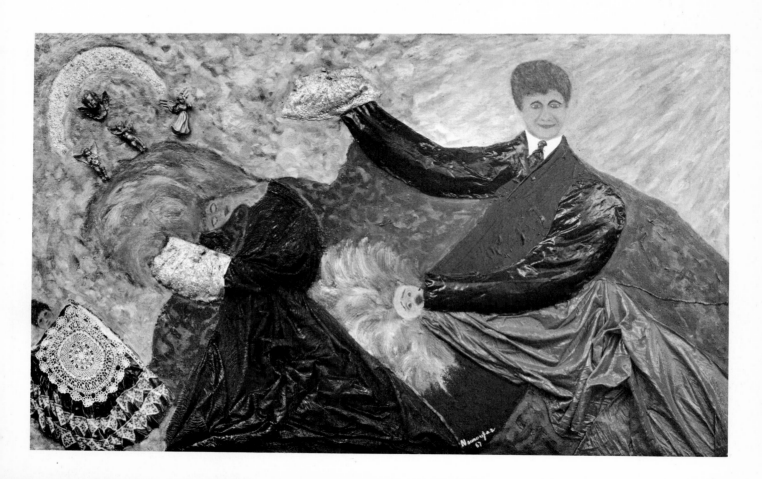

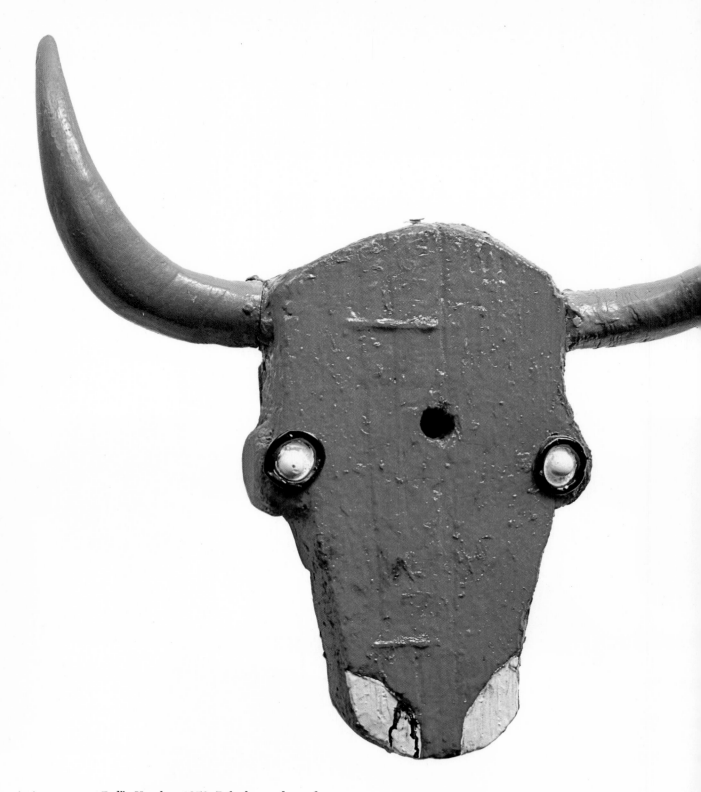

209 (above). Anonymous: *Bull's Head*. c. 1970. Polychromed wood.
H. 19″; W. 20½″. Courtesy Roger Brown. Photograph: Jonas Dovydenas.

211 (opposite). Charles Moore: *Black Horse*. c. 1950. House paint on
cardboard. 18¾″ x 27½″. Nashville, Tennessee. The artist, a barber,
died in 1952. Courtesy Mrs. Estelle Friedman.

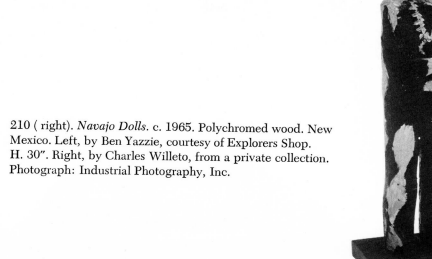

210 (right). *Navajo Dolls.* c. 1965. Polychromed wood. New Mexico. Left, by Ben Yazzie, courtesy of Explorers Shop. H. 30″. Right, by Charles Willeto, from a private collection. Photograph: Industrial Photography, Inc.

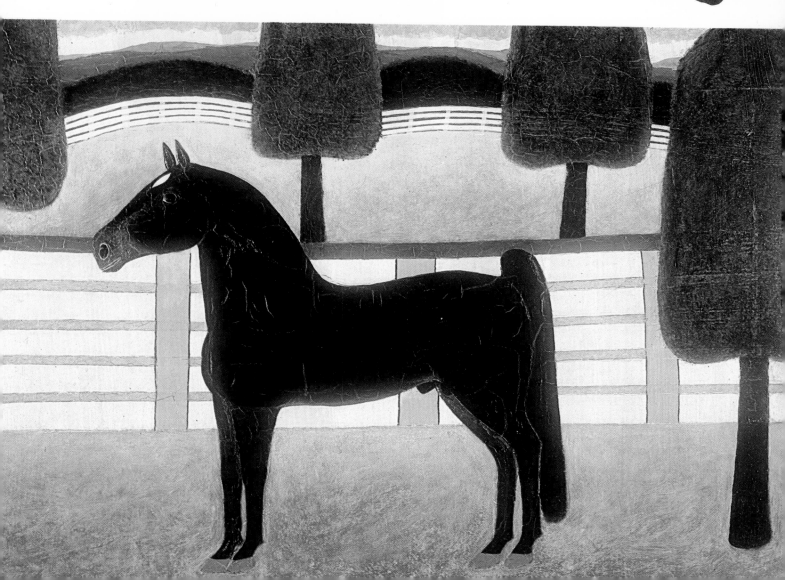

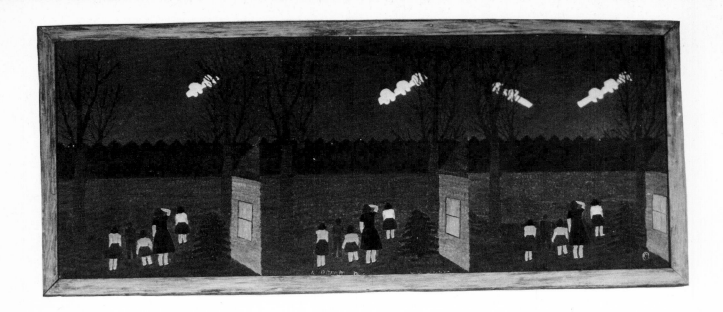

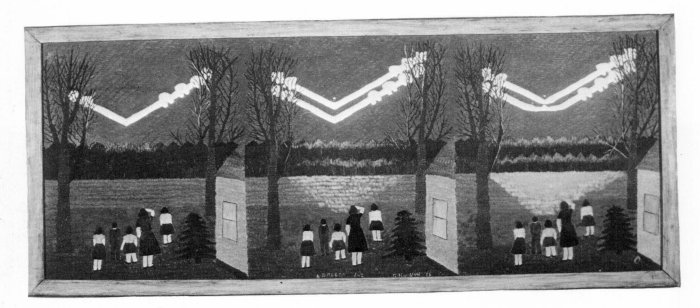

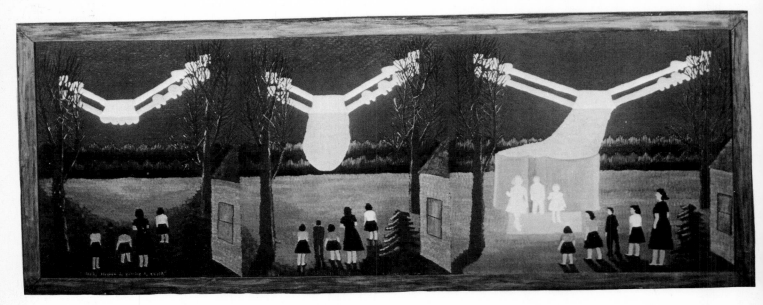

150

212 (opposite). Theora Hamblett: *Heaven's Descent to Earth.* 1955–1959. Oil on masonite. Triptych: two panels are 20″ x 48″, one is 20″ x 54″. Oxford, Mississippi. "All at once this scene and story popped into my mind. Dream or vision, here it is. Several little boys and girls were sitting around me one evening; we saw a golden chariot come from behind the trees; another followed, then another; silver chariots came out. I exclaimed, 'Oh look! Heaven is coming to earth.' Several celestial bodies came out to greet us." (From "Dreams can work for you," by Theora Hamblett. Privately printed.) Courtesy the artist. Photograph: Biggs Studio.

213 (below). Jennie Novik: *Cat in Paradise.* 1966. Oil on canvas. 38″ x 41″. Flushing, New York. Courtesy Mrs. Nora Dorn. Photograph courtesy American Federation of Arts.

THEORA HAMBLETT was born January 14, 1895, on a farm near Paris, Mississippi, and she now lives in Oxford. She began to paint in 1950. To Gregg Blasdel she wrote: "Lifelong infatuation with colors, desire to paint, but finances kept me from formal studying. When Art Department was added to the University of Mississippi, I resolved to try. After a little try, nothing seemed to stop me. A broken hip woke me up to dedicate the rest of my days to painting." A great many of her paintings are visualizations of her dreams, sometimes of childhood games, sometimes of religious matters, often of her memories of other people's memories.

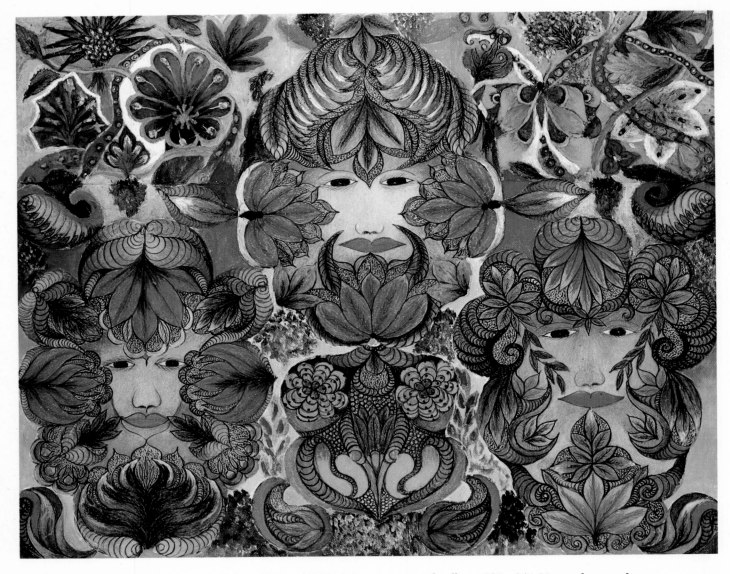

214 (above). Minnie Evans: *Untitled*. c. 1962 to 1967. Oil on canvas and collage. 20″ x 24″. No one has taught me about drawing. No one could because no one knows what to teach me. No one has taught me to paint. It came to me." Courtesy Nina Howell Starr, the artist's New York representative. Photograph: Paulus Leeser.

MINNIE EVANS, Black artist, was born in Long Creek, North Carolina, in 1883, and since infancy, save for a trip to New York in 1966, has lived in the remote, rural quiet of Wilmington, North Carolina. Her schooling ended in the sixth grade. She has little contact with the outside world, except for the tourists entering the Airlie Gardens in Wilmington where she works as gatekeeper. Her dreams, unconscious fantasies, and imagination are sources of her inspiration. Nina Howell Starr quotes her in the Summer 1969 *Bennington Review*: "In a dream it was shown to me what I have to do, of paintings. I never plan a drawing. They just happen."

215 (opposite). William Fellini: *Lily in Boot*. 1951. Oil on canvas. 20″ x 16″. New York. Courtesy Bunty and Tom Armstrong.

WILLIAM FELLINI, a New York City house painter and decorator, died around 1965. Mrs. Nancy Bayne Turner of Florida wrote: "Our family had known Mr. Fellini for more than twenty-five years as he worked for my mother as a decorator and a 'Jack of all trades.' Without a doubt, he was one of the nicest and kindest, a man who was totally misunderstood and not appreciated by his family (artistically). He could not sell one of his pictures during his lifetime. He was so poor he could not afford to buy new canvas and would often buy used canvas for $.25 and paint on the reverse side. All I can tell you about him is that he was the 'Charlie Chaplin' of his group of Third Avenue paint contractors and decorators. They were always teasing him about his 'art' work. He never seemed to mind and would say 'Wait, some day those "big shots" will be surprised!' Well, it's all come true and I'm so sorry he isn't here to enjoy it."

216 (above). Velox Ward: *The Life of a Tree*. 1961. Oil on canvas. 16″ x 20″.
Longview, Texas. "I have been painting for ten years. That is the longest time I have
ever spent in any vocation. I will be striving for the rest of my days to attain what
I want on canvas." This painting was inspired by a double-exposure photograph.
Courtesy Mr. Eric S. Vogel. Photograph courtesy Valley House Gallery.

VELOX WARD was born on a farm near Hopewell, Texas. His mother found his
name on her German-made sewing machine. His early life, a happy one of hard
work combined with many enjoyable family gatherings at his grandfather's
house, furnished subject matter for many of his paintings. In 1910 his father
sought to better himself financially in Foard City, but his general store and
lumber yard failed, and they moved back to East Texas and more failure—this
time a sawmill. They went next to Everton, Arkansas. His father died, and Velox,
now in the seventh grade, his last year of formal schooling, went to work. He
became a fur hunter, then a farmer—a successful one. He moved back to Texas,
and since then has had a variety of jobs: car painter, shop foreman, sales man-
ager of the car shop; shoe shop owner, furniture restorer, wrestler (as an avoca-
tion), and the ministry, the last being the only one at which he felt he had been
a failure.

"He moved around the country to accommodate his children in their quest for
higher education. When a young Ward had selected a college, Velox would
simply move the whole family to that college town, find a new job, and provide
room and board on the spot for his college student." In 1960, his now grown
children suggested he paint each one a picture for a Christmas present. "So I
went out and bought three brushes, five tubes of paint—red, yellow, blue, black,
and white—and four 10″ x 12″ canvases. I knew neither of them would want my
first attempt. However, I really enjoyed painting. I got two more canvases. I was
very pleased with my first sale of $35." He gave up his "Shoe Service" business
to begin his career as an artist. "I will be striving the rest of my days to attain
what I want on canvas." His favorite model is his wife Jessie. "I learned that if
a kid really wanted to learn something, or be something, he would do it if you
let him go his way . . . there'd be no telling how far they could go." (Excerpt
from *Velox Ward* by Donald and Margaret Vogel.)

154

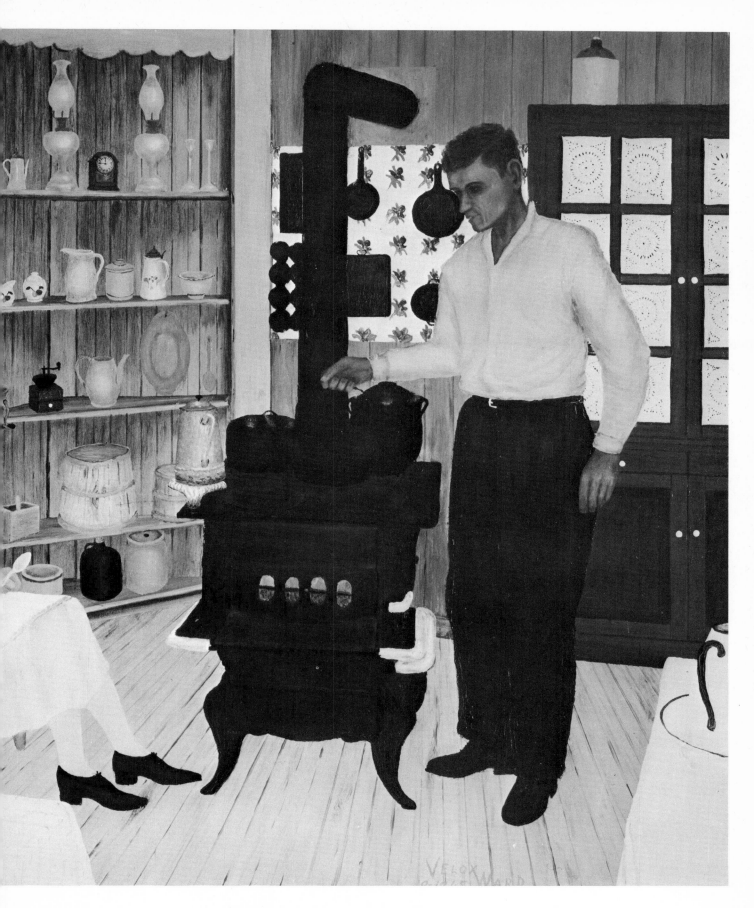

217 (above). Velox Ward: *Water's Boiling.* 1965. Oil on canvas. 16″ x 18″. Texas. Courtesy Mr. and Mrs. Dan C. Williams. Photograph courtesy Valley House Gallery.

MARY BORKOWSKI was born March 28, 1916, in Sulphur Springs, Ohio; she now lives in Dayton, Ohio. Answering a request for biographical information, she wrote: "I have always, all my life, been a firm believer in God. There had to be an unseen Power that could make something as beautiful as a wild flower, or even a weed. I had an experience. I knew I had seen the hand of God—as if to say, 'all my creations are welcome home and are whole in MY eyes.' I never made a painting before in my life, thread or otherwise until 1965. They are the pieces of my life that shouldn't have been —the world of Mary Borkowski. I always feel safe when applying thread with my hands. I feel my hands are a second brain, just automatically pushing a needle around. These paintings, done with needle, thread, and cloth, are expressions of awful truths and deep emotional experiences of self, of others, and God's creations."

218 (above). Mary Borkowski: *The Crash*. 1968. Needle painting, silk thread on silk. 39½" x 16". Dayton, Ohio. "My thread paintings are not embroidery. This is something learned all alone. The designs are built in thread as you would a piece of clay, but in the same manner as paint. I didn't make it for money, but a feeling so deep about something so wrong, I had to make it. After making it, all the original hostility I felt was gone." Private collection. Photograph: Eeva-Inkeri.

219 (right). Henry Jackson: *The Christ*. Found 1961. Poster paints on board. 38" x 4⁻". Chicago. Found in the window of a store-front church. The artist was seventeen when he painted it. Courtesy Nina Howell Starr. Photograph: Paulus Leeser.

PAULINE SHAPIRO was born in New York, and died in the borough of Queens in the summer of 1972. She is believed to have been about 52 years old. Although she lived in the same garden apartment complex for 25 years and was well liked and considered friendly by her neighbors, very little is known about her. When visited on April 25, 1972, she did reveal that she had been widowed since her son was a small child, and that she had never traveled outside the city. She began to do embroidery and needlepoint in the occupational therapy program of a hospital where she had been an ambulatory patient. Her pictorial works were entirely imaginary, although often, she said, inspired by nature. "After I get something of an idea, I start in one corner of the canvas and move on. I select my colors carefully, and I shop around for just the right kind of cotton thread."

220 (below). Pauline Shapiro: *America 1963*. 1963. Needlepoint, cotton thread on canvas. 39" x 46". Queens Village, New York. "I subdivided the canvas into eighteen units, all linked together by roads on which automobiles and buses are traveling throughout the country: right to left, Maine and Vermont; education; America's favorite sport, baseball; the church, its beauty and isolation; Montana; Oregon; Manhattan; Ohio—typically drive-in movies, shopping center, suburbia; our flag; the atomic explosion; Southern American life; New Orleans Mardi Gras; wheat fields; gambling in Nevada and the innocence of Disneyland; Florida." (The artist had never traveled.) Courtesy of the artist. Photograph: Eeva-Inkeri.

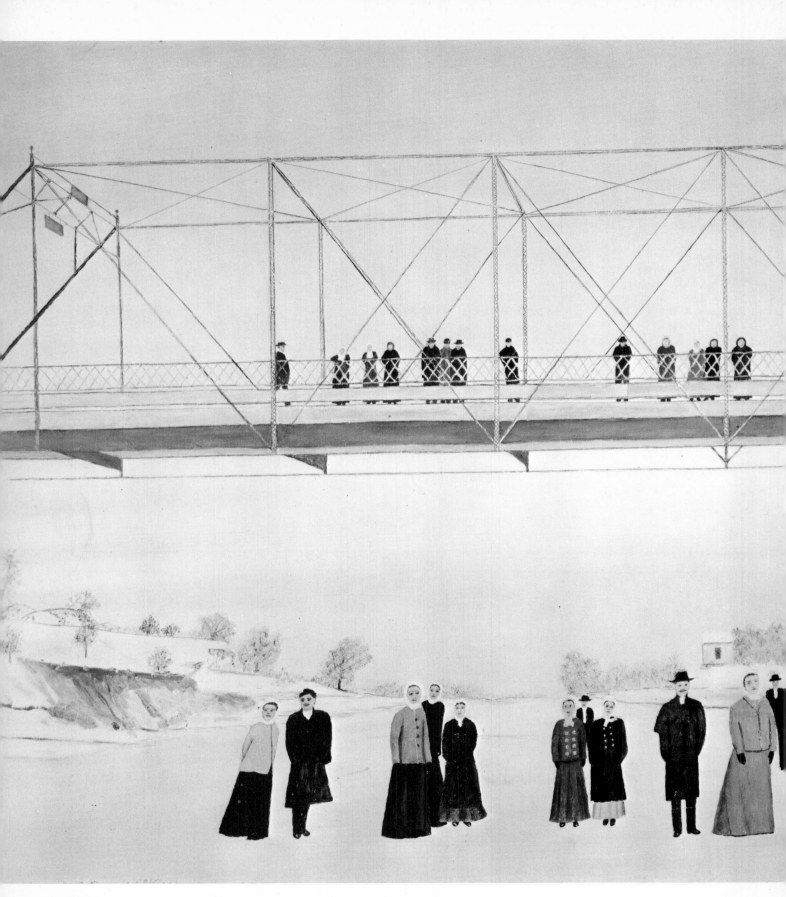

221 (above). Clara McDonald Williamson: *The Day the Bosque Froze Over*. 1953. Oil on panel. 20″ x 28″. Dallas, Texas. A memorialization of the only time that anyone could remember the river was frozen solid enough to drive a team of horses across it. Courtesy The Museum of Modern Art.

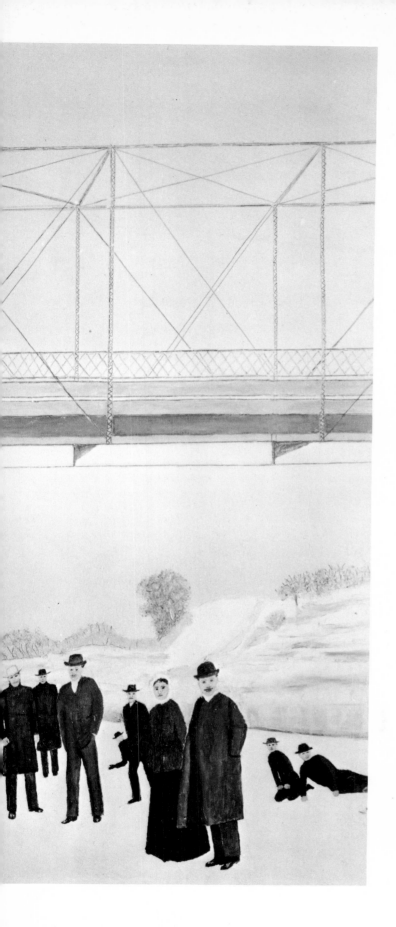

CLARA MCDONALD WILLIAMSON was born on November 20, 1875, in Iredell, a frontier town in Bosque County, Texas. Her mother and father had driven there in a wagon train. Her recollections of her childhood and youth there are found in many of her paintings. She is quoted by Donald and Margaret Vogel: "Of course, now, that was my world; that was all I knew, that little town, and of course that's all I had to remember and put on canvas, and I think a painter ˊought to paint what he knows like an author ought to write what *he* knows." As the oldest child, she was saddled with surrogate mother and household chores, and her schooling was almost catch-as-catch-can. "I'll tell you how I went to school. I'd get to go maybe two days in a week, and then I'd have to miss three days. Then, if Mama needed me, if any of the little brothers or sisters got sick, well, I'd stay at home . . . I went to school when I got a chance." But her avidness to learn and her retention were phenomenal.

When she was 20, and considered a spinster, she was invited by her uncle, the county clerk of Ellis County, to work for him in Waxahachie. This ushered in a seven-year period of freedom as an emancipated woman, such as she was not to experience again until after her husband died. Family problems forced her unwilling return home, but marriage to a widower helped her fulfill her desire to have her own home and at least one child of her own. Her husband ran a dry goods store, and Clara made a good businesswoman.

In 1920, they moved to Dallas and started another business, and again Clara bore the brunt of the hard work, on top of running a boardinghouse. But she managed, as she had done throughout her life, to cling fast to her sense of humor, her pleasure in learning new things, and to her delight with life itself. At the age of 68, she was "left alone, with nothing especially to do." She began to draw, and then she enrolled in a class at Southern Methodist University in 1943, and the following winter, entered evening classes at the Dallas Museum, where she was discovered by Donald Vogel, painting the first of her more than 160 works.

222 (above). Kivetoruk (James) Moses: *White Doctor and Eskimo Medicine Man.* c. 1965. Ink wash with color on illustration board. 10½" x 15½". Shismaref, Alaska. "The scene, on board an early whaling ship, depicts an event when a ring puzzle performed by the ship's doctor was countered with a dramatic trick performed by a visiting Eskimo shaman." Courtesy U.S. Department of the Interior, Indian Arts and Crafts Board. Photograph: Charles Phillips.

KIVETORUK (JAMES) MOSES was born in 1908 near Cape Espenberg, Alaska, but has lived in Deering, Shismaref, Brevig Mission, and Nome. He left school after the third grade to learn reindeer herding and the traditional Eskimo pursuits of hunting, fishing, and trapping. He was in an airplane accident in 1954 and began to paint to while away the hours. Since then, he has concentrated on art. He uses pencil, India ink, colored pencils, watercolors, and photographic coloring pencils. His compositions, generally done on cardboard, are interpretations of Eskimo folktales or of actual historical events.

223 (above). James Crane: *Dream Island.* c. 1966. House paint on bed sheet with paper collage. 18½″ x 31″. Vicinity of Ellsworth, Maine. Courtesy Mr. and Mrs. Michael D. Hall.

224 (below). James Crane: *The Titanic.* c. 1968. House paint on plywood. 21″ x 37″. Vicinity of Ellsworth, Maine. Courtesy Mr. and Mrs. Michael D. Hall.

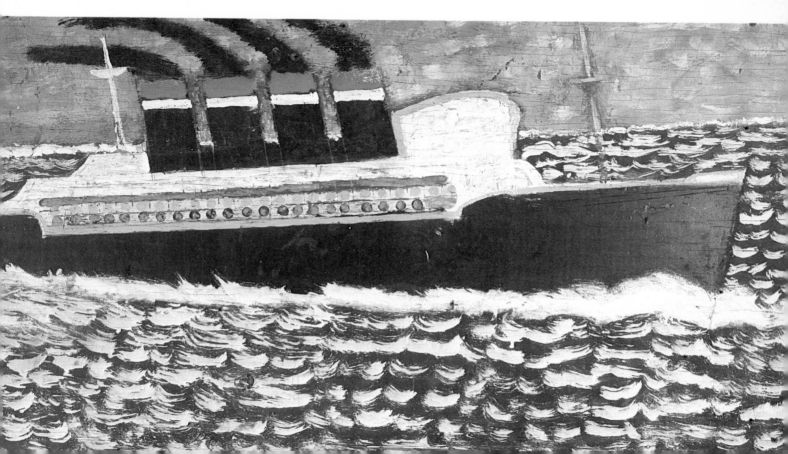

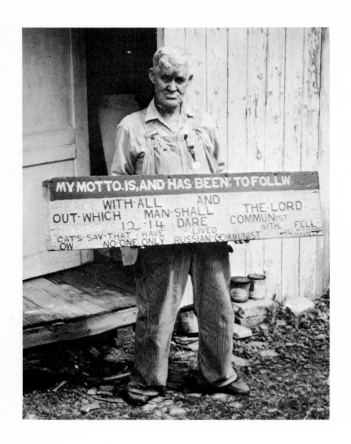

JESSE HOWARD (figure 225, left) was born June 4, 1885, in Shamrock, Callaway County, Missouri. His formal schooling, which was limited to three months a year, ended after the sixth grade when he decided to leave home. He worked on the railroads, became a transient worker, made friends with hoboes. His restlessness took him to Illinois, North Dakota, California, Montana, and Yellowstone National Park, where he worked as a cook and dishwasher. By the 1930s he was married, had five children, and had settled in Fulton, Missouri. A friend's display of a collection of old-time farm machinery inspired him to build his own showplace for his own relics and antiques, which he embellished with innumerable signs based upon his extensive knowledge of and faith in the Bible. His property was often subject to vandalism, some of it prankish, some of it born of hostility, and some plain thievery. He wrote: "The beauty of old men is the gray head. Prov. 20–29, Verse 6. I Am Ready to Go or I Am Ready to Stay. Verse 7. I have this quote on my little windmill in my yard. Yes, I have Fought a Good Fight and I am going to KEEP ON FIGHTING." (Letter to the authors, January 1972)

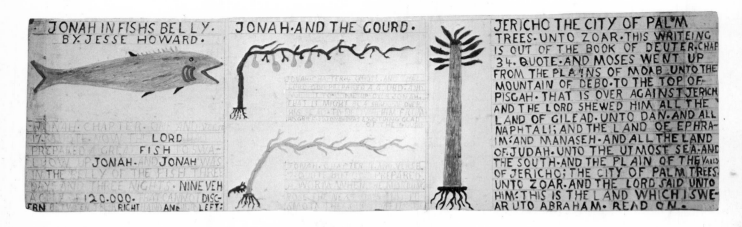

226 (above). Jesse Howard: *Jonah in Fishs Belly.* c. 1967. Oil on board. Fulton, Missouri. "I have THE SATISFACTION OF MY WORKS GOING EVERY WHERE. MOST ALL OF MY WRITING IS FROM ACTUAL EXPERIENCE AND I WILL ASK IF YOU DON'T THINK THAT I DO PRETTY GOOD FOR A MAN 86 AND PAST. AND A SIXTH GRADE EDUCATION." (Letter to the authors, January, 1972.) Courtesy Ray Yoshida. Photograph: Jonas Dovydenas.

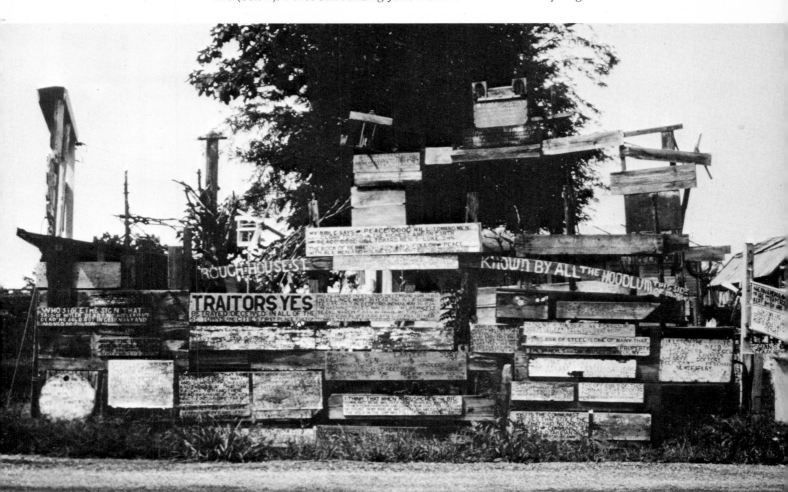

227 (above). Jesse Howard: *Snow Shovel*. c. 1967.
17½" x 13½" x 47½". Courtesy Roger Brown.

228 (below). Fence surrounding Jesse Howard's house. Courtesy Roger Brown.

J. R. ADKINS was born October 9, 1907, in York County, South Carolina. In 1969 arthritis forced him into retirement after many years of traveling throughout the U.S. and Panama with a road construction company and the Army. He died in Seffner, Florida, in 1973. He is quoted by Gregg Blasdel in the *Symbols and Images* catalogue: "Self taught. Never had a lesson in art or drawing. I've taught myself all that I know about painting. I like to paint things that happened in the past. Civil War, Revolutionary War, Tom Sawyer, Daniel Boone, Kit Carson, Jim Bridger, western landscapes, not just one thing but a combination which gives a variety of subjects. That way you have something that everyone will like."

HELEN DUNN writes: "I was born Helen Viana in 1914. When people ask my nationality, I answer, 'I am a New Yorker.' My dream of a Hollywood career led me, at 17, into a Broadway taxi dance hall, to vaudeville, and Tirza's Wine Bath show in Coney Island, where I became known as Rusty Marlow, the first go-go girl. I got seriously involved in Off-Broadway theatre. I was a TB patient in Saranac Lake. Evicted from the craft class for my lack of interest in doilies and table mats, I experimented with a wooden loom, and devised my own method of using a crochet hook instead of a bobbin with the ease and freedom a painter uses a brush." She lives in Greenwich Village, New York.

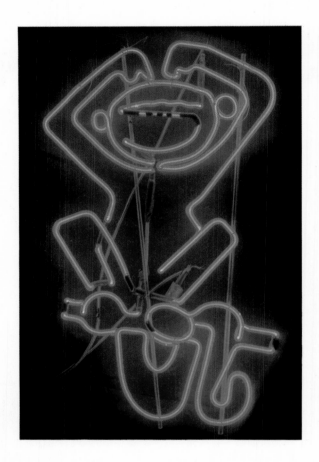

230 (above). Anonymous: *Monkey Sign.* c. 1940. Neon. 31″ x 14″. Found in Philadelphia. Private collection.

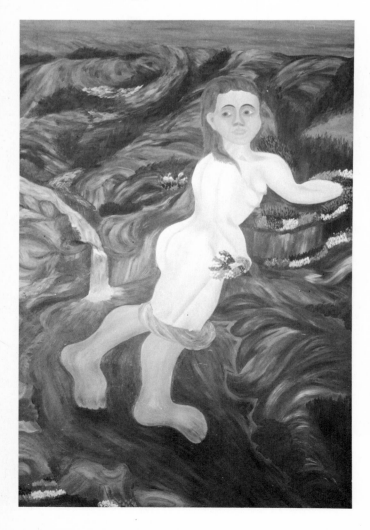

229 (left). J. R. Adkins: *Wild Flower.* 1966. Oil on board. 24″ x 36″. Seffner, Florida. Courtesy Mr. and Mrs. Elias Getz. Photograph: Eeva-Inkeri.

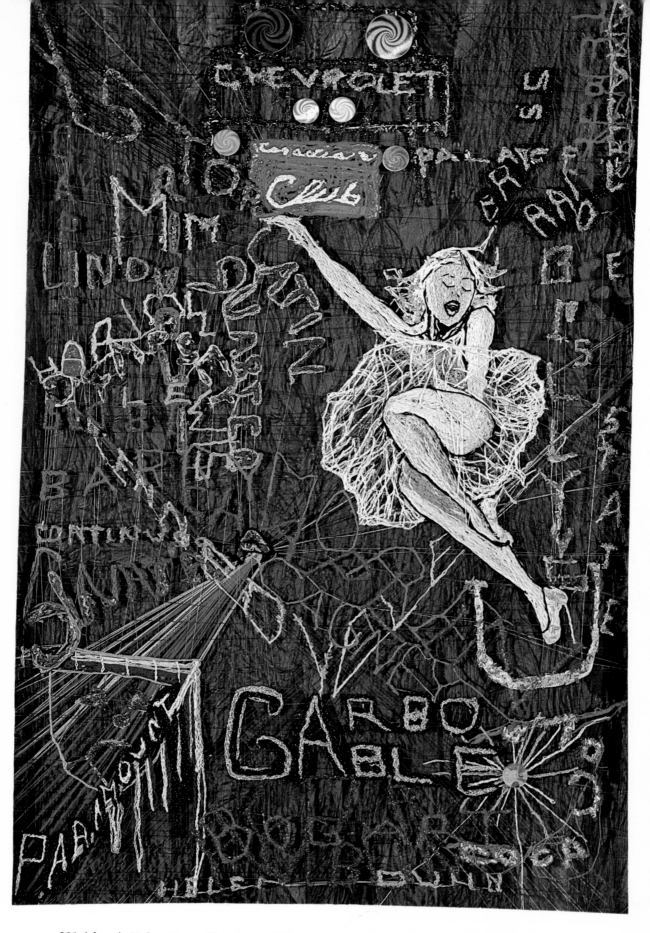

231 (above). Helen Dunn: *Broadway*. 1968. Loom-art collage, mixed thread and mixed media. 35″ x 24″. "To me New York is a Pagliacci Opera with African Drums. I think of it always in terms of colors." Courtesy the artist. Photograph: Eeva-Inkeri.

233 (right). John Ehn: *The Pioneer Mother*. c. 1955 to 1970. Painted Medusa cement and sand over iron core and wire meshing. Life size. Figures in the artist's open-air Museum of the Old West at his Old Trapper Lodge, near Burbank, California. There are a dozen such figures. "I thought these would be a good attraction and also have some advertising value. It's hard to put up anything people are interested in, but statues they will look at." Photographs: Tim Brehm.

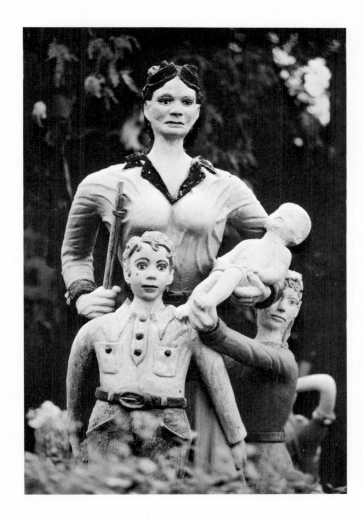

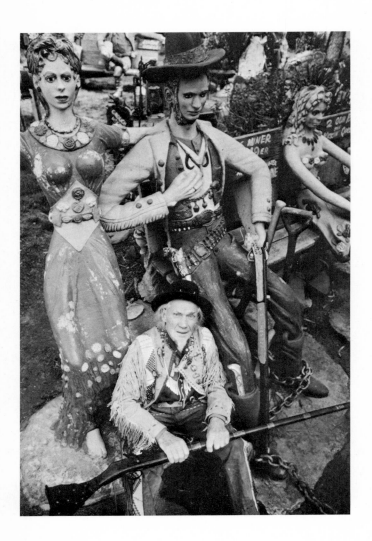

JOHN EHN (figure 232, left) was born in 1896, somewhere in the Great Northeastern Territories, near the Georgian, James, and Hudson bays. His parents were Swedish pioneers. He is quoted by Jane Wilson in *West* Magazine, June 20, 1971. "There wasn't much of anything in that country, so it was natural for us to make things and most people were skilled in one way or another. I don't go for the word *talent*. Any kind of handwork is mostly practice, and the average workman today who has a will to learn could make statues if he had a mind to." Prior to moving to Los Angeles in 1940, Mr. Ehn lived in a house trailer with his family, trapping in Arizona in the winter and in the north in the summer. He ran a traveling school for apprentice trappers and wrote booklets on the subject. He gave up his nomadic life for the sake of his children's education. Around 1955 he had a heart attack and, he said, "One day I thought to myself, 'I'm feeling stronger now, and by golly the time is right—I'll make a statue!' I did the best I could, but I wonder why I couldn't have done it better." He has a ruby set in one of his front teeth.

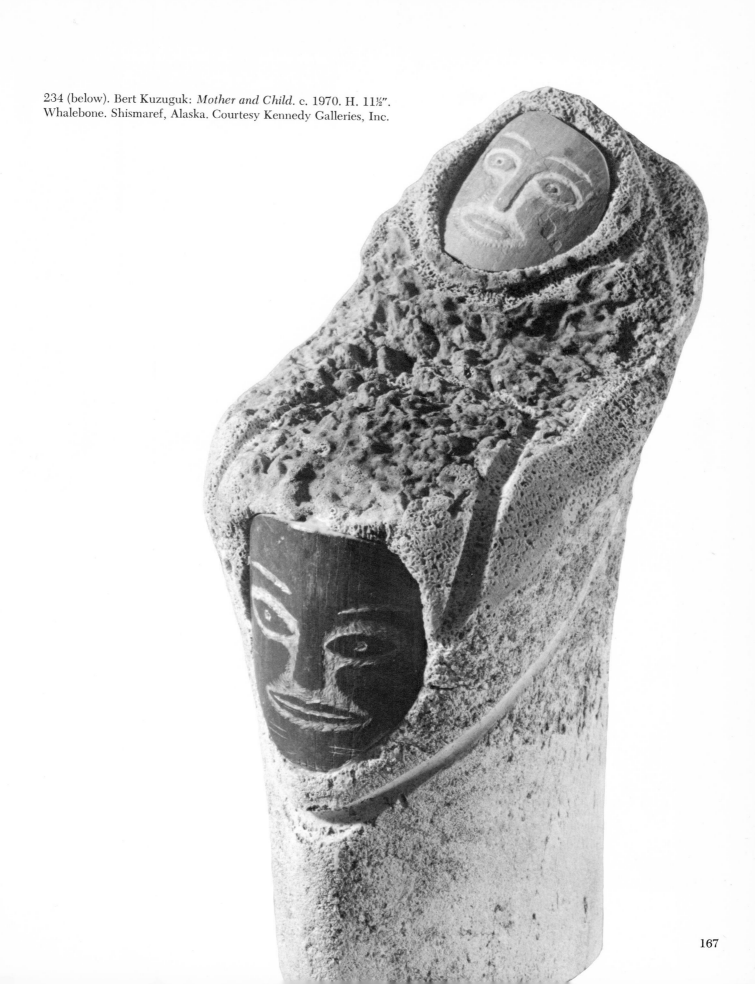

234 (below). Bert Kuzuguk: *Mother and Child.* c. 1970. H. 11½".
Whalebone. Shismaref, Alaska. Courtesy Kennedy Galleries, Inc.

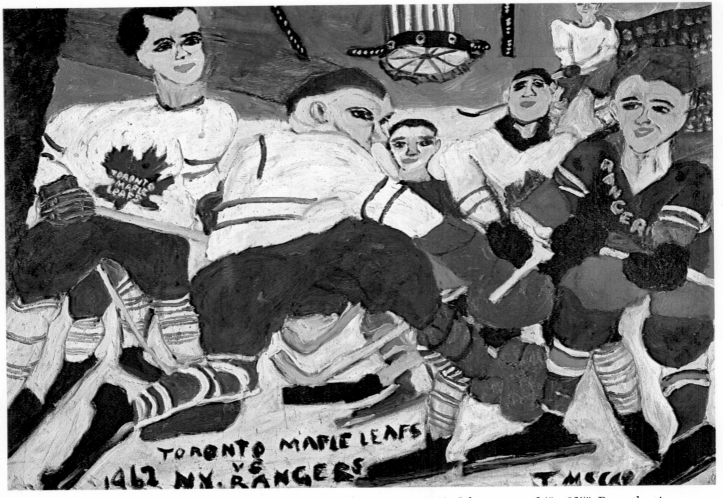

235 (above). Justin McCarthy: *Toronto Maple Leaves*. c. 1962. Oil on canvas. 24″ x 32½″. Pennsylvania. Courtesy Mr. and Mrs. Elias Getz. Photograph: Eeva-Inkeri.

237 (opposite). Justin McCarthy: *Ava Gardner*. 1944. Oil on canvas. 16″ x 12″. Pennsylvania. Courtesy Herbert W. Hemphill, Jr. Photograph: Eeva-Inkeri.

236 (below). Justin McCarthy: *Saratoga Trunk*. c. 1948. Watercolor, pen and ink on paper. 17″ x 18½″. Weatherly, Pennsylvania. Inspired by the motion picture of the same name. Courtesy Mr. and Mrs. Elias Getz. Photograph: Eeva-Inkeri.

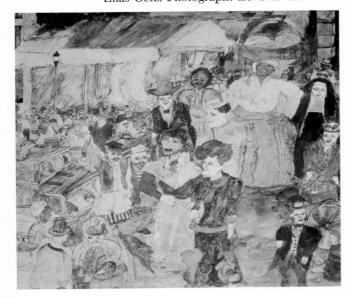

JUSTIN McCARTHY was born in Weatherly, Pennsylvania in 1892, son of a newspaper executive. Until recently, he lived—alone—in the stone mansion on the 17-acre estate where he was brought up. He studied law at the University of Pennsylvania, but failed the bar examination. He began to paint in 1920, thus releasing an urge instilled by a visit to Paris and the Louvre when he was 15. His family lost their money, and he was forced to earn his living in diverse ways, and for the last 20 years has been raising and selling vegetables. He has been quoted as saying: "I paint for money, period, I paint what I can sell. I have no messages." Sterling Strausser, who discovered him, reports that he recently bought himself a house with the proceeds from the sale of his paintings. He is now 81.

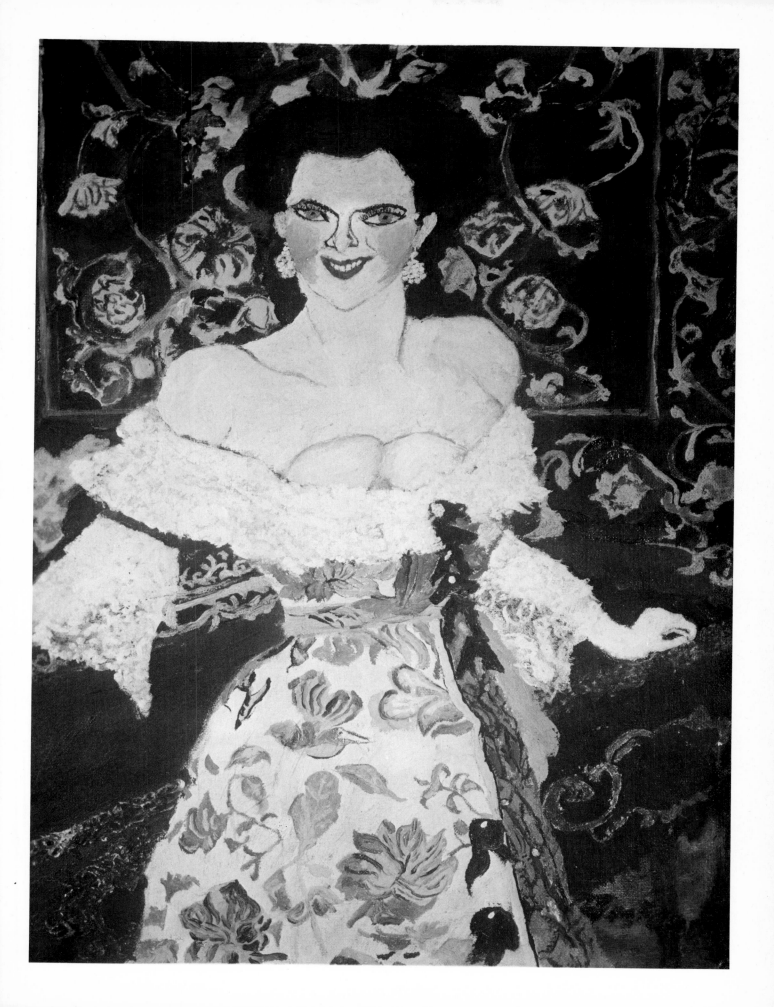

JAMES CASTLE was born September 25, 1900, in Garden Valley, Idaho. He is a deaf-mute. Alfred Frankenstein wrote in *The Oregonian:* "Castle has lived all his life on a remote farm in Idaho. His one and only form of communication is drawing. His sole indication that the world outside has gotten through to him is the subject matter of his pictures, some of which depict the farm; others reflect illustrated religious calendars in his home, and still others, old-style family photograph albums. Castle has been drawing for years, using burnt matchsticks and oddments of paper."

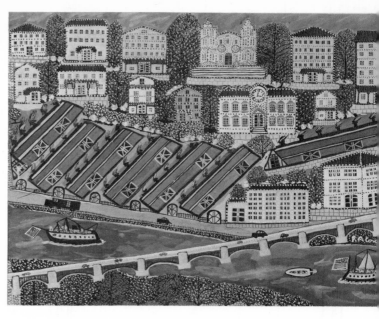

PETER A. CONTIS was born in Greece in 1890, and came to the United States at the age of 19, settling in Pittsburgh, where he was active in the restaurant business until his retirement in 1964. A gift of watercolors and brushes from one of his sons led to his teaching himself to put on paper his thoughts and reflections of extensive travels in Europe and Greece, his reading and study of history, and his active participation in the affairs of his church.

238 (above). Peter A. Contis: *Bridge to Steeltown*. c. 1968. Gouache on paper. 17″ x 23½″. Pittsburgh, Pennsylvania. "I paint because I like to express my feelings about what I see around me." Courtesy Mr. and Mrs. Shalom Comay. Photograph courtesy American Federation of Arts.

239 (opposite, below). James Castle: *Calendar*. 1969. Soot on paper. 9″ x 12″. Garden Valley, Idaho. The artist is a deaf-mute, unable to read or write. Photograph courtesy American Federation of Arts.

240 (above). Frank Jones: *Hookin' Devil House*. c. 1967. Colored pencils on paper. 25″ x 38″. Huntsville, Texas. Frank Jones could neither read nor write. He said of his work, "I draw what I feel." Courtesy Museum of American Folk Art. Photograph: Eeva-Inkeri.

FRANK JONES, born in Clarksville, Texas, in 1901 and died in prison in Huntsville, Texas, February 1969. His part Indian-part Black mother abandoned him when he was an infant. Given to daydreaming, he became something of a town character and the butt of practical jokers. He himself, however, was not a mischief-maker and supported himself, his mistress, and her two troublesome adult sons by working at odd jobs. In 1949, accused, but totally innocent, of involvement in a murder committed by one of his "stepsons," he was sentenced to life imprisonment. His first drawings of "devil houses" were done with discarded red and blue pencil stubs. He used scraps of paper salvaged from the litter collected during his chores as prison-yard porter. His work was shown at a prison art show and won him a prize and the patronage of the Atelier Chapman Kelley of Dallas, Texas, which then supplied him with new pencils and better paper. He gave his houses names such as *Bee Devil Spitting Fire, Fire in the Bush, Jimbo Spider—Philippines, Devil's Cross, Grandpa Devil House, Clipping Wing Devil Vietnam*. Over 90 drawings remain.

241 (right). Anonymous: *Moon Landing Monument*. c. 1970. Marble and mixed media. Sparta, Wisconsin. Photograph courtesy Roger Brown.

242 (above). Joseph Fracarossi: *Steeplechase Park.* c. 1965. Oil on canvas. New York. "You know I am very particular on details and such style requires a lot of time to do & then who will be interested? Oh I know it is the pleasure of painting to keep in mind, I could always give away the paintings as present, but I figure the people really appreciate only when they are willing to part with their money to get it." (Letter to Morris Weisenthal of Morris Gallery, New York.) Courtesy Marshall M. Reisman.

JOSEPH FRACAROSSI came to New York in 1914, and died in Coventry, Rhode Island, 1970. He wrote to Morris Weisenthal, the gallery owner who discovered him in a Washington Square outdoor show: "Here is my biography. I was born on July 2, 1886 in Trieste, made elementary school to the 7 term. In 1914 arrived Brooklyn 3 days after the start of the war. I worked as a baker, then in an accident lost right eye and made embroidery, doing patterns and stamping on women's dresses for 40 years. In my last few years, I visited the Open Art show in Washington Sq. and thought I could do something too, so I started to paint in 1957." Ill health compelled him to leave the city to live with a son. Small-town life was difficult, and although he continued to paint, he wrote, "I feel to be alive in a grave, such a boring life."

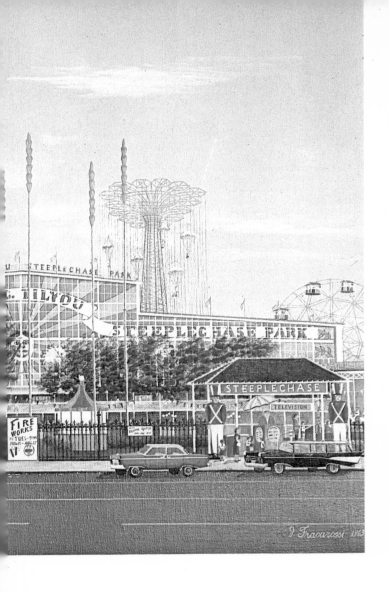

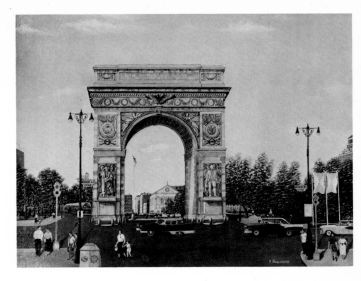

243 (opposite, below). Joseph Fracarossi: *Conservatory Lake*. c. 1965. Oil on canvas. 24″ x 30″. New York. Courtesy Morris Gallery.

244 (above). Joseph Fracarossi: *Washington Square Arch*. c. 1965. Oil on canvas. 18″ x 24″. New York. Courtesy Morris Gallery.

245 (below). Joseph Fracarossi: *Sheridan Square*. c. 1963. Oil on canvas. 20½″ x 40½″. New York. Courtesy Morris Gallery.

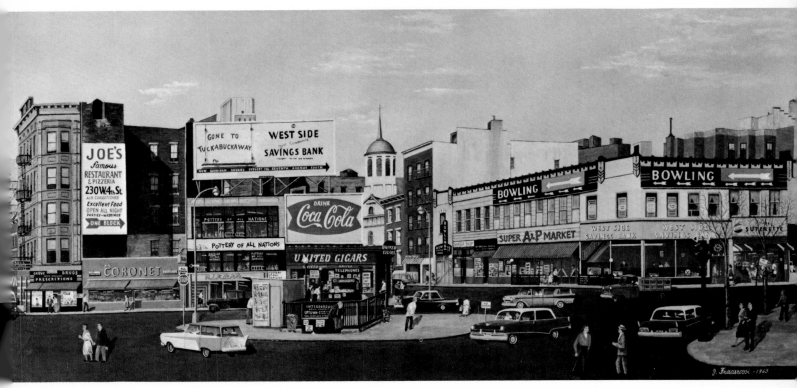

246 (below). Vernell Mitchell: *Rape of Europa.* c. 1971. Oil on canvas board. 20″ x 24″. Jolliet, Illinois. The artist, a prisoner, was 48 years old when he painted this work. Private collection. Photograph: Eeva-Inkeri.

247 (opposite). T. J. Little: *One of My Windmills.* c. 1968. Scrap wood, metal, dolls, and other odd bits and pieces. 5′6″ x 4′. Bellingham, Washington. As the wind blows the propellers, the windmill pivots and the figures move. A man saws a log, two women scrub clothes in a tub, and a woman hits a little boy with a bat. Photograph: J. A. Vitaljic.

T. J. LITTLE, 67, is a retired logger living in Bellingham, Washington. He has spent most of his life in the Northwest. His letter states: "The only occupation I ever knew caused my forced retirement. I was only 48 years old when totally disabled. At the age of 13 years my first job in the logging camp was that of a whistle punk. My Dad being unable to work and having nine children, we all had to help out. Windmills have always held something for me, but I wanted them to do something besides turn. Each small figure moves separately; it was a real challenge to me. Just to see the many people, the children who enjoy seeing them has been worth my efforts." The figures in his large whirligigs are activated by a crankshaft running in oil. Made from scraps, each windmill takes several months to build. Mr. Little has been making them as a hobby for about five years.

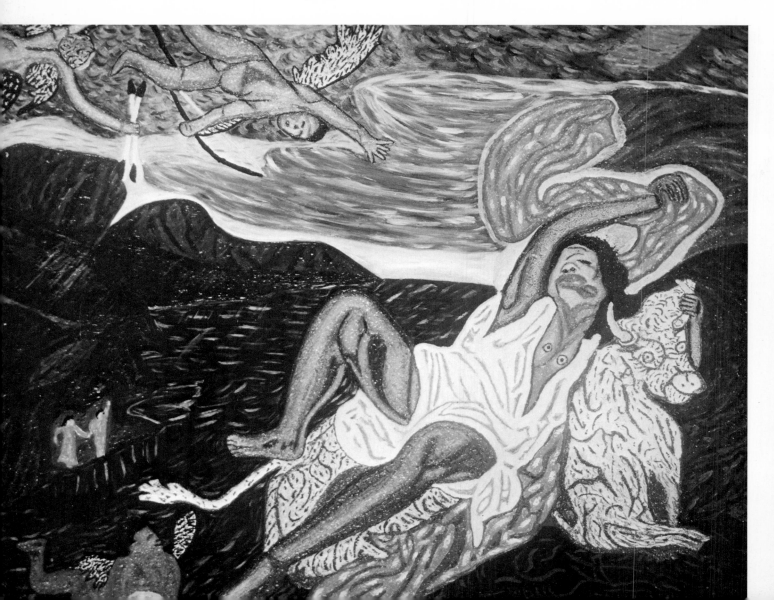

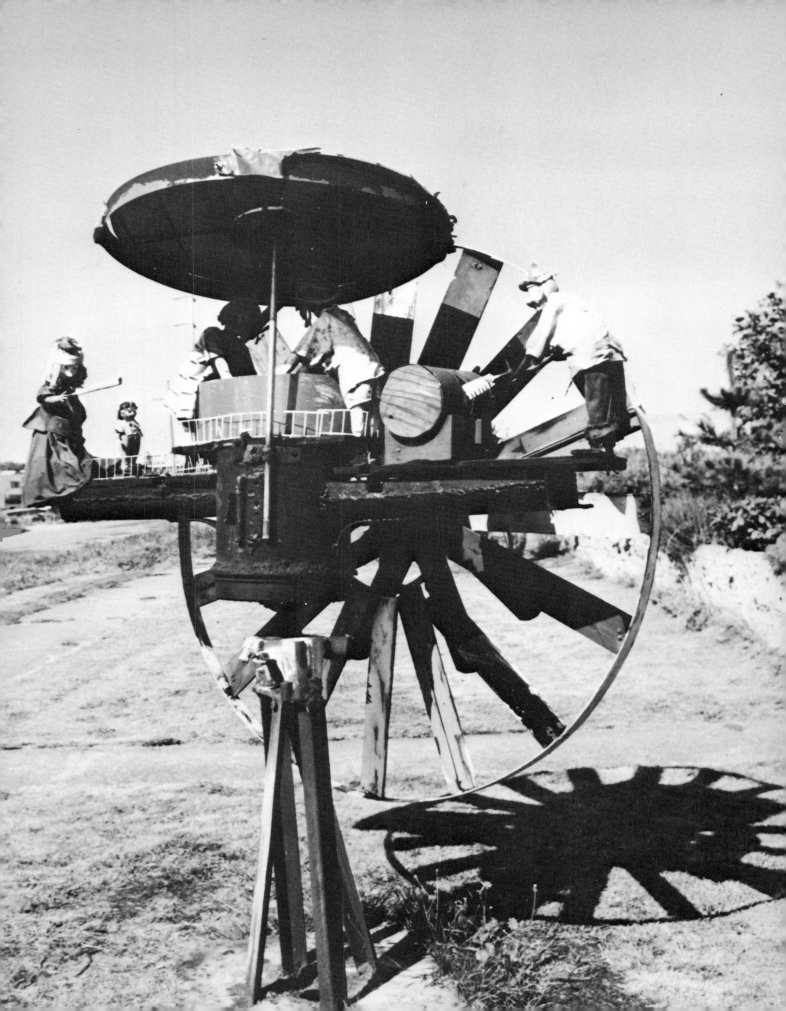

JOSEPH YOAKUM was born around 1886 in Window Rock, Navaho Reservation, Arizona, and died December 25, 1973. In 1901 he ran away to join the Adams Fourta Circus. A year later he was with the Buffalo Bill Circus and went to China. Six years later he went around the world as a stowaway and a hobo. He settled ultimately in Chicago's South Side, and in 1962, now 70, he began to draw, using pencils or ballpoint pens and brown paper from grocery bags. He was impelled to do so, he said, because of a dream in which "the Lord gave me instructions."

JACK SAVITSKY was born in 1910 in Silver Creek, Pennsylvania, and now lives in Lansford. He has been a coal miner for most of his life. "My father got me a job in the mines at $2.00 for a 10-hour day. When I got married—I was 21—I went inside the mines for $5.45 a day. It was hard work; the mines were dark and dangerous. The mines shut down in 1959 when I was over 50; I couldn't get a job. My son said, 'Why don't you start painting again?' I said, 'What the hell. Why not?' I sold my early paintings for a few dollars, now I get a good price. I like to do my oils on masonite, and to work with crayons, pen and ink, charcoal, colored pencils. I never took a lesson. Figured everything—mixing paint, glazing with varnish—myself."

248 (below). Joseph Yoakum: *Sullivan Coal Company*. 1966. Crayon, pen, on paper. 18½" x 24". Chicago. "I paint in anything that will make a color. I don't care for oils, you have to be so particular about them. Pastels, you take a ball of bathroom tissue and polish so it looks like a water color. What I don't get, God didn't intend me to have, and what I get is God's blessing." Courtesy Herbert W. Hemphill, Jr. Photograph: Eeva-Inkeri.

249 (right). Jack Savitsky: *The Miner's Week*. 1968. Oil on board. 12" x 30". Lansford, Pennsylvania. Courtesy Mr. and Mrs. Elias Getz. Photograph: Eeva-Inkeri.

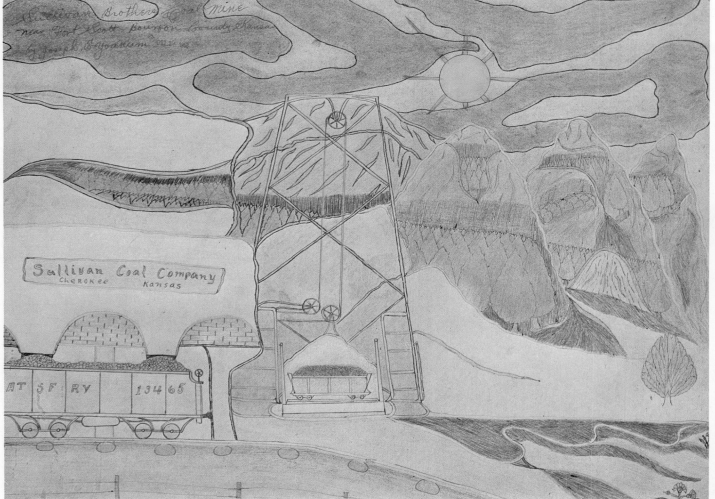

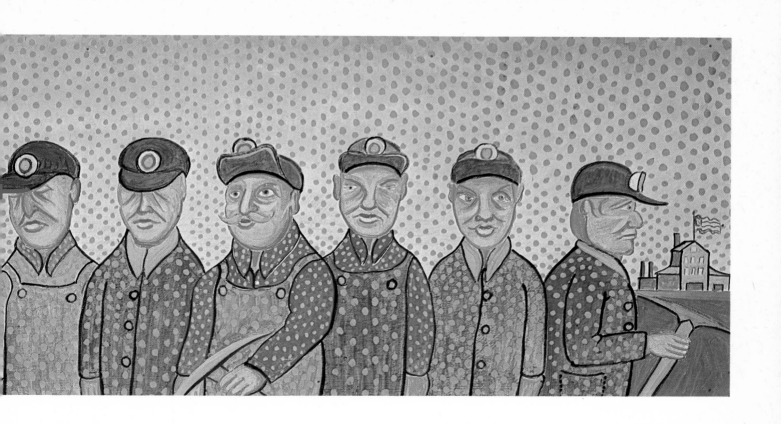

250 (below). Jack Savitsky: *Train in Coal Town*. 1970. Oil on board. 31¼" x 48". Lansford, Pennsylvania. Courtesy Herbert W. Hemphill, Jr. Photograph: Eeva-Inkeri.

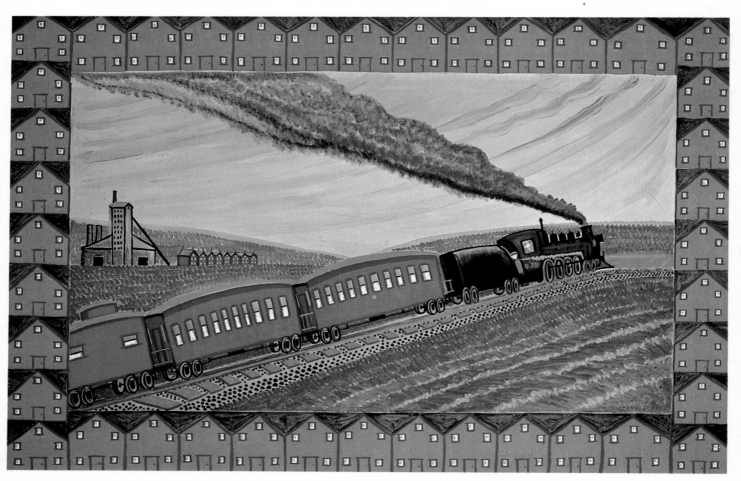

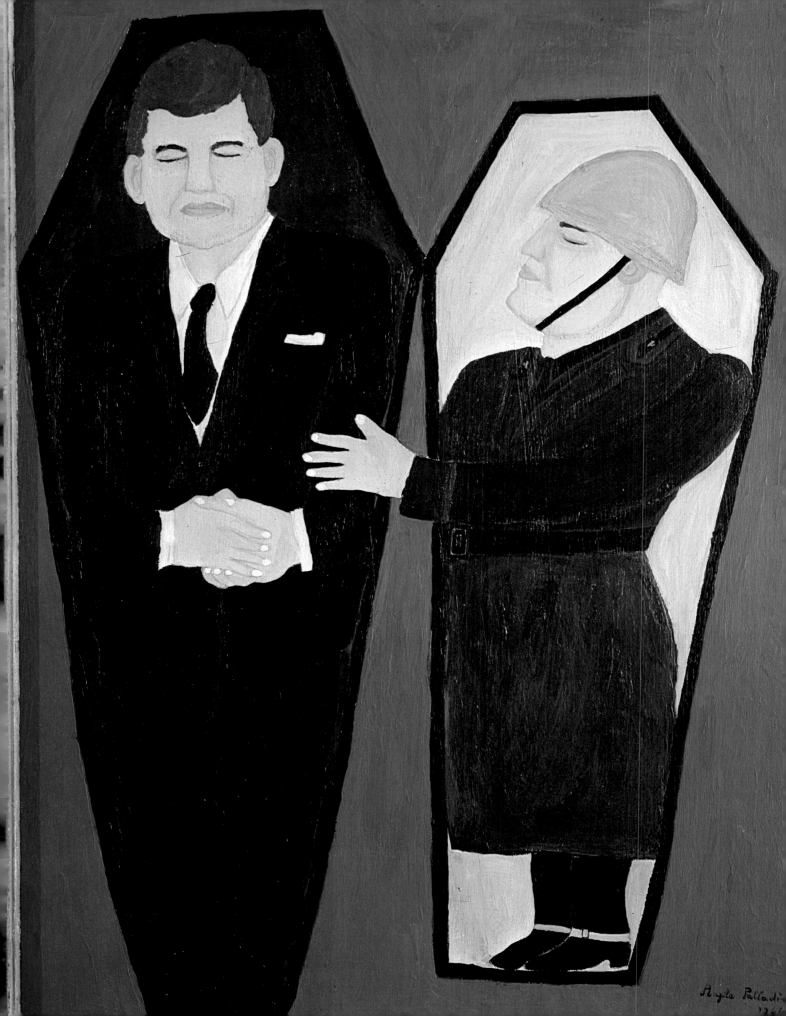

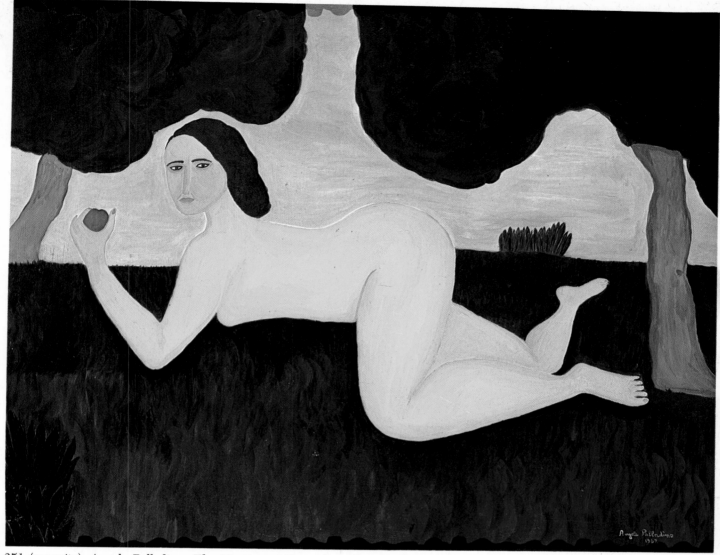

251 (opposite). Angela Palladino: *The Meeting of Kennedy and Mussolini*. c. 1966. Acrylic on wood. 18" x 25". New York. "Some people may think it's a peculiar thing, I paint this picture. But I think it is like they are a little bit the same, and there, after they die, they get together with all the people like them. 'Look,' Mussolini is saying, 'it's terrible what happened to you. I understand. It was the same with me. You try for yourself. I try for myself. Here we can talk about it.'" The artist and her family were in Italy in 1963 Upon hearing of Kennedy's assassination, she insisted they "go home," and they returned immediately to New York. Courtesy the artist. Photograph: Eeva-Inkeri.

252 (above). Angela Palladino: *The Nude in the Grass*. 1967. Acrylic on wood. 31" x 25". New York. "I like her. She has such dignity and she is strong." Courtesy the artist. Photograph: Eeva-Inkeri.

ANGELA PALLADINO was born in Trapani, Sicily, in 1929, and was educated there and in Rome, where she studied the classics. Her father, though Italian by birth, had been brought up in the United States. He went to Italy on a visit, and married there, but political circumstances prevented his return. He described his life in America so vividly, says the artist, that as far back as she can remember, she wanted to come to the United States, to see the buildings and particularly to see Tom Mix, the cowboy movie hero. She emigrated in 1959 and married an American, Tony Palladino. "After my children were born," she said, "I say to myself, it's great, it's beautiful. I love my children and they are what I wanted. But I want to do something just for myself, just by myself." During a brief illness, she began idly sketching, and at her husband's urging, began to paint. She speaks with much amusement of her lack of artistic ability as a child and how she irritated the art teacher with her ineptness. Recently, she has become interested in ceramics as well, and says she tends to divert the instructor because of her unorthodox tactics with the materials. She says she prefers to discover for herself, rather than be told, the potentials of her media.

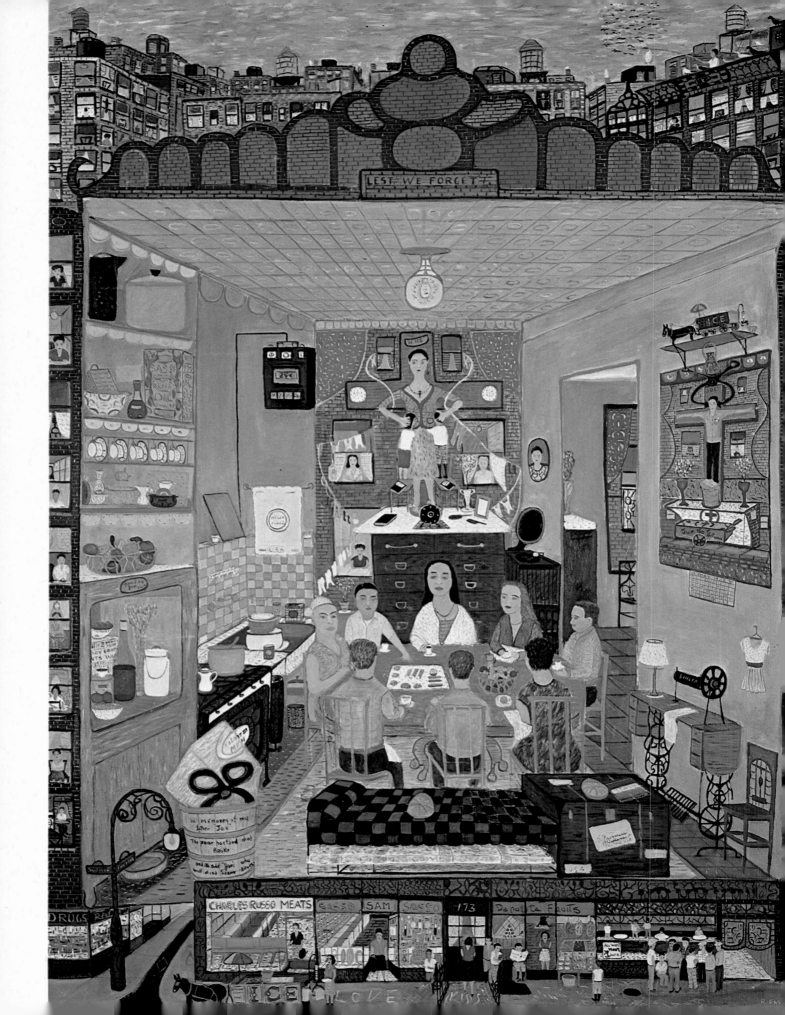

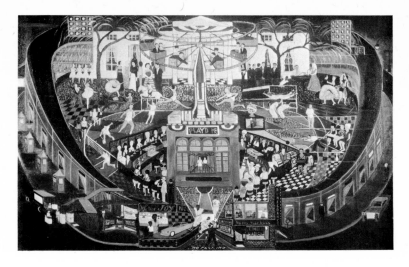

253 (opposite). Ralph Fasanella: *Family Supper*. 1972. Oil on canvas. 70″ x 50″. Ardsley, New York. "I wanted to show something that doesn't happen anymore. It's how we lived. It's like it was the last time the family was together. Not just my family, other working-class Italian families." The artist has also referred to this work as *The Last Supper*. Courtesy Jay K. Hoffman Associates, New York, the artist's representative. Photograph: Eeva-Inkeri.

254 (above). Ralph Fasanella: *Sports Panorama*. 1958. Oil on canvas. 35″ x 54″. Ardsley, New York. Courtesy Jay K. Hoffman Associates, New York, the artist's representative. Photograph: Eeva-Inkeri.

255 (below). Ralph Fasanella: *Reform School*. 1961. Oil on canvas. 30″ x 40″. Ardsley, New York. "It was a 'protectory' for Catholic boys. My folks sent me there for running away after a beating. I wasn't a mean or bad kid. Active. They didn't understand a kid would want to play instead of help his father haul ice. I hated that place and was always doing penance during games, like those kids against the wall." Courtesy Jay K. Hoffman Associates, New York, the artist's representative. Photograph: Eeva-Inkeri.

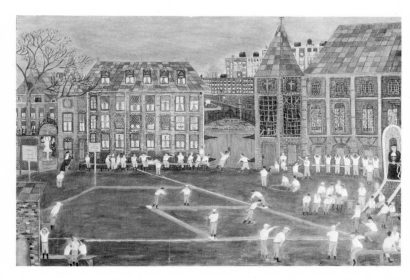

RALPH FASANELLA, son of Italian immigrant parents, was born in September 1914, in New York City's Greenwich Village. Rebellion against having to help his father haul ice led to three different terms in a Catholic reform school. As a young man, he joined the Workers' Alliance, became a union organizer, fought in the Spanish Civil War, and went into politics as a supporter of Vito Marcantonio, the American Labor Party leader. At present he runs a garage and lives in a Westchester suburb. He began painting over 25 years ago. "There's no place like New York, and I wanted to get it all, hug it all, everything. I make a portrait of every window. Every face is a person I know. I painted in memory my mother, my old man, working-class Italian families, Marcantonio, injustice: Italians, Jews, Blacks, Puerto Ricans. I wanted the cars, the movement, the streets that pour people into sweatshops, the McCarthy era—the Rosenbergs . . . I wanted to show that the city goes on anyway." (Excerpted from *New York Magazine*, October 30, 1972.)

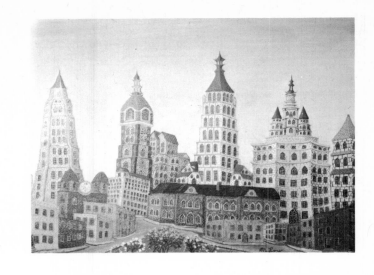

257 (right). Max Low: *Lower Manhattan*. 1944. Oil on canvas. 18″ x 24″. New York. Courtesy the Low family. Photograph: Howard Legge.

256 (below). Max Low (1899–1974): *Four Generations of the Low Family*. c. 1965. Jamaican mahogany. H. approximately 8′. New York. Courtesy the Low family. Photograph: Howard Legge.

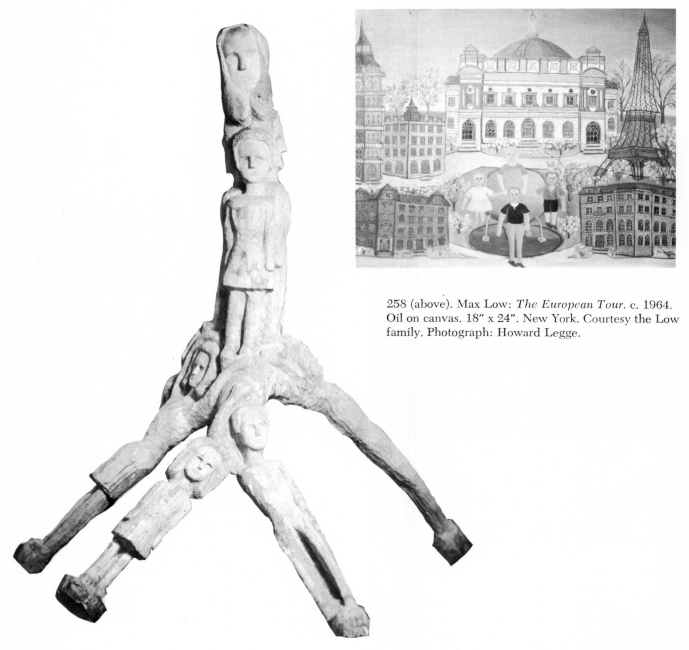

258 (above). Max Low: *The European Tour*. c. 1964. Oil on canvas. 18″ x 24″. New York. Courtesy the Low family. Photograph: Howard Legge.

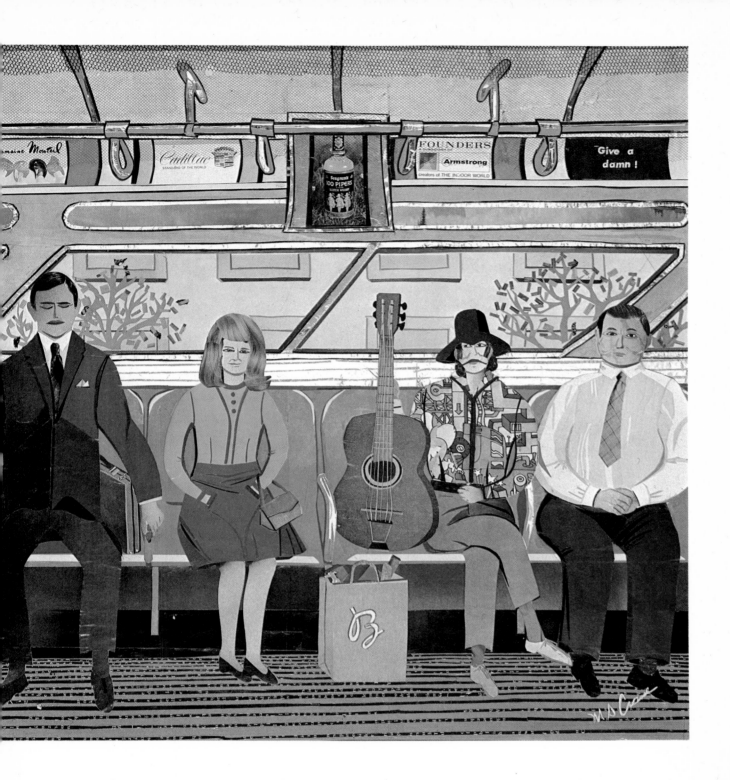

259 (above). Margaret Smyser Crane: *72nd Street Crosstown Bus.* 1969. Paper collage. 19¼″ x 19¼″. New York. "From the start I determined to use paper for every detail, tulle for shadows, and cut my signature out of paper. The bus starter looked at it and said, 'Mmm, it has the feeling.' Ample reward for all my pleasure in making it." Courtesy Mrs. Lois Wright. Photograph: Eeva-Inkeri.

MARGARET SMYSER CRANE lives in New York and is retired. Asked for a statement, she wrote: "Cut and paste? Not after teaching and directing a school for young children for 30 years! But I had seen a collage in a store window. I bought it. One night at Philharmonic Hall, looking down I thought—there, that would make a wonderful collage! The next day I went searching for masonite, leafed through some *New Yorker* magazines, found plenty of colored ads from which to cut pieces. On my first collage I spent an average of an hour a day from September to the next spring. I stick to my rule never to touch pen, pencil or paint to it."

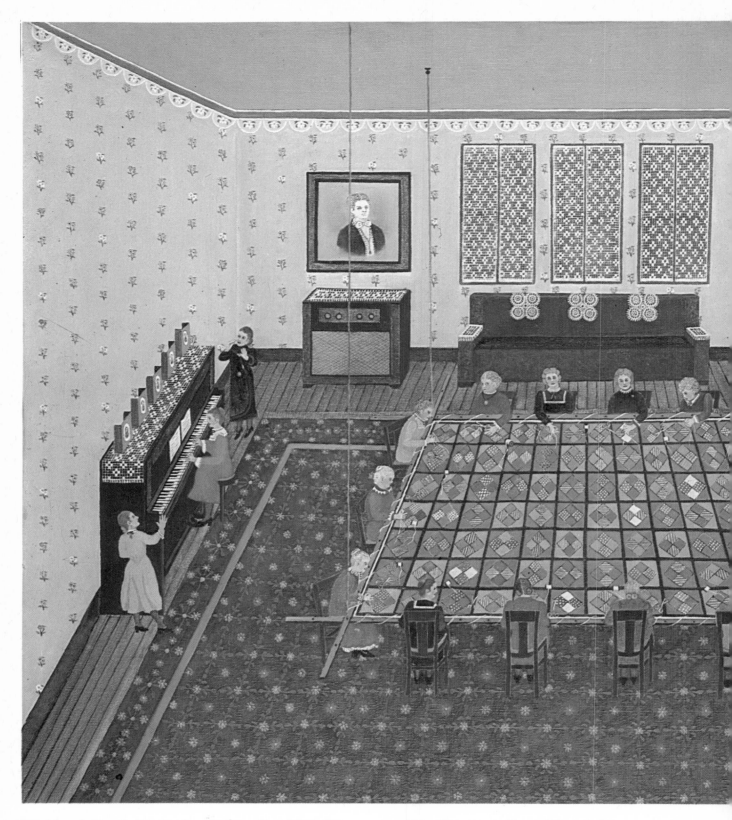

260 (above). Fannie Lou Spelce: *Quilting Bee*. 1968. Oil on canvas. 28″ x 38″. Austin, Texas. The artist's memory of her mother and friends in the living room of their home. Courtesy Fannie Lou Spelce Associates.

261 (opposite). Fannie Lou Spelce: *Telephone Company of the Ozarks*. 1970. Oil on canvas. 16″ x 20″. Austin, Texas. The artist's recollection of her father running the switchboard in the living room of their home, as a sideline to farming. Courtesy Kennedy Galleries, Inc. Photograph: Eeva-Inkeri.

FANNIE LOU SPELCE was born on June 19, 1908, in Dyer, Arkansas, a small town in the foothills of the Ozark Mountains. She left there at the age of 18 to go to nurses' training school in Fort Smith, Arkansas. Except for time out to marry and have two sons, she worked almost daily for 40 years as a registered nurse. The last 11 years of her nursing career were spent as the resident school nurse at St. Stephen's Episcopal School near Austin, Texas. This gave her totally free summers, and in 1966 she signed up for an art course at Laguna Gloria Art Museum in Austin. Her first assignment was a still life, and it was not a very successful one. But her next effort was an oil painting of the still life, which she did at home from memory. Her instructor, Owen Cappleman, instantly advised her to drop out of the class and never take art lessons; but he also said she was to continue to paint, and to paint what she wanted as she wanted. Since then she has been painting "delightful memories that I am eager to share with others."

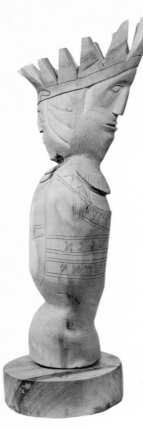

262 (left). Frank Mazur: *Queen Esther and King Ahasuerus.* 1973. Wood. Approximately 36″. Brooklyn, New York. "The Scroll of Esther in the Hebrew Bible tells the story of Purim. Haman, the King's wicked minister, persuaded Ahasuerus to destroy all the Jews. Esther pleaded and saved her people." Courtesy the artist. Photograph: Helga Photo Studio.

263 (below). Frank Mazur: *The Wailing Wall.* 1972. Unglazed terra-cotta. Approximately 12″ x 20″. Brooklyn, New York. Courtesy the artist. Photograph Eeva-Inkeri.

264 (opposite, left). Frank Mazur: *The Graduate.* 1971. Unfinished wood and black paint. H. 25½″. Brooklyn, New York. "My brother, who is no longer with us. For the outside world it is another piece of art. To me, this has a personal and special meaning." Courtesy the artist. Photograph: Helga Photo Studio.

265 (opposite, right). Frank Mazur: *The Messenger—Let My People Go.* 1972. Unfinished wood. H. 47½″; base, 11½″ x 4″. Brooklyn, New York. ". . . the young woman has a message on her chest—*Shelach et ahmee— Let my people go.* She is telling, to whom it may pertain, let my people go join their relatives, and continue their traditions, customs, and heritage as a free people. At the bottom, Shelach means *The Messenger.*" Courtesy the artist. Photograph: Helga Photo Studio.

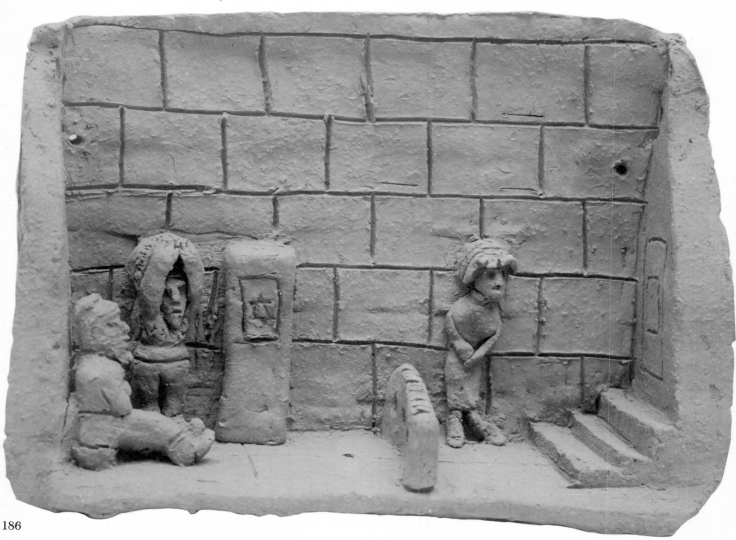

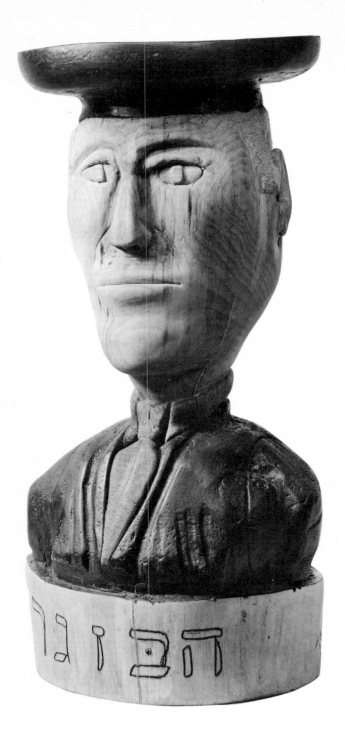

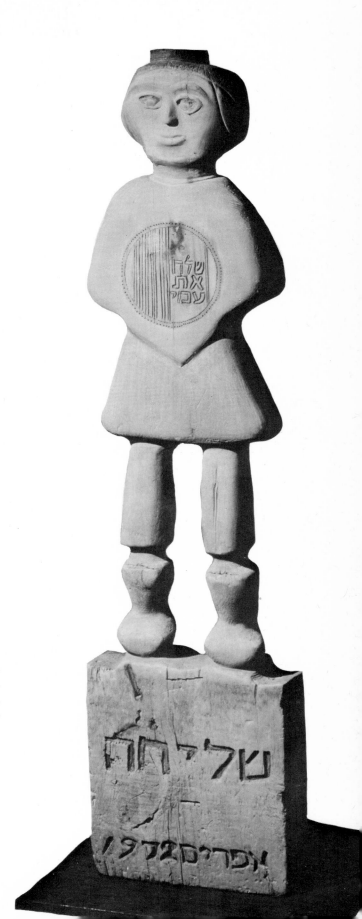

FRANK MAZUR was born in Lozowa, a village in Gubernia, which is a section of the Ukraine, on December 30, 1910. He emigrated to the United States in 1921, and is at present a taxi driver in Brooklyn. He writes: "I started painting and drawing at The Brooklyn Museum Art School in 1967. In the Spring of 1970, I registered in a sculpture class under the direction of Mr. Toshio Odate. As to what made me interested in the fine arts is a mystery, it is unexplainable, because I do not know myself. It is like a book that is a thousand years old—I don't know if it is new or old—to me it is new." Mr. Odate lets Mr. Mazur solve his problems without instruction.

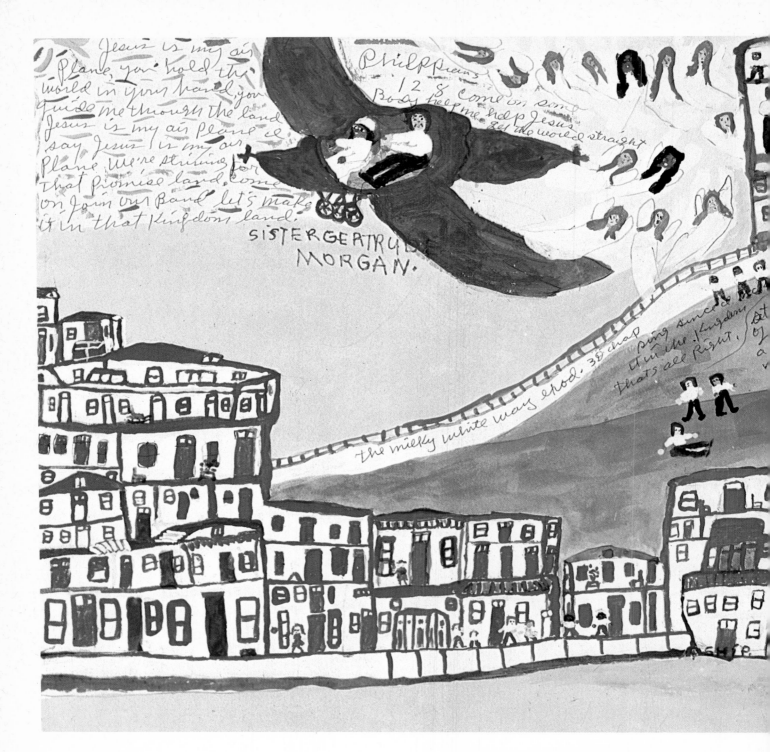

266 (above). Sister Gertrude Morgan: *Jesus Is My Air Plane*.
c. 1970. Ink and watercolor on paper. 18" x 26⅜". New
Orleans, Louisiana. Courtesy Herbert W. Hemphill, Jr.
Photograph: Eeva-Inkeri.

267 (right). Sister Gertrude Morgan: *Double Self-Portrait*.
c. 1969. Acrylic on paper. New Orleans, Louisiana. Private
collection. Photograph: Helga Photo Studio.

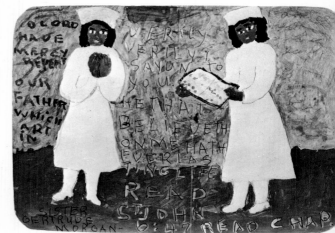

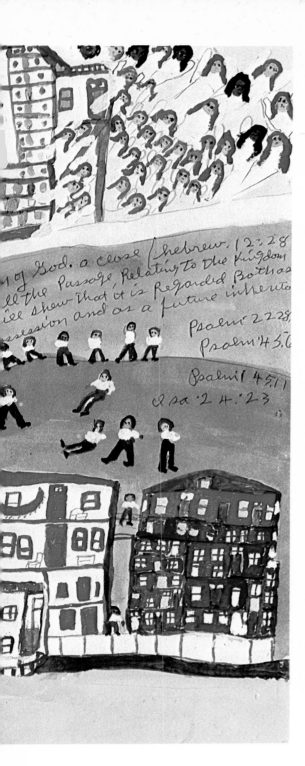

SISTER GERTRUDE MORGAN (figure 268, above), formerly a street preacher and gospel singer, was born around 1900 and lives in New Orleans. Ever since she became "the bride of the Father and the Christ," she has worn only white. Several years ago "the Lord commanded" her to give up street preaching and music, and to speak the Gospel in a different manner. When the written word alone seemed inadequate, she began to illustrate her perorations, using paper and crayons, dime store paints, tempera—whatever was handiest. If asked, she will "rebuke the devil" with exorcist shouts, prayers, and stamping to help a sick person.

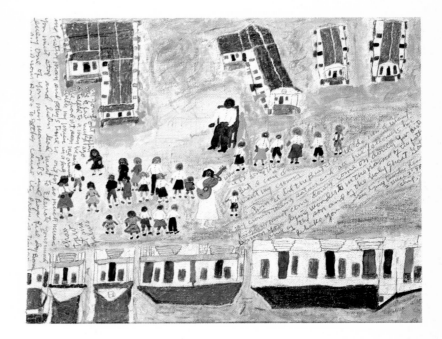

269 (above). Sister Gertrude Morgan: *I've Done the Best I Can.* c. 1969. Watercolor on paper. New Orleans, Louisiana. Courtesy E. Lorenz Borenstein Gallery. Photograph: Paulus Leeser.

270 (left). Hot dog cart on Maxwell Street, Chicago.

271 (above). Wall in Nebraska.

273 (right). Live reptiles.

272 (left). Producers Creamery.

275 (above). License Plate Barn, property of Millard Wagner, Belle Fouche, South Dakota.

276 (below). Musical Barber Pole Machine. Metal reflectors, lights, photographs, and record player. Chicago.

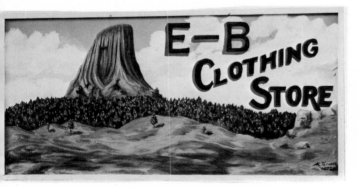

274 (above). E–B Clothing Store.

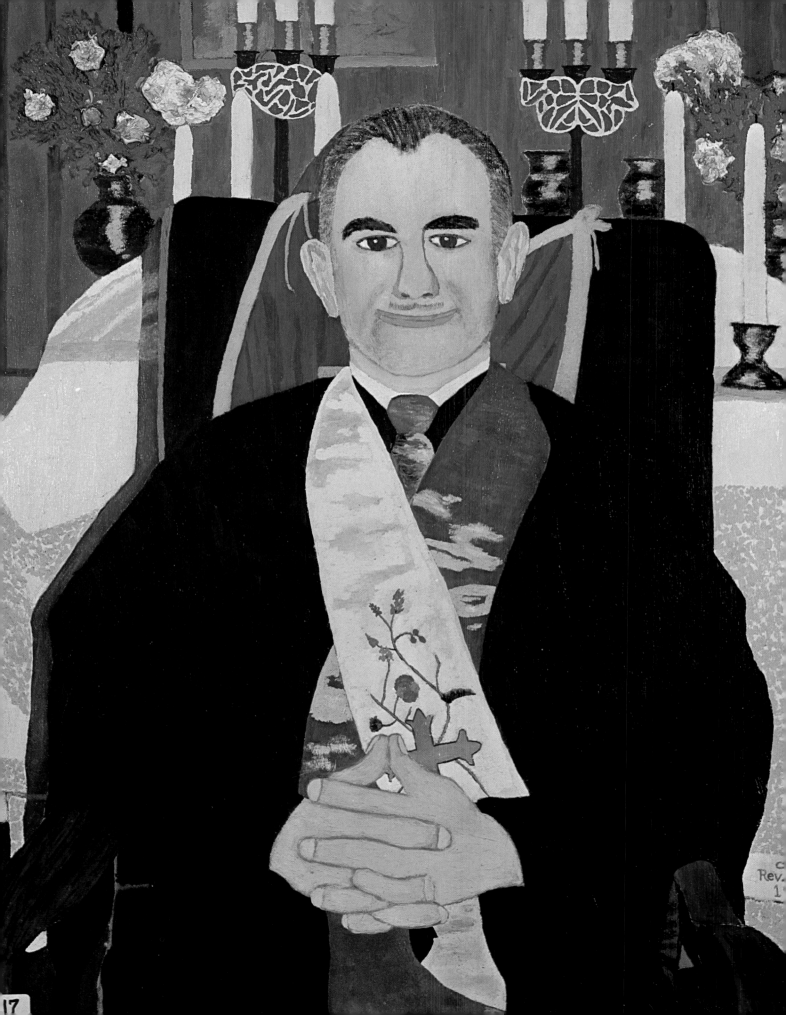

277 (opposite). The Reverend Maceptaw Bogun: *Self-Portrait*. 1972. Oil on canvas. 30″ x 24″. New York. "Being an ordained minister of Spiritualism, I decided to try oil painting but only when the green light was given me by the Almighty. After all, what is faith without works?" Courtesy the artist. Photograph: Eeva-Inkeri.

278 (above). The Reverend Maceptaw Bogun: *Sail On, Old Ironsides*. 1970. Oil on canvas. 24″ x 30″. New York. "The islands represent the few territories the U.S.A. owns, the large clouds, war and peace, peace is trying to emerge. If the spirits of faithful seamen were called to battle today in defense of the nation's freedom or integrity, I do not think they would hesitate and use the 'bark'—Old Ironsides!, portrayed as a spirit or ghost ship sailing on small white clouds." (Artist's description.) The artist asked that his work be referred to as spiritual art. Courtesy the artist. Photograph: Eeva-Inkeri.

THE REVEREND MACEPTAW BOGUN was born in 1917 in New York City. His parents were Polish immigrants. In addition to being a minister and trustee of the St. Andrews Spiritual Church, he is a tape librarian for the New York City Transit Authority. He writes: "It was at the age of fifty when viewing an art exhibit given by the Transit Authority Art Association that I received the urge to paint. To become another Rembrandt or da Vinci was out of the question, there was no painting experience in my background. After meditating on the idea of painting for weeks on end, I finally received impressions to buy tubes of oil paints,

brushes, canvas, etc.—the 'go' signal from the Creator or one of his able Spirits. As I started my first canvas, I felt that if the 'Big Boss' is with me, I might as well go ahead. I know now some angel must have been guiding my hands, putting the ideas of what to do next into the empty canvas of my mind. To the many entities or angels who are on the other side of life, who have heard my mental meditations and prayers, I say 'Thanks—thanks a lot for helping me to create "our" art.' In my humble opinion, I believe that our Creator has put into all of us a part of Himself with which to create."

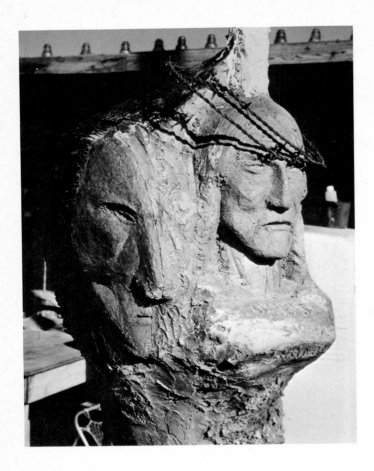

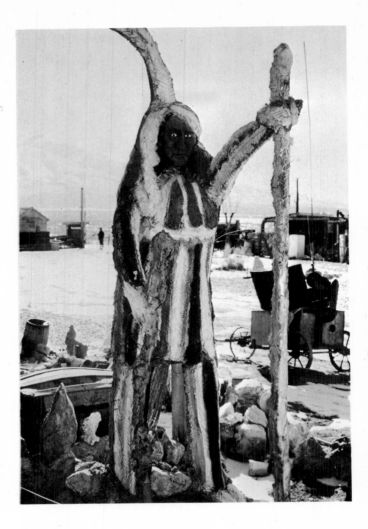

279 (above), 280 (right). Chief Rolling Mountain Thunder: *My Ranch.* c. 1969. Cement, found materials, paint. Imlay, Nevada. Photographs courtesy Chris Sublett.

CHIEF ROLLING MOUNTAIN THUNDER writes: "I was born in the old Creek capitol, Okmulgee, 11/11/11. Lived mostly in remote mountain areas, alone." He says at 19 he was driving a yellow cab, was a tree trimmer, fruit picker, gold miner, mail stage and armored car driver, construction workman, ball-mill operator, soldier, service station attendant, youth worker and organizer; Methodist pastor, federal employee, county assessor, deputy sheriff, police officer, housebuilder, wood sculptor, private investigator, museum "establisher." "Most of these jobs were two and three at a time, to finance working people in need. From the age of 40 on, full time 18 hours a day sculpturing spirits of the living.

"My tribe name is now Chief Thunder Eagle. However, I have been, and still am to some, Thunder Spirit, Rolling Thunder in the Mountain, Frank Thunder. I do not correct any visitor or friend if he wishes to call me a certain name. I never ask anyone's name or past.

"I started this ranch in May 1968. It was my wish to present figures of wise Indian leaders and their words. I early took umbrage at the way the West's Indian Nations were put down. Having spent many years where evi-

dence of the ancient ones and their civilization was comparatively unmolested, I grew to know they had the finest civilization and were industrious workmen and accomplished artists.

"Peoples who always asked the Power always respected the Power—God. We are here because we follow the Great Spirit trail. He directed us here and said "build." In unsought vision to me, he said 'You are the Big Eagle and the Eagle shall return to His nest.' The Eagle, according to ancient wisdom, is to scream a warning when danger approaches and meet that danger. We are doing that with our sculpture and buildings. We know he wanted us to build this place; he places everything we need where we are. We just have to recognize and use it.

"We do not accept welfare, or drugs, liquid, or otherwise, unless prescribed. We do not refuse anyone in need. We do not ask any guest to work nor the help of any other nation or individual without payment. We do require that everyone here obey the laws of the ancients, which are essentially consideration, total respect for old ones, total love for young ones. Our statues are to bring these ancient messages to all peoples."

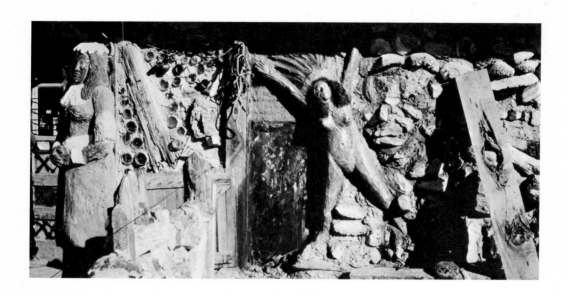

281 (above), 282 (below). Chief Rolling Mountain Thunder: *The Monument.* Concrete, wood, paint, found materials. Imlay, Nevada. "Started doing this type art work during the fifties. Started this ranch in May 1968 as a monument to the West's earliest peoples and to all Indian leaders. I was brought to this place as a result of visions. We know He wanted us to build this place. It is all sculptured. Buildings, roads, everything, from contemporary discards. Junk." The property is approximately two acres in area. Photographs courtesy Chris Sublett.

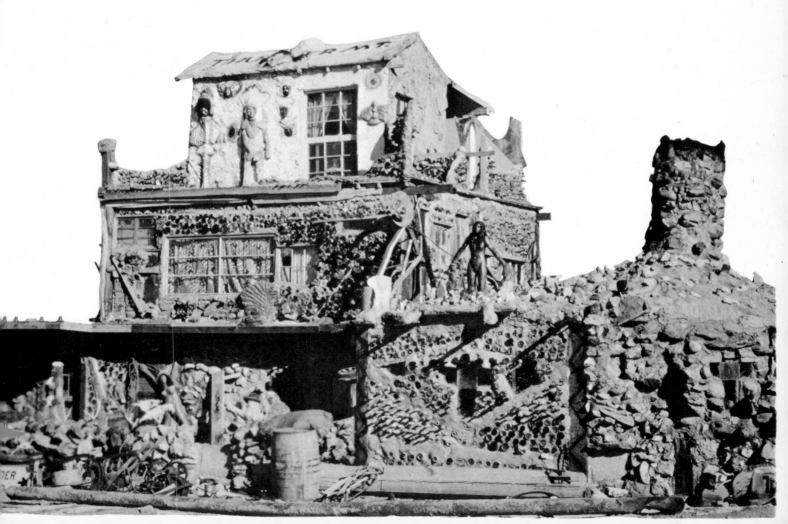

VESTIE DAVIS was born in Baltimore, Maryland, in 1904 and came to New York City in 1928. He has been a circus barker, undertaker, and newsstand manager, but since 1947 has considered himself to be only an artist. "I am an artist. Everything else in my life is past, and it's over. I paint what people want and they want what's familiar to them. I painted Nathan's hot-dog stand with three hundred people, all of them eating or drinking. The more people I put in, the faster they sold." Davis photographs scenes he wants to paint, pastes them together to create a panorama, and presketches his ideas.

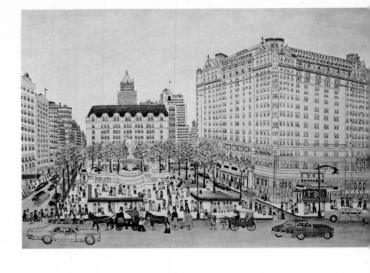

284 (below). Vestie Davis: *The Cyclone.* 1970. Oil on canvas. 24″ x 30″. Brooklyn, New York. "You learn from experience. Art school is only one thing—criticism. They can't paint for you. I've seen art schools from a distance, but I won't go in. I bat it out right here." Courtesy Joan and Darwin Bahm. Photograph: Paulus Leeser.

283 (above). Vestie Davis: *The Plaza.* 1970. Oil on canvas. 24″ x 36″. Brooklyn, New York. "One day in 1947 I was walking on 57th Street and came to a big gallery. I looked in, saw some pictures I liked, said to myself, 'I can paint like that.' So I walked into an artists' material store . . ." Courtesy Joan and Darwin Bahm.

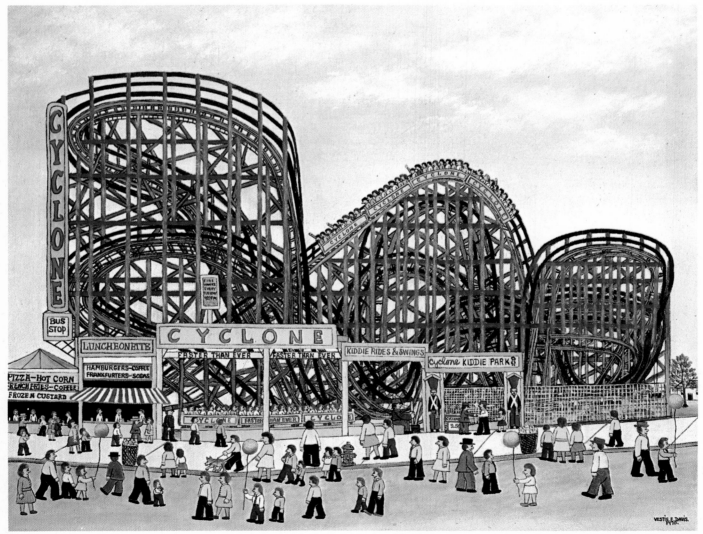

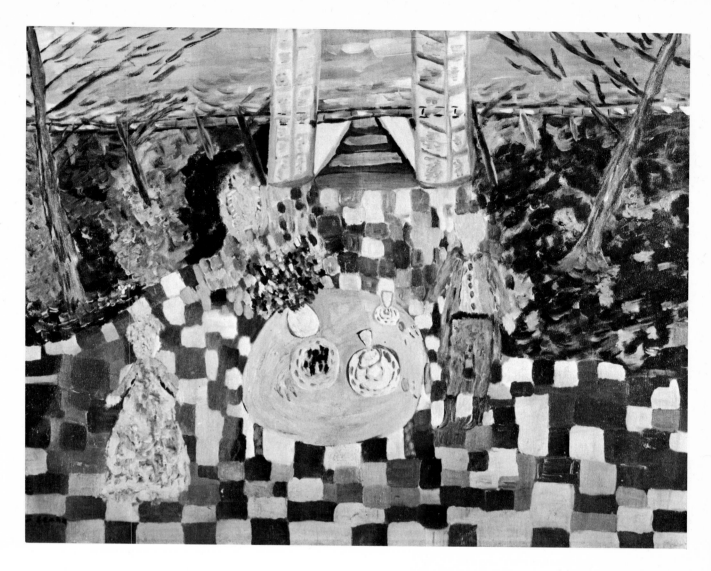

JEFFREY STARK is a 30-year-old salesman who lives in New York City. His wife writes: "He began painting six years ago because it seemed right that he paint and express how he feels through painting."

285 (above). Jeffrey Stark: *Luncheon Party*. 1971. Oil on canvas. 30″ x 40″. New York. Courtesy the artist.

JESSIE DUBOSE RHOADS was born April 21, 1900, on a farm near Elba, Alabama, in Coffee County. She died on November 3, 1972 in Columbus, Georgia. On February 2, 1972, she wrote: "Was reared and grew up on a farm. I became very ill [in 1961]. Trying to recuperate, I took up painting seriously and found it a wonderful therapy and a deeply satisfying way to fill my time. I painted in my primitive way, without training, but experimented. What a joy it has been! How pleased I am when people identify themselves with my paintings."

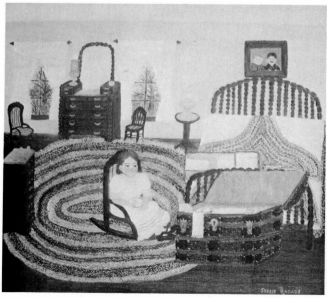

266 (right). Jessie Dubose Rhoads: *The Hope Chest*. 1970. Oil on canvas. 22″ x 24″. Phenix City, Alabama. "I loved things that were simple, real and lifelike. Each painting is born from memories of my growing up on an Alabama farm and in a small town and simple everyday happenings." Private collection. Photograph: Eeva-Inkeri.

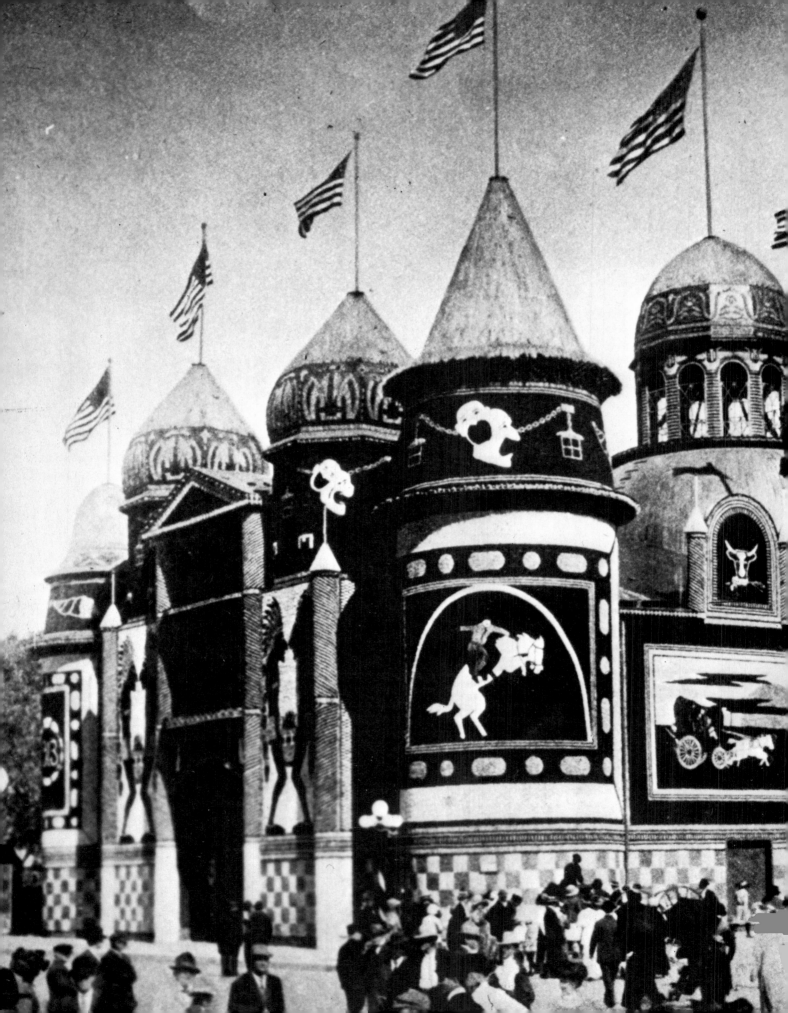

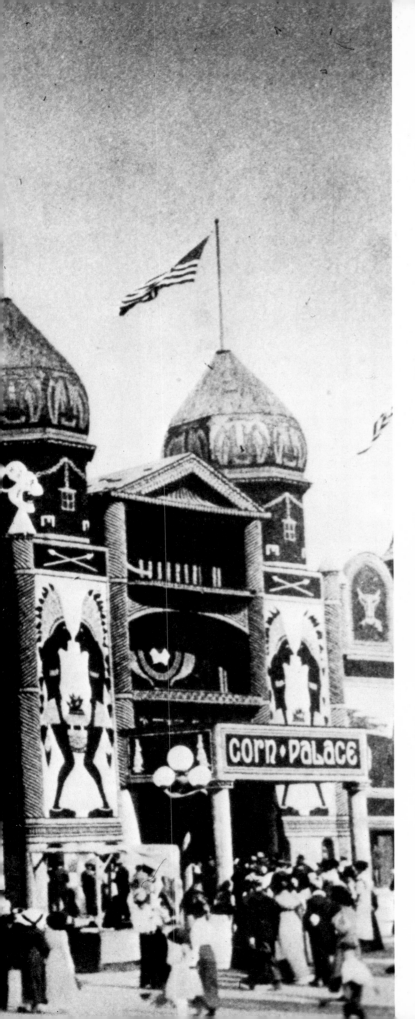

The original Corn Palace in Mitchell, South Dakota, was built in 1892 to house a harvest festival of produce and entertainment. In 1919 the third and present building was erected on the site. Except for short periods of construction, drought, and war the building has yearly been redecorated by local artists with the cereal wealth of the state—naturally colored red, purple, yellow, white, and calico corn, together with other grains and native grasses.

287 (left). The Corn Palace in 1913.

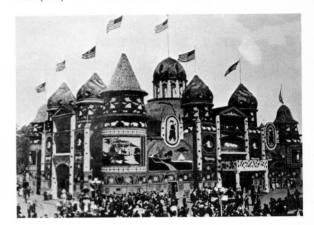

288 (above). The Corn Palace in 1914.

289 (above). The Corn Palace in 1929.

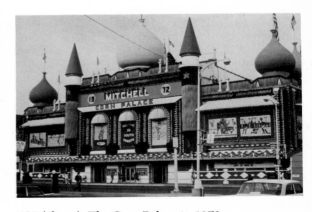

290 (above). The Corn Palace in 1972.

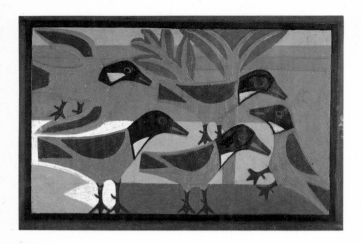

291 (above). Eddie Arning: *The Birds*. 1970. Crayon on paper. 22″ x 32″. Austin, Texas. Private collection. Photograph: Eeva-Inkeri.

292 (below). Eddie Arning: *Man on a Bench*. c. 1970. Crayon on paper. 22″ x 32″. Austin, Texas. Private collection. Photograph: Helga Photo Studio.

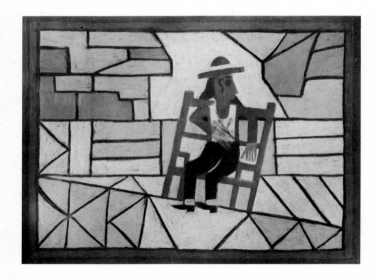

294 (above). Eddie Arning: *Airplane*. c. 1965. Crayon on paper. 22″ x 32″. Austin, Texas. Courtesy Herbert W. Hemphill, Jr. Photograph: Eeva-Inkeri.

293 (right). Eddie Arning: *The Breakfast*. 1970. Crayon on paper. 22″ x 32″. Austin, Texas. Private collection. Photograph: Eeva-Inkeri.

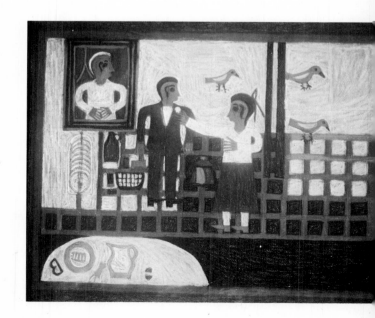

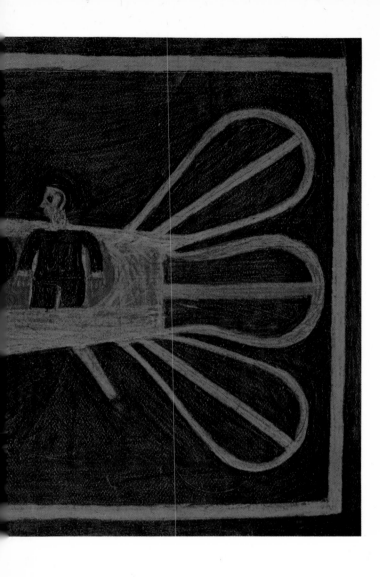

EDDIE ARNING (figure 295, right) was born in 1898 near Kenney, Texas, in Austin County. His parents were German immigrants. He began drawing in 1965, at the age of 67, after his release from the mental hospital where he had been a patient for many years. He started out with wax crayons, and his first drawings were memories of his childhood on the farm. He regarded these as faithful to reality. More lately, he has been using crayons made of oil and wax (such as Craypas) and getting his inspiration from pictures and advertisements. Consciously, all he wants is to make a "nice picture," and he is interested only in subject, not composition. However, he must choose the subject himself, and will politely but definitely reject suggestions or pictorial offerings from others.

296 (left), 297 (above), 298 (below). "Driftwood Charlie" Kasling (b. 1901): *Charlie's World of Lost Art*. From his sculpture garden of 98 figures near Yuma, Arizona. "I make 'em outa dirt, I carve 'em out. What comes out, that's it. I work at random. I never do Americans—all these are Orientals, Buddhists, Columbians, Peruvians, Chiefs, Indians. My tools are a spoon for cement, a kitchen knife for the pumice, files for the harder stones. That's how I do everything—outa my head." (Statement to Jacqueline Airamée, Mariposa, California.) Photographs courtesy Peter Odens.

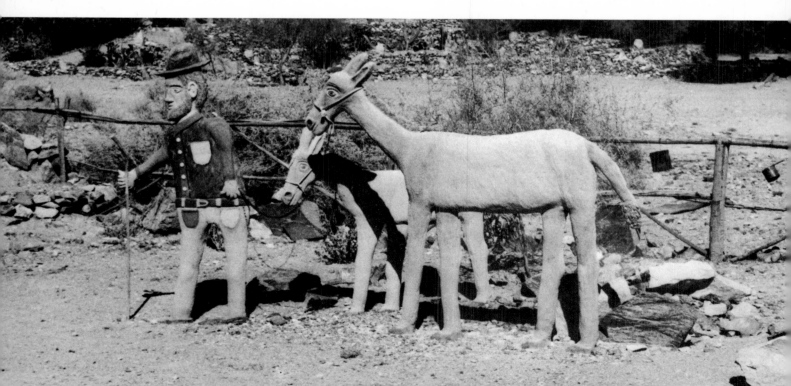

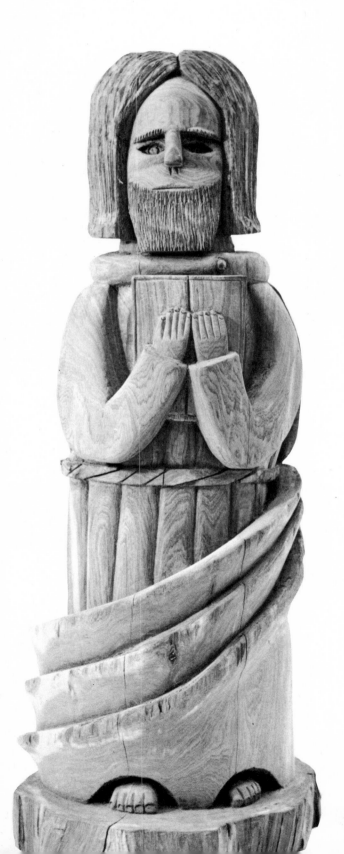

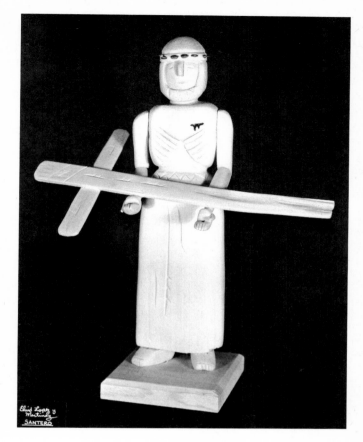

300 (above). Eluid Lopez y Martinez: *Cristo y la Cruz.*
c. 1968. Unpainted cottonwood. H. 12″. Cordova, New
Mexico. Courtesy Taylor Museum, Colorado Springs Fine
Arts Center.

299 (left). Leon Salazar: *Moses.* 1972. Cedar. H. 26″. Taos,
New Mexico. Courtesy Mr. and Mrs. Milo M. Naeve.

LEON SALAZAR was born on May 20, 1933, in Taos, New
Mexico. He went to high school there, joined the Marine
Corps in 1950, and afterward in 1960, went to Ari-
zona for five years, then returned to Taos, where he now
lives and works as a heavy equipment operator and fore-
man for a construction company. He began to carve in
1966, about two years after the death of his uncle, the
noted and untutored Taos woodcarver, Patrocinio Barela
(see page 126), who to some degree both inspired and
influenced him. He carves primarily in the winter months,
during the construction layoff period, and uses only three
hand tools—two chisels and a mallet. He looks for dry
wood from dead trees or fallen limbs, and develops his
figures from the natural form of the wood. He is quoted:
"When I see a tree or branch . . . I see it. The statue is
there." He envisions the complete piece before starting.

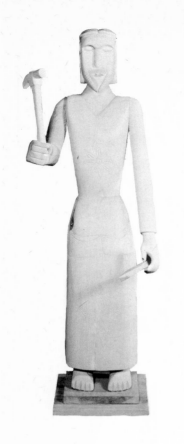

301 (left). José Mondragon: *San José.* 1963. Cottonwood. H. 44″. Cordova, New Mexico. Courtesy Taylor Museum, Colorado Springs Fine Arts Center.

304 (opposite). José Dolores Lopez: *Nuestra Señora de la Luz.* 1936. Cottonwood. H. 40″. Cordova, New Mexico. Courtesy Taylor Museum, Colorado Springs Fine Arts Center.

303 (below). José Dolores Lopez: *Adam and Eve and the Tree of Life.* 1936. Pine and cottonwood. H. of tree 27″. Cordova, New Mexico. Courtesy Taylor Museum, Colorado Springs Fine Arts Center.

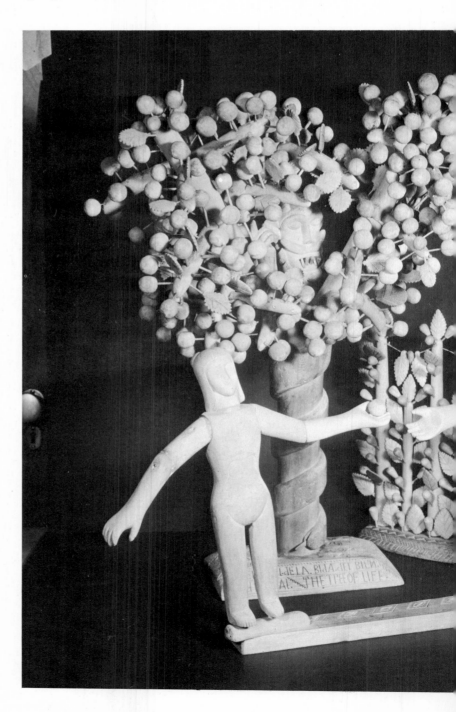

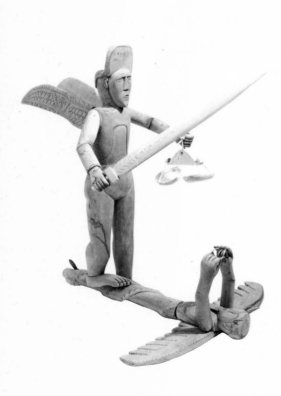

302 (above). George T. Lopez: *Saint Michael and Satan.* c. 1960. Cottonwood. Cordova, New Mexico. Courtesy Smithsonian Institution, Washington, D.C.

Santos carvings (representations of saints) are a unique folk art from the autonomous villages isolated in the mountains of New Mexico. José Dolores Lopez, George T. Lopez, and Eluid Lopez y Martinez (the grandson of José and nephew of George) are members of a family that has produced *santos* carvings for over six generations.

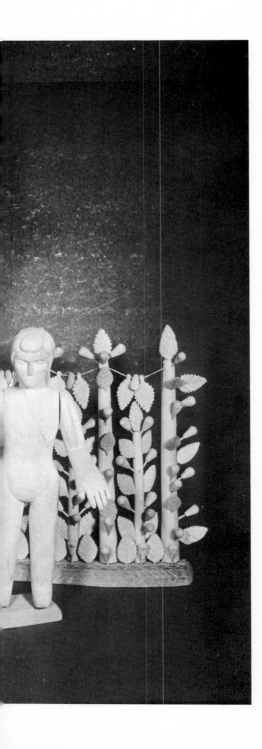

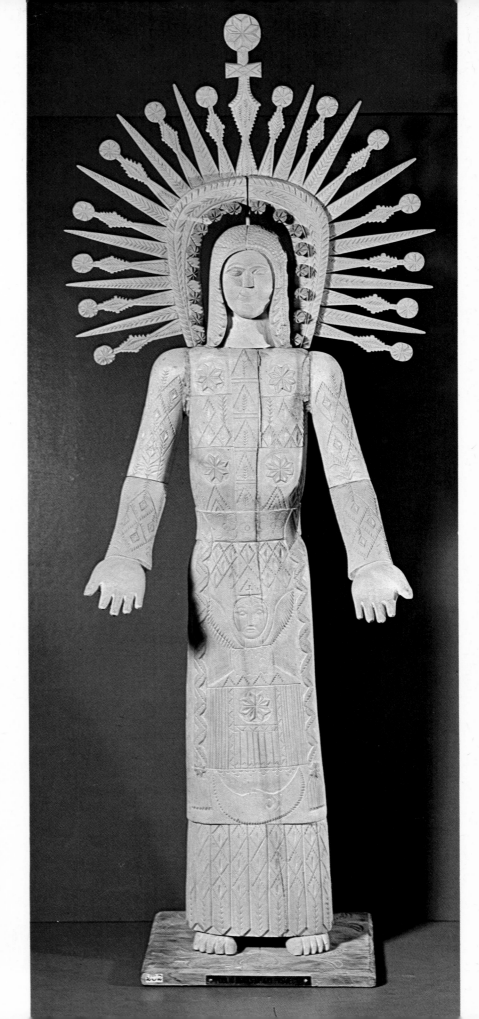

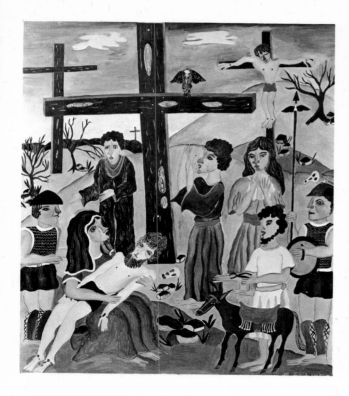

306 (above). Malcah Zeldis: *Pietà*. 1973. Oil on masonite. 26″ x 22″. New York. "It is very difficult for me to explain why I did *Pietà*, to write about it. All I can say is that it was done after I attended a wedding which moved me very deeply. Somehow, very strong feelings were stirred up. I felt the inexorable movement of life itself from birth to marriage to death, which bears in it the presage of pain as well as joy." Courtesy Herbert W. Hemphill, Jr. Photograph: Helga Photo Studio.

PAULINE SIMON (figure 307, below) was born in Poland in 1894. Wanting to go beyond the restricted educational opportunities open to her, she emigrated to the United States when she was about 18 and went directly to Chicago. She worked as a theatrical hairdresser for a time, married a dentist, and when not preoccupied with her two children, worked with him in his office. In 1964, after his death, she enrolled in a painting class under Don Baum at the Hyde Park Art Center. Phyllis Kind, owner of the gallery where her works are shown, quotes her: "Mr. Baum just says to me, 'It's all right. Keep on painting.' I used to play pinochle, poker, and Mah-Jongg, but my interest now is painting."

MALCAH ZELDIS writes: "I was born in New York in 1931 and grew up in Detroit. My father, a window washer by trade, was a 'Sunday painter' and during most of my childhood I remember wanting to paint, but my father discouraged me. I did begin to paint when I was 16. I abandoned it, however, when I went to Israel in 1949. I married there, had two children, lived in several collectives, working at jobs such as sewing, cooking, in the vineyard, and the flower nursery. In 1958, I returned to the United States and began a long, difficult job of readjusting to the city. I returned intermittently to painting, but motherhood interfered with my efforts. It is only during the last year and a half, now that my son is 21 and my daughter 15, that I have been able to return to painting as though I were a traveler returning to my 'native shore.' Suddenly, all the years of waiting have been erased and the emotional depths from which my paintings arise give me a great sense of fulfillment. The world is infused with greater meaning. I feel I have undergone a profound transformation. It is though I am a vessel waiting for the experiences of my life, the lives of others, the meanings of the universe to come into my being as visitors telling me about the wonder of their existences. All my life seems to have taken on a mystery and beauty for which I am deeply grateful."

305 (opposite). Pauline Simon: *Man Reaching to the Lady*. 1962. Acrylic on canvas. 36″ x 28″. Chicago. "All those tiny pieces in the picture took time to paint. I didn't mean to be abstract— I just wanted it to show how people become different pieces when they are reflected in a glass." (*Chicago Magazines*, July/August, 1972.) Courtesy Phyllis Kind Gallery. Photograph: Jonas Dovydenas.

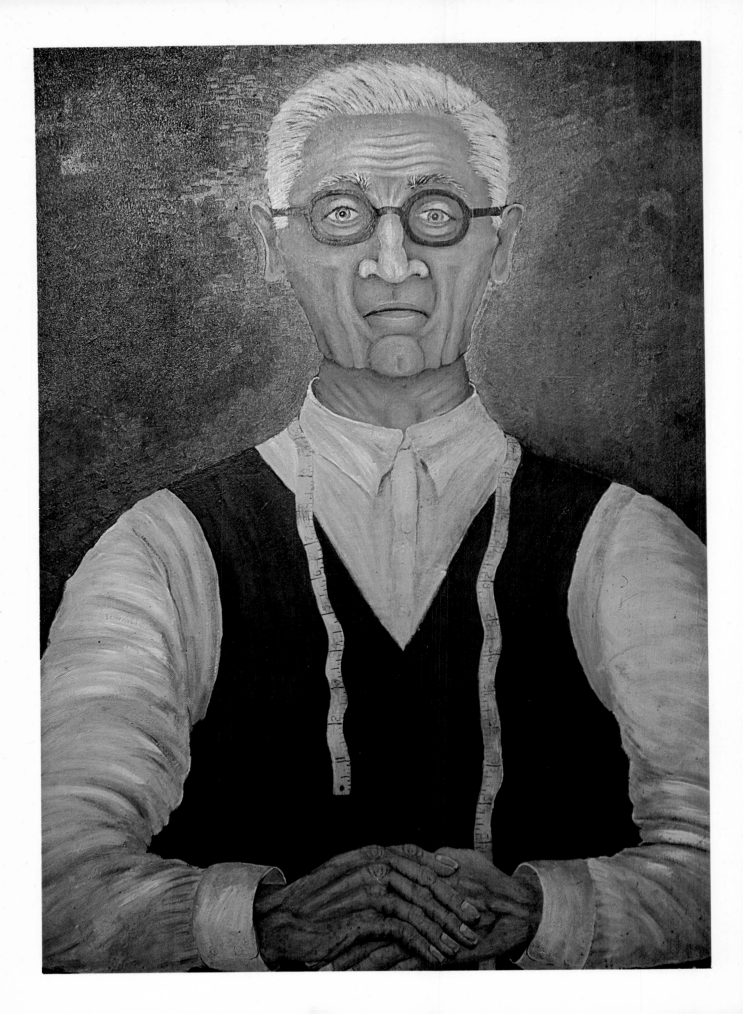

JOSEPH P. AULISIO was born in Old Forge, Pennsylvania, in 1910 and died in 1974. He said, "I always dreamed of becoming an artist and writer, but early years were too busy earning a living, working in a dry-cleaning establishment. I paint because I love it. Winning a top prize in a regional show at Everhart Museum, in Scranton, encouraged me to paint more."

JERRY CASEBIER was born in Topeka, Kansas, in 1942 and has lived most of his life in North Little Rock, Arkansas. He has had no training in art, and left school after the ninth grade to work in furniture- and cabinetmaking. "I had a friend to help me write the biography because it is hard to express my feeling on paper," he said. The friend writes: "While he was in school he liked to draw the movement of fire, taffy twisting, moving things such as snakes and spiders and sharks. He particularly loved to draw the feelings felt in nature and best expressed his own feelings through drawings. While working in a furniture factory he found an old chisel and started working with some reject ladder backs of chairs, fashioning a head from this wood. He found that he could express his feelings in wood as he was at home with wood."

308 (opposite). Joseph P. Aulisio: *Portrait of Frank Peters, the Tailor*. 1965. Oil on canvas. 28″ x 20″. Stroudsburg, Pennsylvania. Courtesy Mr. and Mrs. Sterling Strausser.

309 (right). Jerry Casebier: *My Father, W. H. Casebier*. c. 1970. White maple, laminated under pressure of the artist's car, brown stain, lacquer. H. 16½″. North Little Rock, Arkansas. "Each piece I carve is different and I don't know what I am looking for and it scares me to think I may never find it." Courtesy Arkansas Art Center.

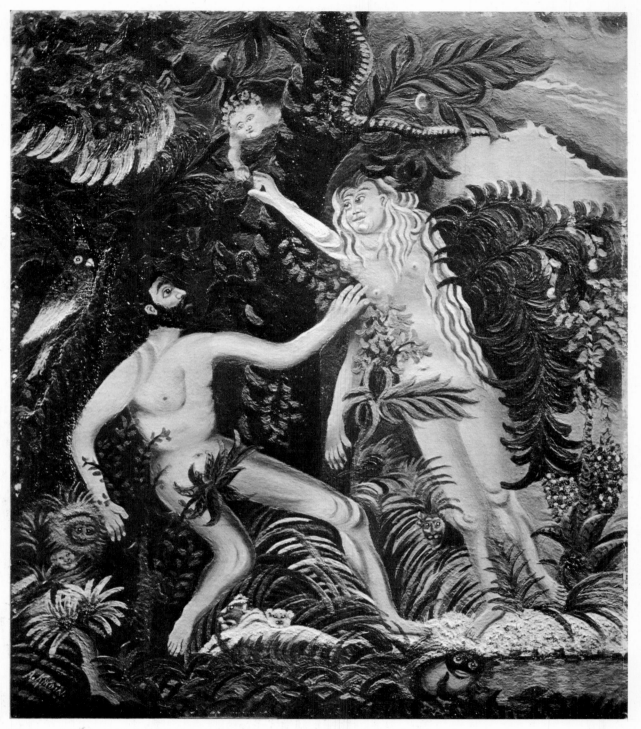

310 (above). Aaron Kikoin: *Adam and Eve—Garden of Eden.* c. 1970. Oil on board. 24⅜" x 20½". New York. The artist says that this painting is a faithful depiction of the Garden of Eden as described in the Bible. All the animals, including the frog and the monkey with baby, are in the biblical account. Mr. Kikoin says that the devil changed himself into an angel in order to get Eve to accept the apple. Courtesy Mr. and Mrs. Joseph Wetherell.

AARON KIKOIN was born in Minsk, Russia, 78 years ago. He emigrated to the United States at the age of 16 with the intention of studying art at the National Academy. However, he was unhappy with the kind of instruction he was receiving, and returned to Russia after six months, and served in the Russian army. After the revolution and during the purges of the Jews, he fled to China, where he lived for many years, working, he said, as a graphic designer for a tobacco firm. When the state of Israel came into being, he went there and remained for 10 years. He has been living in New York with his wife for some 16 years.

311 (below). Sadie Kurtz: *Two Women*. c. 1965. Poster paint on paper. 16¼″ x 13¼″. Bayonne, New Jersey. Courtesy Mr. and Mrs. Elias Getz. Photograph: Eeva-Inkeri.

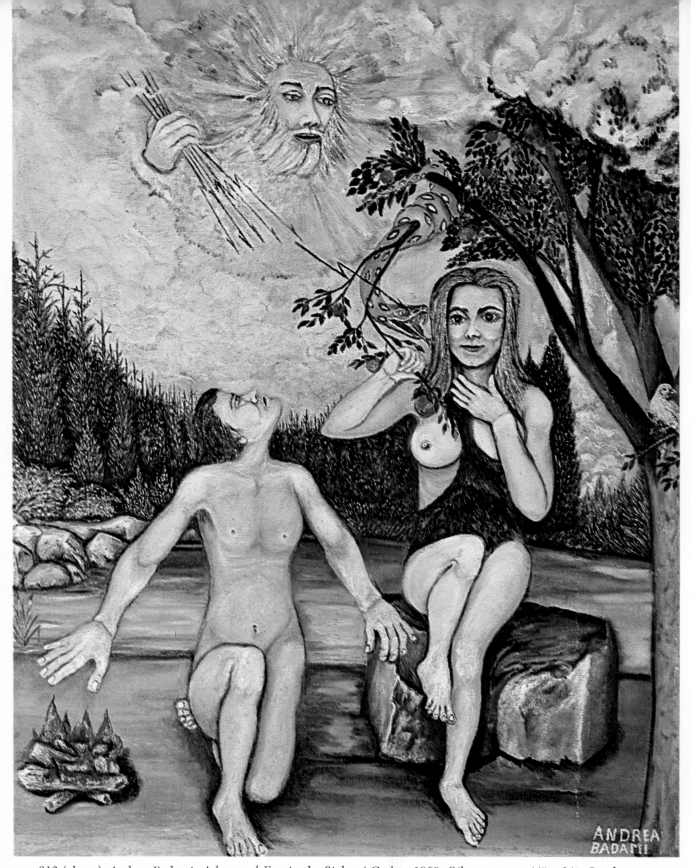

312 (above). Andrea Badami: *Adam and Eve in the Sight of God.* c. 1969. Oil on canvas. 44" x 34". Omaha, Nebraska. Badami was born in 1913 in Omaha. Gregg Blasdel quotes him in *Symbols and Images*: "I enjoy painting sometimes. Some day I will make a good painting—a masterpiece of work, some day before I die. It' gonna take time. Maybe this winter, before spring, maybe next year. I want to make something beautiful sometimes. Seventy-five percent or 80 percent perfect—no pictures are 100 percent perfect." Courtesy Mr. and Mrs. Elias Getz. Photograph: Eeva-Inkeri.

313 (opposite). Andrea Badami: *Queen Elizabeth's Canadian Tour.* c. 1968. Oil on canvas with rhinestone. 50" x 32½". Omaha, Nebraska. Courtesy Mr. and Mrs. Elias Getz. Photograph: Eeva-Inkeri.

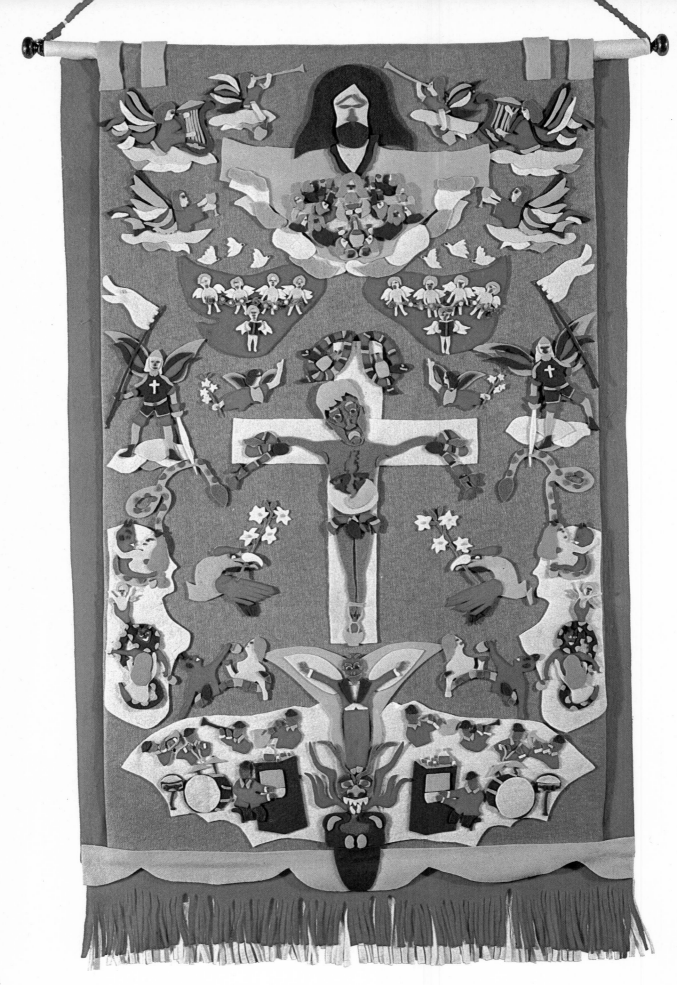

DON (DUKE) MARTIN was born in Trieste, Italy, in 1920. A member of the Fascist Truth Movement at 12, he was horrified by their "reverse" moralities, and with his mother's help, emigrated to the United States in his late teens. He says little of what he did, except that he had been a bartender and a messenger before becoming a patient at the Goldwater Memorial Hospital in New York. In his biographical statement he writes of "fun-filled years—full of irresponsibilities, romantic adventures, asserting my masculinity . . . desire to outdrink Bacchus himself. As Gods will he decided to curse me with a Drunkard's Penance—cirrhosis. During my hospital confinement, I discovered I had a talent I never knew I had before—making designs in felt. I can't help asking myself: Could this be the beginning of a new fun-filled but sordid life???" He is an avid reader of the classics and philosophy.

314 (opposite). Don (Duke) Martin: *Quo Vadis.* 1972. Felt collage. 30″ x 36″. New York. "I call them felt outs, it shows me in effigy—tied to the imaginary Cross some alcoholics have to bear. My feet—secured by a bottle of Chianti. My hands tied by two snakes (some of my best friends). My exposed middle section—the liver, the top—a Drunkard's Delirious Conception of the Eternal Exhilaration that Heaven could be, Gabriel and a bottle of Chianti, below a snake embracing a disciple of the Devil, another following a fallen angel.—Every good little snake does a five-piece Barrell House Band." Courtesy the artist. Photograph: Eeva-Inkeri.

315 (below). B. J. Newton: *The Reaper* (Signed: B. Jesus). c. 1972. Oil on cardboard. 18″ x 24″. California. Courtesy Phyllis Kind Gallery. Photograph: Jonas Dovydenas.

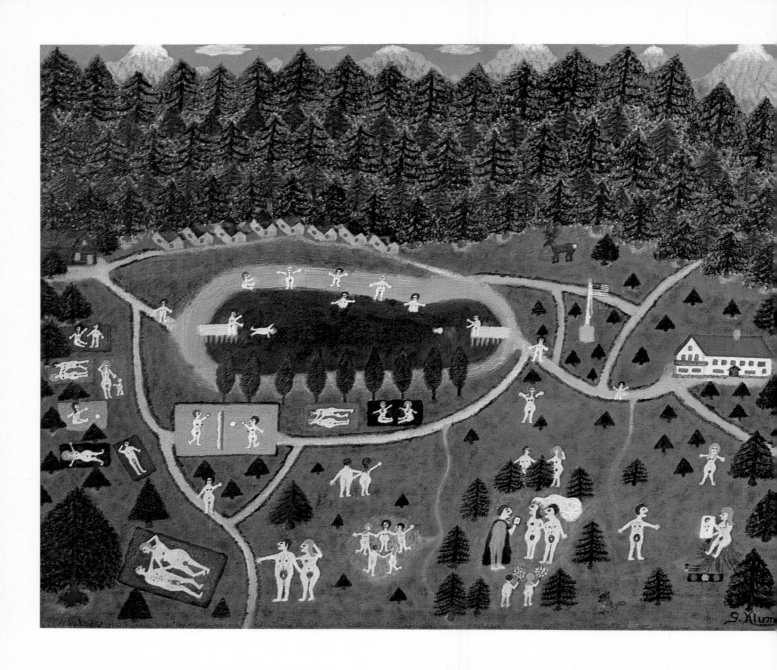

316 (above). Gustav Klumpp: *Dream of a Nudist Camp Wedding*. 1971. Oil on canvas. 24″ x 30″. Brooklyn, New York. Courtesy Herbert W. Hemphill, Jr. Photograph: Eeva-Inkeri.

317 (left). Gustav Klumpp: *The Art Gallery Saluting the Nude*. 1972. Oil on canvas board. 20″ x 24½″. Brooklyn, New York. "If you notice, almost all my paintings speak for themself. There is some kind of action, comical or something interesting in it. I am not fond of dull paintings of landscapes or otherwise." Courtesy Mr. and Mrs. Michael D. Hall. Photograph: Howard Legge.

216

318 (left). Flora Fryer: *The Maxi.* 1970. Acrylic on canvas. 64″ x 45″. Seattle, Washington. "Some of my paintings reflect a mystic quality. Others may be entertaining." Photograph courtesy Henry Gallery, University of Washington School of Art.

319 (below). Flora Fryer: *Area Festival in the South of France.* c. 1965. Oil on canvas. 47″ x 55″. Seattle, Washington. "Painting for me is a fulfillment for self action in which I express ideas. My primary goal is to create and record the philosophy of an environment common to an audience. It must reflect back to me and to the audience a message true to my philosophy." Courtesy Mr. and Mrs. Elias Getz. Photograph: Eeva-Inkeri.

GUSTAV KLUMPP, asked for a biography, wrote an "Abbreviated History of My Life": "I am born in 1902, the son of a photographer in the Black Forest Mountains, Germany. After my apprenticeship as a compositor, I left Germany and arrived in the U.S. in 1923. I was employed as compositor and linotype operator in New York. I retired 1964. I visited the Senior Citizen Center, March 1, 1966. The director suggested maybe you like painting. I said I have never painted before in my life but I'll try. So I started painting. For a test I painted a reproduction of Abraham Lincoln and I liked it. After painting a few landscapes, I decided to paint fantasies like the *Wedding of the Mermaid.* This was a thrilling experience for me.

"My philosophy of art painting which is expressed in the visualization of painting beautiful girls in the nude or seminude and in fictitious surroundings including some other paintings of dreamlike nature. This is one reason I love to paint and I was trying to accomplish something particular at the golden age and as an inspiration to other Senior Citizens or the younger generation. To beautify and enhance the place where it is displayed."

FLORA FRYER was born in St. Paul, Minnesota, in 1892, and was graduated from nursing school in 1917. She joined the armed forces and served in Europe. She moved to the Seattle area in 1943 to work in rural public health nursing, and retired in 1960. She began to paint in 1962. She has traveled extensively. In her letter she says: "From early childhood I had a desire to paint, but because of conditions and cost, it was necessary to postpone same until maturity. I am convinced my paintings are related to environment in my early childhood. Painting is a pleasure; it is also fulfilling the desire of early childhood and the need to be busy."

MILES CARPENTER was born in May, 1889, near Lititz, Lancaster County, Pennsylvania, where his father was a farmer and cigar maker. Mr. Carpenter gives his customers a one-page biography mimeographed on his stationery, the heading of which states: "Dealer in ICE, ANTIQUES—BOTTLES, WOOD CARVING." He writes, in part: "In 1901 my father decided to move to Va. near Waverly [where Mr. Carpenter still lives]. Father bought a sawmill." Carpenter went into the lumber business for himself in 1912, and was married in 1915 to "a nice girl from Pa. We had a most pleasant life for 50 years." He acquired an ice-manufacturing business and a moving-picture house, but continued lumbering as well. "Somehow in 1940 the lumber business got dull and to keep doing something I started carving, mostly animals. A year or two later I quit carving until I retired in 1957. I could not sit down and do nothing, so I went back to carving again. In 1966 I lost my dear wife and things seemed real dull. However, I kept on carving and am at it now. I love to make things out of wood."

320 (below). Miles B. Carpenter: *The Devil and the Damned.* 1972. Painted wood and cellophane. H. 19″. Waverly, Virginia. Private collection. Photograph: Eeva-Inkeri.

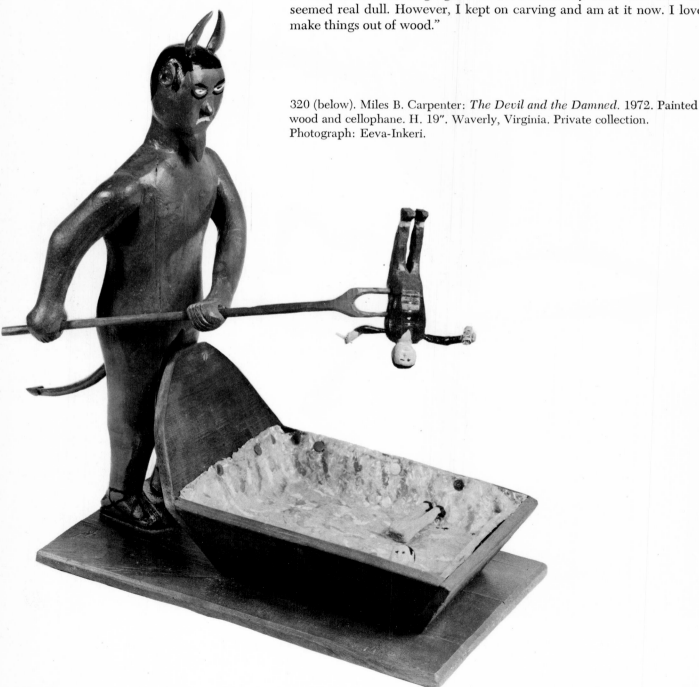

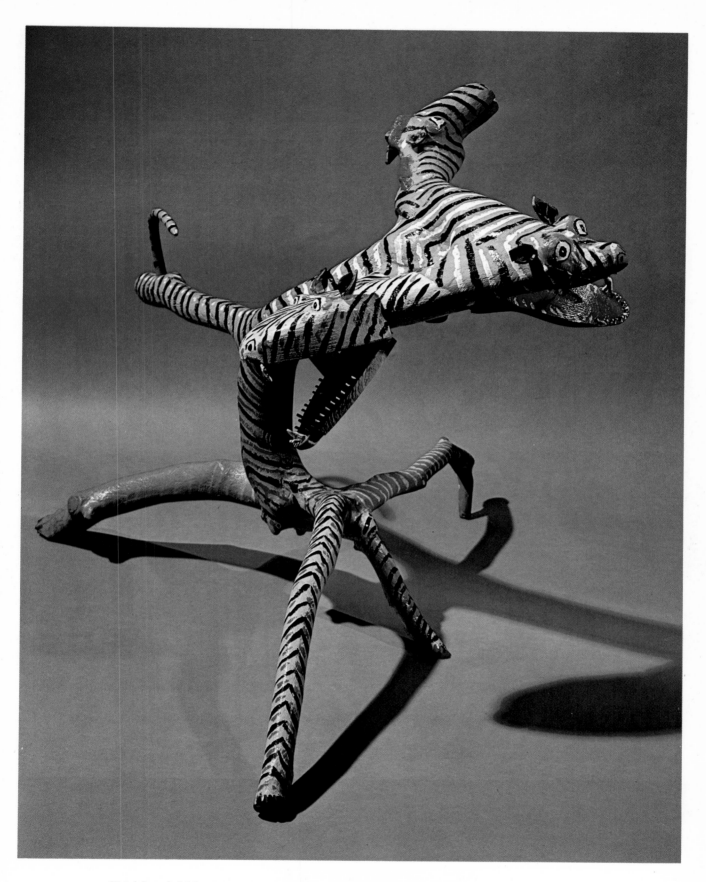

321 (above). Miles B. Carpenter: *Hydra-headed Monster.* 1972. Found root structure, painted. H. 13½". Waverly, Virginia. Courtesy Herbert W. Hemphill, Jr. Photograph: Eeva-Inkeri.

HARRY LIEBERMAN was born November 15, 1877, in Gnieveshev, Poland. Nephew of a Hasidic rabbi, he prepared for the rabbinate, but forsook this career, and emigrated to the United States in 1906. First a clothing cutter, then a candy manufacturer, he retired in his late 70s and joined a Golden Age Club in Great Neck, New York. One day, when his chess partner failed to arrive, he took a suggestion to try the painting class. Much taken with this new activity, he supplied himself with art materials and began his present career as an artist, painting subjects related to his study of the Talmud, the Gemara, the Cabala, Hasidism, the Old Testament, and Hebrew and Yiddish literature.

He recalled: "I 'noticed the teacher, Mr. Larry Rivers, was going around to all the others and talking about what they were doing. But to me, he never came. I felt a little disturbed. Am I so bad? So one day I went to him. 'Mr. Rivers,' I said, 'why is it you go to everyone and you don't come to me? What is it? Have I got chicken pox or something, you're afraid?' 'No, Mr. Lieberman,' he says. 'Only, to you, I can't teach you more than what you are already doing.' 'So,' I said, 'Mr. Rivers, you want I should teach you, then?' He says to me, 'Mr. Lieberman, some things I can do that you can't do. But some things you can do, I can't do. What you do is right the way it is.'" At 97 he said: "I do feel painting is my most important work. I don't believe there is a life Upstairs. The life I got now is the heavenly reward because when I die my paintings will be here and people will enjoy."

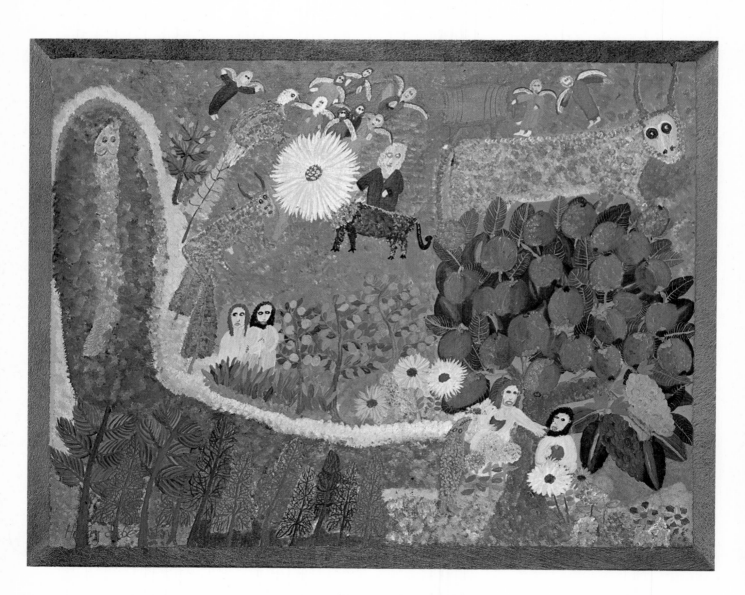

322 (above). Harry Lieberman: *Before and After.* 1972. Acrylic on canvas. 24" x 30". Great Neck, New York. "Genesis 2:16, 17; 3:4, 6, 8, 9. And the Lord G—d commanded the man, saying: of every tree of the garden thou mayest freely eat. But of the tree of knowledge of good and evil, thou shall not eat of it. They did eat; they knew they were naked. The man and the wife hid themselves from the presence of the Lord G—d amongst the trees of the garden." Courtesy Morris Gallery, with permission of the artist. Photograph: Eeva-Inkeri.

323 (below). Harry Lieberman: *Faith Is Stronger than Science*. 1969. Acrylic on canvas. 24″ x 30″. Great Neck, Neck, New York. "I was sitting at the third Sabbath meal with the Rabbi of Los Angeles, whose family was burned in the ovens at Auschwitz. Before dinner, he ·went to *dov'n*—that means to pray—and when he came to the words 'God was, is and will be King,' it was like he was flying in the air, like he was floating near the ceiling. How is it possible a person should go through so much misery and still have such a great faith? I came to the conclusion the words *I believe* are more powerful than any force." Courtesy Morris Gallery, with permission of the artist. Photograph: Eeva-Inkeri.

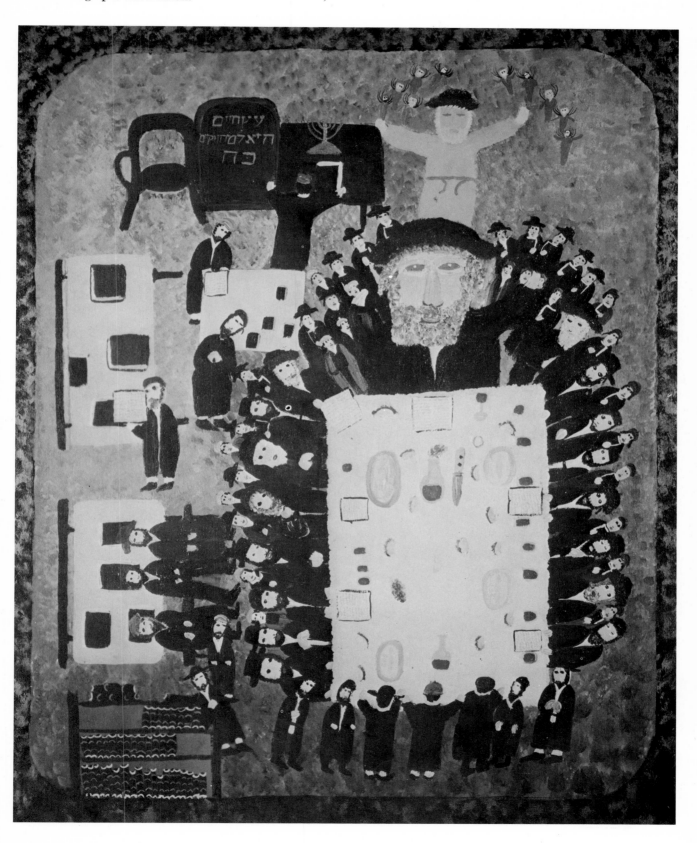

ALBINA FELSKI is in her late forties, and lives in Chicago. Her letter about herself says, in part: "I'm painting for eleven years. I was born in Ternie, British Columbia. My father was a coal miner. That's where I had a great idea—painting a coal miner picture. I also worked in the shipyards, where I painted a lovely picture which won honorable mention. My brothers would take me on fishing trips. They would photograph pictures of Bears, Deers, Mountain Goats, Wild Sheep, Grizzly Bears, Moose. I would see all these lovely animals on the screen—that's where I got all my ideas on painting Beautiful Animal Scenes. Mrs. Phyllis Kind assembled a lovely exhibition for me, I sold seven paintings. Everyone admired the Circus painting so much."

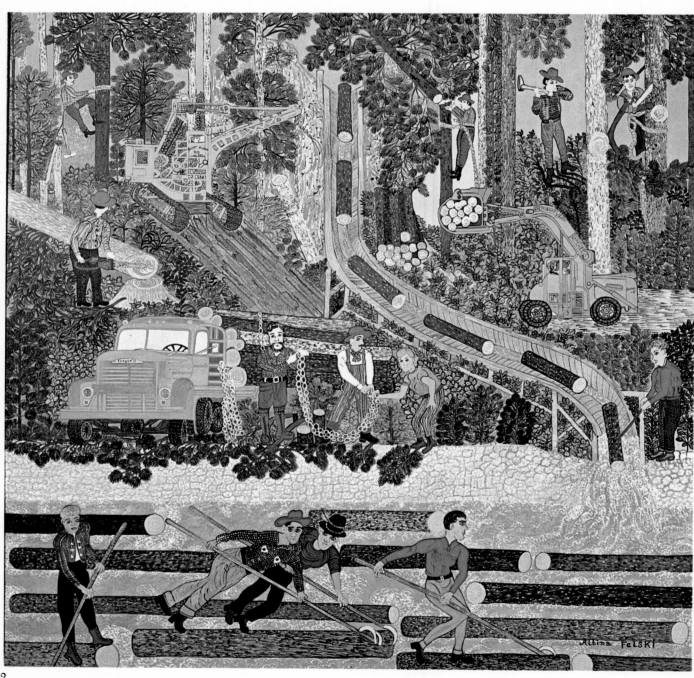

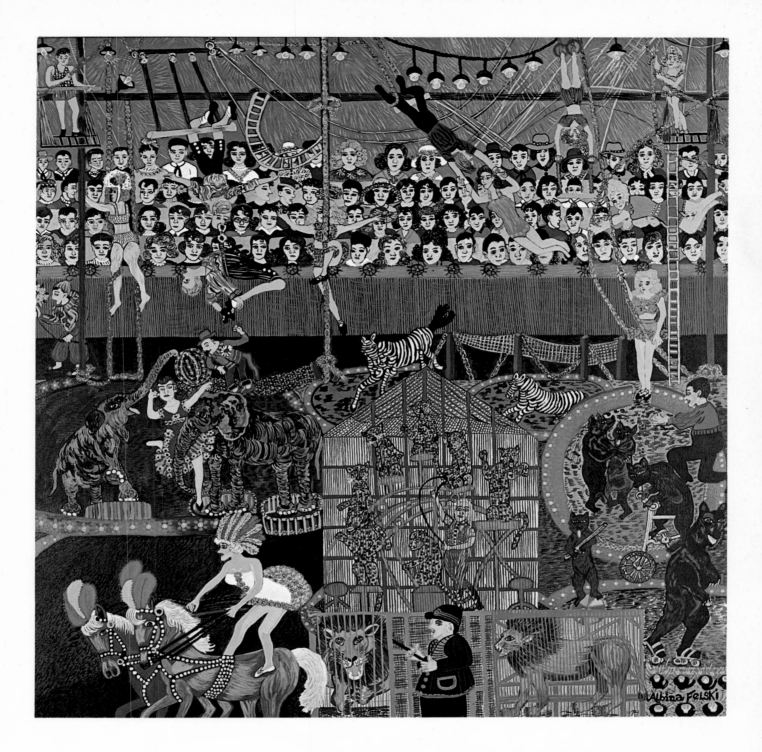

324 (opposite). Albina Felski: *Logging Operation*. 1972. Oil on canvas. 48″ x 48″. Chicago, Illinois. Private collection. Photograph: Eeva-Inkeri.

325 (above). Albina Felski: *The Circus*. 1971. Acrylic on canvas. 47″ x 47″. Chicago. "I am very busy around the house and I work in a factory. I paint in fall, winter, and springtime." Courtesy Combank Mortgage Funding Ltd. collection, Chicago. Photograph: Jonas Dovydenas.

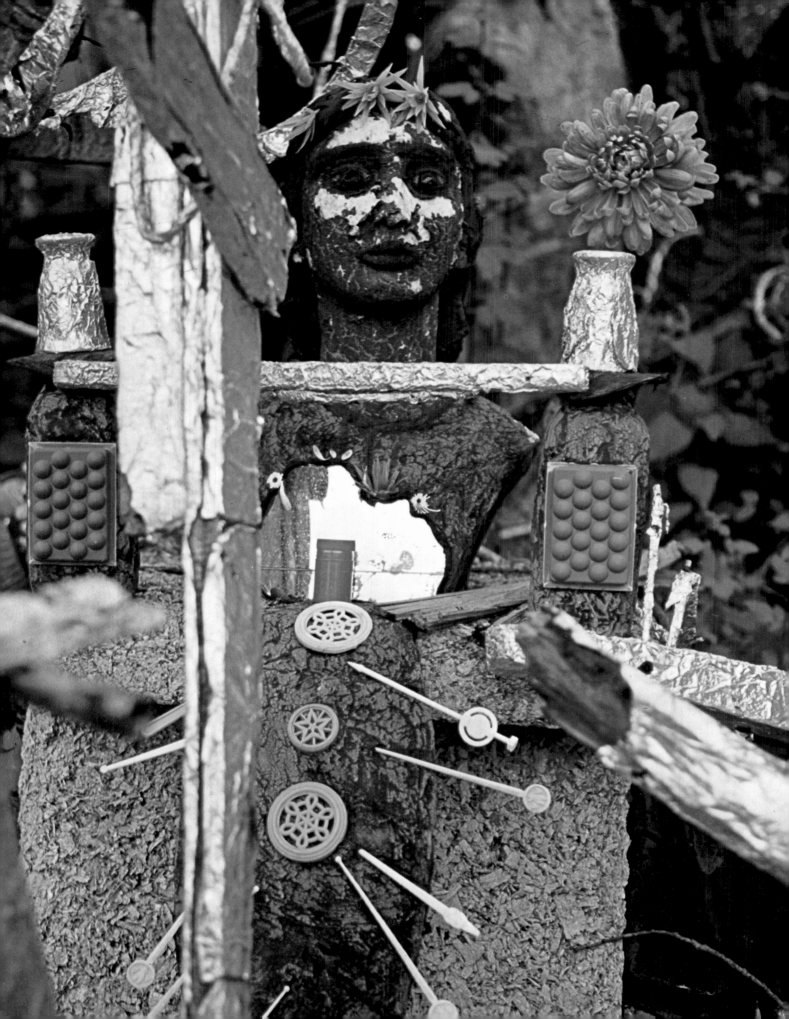

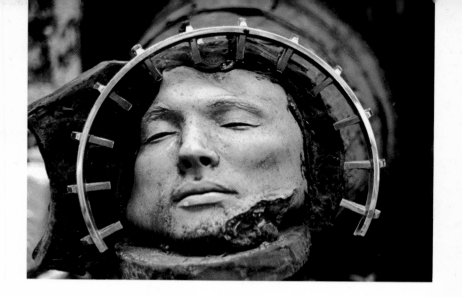

326 (opposite), 327 (right), 328 (below).
Clarence Schmidt: *Garden and House*.
c. 1970. Found and contributed objects,
assembled and painted. Woodstock, New
York. Photographs courtesy Michael Malone.

CLARENCE SCHMIDT was born in New York City in 1898. A former stonemason and plasterer, he moved to the Catskills in 1920. In the 1930s he began building a cabin on a mountain near Woodstock, and within 30 years it was a seven-story house with 35 rooms connected by labyrinthine hallways thickly furnished with tinsel-encrusted shrines and assemblages. Outside, it was surrounded with constructions of junk that were glued together with tar, gilded with foil, adorned with plastic flowers and mirrors, and then set among the trees and foliage, some of which were also covered with foil. The house burned—arson was suspected—but Schmidt started rebuilding it. A nearby medical supply house and the local artists supplied him with castoffs. Roger Cardinal quotes him in *Outsider Art*: "There's more art here than in all the museums in the entire country! Forget the Pyramids and the Mona Lisa! I love to see the light on it, the reflections and shadows keep changing. The pieces are wonderful in the moonlight and at sunset and after a snowfall." Schmidt is now in a nursing home; his house and garden are totally desecrated.

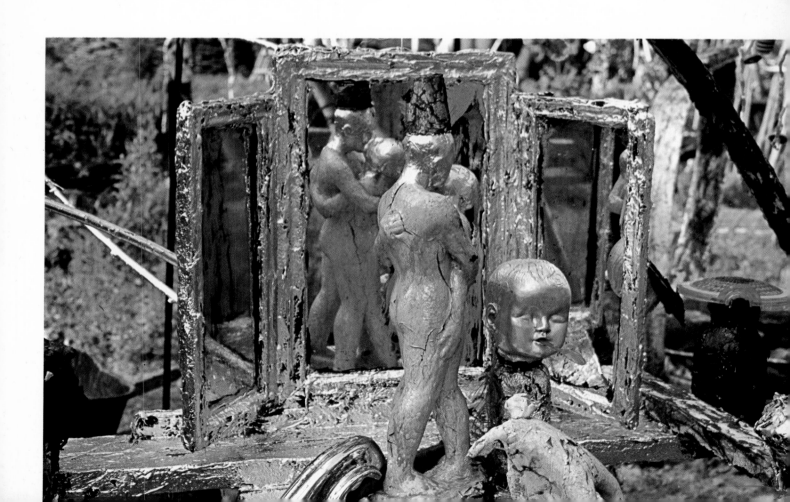

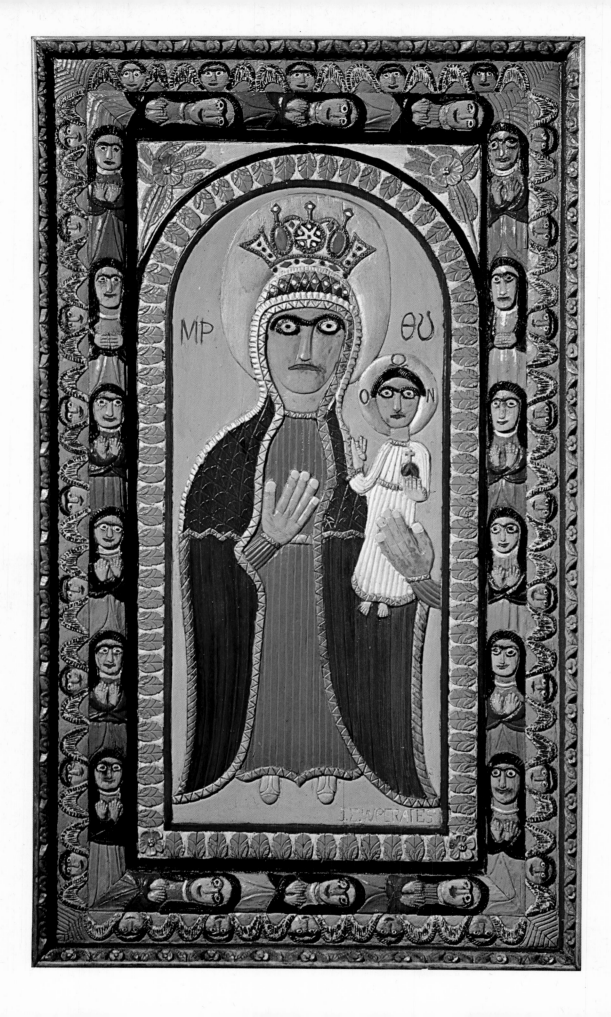

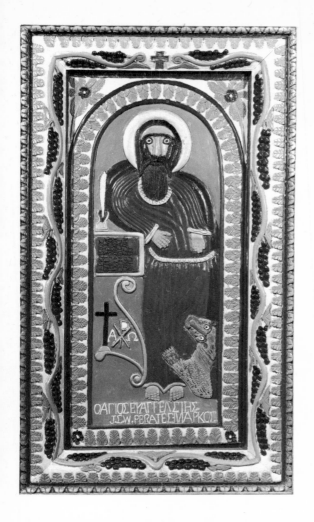

329 (opposite). John W. Perates: *Icon of the Madonna and Child*. c. 1940. Carved and assembled wood relief with enamel paint. 53″ x 30½″. Portland, Maine. Courtesy Mr. and Mrs. Michael D. Hall. Photograph: Helga Photo Studio.

330 (left). John W. Perates: *Icon of Saint Mark*. c. 1940. Carved and assembled wood relief with enamel paint. 49½″ x 28″. Portland, Maine. Courtesy Mr. and Mrs. Michael D. Hall. Photograph: Helga Photo Studio.

331 (below). John W. Perates: *Icon of the Dormition of the Virgin*. c. 1940. Carved and assembled wood relief, varnished. 29″ x 47″. Portland, Maine. Courtesy Mr. and Mrs. Michael D. Hall. Photograph: Helga Photo Studio.

JOHN W. PERATES (1894–1970), a Portland, Maine, cabinetmaker, combined his knowledge of the Bible with his woodcarving skill to produce a Byzantine-style pulpit and related icons that were intended to be used in a Greek Orthodox church in Portland. Perates, an immigrant, came to America from his native town of Amphikleia in Greece. He began carving in 1938, and his monumental icons are a significant contribution to American folk art of the twentieth century.

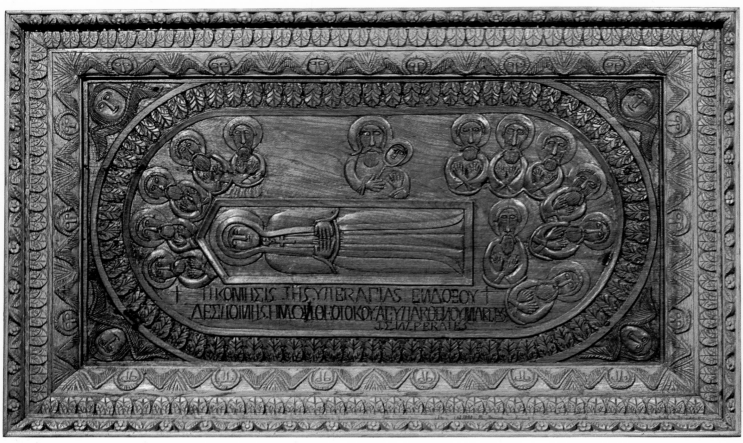

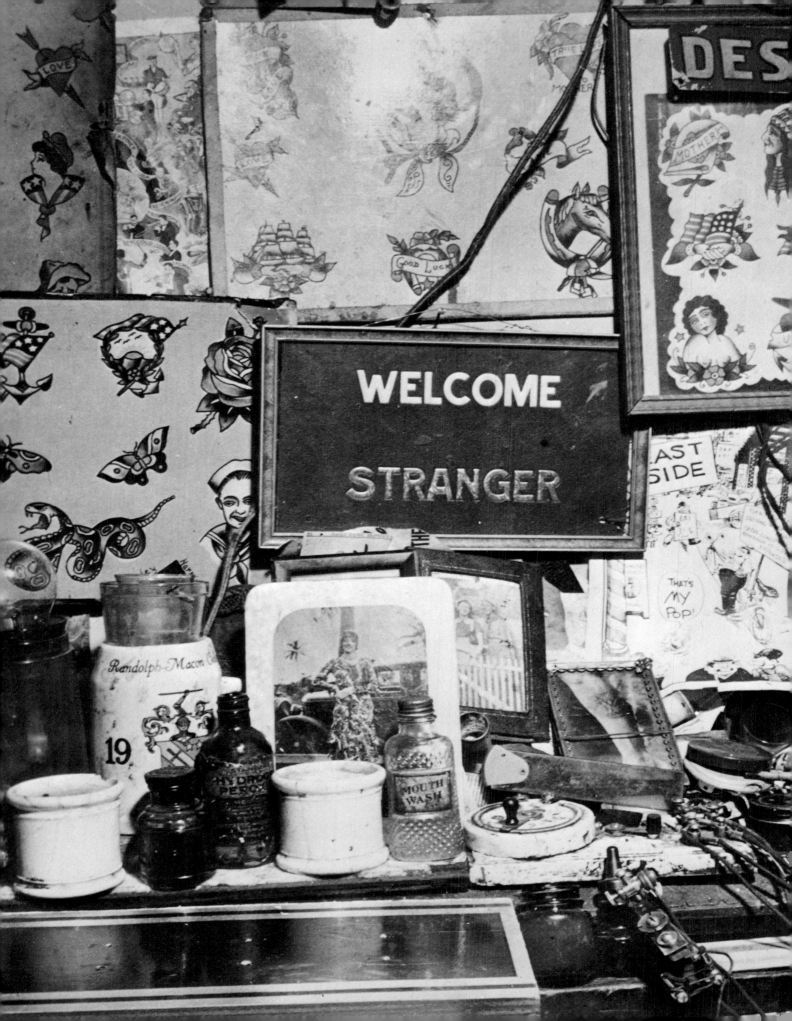

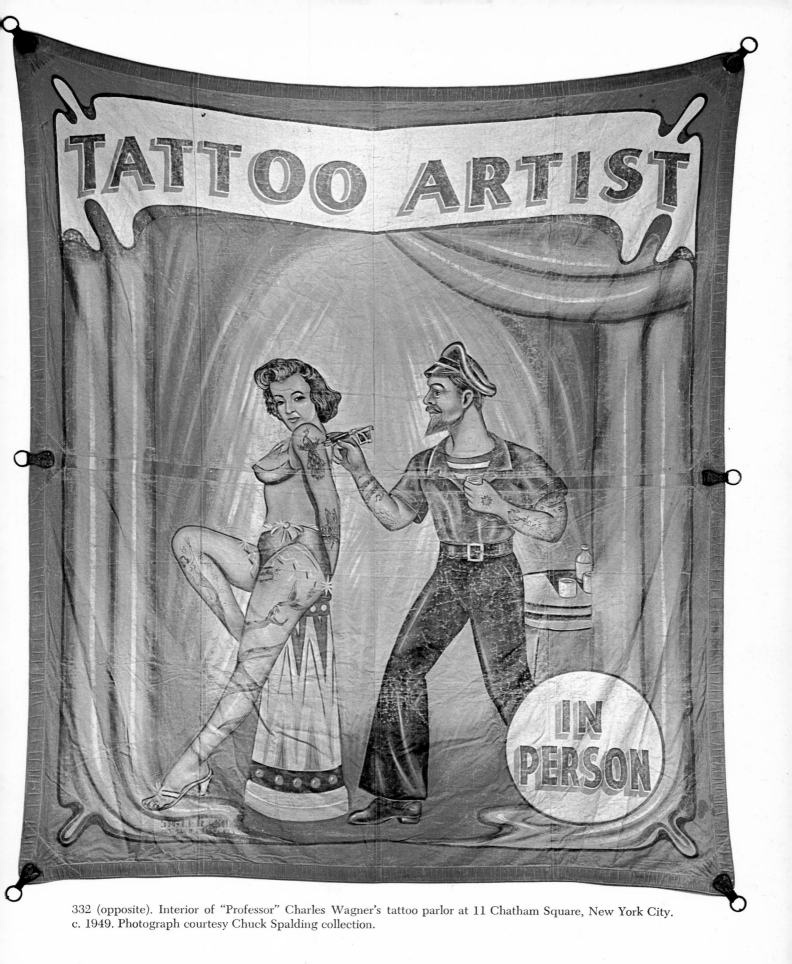

332 (opposite). Interior of "Professor" Charles Wagner's tattoo parlor at 11 Chatham Square, New York City. c. 1949. Photograph courtesy Chuck Spalding collection.

333 (above). Snap Wyatt: *Tattoo Artist*. c. 1950. Oil on canvas. 10′ x 8′. Tampa, Florida. Private collection.

BRUCE BRICE, born in New Orleans' French Quarter, is a 31-year-old Black artist. *Dixie Magazine*, New Orleans, in its October 8, 1972, issue quotes him: "When I was eight years old, I shined shoes and hamboned it. I wanted to be a puppeteer. I worked with marionettes when I was little, did puppet shows for kids in Desire [a housing project]." In his own statement, he says, "Painting is something I have always wanted to do since I was a child. Now that I am old enough I am able to do it and I know where I am going as an artist. I enjoy it. I don't look at other works. I paint out of my past and let my head go. Lots of kids are not on their own. They're in school and under a teacher. They don't know what it's all about. They don't have experience."

334 (below), Bruce Brice: *Treme Wall Mural.* 1971. Exterior wall mural, New Orleans, Louisiana. A commemoration of the destruction of Treme, a Black neighborhood, to make way for a parking lot for the new Cultural Center. One of the buildings depicted is the Caledonia Bar, an important stop on the Zulu Parade route, and a place where coffins were rolled in for wakes by poorer Treme residents. Many a jazz funeral started there. Photograph: Weber Studios.

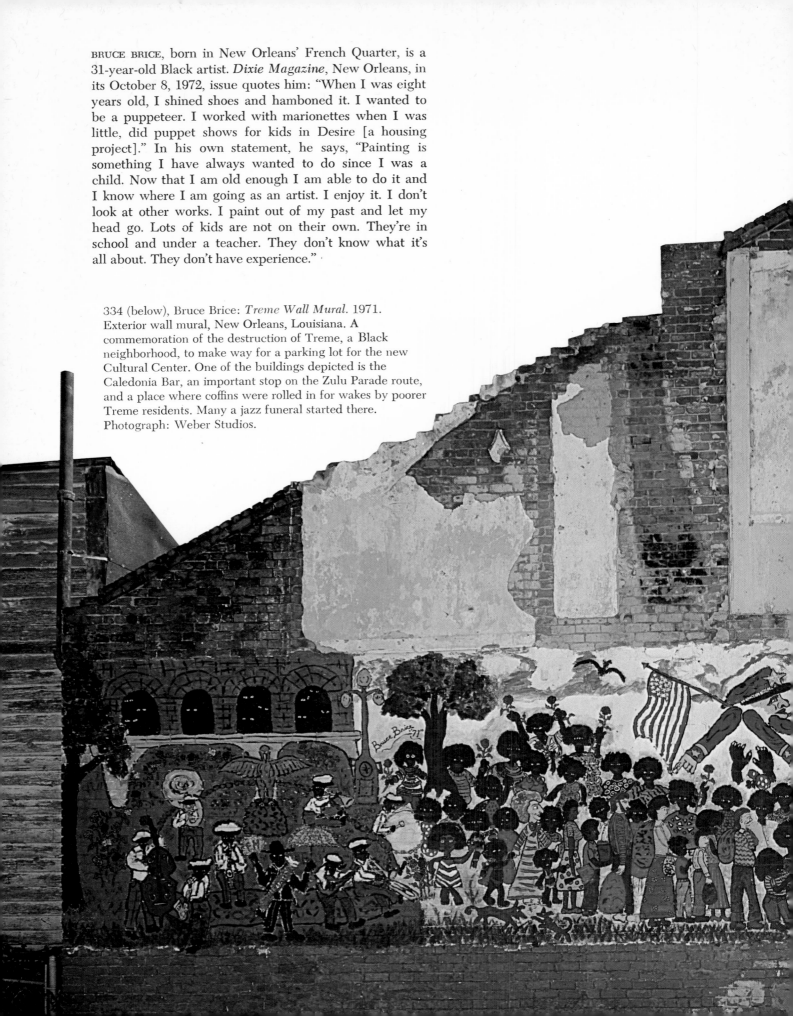

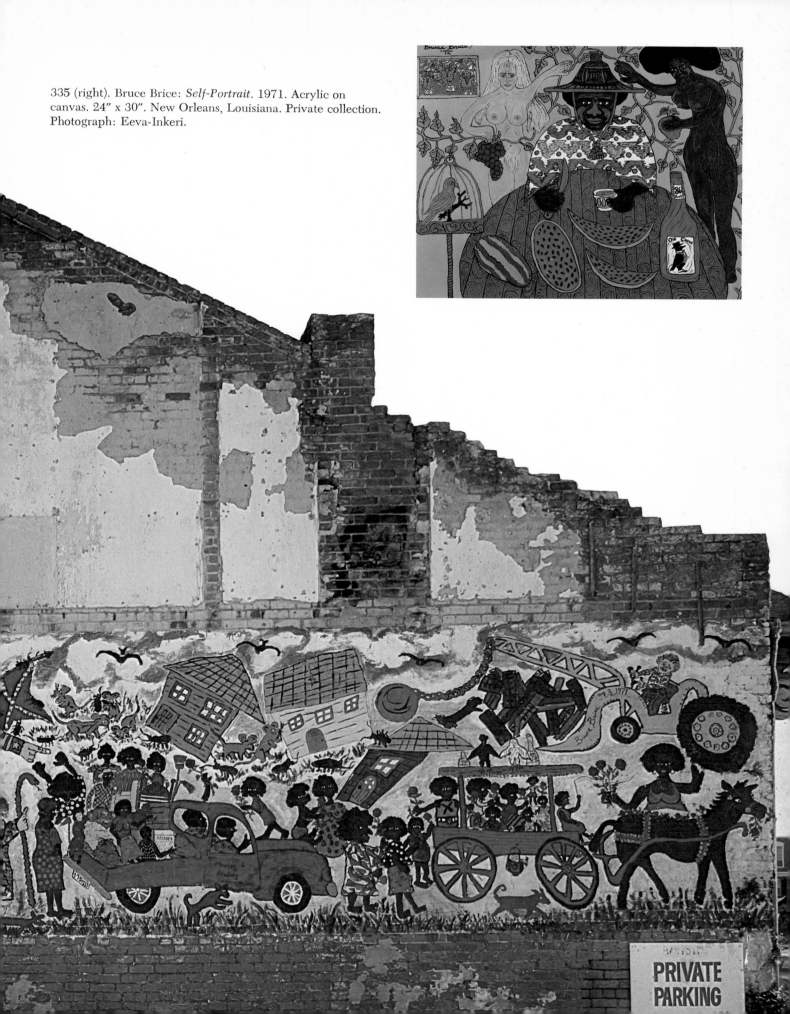

335 (right). Bruce Brice: *Self-Portrait*. 1971. Acrylic on canvas. 24″ x 30″. New Orleans, Louisiana. Private collection. Photograph: Eeva-Inkeri.

PRIVATE PARKING

BIBLIOGRAPHY

BOOKS:

Arnason, H. H. *History of Modern Art.* Englewood Cliffs, N.J.: Prentice-Hall, and New York: Harry N. Abrams, Inc., n.d.

Bahti, Tom. *Southwestern Indian Ceremonials.* Las Vegas, Nevada: KC Publications, 1970.

——. *Southwestern Indian Tribes.* Las Vegas, Nevada: KC Publications, 1968.

Bearden, Romare and Henderson, Harry. *Six Black Masters of American Art.* Zenith Books. Garden City, N.Y.: Doubleday & Co., Inc., 1972.

Bilhalji-Merin, Oto. *Masters of Naive Art: A History and World Wide Survey.* New York: McGraw-Hill & Co., 1971.

——. *Modern Primitives: Masters of Naive Painting.* New York: Harry N. Abrams, Inc., 1959.

Black, Mary and Lipman, Jean. *American Folk Painting.* New York: Bramhall House, 1966.

Blanch, Arnold and Lee, Doris. *Painting for Enjoyment.* New York: Tudor Publishing Co., 1947.

Bond, Peter Mason (Pemabo). *The Trio of Disaster.* San Francisco, California: Privately printed, 1959.

Boyd, E. *The New Mexico Santero.* Santa Fe, N.M.: Museum of New Mexico, 1972.

Boyd, E. *New Mexico Santos: How to Name Them.* Santa Fe, N.M.: Museum of New Mexico, 1966.

Cahill, Holger. *American Folk Art: The Art of the Common Man in America 1750–1900.* New York: W. W. Norton & Co. for The Museum of Modern Art, 1932.

Cahill, Holger, Gauthier, Maximilien, Cassou, Jean, *et al. Masters of Popular Painting: Modern Primitives of Europe and America.* New York: Arno Press for The Museum of Modern Art, 1932, 1966.

Cardinal, Roger. *Outsider Art.* New York: Praeger Publishers, 1972.

Carraher, Ronald G. *Artists In Spite of Art.* New York: Van Nostrand Reinhold Co., 1970.

Christensen, Erwin O. *The Index of American Design.* Washington, D.C.: National Gallery of Art, 1950.

Dickey, Roland F. *New Mexico Village Arts.* Albuquerque, N.M.: University of New Mexico Press, 1970.

Dinsmoor, S. P. *Pictorial History of the Cabin Home and Garden of Eden of S. P. Dinsmoor.* Lucas, Kansas: Privately printed, n.d.

Dockstader, Frederick J. *The Kachina and the White Man.* Cranbrook Institute of Science, Bulletin No. 35. Bloomfield Hills, Mich., 1954.

Drace, Charley. *The Saga of Outlaw Howard.* Fulton, Missouri: Privately printed, n.d.

Drepperd, Carl W. *American Pioneer Arts and Artists.* Springfield, Mass.: The Pond-Ekberg Co., 1942.

Eaton, Allen H. *Handicrafts of the Southern Highlands.* New York: Russell Sage Foundation, 1937.

Fischer, Ernst. *The Necessity of Art.* Translated by Anna Bastock. Baltimore, Md.: Pelican Books, Ltd., 1964.

Fitzgerald, Ken. *Weathervanes and Whirligigs.* New York: Bramhall House, 1967.

Ford, Alice. *Pictorial Folk Art, New England to California.* New York: Studio Publications, 1949.

Frankenstein, Alfred. *Angels over the Altar.* Honolulu: University of Hawaii Press, 1961.

Friedman, Martin, Libertus, Ron, and Clark, Anthony M. *American Indian Art: Form and Tradition.* Walker Art Center, Indian Art Association, the Minneapolis Institute of Art. New York: E. P. Dutton & Co., Inc., 1972.

Girard, Alexander. *Magic of a People: Folk Art and Toys from the Collection of the Girard Foundation.* New York: The Viking Press, 1968.

Hopmans, Susan. *The Great Murals of Farmer John Brand, Clougherty Meat Packing Co. in Vernon, California.* Photographs by Peter Kenner. New York: Colorcraft Lithographers, Inc., 1971.

Janis, Sidney. *They Taught Themselves.* New York: The Dial Press, 1942.

Kallir, Otto. *Art and Life of Grandma Moses.* New York: The Gallery of Modern Art, 1969.

Kane, John. *Sky Hooks.* Notes and postscript by Mary McSwigan. Philadelphia: J. B. Lippincott Co., 1938.

Kellog, Rhoda, with Scott O'Dell. *The Psychology of Children's Art.* New York: CRM–Random House, 1967.

Laliberte, Norman and Jones, Maureen. *Wooden Images.* New York: Reinhold Publishing Co., 1966.

Leedskalnin, Edward. *A Book in Every Home.* Homestead, Florida: Privately Printed, 1936.

Lipman, Jean. *American Folk Art in Wood, Metal and Stone.* New York: Pantheon Books, 1948.

——. *American Primitive Paintings.* New York: Oxford University Press, 1942.

Lipman, Jean and Winchester, Alice. *Primitive Painters in America, 1750–1950.* New York: Dodd Mead & Co., 1950.

Mundt, Ernest. *Art, Form, and Civilization.* Berkeley, Calif.: University of California Press, 1972.

Neal, Avon, and Parker, Ann. *Ephemeral Folk Figures.* New York: Clarkson N. Potter, Inc., 1969.

Pohribny, Arsen and Tkac, Stefan. *Naive Painters of Czechoslovakia.* Prague: Artia, 1967.

Read, Herbert. *The Meaning of Art.* New York: Praeger Publishers, 1972.

——. *Art Now.* New York: Pitman Publishing Corp., 1968.

——. *The Origins of Form in Art.* New York: Horizon Press, 1965.

——.*Art and Society.* London: Faber and Faber, 1956.

Schaafsma, Polly. *Early Navaho Rock Paintings and Carvings.* N.p. Museum of Navaho Ceremonial Art, Inc., 1966.

Schaefer-Simmern, Henry. *The Unfolding of Artistic Activity.* Berkeley, Calif.: University of California Press, 1970.

Shalkop, Robert L. *Wooden Saints: The Santos of New Mexico.* Colorado Springs, Colo.: The Taylor Museum of The Colorado Springs Fine Arts Center, 1967.

Vogel, Donald and Margaret. *Aunt Clara: The Paintings of Clara McDonald Williamson.* Austin, Tex.: University of Texas Press for the Amon Carter Museum of Western Art, 1966.

Wiggington, Eliot, *The Foxfire Book.* New York: Anchor Books, 1972.

PERIODICALS:

Arizona Highways. "A Treasury of Arizona's Colorful Indians" (Special supplement). Phoenix, Arizona, 1967.

Arizona Highways, June 1973.

"The Eskimo World." *Artscanada.* December 1971.

"Grassroots Art." *Artscanada.* December 1969.

Black, Mary. "Art in the City." *Status.* New York, March 1970.

Blasdel, Gregg N. "The Grass-Roots Artist." *Art in America.* September–October 1968.

Bock, Joanne. "Grandpa Wiener, Painter of Many Worlds." *Antiques,* August 1970.

Cooper, Wyatt. "Of Art and Beauty." *Status.* New York, March 1970.

Journal of the Illinois State Historical Society. "Olaf Krans." Vol. 34, No. 32, June 1941.

Pileggi, Nicholas. "Ralph Fasanella: Portrait of the Artist as a Garage Mechanic." *New York Magazine,* October 30, 1972.

Rachleff, Owen. "The Innocent Eye: Naive Art." *Famous Artists Annual 1.* New York: produced by Chanticleer Press.

Stock, Ellen. "Vestie Davis: The City Primitive." *New York Magazine,* July 7, 1969.

Weissman, Julia. 'Harry Lieberman, Jewish Naive Artist." *Midstream,* New York, May 1974.

CATALOGUES:

Black, Mary. *What Is American in American Art.* New York: M. Knoedler & Co., Inc., February 9–March 6, 1971.

Blasdel, Gregg N. *Symbols and Images.* American Federation of Arts, 1970.

Campbell, William P. *101 American Primitive Watercolors and Pastels from the Collection of Edgar William and Bernice Chrysler Garbisch.* Washington, D.C.: National Gallery of Art, 1966.

Crispo, Andrew J. *Four American Primitives.* New York: ACA Galleries, February 22–March 11, 1972.

The Goldwater Kachina Doll Collection. Heard Museum. Tempe, Arizona, 1969.

Hall, Michael D. *American Folk Sculpture: The Personal and the Eccentric.* Cranbrook Academy of Arts Gallery, November–January 1972..

Hemphill, Herbert W., Jr. and Weissman, Julia: *The Fabric of the State.* New York: Museum of American Folk Art, May 23–July 10, 1972.

Morris Hirshfield—1872–1946—American Primitive Painter. New York: Sidney Janis Gallery, March 2–April 3, 1965.

Kubler, George. *Santos: An Exhibition of the Religious Folk Art of New Mexico.* Fort Worth, Tex.: Amon Carter Museum of Western Art, June 1964.

Elijah Pierce: Painted Carvings. New York: Bernard Danenberg Galleries, June 6–24, 1972.

Smith, H. R. Bradley *et al. The Herbert Waide Hemphill, Jr. Collection of 18th, 19th, and 20th century American Folk Art.* Sandwich, Massachusetts: Heritage Plantation of Sandwich, May 1–October 15, 1974.

Vogel, Donald and Margaret. *Velox Ward.* Fort Worth, Tex.: Amon Carter Museum of Western Art, 1972.

Welsh, Peter. *American Folk Art: The Art and Spirit of a People.* From The Eleanor and Mabel Van Alstyne Collection. Washington, D.C.: Smithsonian Institution, 1965.

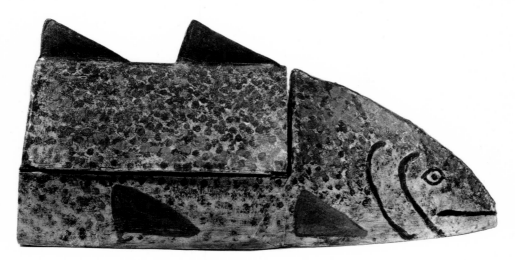

336 (above). Anonymous: *Box with Hinged Lid.* c. 1910. Painted wood and cardboard. L. 30″, Maine. Private collection. Photograph: Helga Photo Studio.

INDEX TO ARTISTS

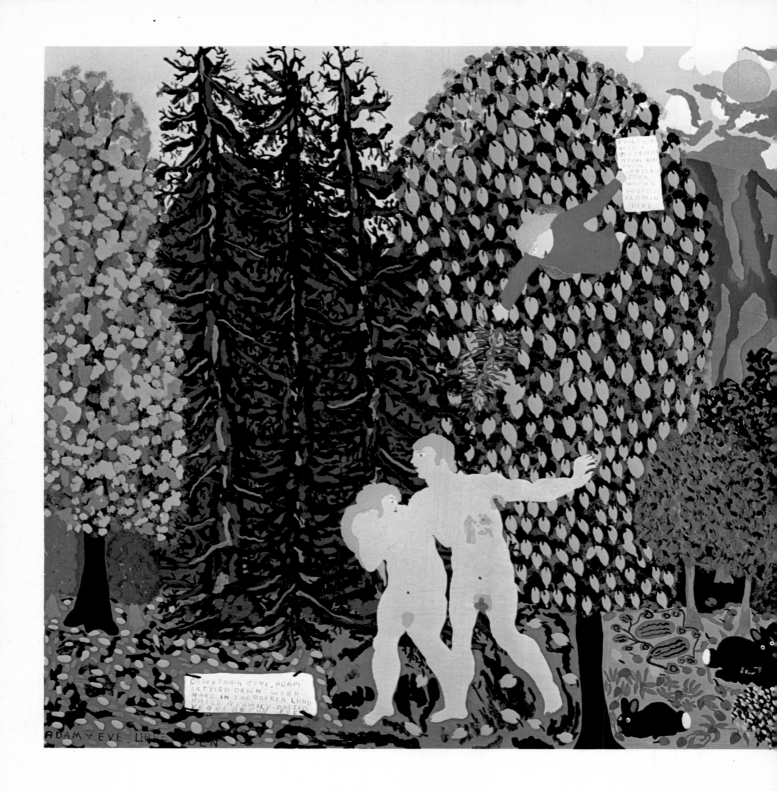

JOHN "UNCLE JACK" DEY is a 60-year-old retired policeman and former barber living in Richmond, Virginia. He was dubbed "Uncle Jack" years ago by the neighborhood children who brought their bicycles and toys to him for repairing. The nickname stuck; so Mr. Dey uses it as the signature for his paintings. Dey began painting in 1955 after his retirement from 13 years on a police beat. He paints for the pleasure of it and lets his wife make the decision about which of the paintings will be kept. Uncle Jack doesn't paint scenes of city life; he much prefers country landscapes and animals.

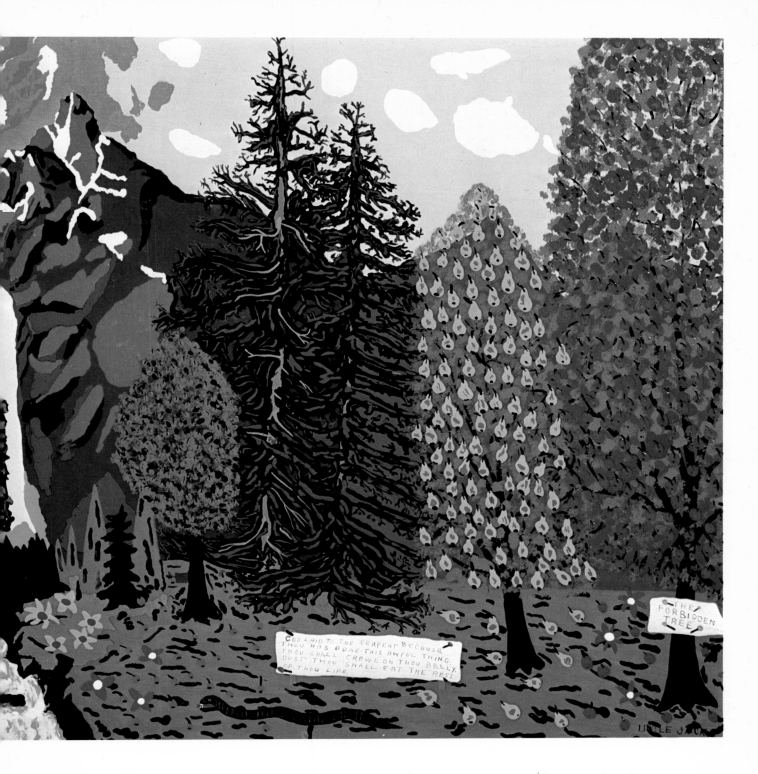

337 (above). John ("Uncle Jack") Dey: *Adam and Eve Leave Eden.* 1973. Airplane model paint on board. 23″ x 47″. Richmond, Virginia. Courtesy Herbert W. Hemphill, Jr. Photograph: Helga Photo Studio.